Bonaparte
and the British

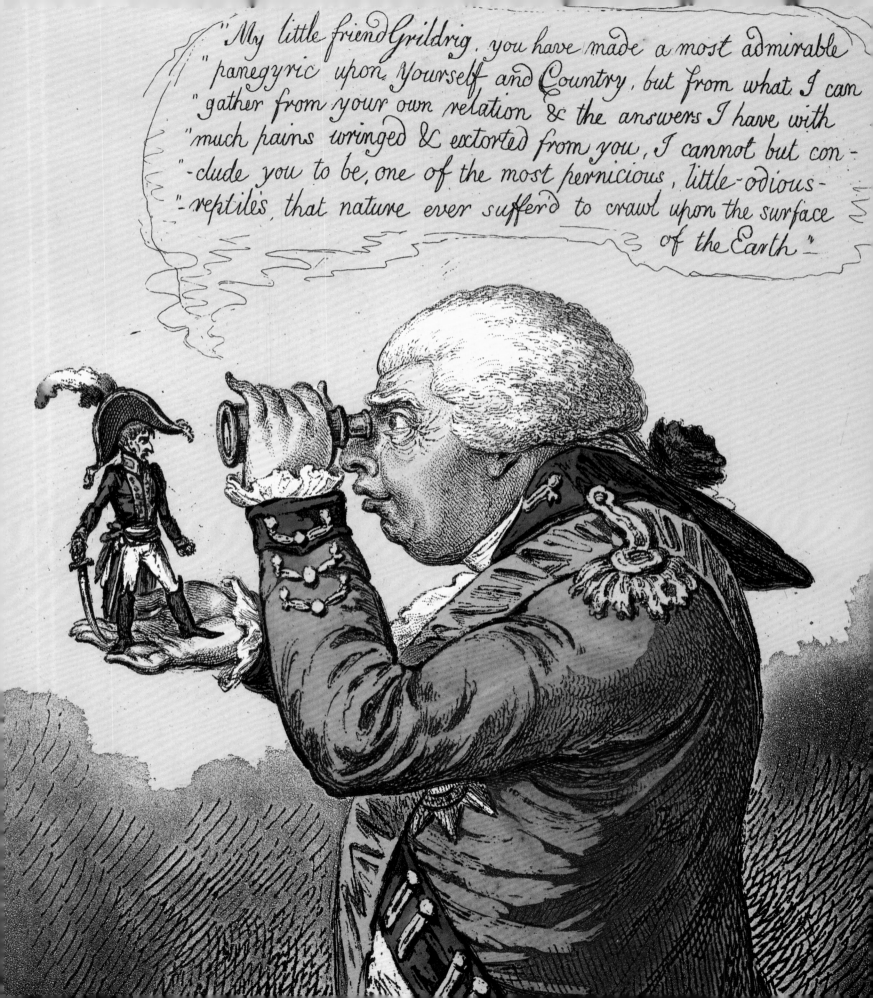

Bonaparte and the British

prints and propaganda
in the age of Napoleon

Tim Clayton and Sheila O'Connell

The British Museum

The Trustees of the British Museum
gratefully acknowledge the generous
assistance from The Charity Fund
of International Partners Limited
in memory of Melvin R. Seiden
towards the publication of this book.

Published to accompany the exhibition *Bonaparte and the
British: prints and propaganda in the age of Napoleon* at the
British Museum from 5 February to 16 August 2015.

This exhibition has been made possible by the provision
of insurance through the Government Indemnity
Scheme. The British Museum would like to thank
the Department for Culture, Media and Sport, and
Arts Council England for providing and arranging
this indemnity.

First published in 2015 by The British Museum Press
A division of The British Museum Company Ltd
38 Russell Square, London WC1B 3QQ
britishmuseum.org/publishing

A catalogue reference for this book is available from
the British Library.

ISBN: 978-0-7141-2693-7

Designed by Andrew Shoolbred
Printed in Italy by Graphicom srl

The papers used in this book are natural, renewable and
recyclable products, and the manufacturing processes are
expected to conform to the environmental regulations of
the country of origin.

Frontispiece: James Gillray after Thomas Braddyll,
The King of Brobingnag and Gulliver (detail), 1803.
See cat. 61.

Contents

Director's foreword

When the British Museum opened to the public in 1759 the country was at war with France. Wars with our nearest neighbour had been fought with disturbing regularity from the late seventeenth century as the two nations vied for power in worldwide colonies as well as nearer to home. This exhibition looks at the last great struggle between Britain and France – a war that lasted with only two short intervals from 1793 to 1815.

Our focus in this exhibition is not so much the conflict itself, but the propaganda war between the two countries. The age of Napoleon Bonaparte coincided with the flowering of the satirical print in Britain and the Museum's outstanding collection of such material includes 1,400 satires on Napoleon, many of which portray the brilliant general and formidable administrator as the ridiculous 'Little Boney'. The exhibition also includes anti-British satires, in the form of prints and medals, made as part of Napoleon's own propaganda machine.

But we hope that visitors will come away from the exhibition with a more nuanced view of cross-Channel relations than these hostile images suggest. There were many British enthusiasts for Napoleon, especially in his early days, and we are showing a number of the portraits that were published in large quantities to feed that market, some made in Britain, some in France by artists who moved from London to Paris as part of the ever shifting international art world. This to and fro of imagery is particularly apparent when we look at prints, easy to transport and an endless fund of inspiration for copyists, so that by the last years of Napoleon's power his opponents were producing the same mocking satires of the 'Devil's Darling' across the whole of occupied Europe.

We have to thank a number of lenders for allowing us to show some of the memorabilia of Napoleon preserved by his British admirers, including Sir John Soane's Museum, the Wellington Collection at Apsley House and others who wish to remain anonymous. We are also grateful to The Charity Fund of International Partners Limited for funding the publication of this catalogue in memory of Melvin R. Seiden who admired the work of James Gillray, the great printmaker whose magnificent satires are central to this exhibition; and to the Gamboge Group for supporting the costs of transport and installation. We are particularly grateful for the continuing support of the Paul Mellon Centre for Studies in British Art, who have over many years done so much to allow the Museum to make its collections available to a wide public, both virtually through our online database and through exhibitions like the present one. The Paul Mellon Centre's generosity enabled Tim Clayton's role as co-curator of the exhibition working with Sheila O'Connell from the very earliest stages of structuring the narrative and selecting exhibits from many thousands of possibilities; we are particularly glad to be able to bring to light his new research on Napoleon's use of prints as propaganda, an area which has until now been surprisingly little examined.

Neil MacGregor
Director, British Museum, London

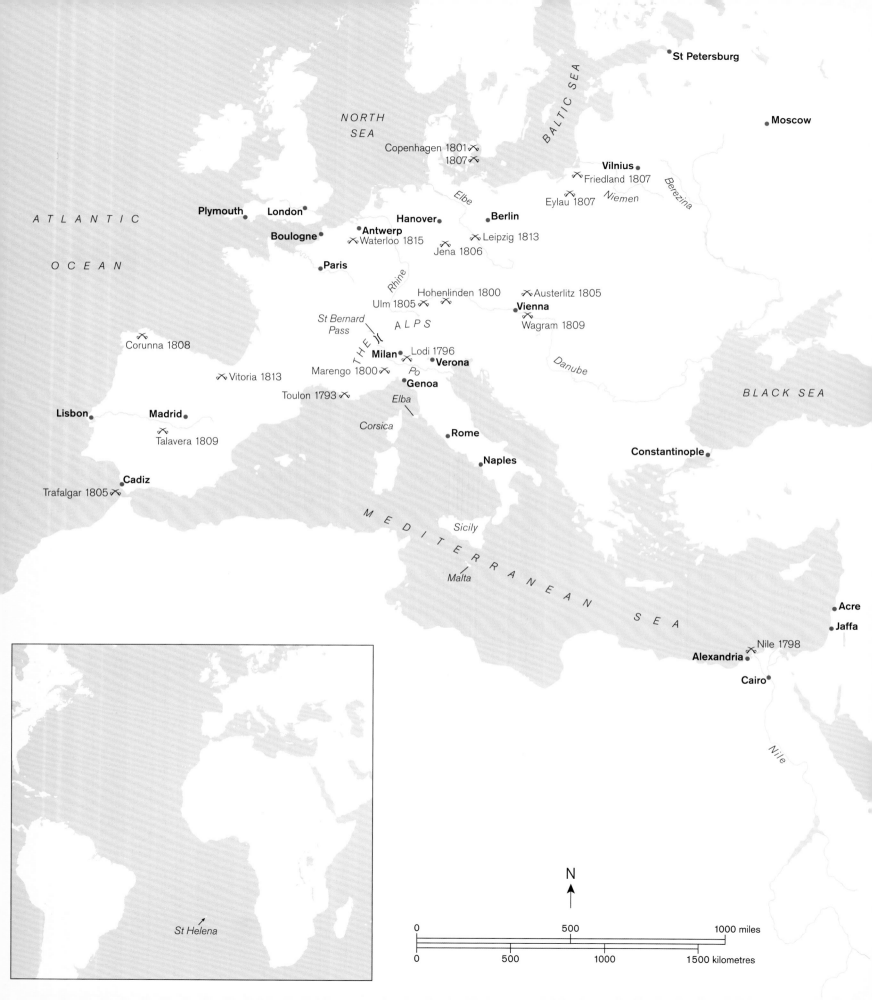

NORTH
SEA

ATLANTIC

OCEAN

BALTIC SEA

St Petersburg

Moscow

Copenhagen 1801
1807

Vilnius

Friedland 1807

Eylau 1807

Niemen

Berezina

Elbe

Plymouth

London

Hanover

Berlin

Boulogne

Antwerp

Waterloo 1815

Leipzig 1813

Jena 1806

Paris

Rhine

Hohenlinden 1800

Austerlitz 1805

Ulm 1805

Vienna

Wagram 1809

St Bernard
Pass

ALPS

Corunna 1808

Milan

Lodi 1796

Danube

Marengo 1800

Po

Verona

Vitoria 1813

Toulon 1793

Genoa

Elba

BLACK SEA

Lisbon

Madrid

Corsica

Talavera 1809

Rome

Cadiz

Naples

Constantinople

Trafalgar 1805

MEDITERRANEAN

Sicily

SEA

Malta

Acre

Jaffa

Nile 1798

Alexandria

Cairo

Nile

St Helena

N

0 500 1000 miles

0 500 1000 1500 kilometres

Authors' note

Napoleone Buonaparte was born to Italian-speaking parents. He started to use the French form Napoleon Bonaparte consistently from 1799. From 1804 he was Napoleon I, Emperor of the French. The British, who did not acknowledge his title as legitimate, continued to call him Bonaparte or, if really hostile, Buonaparte. We intend, for the sake of convenience, to use Bonaparte and Napoleon as interchangeable synonyms without any intended nuance.

Other names have been anglicized as was usual during the period. Place names are likewise given in the form that was used at the time in Britain. Punctuation and spelling have been silently modernized in quotations from English; quotations from other languages have been translated by the authors.

Prints and other objects not included in the exhibition are identified by the name of the institution holding them, followed by a reference number, e.g. British Museum PD 1994,0515.12 or British Library Add MS 27,337.

Republican calendar

The French Republican calendar was introduced in 1793. It was calculated from the foundation of the Republic on 22 September 1792, which became the first day of *L'an 1*. The year was divided into twelve months of thirty days each, plus five additional days. The names given to the months reflect the seasons: *Vendémiaire*, *Brumaire*, *Frimaire*, *Nivôse*, *Pluviôse*, *Ventôse*, *Germinal*, *Floréal*, *Prairial*, *Messidor*, *Thermidor*, *Fructidor* (Grape harvest, Fog, Frost, Snow, Rain, Wind, New growth, Flowering, Meadow, Harvest, Heat, Fruitful). The months were divided into three ten-day units and each day was given the name of a plant, animal or agricultural tool. The days were divided into ten hours, each hour into one hundred minutes, and each minute into one hundred seconds.

In 1806 France returned to the Gregorian calendar.

Legal deposit of prints

In July 1793 a decree from the French government required that 'Every citizen who publishes a work of literature or print of any kind, shall be obliged to deposit two examples of it at the National Library [Bibliothèque nationale] or the Print Room of the Republic, for which he will receive a receipt signed by the librarian, without which he cannot pursue legal action against counterfeits.' The precise rules changed under the Empire but the principle remained the same.

From 1795 to 1811 about 2,000 entries of legal deposit (sometimes consisting of more than one print) were recorded in manuscript registers by the Department of Prints of the National Library. About 198 entries were made between 1810 and 1811 in the General Journal of the Printing Office and about 109,000 entries were made in the journal *La Bibliographie de la France* from 1811–80. The legal deposit was made more frequently with expensive prints where copyright protection was considered worth obtaining; publishers of cheap prints rarely bothered to make the *dépôt légal*. Thus only a proportion of prints that were published appear in the registers and journals, but for those that were listed they provide dates of publication and other invaluable information. The information is readily searchable via the indexes on the *Image de France* database (https://artfl-project. uchicago.edu/content/image-france).

There is no equivalent record of print publication in Britain. Laws had been in place since the sixteenth century requiring the registration of printed material with the Stationers' Company, but by the late eighteenth century few prints were registered. Copyright was obtained simply by engraving the publisher's name and the date of publication on the plate: for this reason nearly all British prints of the period were dated.

Chronology

1769 Birth of Napoleon.

1782 Samuel William Fores sets up his caricature shop in Piccadilly, London.
By this date Hannah Humphrey's caricature shop is in Bond Street, London.

1783 William Pitt becomes prime minister of Britain, aged 24.

1787 William Holland moves his caricature shop to Oxford Street, London.

1789 Start of the French Revolution.

1792 The First Coalition against Revolutionary France is formed, lasting until 1797; the main allies are Austria, Prussia, Spain and Britain.
Founding of the Association for Preserving Liberty and Property against Levellers and Republicans, at the Crown and Anchor Club in the Strand, London (1792–3).

1793 Execution of Louis XVI.
France declares war on Britain.
Royalist insurrections in the Vendée and Brittany.
Siege of Toulon.
The 'Terror' (September 1793–August 1794).
William Holland is imprisoned in Newgate, London, for a year for selling a pamphlet by Thomas Paine.

1794 Habeas Corpus is suspended for a year in Britain.
The Whigs in parliament are split and the majority, led by the Duke of Portland, unite with Pitt's government to support the war.

1795 Napoleon disperses a Royalist insurrection in Paris on 13 *Vendémiaire* with a 'whiff of grapeshot'.
The Treasonable Practices Act and the Seditious Meetings Acts are passed in Britain.
The Cheap Repository for Moral and Religious Tracts is set up by Hannah More in London.
Rudolph Ackerman sets up his printshop at 96 Strand, London.

1796 Napoleon marries Josephine de Beauharnais.
Napoleon's first Italian campaign.
James Gillray is arrested for publishing a caricature attacking the Prince of Wales and his political allies.

1797 The Treaty of Campo Formio ends Napoleon's Italian campaign.
The Treaty of Tolentino allows for the removal of works of art from Italy to France.
Napoleon prepares for the invasion of Britain.
British naval mutinies at Spithead and the Nore.
The Bank Restriction Act is passed in Britain.
Assessed taxes are tripled in Britain.
Gillray's government pension of £200 a year begins (running until 1801, and probably renewed in 1804 or 1807).
George Canning sets up *The Anti-Jacobin*, a weekly newspaper published in London that runs from November 1797 to July 1798.
Hannah Humphrey moves her caricature shop to St James's Street, London.
Rudolph Ackerman moves his printshop to 101 Strand, London.

1798 Napoleon's Egyptian campaign.
Nelson becomes a national hero after the Battle of the Nile.
Austria, Prussia and Britain form a Second Coalition against Revolutionary France lasting until 1802.
United Irishmen rebellion.
The Defence of the Realm Act encourages the creation of local armed volunteer associations throughout Britain.
Death of Richard Newton, aged 21.
The Anti-Jacobin Review runs from 1798–1821.
The journal *London und Paris* is launched in Weimar.

1799 Napoleon becomes First Consul after the coup of *Brumaire*.
Income Tax is introduced in Britain.

1800 Napoleon leads his army across the Great St Bernard Pass.
Napoleon's army defeats the Austrians at Marengo.
General Moreau's army defeats the Austrians at Hohenlinden.
Attempt on Napoleon's life – the *Machine infernale*.

1801 Union of Great Britain and Ireland.
Pitt resigns as prime minister, and is succeeded by Henry Addington.
Tsar Paul I assassinated.
Treaty of Lunéville between France and Austria.
Napoleon builds a camp at Boulogne in preparation for an invasion of Britain.
Napoleon signs the Concordat with Pope Pius VII.
The French army in Egypt capitulates to the British.

1802 Treaty of Amiens between France and Britain.
The Rosetta Stone and other antiquities acquired by Napoleon's savants are presented by George III to the British Museum.
William Cobbett begins to publish his weekly *Political Register* in London, at first strongly anti-Napoleon but from 1804 increasingly critical of the British government.

1803 War resumes between Britain and France.
Robert Wilson's *History of the British Expedition to Egypt* is published in London.

1804 Georges Cadoudal's 'Grand Conspiracy' to assassinate Napoleon leads to the kidnapping and execution of the Duke of Enghien.
Napoleon becomes Emperor of the French.
Pitt returns as British prime minister.
Thomas Tegg moves his book and print shop to Cheapside, London.

1805 Austria, Russia, Britain and Sweden form a short-lived Third Coalition against France and Spain.
Napoleon accepts the surrender of the Austrian General Mack at Ulm.
Nelson's fleet defeats a Franco–Spanish fleet at Trafalgar; death of Nelson.
Napoleon's army enters Vienna.
Napoleon's army defeats those of Emperor Francis of Austria and Tsar Alexander at Austerlitz.

1806 Death of William Pitt in January.
William Wyndham Grenville, Baron Grenville becomes prime minister with Charles James Fox as Foreign Secretary in the so-called Ministry of All the Talents.
Death of Charles James Fox in September.
Napoleon institutes the Continental System according to his Berlin Decree.
Prussia joins Austria and Britain in a short-lived Fourth Coalition against France.
The Confederation of the Rhine is founded.
Napoleon's army defeats the Prussians at the battles of Jena and Auerstädt.

1807 Napoleon's army defeats the Russians and Prussians at the battle of Friedland.
Treaty of Tilsit between France, Russia and Prussia.
A British fleet attacks Copenhagen.
Napoleon's army enters Spain and invades Portugal.
Grenville's ministry is replaced by one led by the Duke of Portland.

1808 Joseph Bonaparte becomes King of Spain.
John Hookham Frere is sent as plenipotentiary to Spain.
The first satirical print signed by George Cruikshank, aged 16, is published; the subject concerns the Peninsular War.

1809 Austria forms the Fifth Coalition with Britain.
Napoleon's army defeats the Austrians at the battle of Wagram.
A British expedition to the island of Walcheren at the mouth of the River Scheldt ends in failure.
Napoleon divorces Josephine.
Portland is replaced as British prime minister by Spencer Perceval.

1810 Napoleon marries Marie-Louise of Austria.

1811 Prince Napoleon François Charles Joseph Bonaparte is born and given the title King of Rome.
George, Prince of Wales, becomes Prince Regent of Great Britain and Ireland.
Gillray works on his last etching.

1812 The Sixth Coalition is formed; the main allies are Russia, Austria and Britain.
Wellington's Anglo–Portuguese army defeats the French at the battle of Salamanca.
Napoleon's army invades Russia and is forced to retreat from Moscow.
Russian anti-Napoleon prints begin to appear.
War between Britain and America until 1814.
Assassination of the British prime minister, Spencer Perceval; he is replaced by Robert Jenkinson, Lord Liverpool who holds the office until 1827.

1813 Wellington's Anglo-Portuguese-Spanish army defeats the French at the battle of Vitoria.
Napoleon's army is defeated by armies of Russia, Prussia, Austria and Sweden at the battle of Leipzig.
Anti-Napoleon caricatures are distributed widely across Europe.

1814 Coalition forces enter Paris.
Napoleon abdicates and is exiled to Elba.
Death of Empress Josephine.
Representatives of the European powers meet at the Congress of Vienna.

1815 Napoleon returns to France for the 'Hundred Days'.
A Seventh Coalition is formed of all the major European states.
Battle of Waterloo.
Napoleon abdicates a second time, surrenders and is exiled to St Helena.

1821 Death of Napoleon.

Introduction

This is the story of the greatest ever self-made man, the Corsican captain of artillery who became Emperor of the French, and of his struggle against a people he admired but who became his inveterate enemy. Between Napoleon's first fight with the British in 1793 and his final defeat stretched twenty-two years of warfare, Britain's greatest war, a war in which the country came perilously close to catastrophe but that ended with its triumph as the world's dominant power. The climax was an appallingly bloody battle fought near Waterloo in present-day Belgium two hundred years ago on 18 June 1815. Young men fighting at Waterloo had not been born when the conflict commenced.

Napoleon was born in Corsica in 1769, a year after the formerly Genoese island became French. In 1756 Corsican patriots led by Pasquale Paoli had driven out their Genoese overlords, but in 1768 the island was taken over by France. Napoleon's father, a lawyer and a nobleman, though not wealthy, had been a key supporter of Paoli and his son also shared Paoli's Anglophilia. Napoleon was an admirer of Britain's seventeenth-century struggle for liberty: he annotated a history of England more than any other of the books he possessed as a youth and wrote a gothic novel, *Le comte d'Essex*, about resistance to tyranny set in the reign of Charles II. Being technically a French nobleman, Bonaparte was able to attend the French artillery school and become an officer, but his sympathies lay with reform and in 1789 he welcomed the French Revolution. In Spring 1793 when the French National Assembly executed the Bourbon King Louis XVI and declared war on Britain, Napoleon continued to distinguish the hostile British government led by William Pitt from the potentially sympathetic British people, a stance he maintained to the end of his days.

Bonaparte first fought the British in that year at Toulon where he was placed in charge of the artillery that drove a foreign fleet out of the rebellious port. In storming a British-held fort he was wounded in the calf by a sergeant's pike. However, his role at Toulon was barely noticed in Britain and he first came to prominence after he became general of the Army of Italy at the time of his marriage to Josephine Beauharnais, a celebrated beauty, born in Martinique and the widow of an aristocrat guillotined in 1794 during the period of mass executions of 'enemies of the revolution' known as the 'Terror'. Through a rapid series of victories Bonaparte drove the Austrians out of Italy and set up an independent Cisalpine Republic, ruled from Milan. The Protestant British enjoyed his humiliation of the Pope, whose northern territories were ceded to the new Republic by the Treaty of Tolentino in 1797.

Britain continued the war and the French government labelled the British 'vampires of the sea', announcing that 'the liberty of nations demands that we should exterminate them and we shall exterminate them'.[1] Having liberated Italy, Bonaparte hoped to release Britain from tyranny next. He proclaimed in his newspaper, the *Courrier de l'armée d'Italie*, that William Pitt fought because only war could distract his people and neutralize the seeds of insurrection, his government must be annihilated and Bonaparte and the children of the victorious people would do it.[2] General Bonaparte was put in charge of the Army of England (the army which was prepared for the conquest). Prints envisaged a balloon-borne invasion, a tunnel, submarines and an enormous raft. At this point, in 1797–8, with much of the fleet in a state of mutiny, Pitt's government was indeed worried that Bonaparte might be welcomed in.

Bonaparte realized that any attempt to cross the Channel would be foiled by the Royal Navy and so he turned his sights east. He landed in Egypt with an army and a band of scientific advisers, but Admiral Horatio Nelson located and, with brilliant audacity, destroyed his fleet, a feat that turned Nelson into a British national hero. Marooned in Egypt,

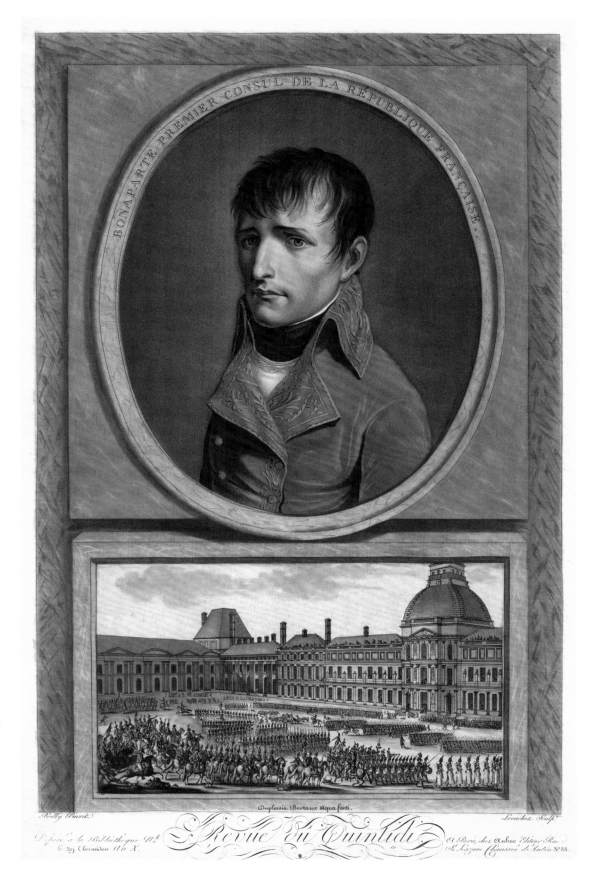

Fig. 1
Charles François Gabriel
Levachez (active 1780–
1820) after Louis Boilly
(1761–1845) and Jean
Duplessi-Bertaux (1747/50–
1819/20)
*Bonaparte, premier consul
de la Republique Française*
and *Revue du Quintidi*
Published by Auber, 1802
Etching and aquatint;
422 x 275 mm
Library of Congress,
Washington D.C.
PC5-1810, no. 2

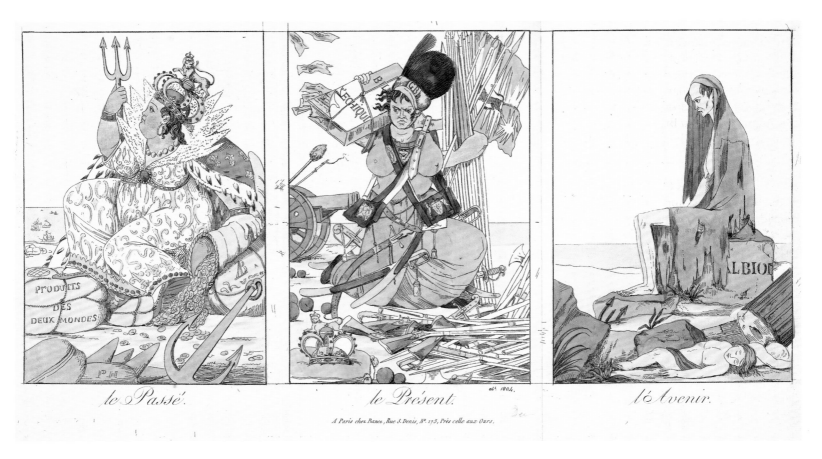

le Passé.

le Présent.

l'Avenir.

A Paris chez Bance, Rue S. Denis, N° 175, Près celle aux Ours.

Fig. 2 *Le Passé. Le Présent. L'Avenir*
Published by Jacques Louis Bance, 1803
Hand-coloured etching; 205 x 393 mm. 1868,0808.7311

Napoleon's attempt to march towards India in the footsteps of Alexander the Great was then foiled when a naval detachment under Commodore Sir Sidney Smith prevented the capture of Acre.

Returning to France, Bonaparte staged a coup in November 1799 and became First Consul (fig. 1). At Christmas he wrote to George III proposing peace. Lord Grenville, the Foreign Secretary, replied requiring the restoration of a legitimate Bourbon king or, failing that, a stable, trustworthy government, before peace could be negotiated. Once it became clear that Bonaparte was not about to facilitate a Bourbon restoration, French Royalists funded by the British government attempted to assassinate him. With troops supported by British subsidies, Austria tried to defend the territories it had taken back in northern Italy but was defeated by Napoleon at the battle of Marengo. In the background negotiations continued and peace was finally agreed in 1801. The Treaty of Amiens was signed in 1802.

Peace and Napoleon were hugely popular in Britain and people flocked across the Channel in both directions for business and pleasure. The 'Washington of France'

entertained British admirers including the Opposition leader Charles James Fox. During the peace Bonaparte's government made good and lasting reforms to French law and education, invited back those exiles who would return on his terms, reached agreement with the Pope to allow Catholic worship, and attempted to restore French authority in the colonies, notably in Saint-Domingue (Haiti).

Peace endured only fourteen months before the British renewed hostilities by attacking French ships. In retaliation Napoleon invaded Hanover and prepared to invade England. To fund the enterprise he sold the Franco–Spanish claim to 'Louisiana' to the United States – thus doubling their territory. This paid for more than 2,000 barges to carry 150,000 men, 11,000 horses and 450 cannon across the Channel. Napoleon pumped out propaganda, denouncing Britain as a mercenary maritime tyranny and echoing the words of the Republican Roman statesman Cato: 'No peace with Pitt: Carthage must be destroyed'.[3] The French cast themselves as Republican Rome and Britain as Rome's bitter rival, Carthage, the maritime, commercial power that Rome eventually destroyed. One writer attacked British perfidy

saying 'the nations that you call to your aid [should] combine to treat you as another Carthage, to annihilate you utterly, so that no trace remains of the ancient existence of Albion but a little scattered debris, covered with corpses and battered by the waves.'[4] One of many caricatures published at this time, *Le Passé. Le Présent. L'Avenir* (fig. 2), envisaged just this outcome. The estimated 20,000 Britons who had visited Paris during the peace had been observed with interest: they were seen as avaricious, ugly, greedy, drunk, indifferent to women, proud and taciturn.

Meanwhile, James Gillray's lean, sallow, thoughtful, driven 'Little Boney' appeared in 1803. With a huge propaganda effort, but widely supported by local patriotism, the British government easily persuaded most Britons that they were fighting militaristic France led by a tyrant, rather than the beneficent exporter of liberty of Napoleon's self-image. His enemies' view of Napoleon was confirmed by his reaction to another British-sponsored plot to assassinate him in 1804. Suspecting that the Bourbon Duke of Enghien was involved, Napoleon had him kidnapped from neutral territory and shot after a hurried trial. The British denied their part in the plot and focussed on the murder of the young duke in much subsequent anti-Bonaparte propaganda.

Napoleon decided in 1804 to crown himself emperor, a move that was encouraged by renewed war with Britain and Royalist plots that raised his popularity in France. For some time he had been behaving like a monarch with all the trappings of royalty and in some respects the coronation merely made the distinction formal. He hoped his title might make his regime more stable.

In early 1805 Napoleon wrote again to George III to propose peace, this time with the authority of an emperor, but his overtures were again rejected. Britain tried to form an alliance with Russia and Austria, offering huge subsidies to help them pay their troops, while Napoleon had himself crowned King of Italy. He forced an Austrian army to surrender at Ulm, captured Vienna and destroyed an Austro–Russian army at Austerlitz.

Meanwhile, in October his navy was decisively defeated at Trafalgar but Admiral Nelson was killed.

Bonaparte dissolved the Holy Roman Empire, created a Confederation of the Rhine from German allies on the river's eastern bank, and made the rulers of Württemburg and Bavaria kings. His elder brother Joseph became King of Naples and soon afterwards he made his younger brother Louis King of Holland. The defeat at Austerlitz was said to have broken the heart of Prime Minister Pitt who succumbed to exhaustion and alcoholism in January 1806.

With Charles James Fox in the Foreign Office, peace talks began in April 1806 but foundered over a French demand to occupy Sicily, where a British army maintained the rule of the Neapolitan Bourbons. The death of Fox in September ended any hope of peace and negotiations concluded in

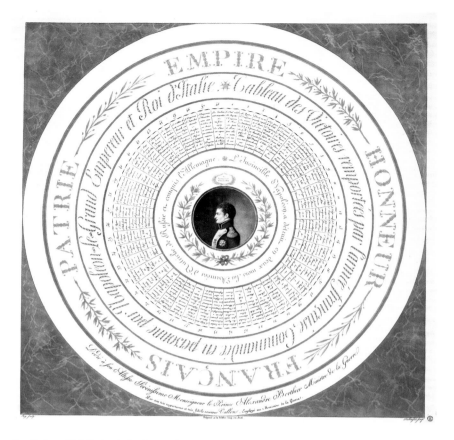

Fig. 3 Roy with lettering by Lachaussée
Tableau des Victoires remportées par l'armée française, 1806
Aquatint, printed in colour; 436 x 454 mm. 1925,1215.7

October. Meanwhile, Napoleon attacked Prussia, destroyed its army in twin battles at Jena and Auerstädt, and marched into Berlin (fig. 3). He created the Duchy of Warsaw, to be ruled by his new ally the former Elector, now King, of Saxony.

After a bloody draw in the snow at Eylau in early February 1807, Napoleon won a decisive victory over the Russians at Friedland in June and held peace negotiations at Tilsit in July. Agreement with Alexander was premised on their common hatred for the British: the Tsar is supposed to have said, 'Sire, I hate the English as much as you do!' and Napoleon to have replied, 'In that case peace is established.'[5] King Frederick William of Prussia was forced to make concessions and much Prussian territory was incorporated into a new kingdom of Westphalia, to be ruled by another of Napoleon's brothers, Jerome.

Bonaparte now had most of Europe under his control and attempted to destroy Britain economically by closing the Continent to British trade. This 'Continental System' had been inaugurated in November 1806 with the Decree of Berlin. In autumn 1807 he invaded Portugal through Spain in

order to enforce the System. Then, in April 1808 at Bayonne, he pushed Charles IV of Spain into transferring the throne to his son Ferdinand VII. Napoleon then forced Ferdinand to abdicate and moved his brother Joseph from Naples to rule as king. Spain promptly rose in revolt and some regional *juntas* (local administrations set up by patriotic insurgents) asked for British assistance. The Spanish victory at Baylen in July brought Napoleon to Spain with 200,000 men and his armies drove back British forces that had advanced from bases on the west coast of the Peninsula.

In 1808 a history of France for children announced that 'all of Europe apart from Sweden had closed her ports [to Britain]: the French flag flies at Lisbon, and the time is perhaps not far distant when it will fly in an India delivered from its oppressors' and Napoleon would reap 'the glory of delivering the seas from English tyranny'.[6] For two periods between July 1807 and July 1808, and between spring 1810 and December 1812, the trade embargo was strictly enforced and did serious damage.

Napoleon's invasion of Portugal in 1807 and the takeover of Spain in 1808 had the adverse side effect for France of opening Portuguese Brazil and Spanish American markets to Britain that had been coveted for centuries. Meanwhile, the Continental System and the restrictions imposed in turn by the Royal Navy did serious damage to all the port cities of Napoleonic Europe and to the lands that had exported raw materials and agricultural products to Britain. The combination of the impairment of trade and the costly provision of ships and troops put a terrible financial burden on Napoleon's allies, most notably Holland. It became ever more apparent that the internal economy of Europe was run for the benefit of France alone.

April 1809 saw revolts against French rule in Tyrol and Westphalia and war with Austria. The British, struggling financially, could not afford much aid and the Prussian king refused to join in a national rising. In June, Napoleon annexed the remaining Papal States with the result that the Pope excommunicated him, and was himself imprisoned for the next five years. In July, Napoleon crushed the Austrians at the battle of Wagram and a British army landed on the Dutch island of Walcheren in an invasion that was to end in misery with nearly half the troops falling ill with malaria. In 1810 Sweden joined the Continental System and France annexed Holland, Oldenburg, the richest part of Hanover and the Hanseatic towns in order to try to eradicate the smuggling of British goods into the Continent. Having divorced Josephine, who could not provide him with a son, Napoleon married Marie-Louise of Austria, who bore him an heir with Habsburg blood.

As France grew more powerful so Napoleon became more bullying and high-handed. His image of concern for the welfare of the peoples of Europe was more and more unconvincing, most obviously in his treatment of Holland, where he ousted and exiled his own brother Louis for putting Dutch interests above those of France. All of this alarmed Alexander of Russia, in whose empire the Continental System was having a dire effect on the economy. Between 1806 and 1812 exports dropped by two fifths, while customs revenue fell from 9 million roubles in 1805 to 3 million in 1808. The embargo on trade with Britain proved, in the words of a Russian countess: 'even more oppressive for those who had undertaken it than for those against whom it was directed'[7] France and Russia squared up to each other and Napoleon was drawn into an attack.

Meanwhile, the British army in Portugal, commanded by the future Duke of Wellington, had received reinforcements. In January 1812, Wellington's troops stormed and sacked the fortress of Ciudad Rodrigo and in April, at heavy cost in lives, that of Badajoz. The withdrawal of French troops from Spain for the Russian campaign allowed Wellington to take the offensive and in July he won the battle of Salamanca. After early successes, the Russian campaign ended disastrously for the French: as the army retreated through the snow, first horses, then troops froze to death or starved, harried mercilessly by Cossacks. Napoleon hurried back to Paris to deal with domestic threats.

Desperate recruiting produced another army for Napoleon, but it was very young and inexperienced. Two early French victories dented the resolve of the Russians and Prussians but Wellington's success in Spain at the Battle of Vitoria in June 1813 encouraged them and they pressed on into Saxony to be joined by the Austrians. At the huge battle of the nations around Leipzig, the French army was defeated and forced into retreat. German allies deserted the French and Napoleon's army retreated west of the Rhine. Wellington had already crossed into France and Holland rose in revolt.

Napoleon fought a brilliant campaign to defend France but the odds against him were too great and in the end some of his Marshals changed sides and he was forced to abdicate. He was exiled to rule the tiny island of Elba with a band of grenadiers and a few loyal followers, while Louis XVIII became King of France. Neither Louis nor his courtiers endeared themselves to the French and within a year Napoleon returned with his Elban troops. The army grew as he marched north and the King fled. Having had his peaceful overtures rejected out of hand, Napoleon attempted to take on the combined might of Europe, inspiring his army with revolutionary ideas of expelling kings and foreign princes. His massive military gamble almost came off when he made a surprise invasion of the new Kingdom of the Netherlands, but in a final bloodbath at Waterloo just south of Brussels, he could not break British, Netherlands and German infantry, who were determined to hold out for Prussian reinforcements. After a second abdication Napoleon tried to escape to America, then surrendered to a British

warship and asked for asylum in Britain. The government refused and shipped him to St Helena, a lonely island in the South Atlantic where he died in 1821.

Throughout Napoleon's career, with just one brief interlude, Britain had refused to accept peace, maintaining that Bonaparte's professed goodwill was never sincere. A wry commentator, Richard Whately, exaggerated only slightly when he exclaimed in 1819 that:

> Bonaparte prevailed over all the hostile States in turn *except England*; in the zenith of his power, his fleets were swept from the sea *by England*; his troops always defeat an equal and frequently superior number of those of any other nation, *except the English* – and with them it is just the reverse: twice, and twice only, he is personally engaged against an *English commander and both times he is totally defeated, at Acre and Waterloo; and to crown all England* finally crushes his tremendous power, which had so long kept the continent in subjection or in alarm; and to the *English* he surrenders himself prisoner![8]

Britain also took the reward. During the war the country had come perilously close to economic collapse but its financial resources were exceptionally strong. The government built up a national debt of £850 million, being 200% of GDP, a figure matched since only at the close of the Second World War when British power finally waned.[9] After Waterloo, however, at the end of what was then known as the Great War – the Napoleonic War – the opportunities gained for British commerce were enormous, and the country, soon also calling itself an Empire, recovered rapidly.

The fall of Napoleon was greeted with general rejoicing in Britain: the poets Wordsworth and Southey, once admirers of Napoleon, danced round a bonfire on Skiddaw, feasting on roast beef and plum pudding. Waterloo instantly became a centre for British tourism. But there were exceptions: the fall of Napoleon drove the Opposition leader Samuel Whitbread to suicide and the writer William Hazlitt spun into a six-month drunken binge, lamenting 'the utter extinction of human liberty from the earth'.[10] The sentiment was shared by Lord Byron (see cat. 155).

During the Napoleonic Wars, Britain's self-image as an island apart from Europe, cultivating global trade, was ingrained in national consciousness. Britain's self-confidence soared after Napoleon's defeat and British greatness was measured against the colossus it had defeated. Walter Scott's *Life of Napoleon Buonaparte* (1827) was massively popular. After the struggle for Reform was won in 1832, Napoleon became more of a hero. More books were written about him in English than about any other man.[11] Marie Tussaud's unrivalled Napoleon collection, begun in 1834, was the heart of her museum in Baker Street and the period around 1900 saw the creation of huge Napoleon collections as well as major biographies and other studies by Britons, the most relevant to this exhibition and catalogue being the print collection of A.M. Broadley whose *Napoleon in Caricature* (London and New York 1911) remains an important source.[12]

Napoleon remained an object of fascination in Britain and even of adulation. The astonishing achievements of one man in so small a time inspired awe, which no amount of misgiving could entirely dispel. 'We may safely say that no subject was ever found so inexhaustibly interesting', wrote Richard Whately.[13] In the nursery, Bonaparte remained a bogey figure – 'Boney will come for you', naughty children were told. We are used to hating our enemies wholeheartedly – Hitler has few redeeming features. But Bonaparte was different. Bonaparte always had potential for good: he was a fallen angel rather than unadulterated evil, and even if viewed as a villain, he always commanded the admiration of his enemies. 'He was and will remain the greatest man of his time' wrote Sir Walter Scott. 'Napoleon, for or against?' remains a famously teasing question.[14]

1 'Circulaire' by Talleyrand of 24 December 1797 in Bertaud 2004, p. 40.
2 *Courrier* (10 November 1797) in Bertaud 2004, pp. 37–8.
3 Ibid.
4 P.F. Barbault-Royer, *Résumé sur l'Angleterre*, Paris 1803, p. 15 in Bertaud 2004, p. 53.
5 Tulard 1984, p. 148; cf. Bertaud 2004, pp. 88–9.
6 C.J.F. Girard de Propiac, 'Histoire de France de la jeunesse' (1808), p. 662 in Bertaud 2006, p. 217.
7 C. Esdaile, *Napoleon's Wars: an International History*, London 2007, p. 435.
8 Bainbridge 1995, p. 7; R. Whately, *Historic Doubts relative to Napoleon Buonaparte*, London 1819, pp. 39–40.
9 In the present financial crisis (2014) the national debt is about equal to GDP.

10 On Whitbread see Lean 1970, pp. 106–11; Duncan Wu, *William Hazlitt, the first modern man*, Oxford 2008, p. 180.
11 Lean 1970, p. 284.
12 Broadley's collection was purchased by Lord Curzon in 1916 and bequeathed by him to the Bodleian Library in 1926. Broadley lists other major Napoleonic print collections in his preface, Broadley 1911, pp. xii–xiii.
13 Whately 1819, op. cit. n. 8, p. 12.
14 Scott in Bainbridge 1995, p. 9. See also Pieter Geyl's brilliant historiographical study, *Napoleon: For and Against*, London 1949.

The London print trade: commerce, patriotism and propaganda

The London print trade and the caricature shops

During the second half of the eighteenth century, print publishing in London saw a remarkable period of growth, and by the late 1780s it had displaced Paris as the most dynamic centre of the print trade. British designers and engravers were highly fashionable and their products were considered to be equal or superior to those of other nations, selling widely as well as being copied across Europe. Most of the prints in this exhibition are either 'fine art' prints or caricatures, but both were branches of a large and wide-ranging industry. The output of printed images was huge, encompassing the whole range of what today might be covered by photography, including fine art, architecture, garden design, topography, landscape, portraiture, military scenes, sport, flowers, insects, animals, technical and scientific illustration, comedy, games, as well as prints of topical incidents and satire. Fans, pots, tiles and textiles all bore printed designs. They ranged from the very fine and expensive to the very crude and cheap.

A French art journal commented in 1803 that 'English engravers being so numerous, their productions have become for England a pretty significant branch of commerce. Many of them are exported to foreign countries and especially to Germany, where English caricatures are also sold, despite the fact that people there are familiar with neither the people nor the facts which make up their subject.'[1] It is possible that this article merely plagiarized the remarks of Pastor Wendeborn of the Lutheran Church in Ludgate, who had already asserted in 1791 that, like other English prints, caricatures went 'in great quantities over to Germany, and from thence to the adjacent countries', but it was true, nevertheless.[2] From about 1787 caricatures were occasionally reviewed in the German periodical press and Hamburg was home to English bookshops and at least one English-language newspaper that carried advertisements for prints.[3] Foreign interest in caricatures is indeed surprising for many caricatures relied on verbal humour for their comic impact and few foreigners spoke much English – although in Germany, especially, knowledge of English was growing fast. Most prints that anticipated foreign sales carried inscriptions in French – then the international language – as well as English, but few caricatures bore bilingual inscriptions.

The most profitable prints to export were expensive and of high quality, reproducing old master and contemporary fine art or decorative designs to be displayed on the wall. The typical routes into Germany were from Antwerp to the Rhine, through Bremen and the Weser, or Hamburg and the Elbe. British goods were shipped into Italy through Livorno, and Russia through St Petersburg. France (via Calais) was also a significant market and in Paris there had been shops specializing in English prints for many years.[4] In 1798 the German periodical *London und Paris* announced that a newly opened printshop in Paris stocked a large collection of English caricatures.[5] This may possibly have been the same enterprise that issued a catalogue in 1798–9 (Year VII) of 'English prints and caricatures offered for sale at the great print gallery at the former Capuchin convent in the Place Vendôme'.[6] Abraham Raimbach, returning from Paris to London in 1802 found himself obliged to wait in an ante-chamber of the French passport office at Calais that was decorated with caricatures of members of the Addington administration by James Gillray.[7]

Fig. 4 James Gillray (1756–1815) after John Sneyd (1763–1835)
Very Slippy-Weather
Published by Hannah Humphrey, 10 February 1808
Hand-coloured etching; 252 × 194 mm. 1851,0901.1248
Presented by William Smith

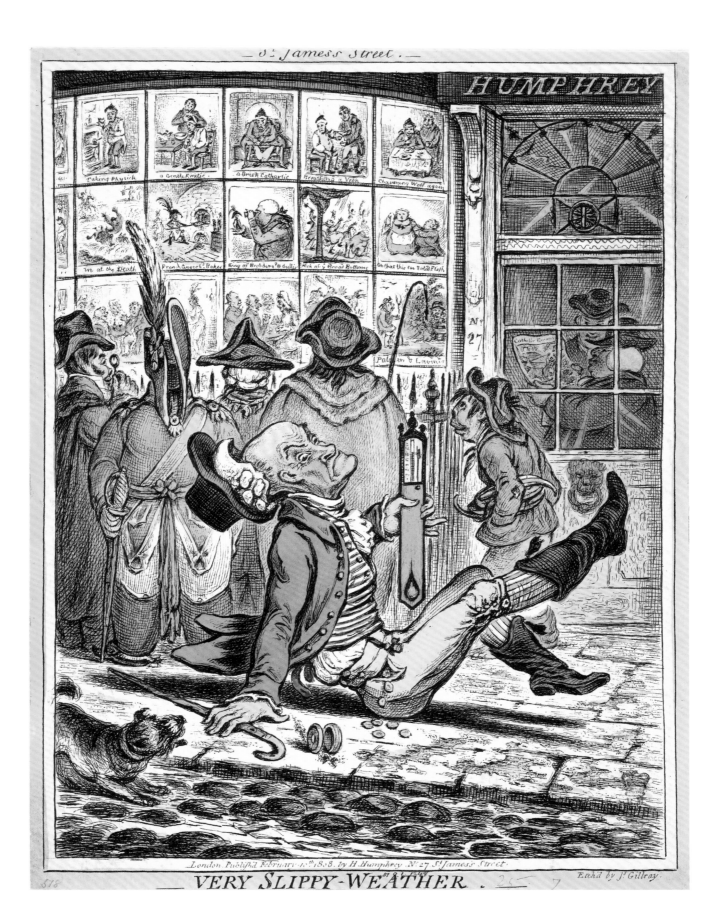

By 1787, Spain was also eager for British prints and the greatest of the merchant printsellers, John Boydell, had placed a consignment said to be worth £1,500 with the Madrid bookseller, Antonio Sancha.[8] Boydell became Lord Mayor of London on the back of this trade and other printsellers, such as Robert Sayer, made large fortunes, while top engravers who sold their own work also did very well. However, the French invasions of the Netherlands and the Rhineland, and Bonaparte's incursion into Tuscany, did significant (and deliberate) damage to British mercantile trade and several printsellers failed or retired in consequence. Valentine Green was in the midst of publishing the Elector Palatine's magnificent art collection in 1798 when the French bombardment of Düsseldorf, 'laid the castle, and the gallery which adjoins it, in ruins, destroyed, together with a very considerable property belonging to Mr. Green and his colleagues'.[9] Green went bankrupt. William Dickinson also suffered a bankruptcy and moved to Paris; John Raphael Smith retired from trade, selling many of his plates to Rudolph Ackermann and in 1803 even the Boydells were in deep trouble, having suffered heavily following Napoleon's seizures of British goods that year.

Although exporters were affected badly by the wars, the home market did not collapse. Political satire usually thrived during wartime and there was a strong demand for military prints that documented and celebrated the events of the war. Tourism within the British Isles flourished, so many views were published, while field sports and racing generated sporting prints and these were also the great years of the coloured – often colour-printed – aquatint, imitating the effect of watercolour. New publishers came to the fore, most notably Edward Orme and Rudolph Ackermann.

Political satire was a specialized sector of this trade, originally sold by those booksellers who dealt in political pamphlets, but by 1796 it was chiefly the province of specialist caricature shops, some of which still also sold pamphlets. Caricature drawing – the exaggeration of physical features – had caught on as a fashionable pastime for amateur artists around 1750 and had been introduced into political satire during that decade. James Gillray was the most talented of a generation of artists born in the mid-century who took caricature to a new level by designing larger and more ambitious etched satires. The increase in size and more frequent application of colour to caricatures was pioneered by the talented amateur designer Henry Bunbury and his publishers James Bretherton and William Dickinson, who in the 1770s had both established shops in Bond Street, in the fashionable residential area of the West End. Specialist caricature printsellers set up in Mayfair and St James's during the 1780s: Samuel William Fores established a 'Caricature Warehouse' in Piccadilly in 1782; by the same year Hannah Humphrey was established in Bond Street; William Holland moved to Oxford Street from Drury Lane about January 1787.

Their choice of location implies that they all hoped that the same fashionable, wealthy and politically active people might buy their product.

By 1796 Gillray was working exclusively for Hannah Humphrey (1750–1818), the sister of his first significant publisher, William Humphrey (1745–c. 1810), who had himself abandoned publishing in favour of dealing in prints, and 'carried on this trade for many years with great success, and imported more curious English Portraits than any other individual, and was of the greatest service to the collections of the late Earl of Orford [Horace Walpole], Sir William Musgrave, Messrs Bull, Storer, Cracherode, Bindley, Tighe, Sykes, &c &c &c'.[10] William Humphrey was in Holland in 1802, doing business with Charles Howard Hodges, an English mezzotint engraver residing in Amsterdam (see cat. 4) and wrote to Gillray to ask for a supply of prints to sell there. Hannah's elder sister Elizabeth ran the London shop of her husband the mineralogist Adolarius Jacob Forster (1739–1806), who also had a shop in Paris and major interests in Spain and St Petersburg, where he died in the middle of a huge deal with the Tsar worth 50,000 rubles. Elizabeth Forster and Forster's nephew and successor Henry Heuland (born Johannes Heinrich Heuland in Bayreuth) witnessed Gillray's will in 1807. Hannah's oldest brother George was an expert international dealer in shells and other curiosities. The Humphrey family was thus extremely well networked into the international world of 'curiosity' at the highest level. Hannah moved from Bond Street to 27 St James's Street (fig. 4) in 1797, close to the official royal residence and centre of political power, as well as to the most influential political clubs, and Gillray lived with her. Their relationship became intimate – just how intimate is not known and George Canning's reference to Hannah as Gillray's 'concubine' may have been jocular.[11] Hannah's main business was in caricature but she did publish and sell some other fine prints.

Samuel William Fores (1761–1838) set up as a caricature printseller as soon as he reached twenty-one. He moved from no. 3 to a larger shop at no. 50 Piccadilly in 1795 where he sold books and stationery as well as prints. He was enterprising and came up with several gimmicks for increasing sales. He issued a number of prints that protested against the government clampdown on free expression in the 1790s, but the names of his many children, who included Horatio Nelson Fores and Arthur Blücher Fores suggest patriotic enthusiasm for the war against Napoleon.

William Holland (1757–1815) 'was himself a man of genius, and wrote many popular songs, and a volume of poetry, besides being the author of the pointed and epigrammatic words which accompanied most of his caricatures'.[12] He certainly designed, and probably also etched, some of his caricatures which were so sympathetic to the political radicals that *The Times* referred to him as 'a great Jacobin'.[13] He had literary tastes and used Garrick's Richard

as a shop sign, presumably a copy of Hogarth's famous painting of the actor in that character. A number of the prints and pamphlets Holland advertised in 1787 were more or less pornographic and he had been targeted by moral reformers as well as political reactionaries some time before he was arrested for selling the radical Thomas Paine's *Letter to the Addressers* in December 1792. The prosecution claimed that it was an odd departure for a printseller to start selling pamphlets, but Holland had always sold such things; he had, in fact, actually published another of Paine's pamphlets.[14] He was fined £100 and imprisoned in Newgate for a year in 1793–4 during which his time wife died. There had been an outbreak of typhus at Newgate but according to the notice of her death, 'the sufferings of her husband … agitated a mind of uncommon sensibility till her feelings preyed upon her life'.[15]

Though other figures, notably James Aitken, made significant contributions at times, these three printsellers dominated the caricature market until 1798 when they were joined by Rudolph Ackermann (1764–1834), for whom caricature was but one of many branches of a business driven by restless entrepreneurial energy and enterprise. Born at Stollberg near Leipzig, Ackermann trained as a carriage designer in Germany, Basel, Paris and Brussels, and was highly successful in that career, producing a state coach for George Washington and, eventually, the design for Nelson's funeral carriage. He arrived in London in 1787 and married an Englishwoman, establishing himself first as a carriage designer, then as a drawing master and finally in the later 1790s as an art dealer and print publisher, acquiring imposing and historic premises in the Strand near Somerset House that from 1798 he called the Repository of Arts, a name he also gave to an illustrated monthly periodical published from 1809 to 1828.[16] Ackermann maintained his links with Germany and there was Austrian capital from Prince Philipp von Liechtenstein behind the expansion of his business, but he was solidly behind the British government. From the first caricatures that he published in 1798, his output was robustly patriotic and by 1803 he was passionately opposed to Napoleon.[17]

Since the 1750s, comic or 'droll' designs had been sold by the most important commercial print businesses of Robert Sayer and Thomas and John Bowles, as well as by a few other printsellers. These 14 x 10 inch mezzotints were very rarely political, but embraced themes of urban life, introducing caricature to the middling classes of Westminster and London, the provinces and colonies.[18] They continued to be published throughout the period, often duplicated in etching and sometimes as large, cheap royal sheet etchings and woodcuts, these being the cheapest forms of decorative print. Both firms were loyalist, the Bowleses had been High Tory all century; one member of the family, John Bowles (1751–1819), was one of the most active of anti-Jacobin pamphleteers. They avoided divisive politics in their publications and

James Whittle (a successor to Sayer) told William Hone, 'no change – church and state, you know! – no politics, you know! – I hate politics!'[19] His firm did, however, move into etched caricatures during this period.

After 1800, a number of other caricature publishers set up in the City of London, often sharing the preference for social over political satire, and selling prints for a cheaper price than in the West End. Piercy Roberts took over much of Aitken's stock of copper plates after his 1801 bankruptcy and ran a shop in Holborn between 1801 and 1806, before in turn selling his plates to Thomas Tegg. The most successful of all the new figures, Tegg set up a book and printshop called the Apollo Library at 111 Cheapside in 1804.[20] He sold his cruder prints for a standard price of 1s., being half the price charged in the West End by the shops of Fores, Humphrey and Ackermann. Tegg's output tended to be less political and was aimed at a broad market in the provinces and colonies as well as the City, on the business model of the old Bowles and Sayer firms. Like them, and like John Boydell, he increased his stock of plates by buying up second-hand plates from publishers who retired or went bankrupt, and he used the same method on a large scale with books. He launched the *Caricature Magazine* in 1806. Some of the new printsellers, however, developed a very radical political agenda after about 1811 and their output included savage attacks on the Prince Regent. By this stage, caricature had established itself as an important mainstream branch of the print trade (see cats 109, 125, 139, 150).

There is no simple model for the production of a caricature print. It was probably sometimes the case that an artist invented a design and then sold it to a printseller. It is most unlikely that an artist ever etched a plate and then tried to sell it to a publisher because the risk of financial loss was too great if the idea was rejected. Most ideas for caricatures were discussed and approved before being made and it was often the case that it was the printseller rather than the artist he employed who devised and selected ideas. Gillray's privileged situation was unusual but even he must have discussed the financial potential of his ideas with Hannah Humphrey. It cannot be stressed too strongly that profit was a principal motive for printsellers and their artists.

Frequently, ideas came from others. In the early 1760s the caricature printseller Mary Darly had advertised that she would etch and publish sketches sent to her, or that she would design and publish customers' written hints and ideas. The practice had probably been common long before that, but with political prints it was often convenient for the authorship of an idea to be a closely guarded secret. Surviving letters, instructions and drawings prove that Gillray etched or designed many ideas sent in by patrons for both social and political subjects and Samuel William Fores also advertised 'Gentlemens designs executed gratis'.[21] The German journalist Johann Christian Hüttner wrote that 'various

artists produce [caricatures] … most of them are by Gillray, Fores, Holland and Rowlandson' and he may not have been speaking from ignorance in describing the printsellers Fores and Holland as artists.[22] The publisher was likely to have been an important creative influence in the origination of the caricatures that he sold: David Alexander suggested that 'we can imagine [Holland's] print shop as a meeting place for a group of lively individuals with political, theatrical and literary interests, eager to give him ideas for new prints' and it is likely that many caricatures were conceived in such a manner. The correspondence of Gillray and his associates confirms that many of his prints evolved from suggestions and discussions.[23]

The usual result of these deliberations was a design that was passed to a printmaker who would draw it with a needle on to a copper plate laid with a wax ground. The plate was then washed with acid, which bit into the copper where it had been exposed by the etching needle. A simple design on a standard-sized plate could be etched and printed relatively quickly, allowing a speedy response to a topical incident. In 1788 Gillray charged Fores 2 guineas each for the typical size (10 x 14 inch, or 250 x 350 mm) *King Henry IVth the Last Scene* and *Bologna-Sausages*, and £1 11s. 6d. for the smaller *A Pig in a Poke*.[24]

The finished plate was entrusted to a professional printer using a rolling press. By 1790 the newly invented wove paper was preferred for its smoother surface, which took a watercolour wash better than the ridged laid paper. Once the sheets had dried, some of them were sized to prepare them for hand colouring, using watercolours and following a pattern. This process was less time-consuming once ready-prepared cakes of watercolour pigment were available to buy in the 1780s.[25] Caricatures rarely merited engraved lettering (a specialized skill), and the etched writing was usually executed by the printmaker.

Relatively high prices set limits on the circulation of caricatures and so, probably, did the print run. Evidence is scarce, but a plausible guess is that in most instances printsellers aimed at a similar total to pamphlet sellers – about 500 for a first edition. Etched plates showed wear and needed refreshing at about this stage. Where demand continued, plates were reworked or in extreme cases, duplicate plates were engraved. When publishers went out of business, other printsellers acquired their copper plates and either printed new editions or the occasional impression when required. Most printsellers had a rolling press in order to print trial proofs of finished and nearly finished plates, and this could be used to print an impression on demand for a collector. Some people wanted every print by an artist, or complete collections of a year's output, and some were prepared to buy random compilations of prints selected by a printseller.

Clever ideas were adapted and copied. On a number of occasions Samuel William Fores published fairly exact copies of plates by Gillray that were owned by Hannah Humphrey. This infringed copyright law, yet Fores went unpunished, perhaps because no customer of Hannah Humphrey would stoop to buy a Gillray idea that had not been etched by Gillray. Johann Christian Hüttner, who had probably spoken to Gillray, wrote that 'because a caricature is not the kind of thing one would care to go to law about, Gillray puts up with this piracy, without attempting to protect his property'.[26] It remained common for shops to swap stock and sell each other's prints, and all printsellers gave a discount to merchants, provincial shopkeepers and foreign dealers.

Printsellers displayed new caricatures in their windows as this attracted the attention of spectators. The German journal *London und Paris* noted that 'You will always see dozens of people standing outside the shops which sell these caricatures'.[27] All printshops, big and small, as well as provincial booksellers, displayed prints in their windows and they seem often to have chosen caricatures. The crowds that gathered outside came to be considered a nuisance, forcing pedestrians into the path of vehicles and attracting gangs of pickpockets. Whether display in shop windows is to be considered a significant factor in broadening the social diversity of Gillray's audience is rather more open to doubt: anybody might see them, but how much did those who were not potential purchasers take in? The French police studied the mood of the crowds outside print shops, and there may have been much to learn. The journalist William Cobbett reported at the time of the cessation of hostilities in October 1801 that:

> In many parts of the metropolis the language openly held, during the whole of Saturday and of Monday evenings, was infamously disloyal, not to say treasonable. At a printseller's in St. James's Street [i.e. Hannah Humphrey's], where a considerable crowd were assembled, a man approached the window, and pointing to a portrait of a Great Person [the king], not unknown to your Lordship, first made the motion of stabbing, and then of ripping up, grinding his teeth at the same time, and exclaiming, "Ah! that I would!" – Then turning to a portrait of Mr. Pitt, "Ah!" said he, "and that long fellow too," repeating, at the same time, the gesticulations expressive of his bloody wishes. After this he pointed to a portrait of Bonaparte, and taking off his hat, gave three huzzas, in which he was joined by all those around him!!!'[28]

Several printsellers opened exhibition rooms inside their shops, usually charging for admission in order to exclude undesirables. William Holland advertised in 1788: 'Holland's Caricature Rooms (fig. 5) are now open, presenting a general Exhibition of all the distinguished Caricatures that have been published the last Ten Years with many original Paintings and Drawings of high celebrity. Admittance once Shilling.'[29]

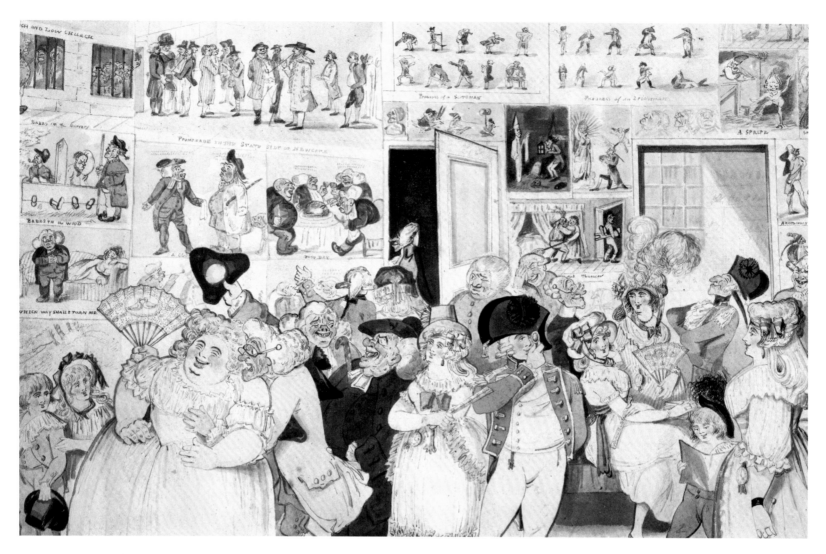

Fig. 5 Richard Newton (1777–1798)
An Exhibition of Caricatures; William Holland's Print Shop (detail), *c*. 1794
Watercolour, with pen and blue ink; 447 x 677 mm. 1876,0510.764

In 1803 he was still letting the public know that 'Holland's Laughing Lounge, or caricature Exhibition is now open. Admittance is allowed in the purchase of any print of his publishing.'[30] In December 1792, Fores announced that he had 'again opened his Caracature Exhibition Room to which he has recently added several hundred new & old Subjects admit 1*s*.', and by the following March he was offering 'compleat Sets of Caricatures on the French Revolution' and showing 'a Complete Model of the Guillotine'.[31]

Although most printsellers operated from London, temporary exhibitions were sometimes established in other cities. In 1792 the *Caledonian Mercury* noted one in Edinburgh:

This week the Public have been highly entertained with an exhibition of Caricatures in South bridge-street. It

consists of an immense collection, both Political and Satirical, and is the first which ever appeared in this city. The proprietors deserve great credit for their judicious selection; as there are none which can offend the eye of delicacy, it must therefore prove a very agreeable *lounge* for the Ladies, where they will find two hours excellent and instructive amusement.[32]

This may have been the first exhibition of caricatures ever to have been held in the city but by the 1780s provincial booksellers and subscription libraries were receiving regular consignments of caricatures from London that could be borrowed as well as bought. In 1799 A. Brown of Homer's Head, Broad Street, Aberdeen, and the 'Musical Circulating Library and Reading Library (subscriptions 25*s*. a year)',

had 'Just received, a parcel of the newest CARICATURE PRINTS, at 3s. – 2s. 6d. – and 2s.'[33]

What did purchasers do with their caricatures? The majority were pasted into blank albums, either as part of a huge and methodically compiled collection or as a more casual selection to be placed in the library and pulled out on a rainy day for general amusement. Publishers offered ready-made collections of caricatures to their customers. In 1788 Holland offered 'the greatest variety in London, of political and other humorous Prints, bound in Volumes, and ornamented with an engraved Title, and a characteristic Vignette; one hundred Prints in a volume, Five Guineas plain, or Seven Guineas coloured.'[34] He claimed in 1794 to have 'the largest collection of old and scarce Caricatures in this Kingdom, which, with those of modern Date, may be arranged in Volumes, so as to form an interesting Display of Wit and Genius, like those he has had the Honour to make up for their Royal Highnesses the Prince of Wales and Duke of York.'[35] The Swedish envoy, Lars von Engeström, was another of Holland's customers, as was the Austrian envoy Count Starhemberg, who formed a large collection of caricatures (see cat. 52).

As an alternative method of collecting, in 1794 Holland offered the oeuvres of particular artists for libraries: 'Compleat Collections of the Works of Hogarth, Rowlandson, Bunbury, Byron, Woodward, Newton and Nixon, made up into Volumes, in a few Days after the Order is given.'[36] Fores, similarly, claimed in 1794 to be able to supply 'all Mr Bunbury's and Rowlandson's works'.[37] Some compiled huge collections in this way. In 1814 the *Morning Post* carried an advertisement for:

An extensive Collection of rare and valuable CARICATURE PRINTS, in twenty folio volumes, and the original works of Hogarth, bound uniformly, with the Works of Austen, R. West, Boyne, Bartolozzi, Bretherton, Collins, Sayers, T. Hook, Lord Townsend, Byron, O'Keefe, Woodward, Williams, Rowlandson, Gillray, Bunbury, and all the celebrated Satirists of the last century, forming a complete Political and Historical Elucidation of that period.[38]

Other collections were much more modest and geared to occasional amusement: Fores, Ackerman, Tegg and McCleary of Dublin all offered to lend out folios of caricatures for the evening or the weekend and Tegg published *The Caricature Magazine*.[39] Some print collectors ignored caricatures: Amabel, Lady Lucas, an assiduous collector of historical subjects and of Bunbury's social caricature, and a close follower of politics, appears to have considered political caricature beneath her consideration.[40] Another female print collector, Sarah Sophia Banks (1744–1818) owned more than 800 such prints, four of which are in the present exhibition.[41]

Many other caricatures were displayed. They were sometimes framed and glazed, or otherwise simply pinned or pasted to a surface. Holland advertised his wares 'as in the highest estimation with Ladies and Gentlemen who have embellished Dressing-Rooms, alcoves, Billiard Rooms &c.'[42] while Thomas Tegg reminded customers that 'Noblemen, Gentlemen, &c. wishing to ornament their Billiard or other Rooms, with Caricatures may be supplied 100 per cent. cheaper at Tegg's Caricature Warehouse.'[43] There was a fashion for making 'print rooms' – rooms embellished by pasting arrangements of prints directly onto their walls, sometimes surrounded by decorative borders. A caricature print room survives at Calke Abbey, and Rudolph Ackermann had George Woodward design comic borders especially for caricature prints.

Some caricature prices are known from broadsheet catalogues, newspaper advertisements and from figures etched on the prints themselves.[44] In the 1780s Holland's ranged from 1s. plain for small, single-figure caricatures, to 2s. for 10 x 14 inch plates, up to 13s. 6d. for long strips printed from several plates. Gillray's larger prints were priced between 5s. and 7s. 6d. uncoloured. Colour doubled the price. Two shillings was still Holland's price for a standard size plate in 1803, while Rudolph Ackermann's prices ranged from 1s. to 7s., with 2s. being his price also for a 10 x 14 inch plate. Samuel William Fores's prices seem to have followed the same scale. Such prices as are known from 1788 to 1789 for Hannah Humphrey and James Aitken suggest that they then charged only half or three quarters of the price that Holland and Fores were asking, but it is likely that they soon adjusted their charges upwards to match.

The vexed issue of who was the audience for caricature has no one, simple answer. The price of the more fashionable caricatures did not exclude middling people, although it certainly excluded the working classes. A footman earning £8 pa was not going to spend several shillings on a caricature, though he might have access to those that were in his employer's library, or have studied those that were displayed on his screens or walls, or he might have joined the crowd at the printshop windows. But these caricatures were not made for him. The content of the top caricatures was geared to those who were politically and socially aware and it is significant that while it existed in the late 1780s, caricatures were most frequently advertised in *The World, or, Fashionable Advertiser*, very much a society rag. Johann Christian Hüttner noted in *London und Paris* in 1806 that 'Caricature shops are always besieged by the public, but it is only in Mrs Humphrey's shop, where Gillray's works are sold, that you will find people of high rank, good taste and intelligence.'[45] Gillray's clients were generally sophisticated people and lowering the price did not change his audience: when Sir John Dalrymple insisted that he sold *Consequences of a Successful French Invasion* for 6d. Gillray was not surprised to

find that 'there has hardly been one sold but to people who would have paid Half a Crown as willingly as sixpence'.[46]

However, it is certain that the audience for caricature broadened between 1790 and 1820 and by then caricature was a vast field: there were caricatures for men and caricatures for women, sophisticated, ambivalent, layered caricatures that invited study and crude designs of which the meaning was instantly obvious. Such indicators as Gillray's ironical comments to Dalrymple suggest that it was only in exceptional circumstances that caricatures were aimed at wide, 'popular' consumption, but the Revolutionary and Napoleonic wars were exceptional circumstances. Repeated intervention in the marketplace by the government and by loyal societies changed normal conditions.

Free speech and government intervention

How much of print production was government inspired? To what extent was it propaganda and to what extent were printsellers merely responding to popular demand? We do not yet have sufficient evidence to answer these complicated questions definitively but some guidelines can be sketched out.

Caricatures were seen in several different lights. Moral reformers viewed them as salacious, prurient and corrupting, but they could be defended on the same grounds as literary satire: 'How often', wrote a Scottish journalist in 1790, '… does the bold caricature lay open to public censure, the interested intrigue of subtle politicians, the mean chicanery of corrupted courts, and the servile flattery of cringing parasites? Is it not in many cases a more effectual check on the dissolute manners of the great, than the keenest satire written for the express purpose?'[47] Others considered them as a way of tracking public opinion: 'the organ through which the feeling and the general mood of the people is expressed freely; and in that respect they are historical monuments of the time, and warning signs for the future, in any case a subject that deserves to be considered historically. They come directly from the people, and act directly on the people.'[48] But did they come directly from the people? A more cynical observer noted that though such prints sometimes expressed public opinion, they could also be used very effectively to manipulate it: 'in all revolutions caricatures have been employed to animate the people … but if it may be remarked that caricatures are the thermometer which indicates the degree of heat of public opinion, it may be remarked even more shrewdly that those who know how to master its variety also know how to master public opinion.'[49] In the case of British prints of Napoleon, there is much evidence of repeated attempts to employ caricatures as part of a campaign 'to master public opinion'.

Gillray's first known payment from the government, £20 (the cost of 200 two-shilling prints), came in 1788,[50] but it seems that along with many liberal Englishmen, he welcomed the French Revolution. At any rate such an attitude is strongly implied by his large 'history' engraving *Le Triomphe de la Liberté en l'elargissement de la Bastille* (1790), dedicated to '*la Nation Françoise – par leurs respectueux admirateurs James Gillray & Robert Wilkinson*' (*The Triumph of Liberty in the Freeing of the Bastille*, dedicated to the French Nation by their respectful admirers James Gillray and Robert Wilkinson'). The French-language inscription implies that Gillray and Wilkinson hoped for foreign sales.[51] William Holland had already expressed similar views and a similar intention to export in *La Chute du Despotisme* (The Downfall of Despotism; 1789).

If in 1790 Gillray was an admirer of the French Revolution, this did not stop him making ten anti-Jacobin prints in late 1792 and 1793 'pro bono publico' (for the public good).[52] It may be that Gillray and Humphrey were alarmed by the declaration of the French Republic, followed three months later by the execution of Louis XVI – the series includes the two most shocking prints of Revolutionary violence, *The Zenith of French Glory* and *The Blood of the Murdered Crying for Vengeance*, as well as the famous contrast of *French Liberty. British Slavery*, which was copied in Naples and in Germany.[53] But of course their prints were also designed to sell, and it is unwise to suppose that caricatures necessarily represent the views of those who etched them. The phrase 'pro bono publico' appended to Gillray's signature might have been his own ironic announcement that he was fulfilling a commission, more probably from one of the loyalist societies than from the government. In 1792 the Association for Preserving Liberty and Property against Levellers and Republicans, known as the Crown and Anchor Club, sold a print that was definite propaganda, Rowlandson's *The Contrast*, a loyalist caricature of which several plates were made, for 3*d*. plain or 6*d*. coloured, or a hundred for a guinea plain. With such a cheap price the Club sought to extend the normal market and the hundred for a guinea offer was aimed at wealthy men who might distribute them freely.[54] According to the collector Sarah Banks, the plate was 'Designed by Lord George Murray. Sent by Him to The Crown & Anchor from whence they have been distributed. & Likewise sold by Mrs Humphrey in Bond Street.'[55] The Cheap Repository for Moral and Religious Tracts run by the evangelical Hannah More from 1795 to 1798 supported these efforts by selling chapbooks and ballads emphasizing Christian moral values and driving home conservative messages with prints such as *The Riot, or Half a Loaf is Better than No Bread*. These tracts were distributed by some of the most powerful figures in the popular print market including the Dicey family, John Marshall (soon replaced by John Evans of Smithfield, see cat. 92) as well as by John Hatchard (see cats 68 and 71) and as many as two million were distributed in the first year.[56]

That is Treason Johnny

Mr BULL

Designd & Etchd by R. NEWTON

London Pub by R. Newton at his Original Print warehouse No 13 Brydges St Covent Garden. March 19 1798

TREASON!!!

19 March 1798

Fig. 6 Richard Newton (1777–1798)
Treason!!!
Published by Richard Newton, 19 March 1798
Etching; 322 × 247 mm. 1868,0808.6712

These exhortations to the people were accompanied by a crackdown on critics of the ministry and royal family. In late 1792 and 1793 the Crown and Anchor Club printed 'a large number of what they called loyal songs' and their members vowed 'to oppose, detect, and suppress, all seditious, treasonable, and inflammatory Publications, whether in News Papers, printed Hand Bills, ludicrous or caricature Prints, or in any other Mode.'[57] As we have seen, Holland was imprisoned in 1793–4. Richard Phillips was convicted for selling Paine's *Rights of Man*. One of the crimes of a Birmingham bookseller, arrested in 1793, was displaying in his shop window caricature prints of the royal family by Gillray.[58] James Aitken was apparently the Mr Aitken convicted in November 1795 for selling *Harris's List and Directory of Covent Garden Ladies* (an annual directory of prostitutes).[59] He was in prison when his shopman James Phillips, Samuel William Fores and James Gillray were all arrested in January 1796 for selling *The Presentation – or – The Wise Mens Offering* on a charge of blasphemy.[60] For Fores

and Gillray this came to no more than a warning but the government had made its point and attacks on the king and the royal family almost disappeared from satirical prints. Richard Newton resisted but he died early in 1798, shortly after publishing *Treason!!!* (fig. 6).

Gillray's arrest coincided with his first meeting with George Canning, a meeting that Canning himself engineered. Having employed the stick, the government now proffered the carrot, at least to Gillray. Between 1797 and 1801, Pitt's administration paid Gillray a pension of £200 a year as a reward for his publication of subjects suggested by ministers or sympathetic to the aims of the British government.[61] It is not yet known whether other caricaturists were rewarded except that James Sayers was certainly on the government payroll in 1790, when he was paid £125.[62] Gillray seems to have been quite content with his auxiliary role in 'skirmishing against the common enemy' and wrote of his contributions that 'as to myself, I feel no uneasiness whatsoever from what may be the result of ridiculing the Abettors of Vice & French Principles'.[63] The recruitment of Gillray coincided with the creation of the *Anti-Jacobin* or *Weekly Examiner*, the weekly newspaper that George Canning set up to counter the liberal press. This was edited by the Tory satirist William Gifford and the other principal contributors were Canning, John Hookham Frere and George Ellis. It ran only from November 1797 to July 1798, but its mission was continued by the ultra Tory *Anti-Jacobin Review* (1798–1821).

Napoleon's Egyptian campaign inspired a number of other Canningite suggestions, several connected with the *Copies of Original Letters from the Army of General Bonaparte in Egypt* (1798) that Canning edited. For *Siege de la Colonne de Pompee* (cat. 27) Canning and his friends provided long written instructions and a sketch. This sketch does not survive, but a design for Gillray's print, *French Generals Retiring On Account of Their Health* (fig. 7) was probably the work of one of Canning's associates and was followed closely by Gillray in the resulting print of June 1799 (fig. 8).

Gillray produced six prints for the bookseller favoured by Canning, John Wright. These were based on Canningite suggestions inspired by poetry written for the *Anti-Jacobin*, or as fold-out illustrations to the *Anti-Jacobin Review*. Wright published a collected edition of *Poetry of the Anti-Jacobin* (1799) with an amusing preface dated 20 November 1797 which was directed at the 'Jacobin' poets Robert Southey, William Godwin, Samuel Taylor Coleridge and William Wordsworth, then fully behind Bonaparte and liberty. The Jacobin poet, Canning wrote, was happy to sing of Bonaparte's victories when 'he should find nothing but trophies and triumphs, and branches of laurel and olive, phalanxes of Republicans shouting victory, satellites of despotism biting the ground' but given a British victory, then 'we are given nothing but contusions and amputations, plundered peasants and

Fig. 7
Circle of George Canning
French Generals Retiring
On Account of Their Health,
1799
Pen and black ink and
watercolour; 311 x 399 mm
1906,1016.18

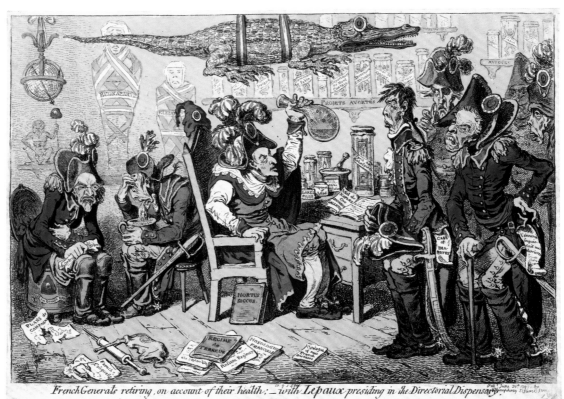

FrenchGenerals retiring, on account of their health;—with Lepaux presiding in the Directorial Dispensary.

Fig. 8
James Gillray (1756–1815)
French Generals Retiring On
Account of Their Health
Published by Hannah
Humphrey, 20 June 1799
Hand-coloured etching;
255 x 364 mm
1851,0901.984
Presented by William Smith

deserted looms.'[64] Canning had cold feet over John Wright's *de luxe* edition of the *Poetry* for which Gillray had prepared illustrations, worried that a libel trial would expose the extent of his own involvement. He wrote to John Sneyd about Gillray: 'though I should not approve of *holding out* the loss of his Pension to him as a *threat;* yet that would be the infallible consequence of any prosecution commenced against the work by any persons who may feel themselves aggrieved by it'.[65] Gillray submitted and was compensated with £150 for the suppression of his plates. Wright failed to comply with Canning's wishes, lost his government contract, went bankrupt and became an assistant to Cobbett. At that point Gillray promised Canning that 'any future work which JGy may engage in, he will take ye liberty of submitting proposals before hand to Mr Canng … very much wishing to publish only that which may give entire satisfaction.'[66] Gillray may not always have been as good as his word, but it is probably true that much of what he produced henceforth of any relevance passed under Canning's eye.[67]

Gillray received suggestions from John Hookham Frere, John Sneyd, George Ellis, William Gifford and even Pitt himself. It was Frere who came up with the idea for the large print of 'an Apotheosis of Hoche – which I suggested to Gillray'.[68] Gillray probably enjoyed working with Canning, who was a brilliantly clever satirist in his own right, and with his talented and well-informed associates; their ideas seem often to have meshed seamlessly. More than thirty plates have been suggested as Canningite ideas prior to 1801.[69]

Of this group, the Rev. John Sneyd (1763–1835), rector of Elford near Lichfield in Staffordshire, was the man who introduced Gillray to Canning. An affluent collector of Gillray's work (to whom Hannah Humphrey bequeathed Gillray's sketch books and drawings) he was an amateur artist and a frequent supplier to Gillray of both suggestions and designs (the famous *Very Slippy-Weather*, fig. 4) was designed by Sneyd). His first design may have been supplied in 1791 and he probably entertained Gillray at Elford in 1794 and certainly in 1795.[70]

Frere was a close friend of Canning since Eton. He was envoy to Lisbon in 1800, to Madrid from 1802–4, member of the Privy Council in 1805; in 1807 he was to be sent to Berlin but the mission was abandoned, and he went as plenipotentiary to Spain 1808. He was recalled from Spain after the retreat to Corunna but appointed undersecretary in the Foreign Office in 1809. George Ellis, author of *Specimens of the Early English Poets* (1790) and a scholarly medievalist, had been employed as an aide to the diplomat Lord Malmesbury since 1784. He assisted him in peace negotiations with France in Paris from 1795–7 and was an MP from 1796–1801.

Others who were probably connected with Gillray included Charles Long (1760–1838), a Cambridge friend and Parliamentary ally of Pitt, who was junior Treasury Secretary from 1791, advised Addington, and joined the Privy Council

in 1802. He was expert on artistic matters (see cat. 165) and a trustee of the British Museum. It was he in 1800 who replaced John Wright with John Hatchard as government bookseller and he may well have been responsible for paying Gillray. Charles Bagot (1781–1843), a Staffordshire connection of John Sneyd, was a Foreign Office minister under Canning in 1807 and married the niece of the future Duke of Wellington. In 1809 he was instructing French journalists in government pay on what they should and should not write about the campaign in Spain.[71]

Gillray's pension probably ended with Pitt's resignation in 1801 and was renewed either in 1804 or in 1807 – no documents have yet been found to confirm or deny Hone and Cobbett's well-informed assertions – but in between he appears to have produced several prints based on suggestions from Canning's circle.[72] He certainly also engraved a number of prints for the government in 1803, some of which are far less subtle than might normally be expected from Gillray (see cats 71, 72 and 76). However, if it was indeed the case that Gillray '*invenit et fecit*' signified a print that was entirely Gillray's own idea, then he seized credit for some of his most famous and complex caricatures of Napoleon, including *Maniac Ravings*, *The Hand-Writing Upon the Wall*, *The Plumb-pudding in Danger* and *Tiddy-Doll, the Great French-Gingerbread-Baker* (cats 60, 69, 89 and 101). Nevertheless, the first two of these express information that suggests a source within ministerial circles.

The government-inspired Gillray prints executed prior to the Peace of Amiens were all aimed at intelligent and influential customers in Britain and abroad. In 1803 there was a dramatic change in government policy with regard to propaganda with a 'hearts and minds' campaign designed to turn Bonaparte into a hate figure and justify the renewal of war. At the same time the government bought the services of the leading French-language newspapers and periodicals.

In a 'Letter to Sheridan' the 'Church and King' traditionalist Cobbett expressed his disgust at the sudden and unprincipled change of opinion from hireling writers who, having been heaping praise on Bonaparte months before, were now indulging in attacks which in many cases were 'scandalously false and foul'. The newspapers, he wrote, ushered in a government-inspired 'age of Placards, or "Patriotic Handbills" and pictures'. They called Bonaparte 'a tyrant, a despot, a cut-throat, a murderer, an assassin, a poisoner, a monster, an infidel, an atheist, a blasphemer, a hypocrite, a demon, a devil, a robber, a wolf, an usurper, a thief, a savage, a tyger, a renegado, a liar, a braggart, a cuckold, a coward and a fool'. The same writers had only recently 'extolled his character, talked continuously of his courage, his magnanimity, his wisdom, and even of his piety.'

In order to get their message across to people at a lower social level, the government resorted to placards that could be pasted on walls. 'Some of the publications alluded to,

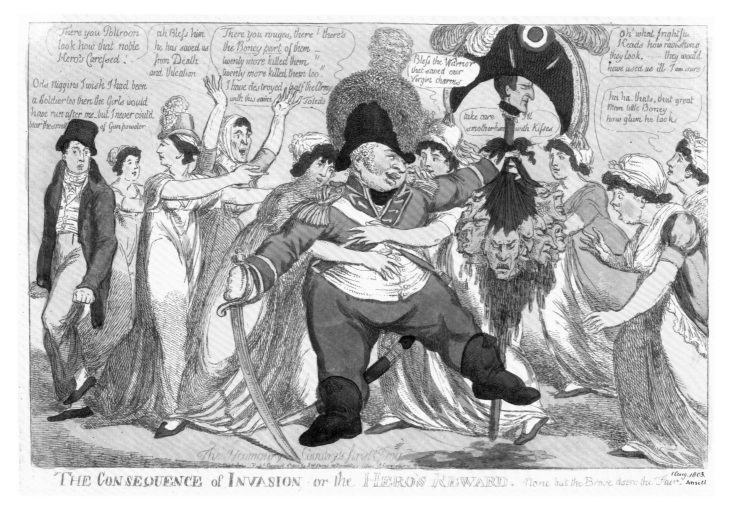

Fig. 9 Charles Williams (active 1797–1830)
The Consequence of Invasion or the Hero's Reward. Published by Samuel William
Fores, 1 August 1803. Hand-coloured etching; 248 x 352 mm. 1868,0808.7163

contained *truths*, and truths very necessary for the public to
be acquainted with; but, in the far greater part of them, the
writers seemed to vie with each other, who should invent
the most shameful, incredible, and ridiculous falsehoods,
conveyed in the lowest and most foul and disgusting
language. This was called "writing to the level of the meanest
capacity".' Cobbett felt that this unprincipled and crude
campaign had 'imprinted on the character of this nation a
stain which will not easily be effaced'.

After giving examples, Cobbett considered the contributions
of the copperplate publishers with their caricatures:

There was, and yet is, to be seen the head of Buonaparté,
severed from his body, and exhibited upon the pike
of a *Volunteer*, with the blood dripping down upon the
exulting crowd [cat. 76]. In another place [Fores's shop in
Piccadilly] you may see [fig. 9] a volunteer, one of your

favourite volunteers, having a score or two of ghastly and
bleeding French heads tied by the hair around the handle
of his pike, and hailed by a whole bevy of females, who
vie with each other to reward him with their charms,
all of them singing, 'none but the brave deserve the
fair'…. Buonaparté, the same Buonaparté, with whom
we made a peace which these printers employed all their
talents to celebrate; that same Buonaparté has been, and
now is, exhibited by them as being in the pillory, at the
whipping-post, on the gallows, at the gates of hell; and
finally, the same window, nay the same pane of glass,
which a few months ago, discovered him shaking hands
with our king while the French and English flags united
waved over their heads; that very identical pane of glass
now shows the Consul no longer in company with King
George III, but with the Devil, who has the little hero
upon a toasting fork, writhing before the flames of hell!

[cat. 72] … he certainly has been ten million times more abused, during the last six months, than ever he was before abused in the whole course of his life.[73]

While Cobbett deplored the placards known as 'Patriotic Papers', another writer who felt that they 'have assisted very powerfully in exciting the Patriotic Spirit of Britons' made a list of seventy-eight of them 'to promote their further Circulation, and to preserve the memory of these laudable and useful Efforts'.[74] A typical example described 'Napoleone Buonaparte, the Corsican Monster alias the Poisoner, who is shortly expected to arrive in England, where he means to massacre, assassinate, burn, sink and destroy.'[75] Priced at between a halfpenny and twopence depending on their size, these were made as propaganda for the common people but some, no doubt, collected them. Collection was much more obviously a motive with 'invasion prints' where publishers enjoyed, possibly with some irony, inventing any new scrape into which they could introduce Bonaparte. On 26 November 1803, at exactly the same moment that Cobbett was railing against caricatures of Bonaparte, William Holland was announcing, 'price 5s., The Funeral Procession of Bonaparte, a caricature, in two sheets, consisting of forty figures; likewise the late farce at St Cloud; the Grand Flotilla; or Bonaparte really coming; John Bull viewing the preparations on the French coast [cat. 73]; Mrs Bull viewing the same; John Bull sounding his bugle; and sixty other caricatures on the invasion, all at 2s. each.' He promised that 'Collections of all the Caricatures on the Invasion' could be 'made up at a day's notice'.[76] This was hardly panic at the threat across the Channel, nor was it even really propaganda, but rather joyous commercial opportunism from caricaturists presented with a fertile theme on which they could design endless variations. Many of the designs of 1803 were also used on printed pottery of various kinds (see cats 56–59, 77–79).

It was not difficult to unite most of the British population against France in 'its ancient character of an ambitious, intriguing military power' as Coleridge put it in the *Morning Post*, under an exceptionally capable leader.[77] Tory journalists had depicted Napoleon as the heir of atheist levelling Jacobinism; Whigs saw him as the dictator who had betrayed the liberal aspirations of the Revolution. The two strands fused in propaganda that was directed against Napoleon personally, inconsistent and all-embracing in its accusations, but effective in uniting Britons. Attacks on the government tended to be for incompetence, and there was little open dissent until 1809, when attacks on the corruption of the government and the royal family recommenced and continued with growing virulence after the Prince of Wales became Regent in 1811. A small minority, including William Hazlitt and William Hone, saw Napoleon, for all his faults, as liberty's last hope, and in 1815 supported the right of the French to choose their leader, seeing Bonaparte as infinitely preferable to the restoration of the Bourbon *ancien regime* (see cats 142, 149–150), while the government's allies tried to remind people of the usurper's ceaseless military ambition. Hone's campaign centred on a fight for the restoration of freedom of speech – one of the rights the British people were thought to have won, but which had been savagely curtailed during the Napoleonic wars.

Exporting satires: commerce and propaganda

Caricature had seemed emblematic of the freedom of expression that so marked out the British people on the Continent. Some Frenchmen found the coarseness of British caricature distasteful and believed their own preferable but, to judge from their published commentaries, Germans enjoyed the crude jokes almost as much as decoding the complexities of Gillray's more sophisticated images.[78] Gillray especially became well-known abroad: the Swiss artist David Hess called himself 'Gillray junior', while the Berliner Johann Gottfried Schadow signed his anti-Napoleonic etchings ironically: 'Gilrai a Paris'.[79] The British government seems to have made some effort to help caricatures to reach influential people in foreign countries, just as they tried to contact and influence such people through the French-language newspapers that they subsidized.[80] Viewed in this context, the collections of caricatures formed by ambassadors such as Starhemberg of Austria and Engeström of Sweden were probably not simply souvenirs of their time in London.

Until 1806 the main battleground of caricature was Germany, where French influence vied with British. Britain might be admired but the country was not much loved in Europe, where British domination of maritime trade was resented and British wealth was envied. Amabel, Lady Lucas wrote in her diary in November 1802: 'all the Court of Russia is Frenchified. And though the Germans dislike the French, yet Eight out of Ten hate England, because they think we gain their Money by Trade.'[81]

One vehicle in particular promoted sympathetic understanding of England and played a major role in popularizing English caricature. In 1798 the publisher Friedrich Justin Bertuch of the Landes-Industrie-Comptoir in Weimar launched the periodical *London und Paris*, which was edited by Karl August Böttiger (1760–1835) who was also the editor of the *Journal des Luxus und der Moden* and the *Deutsche Mercur*. Böttiger was keenly interested in British politics. He wrote that most of his 1,300 subscribers preferred Fox's Opposition to Pitt's ministry and were disappointed that with Gillray serving the ministry, Opposition views were so poorly represented in caricature.[82] This mattered because his journal was illustrated with small copies of prints from London or Paris and of its 350 illustrations in eight years, 180 were caricatures. Prints bought in London were folded

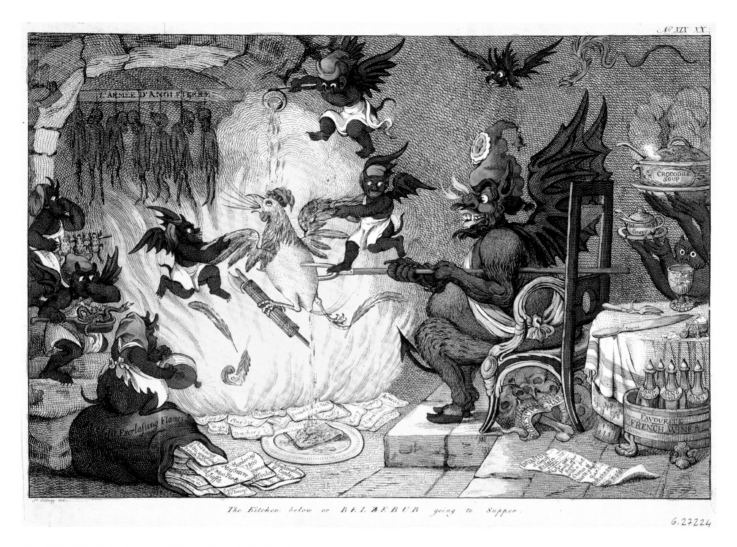

Fig. 10 Carl Starcke (active 1790–1810) after James Gillray (1756–1815)
The Kitchen Below or Belzebub Going to Supper, 1803.
Published by Friedrich Justin Bertuch in *London und Paris*, 1803
Hand-coloured etching; 282 x 356 mm. Musée Carnavalet, Paris G27124

up and sent over to Weimar by a London correspondent, usually Johann Christian Hüttner, with a description of the subject matter written on the back; others were sent from Paris by Friedrich Theophil Winckler. In total, 187 English caricatures were sent, and 60 French. Those prints that were selected for publication were copied by the printmaker Carl Starcke before being hand-coloured by semi-skilled workers who were identified by a travel writer as chiefly local young ladies and children.[83] Böttiger wrote descriptions to tell his German readers what the prints were about. A high proportion of the more important London prints published between 1798 and 1807 were reproduced in *London und Paris*. Hüttner knew Gillray and his sympathetic descriptions of the caricaturist are much more reliable than any other accounts that we have of Gillray's personality.

Böttiger liked to choose the most piquant caricatures for reproduction but local politics required self-censorship. Aware of Napoleon's campaign against personal attacks in England, the journal toned down some of Gillray's most abusive caricatures, while some French caricatures were also considered unpublishable in Weimar. *Maniac Ravings* (cat. 60) became *The Flying Sword run mad* with the raving little Boney transformed into a winged sword, while *The Corsican Pest* (cat. 72) became *The Kitchen below* with Napoleon replaced by a Gallic cock on the Devil's toasting fork (fig. 10).[84] Nevertheless, these and similar prints got Böttiger into trouble and after a French complaint he was called to account by the Weimar domestic council in June 1804. On 9 June Duke Karl August forbade illustrations 'in which political transactions and events are ridiculed or in which

Fig. 11
Anonymous after James Gillray (1756–1815)
La colera de Napoleon
Distributed by Burguillos & Quiriga, and Barco, 25 October 1808
Hand-coloured etching; 185 x 209 mm
1878,0112.43

named persons are mocked'. After Talleyrand ordered a copy of the journal in July, it was banned in French territory.[85] In March 1805 Hüttner reported that Gillray had never worked so brilliantly and 'it is just a pity that I can't send you everything that comes out about Bonaparte etc' for, he explained, there was a very good one showing the Empress and Madame Tallien dancing naked in front of Barras (cat. 86).[86] The journal decamped to Halle and then

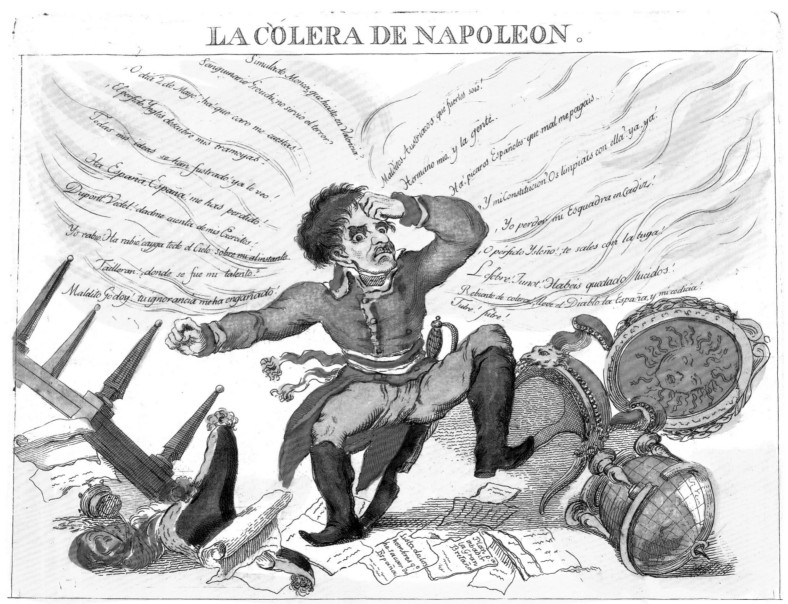

Rudolstadt, but the execution of the Nuremberg bookseller Johann Philipp Palm in August 1806 was a salutary warning; Palm is shown as one of the victims of Napoleon who come to haunt him in a print of 1814 by Cruikshank (cat. 125). Bertuch, who had published an anti-French Prussian manifesto, as well as *London und Paris*, feared that he might meet the same fate; he published no more British caricatures and after the Prussian defeats of October 1806, Napoleon could impose his will on the German press.

One German Jacobin complained that *London und Paris* was biased towards London and while Cillessen and Reichardt have argued that the apparent bias reflected choices made on qualitative rather than political grounds, the magazine did a good job in promulgating a British viewpoint.[87] It may not be insignificant that in 1807, after it ceased to be possible for *London und Paris* to publish caricatures, Hüttner, its London correspondent, was given a job through Canning as a Foreign Office translator, an early task being to translate from Spanish into German Don Pedro Cevallos's appeal to the nations of Europe on Napoleon's invasion of the Peninsula.

Rudolph Ackermann, himself a Saxon, tried to maintain close links with Germany. He was exporting caricatures to a dealer in Hamburg by 1803, was doing regular business with the Artaria family of Vienna and Mannheim and maintained a correspondence with Böttiger who helped to promote his publications.[88] In 1806 Ackermann visited Germany using false papers; at the time of the Battle of Jena in October he was in Vienna and Prague and obtained an introduction to the Emperor of Austria. As the French advanced on Berlin Ackermann fled north, reaching Hamburg by 14 November, and thence back to Britain. Ackermann's correspondence with Böttiger ended in 1806 and did not resume until 1813; and it seems that Napoleon's Continental Blockade was effective in closing most of Europe to normal British commerce; goods were smuggled but at high risk. In 1807 Ackermann organized a relief fund for the Leipzig area, transmitting many thousands of pounds to Germany in circumstances of utmost secrecy, with the probable support of the British government.[89] In the same year he proposed to the British government an aerial balloon fitted with an automatic paper distributor, which would broadcast waterproofed sheets in batches of thirty at a time over France or occupied Europe. The government provided funds for development and staged a successful trial that summer in which balloons floated from London to Salisbury and Exeter distributing sheets of paper. The subsequent report argued strongly in favour of the invention, but nothing happened, probably owing to the change of administration.

In 1808 the focus shifted to Spain as British troops arrived to support the Spanish resistance to Napoleon. British satirical prints were probably known in Spain, although evidence in the form of advertisements for their sale is lacking, but a spate of copies and adaptions of London caricatures appeared suddenly in autumn 1808. It cannot be a coincidence that this occured within weeks of the arrival of John Hookham Frere as British envoy to Spain in October 1808.

Gillray's *Maniac Ravings*, a print of 1803 (cat. 60), was adapted to become *La Colera de Napoleon* (fig. 8), advertised *Gazeta de Madrid* on 25 October as:

> A half-sheet print depicting Napoleon in his office, angry because of the unhappy news from Spain, pulling out his hair, kicking papers, chair, table, globe and whatever else comes in sight, uttering exclamations that announce his imperial and royal anger. To be found in the bookshop of Burguillos & Quiriga, and in that of Barco, calle de las Carretas, at 3 rs. in black and 6 coloured.[90]

On 28 October 1808 two prints were advertised. One might have been Gillray's original, but was more probably a close copy (see p. 169):

> The Spanish Bull-fight, or the Corsican Matador in Danger; caricature published in London on 11 July of the present year. Sold at the bookshop of Perez, calle de las Carretas, at 3 reales in black and 8 coloured on Dutch paper.

The description matches the Gillray print except for the fact that his prints were always on English wove paper, but it may be that the term 'Dutch paper' (*'papel de holanda'*) was simply used to signify good quality. The price was more or less the equivalent of 2*s*. plain, or 4*s*. coloured, which Mrs Humphrey charged for Gillray's prints of this size. A similar print was advertised alongside:

> A print representing the bull-fight in Europe, attended by all its powers. To be found in the bookshops of Escribano, Orca and of Esparza, at 2 reales in black and 4 coloured.

Three copies of Gillray's print with inscriptions in Spanish are known. The first is a close copy of the original (see p. 169) and it has been suggested that the translation of the words on the print into Spanish might betray a foreign translator, for a Spaniard would have translated beef as *carne* not *vianda*. The second, a cruder copy, probably Spanish, and with a title matching the 'bull-fight in Europe' excludes the Pope. The third is similar in all essentials to the first but less English in manner.[91]

It appears that the Spanish bull proved to be a potent image in Spain. An allegory celebrating the abasement of French pride and British triumph in Portugal, advertised on 4 November, was dedicated 'to the English inventor of the Spanish bull'.[92] Gillray's biographer Draper Hill went so

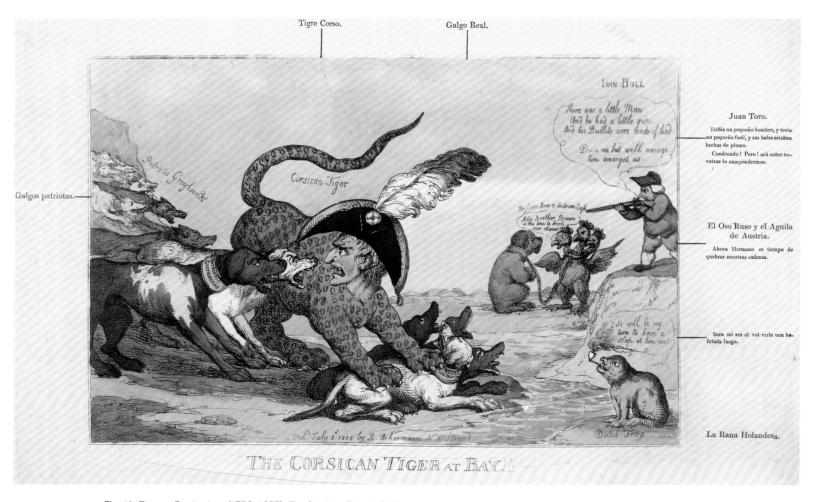

Fig. 12 Thomas Rowlandson (1756–1827), *The Corsican Tiger at Bay!!*
Published by Rudolph Ackermann, 7 August 1808
Hand-coloured etching with superimposed letterpress; 254 x 355 mm
Bodleian Library, Oxford. Curzon B.4(178)

far as to suggest that this was a tribute to Canning, rather than Gillray. On 18 November a Spanish version of Piercy Roberts's *A Gentle Salute from the British Lion* was advertised in the *Gazeta de Madrid*.[93]

Whether some of these Spanish versions might have been produced in England rather than Spain is still uncertain, but according to the advertisement that appeared on 22 November *El Rey de Brobdingnag y Gulliver examinando largamente al Señor Napoleon* was etched by a Spanish lady.[94] Its title betrays ignorance of *Gulliver's Travels*, the suggestion being that Gulliver is the gigantic king rather than the tiny man of Swift's novel, whom Gillray had portrayed as Napoleon:

> The King of Brobdingnag and Gulliver closely examining the great Napoleon; a caricature that was published in London and deserves the greatest success

for its simplicity, as funny as it is meaningful, and which has been copied recently with the greatest speed and engraved by a young lady of this court. It is to be found at the bookshops of Gomez and of Burguillos, calle de las Carretas, and in that of Esparza, puerta del Sol, at 5 rs. coloured and 3 in black; however, those who buy 15 or more examples of either kind will get an eight percent discount.

Other derivations from English prints have not been dated but probably belong to the same period. *La Desesparacion de Josefina*[95] is based like *La Colera de Napoleon* on *Maniac Ravings* with the bloated figure of Josephine taken from the *Hand-Writing Upon the Wall* (cat. 69). An impression of Rowlandson's *The Corsican Tiger at Bay*, published by Ackermann in July 1808, has been over-printed in letterpress with Spanish translations of the English text (fig. 9). This

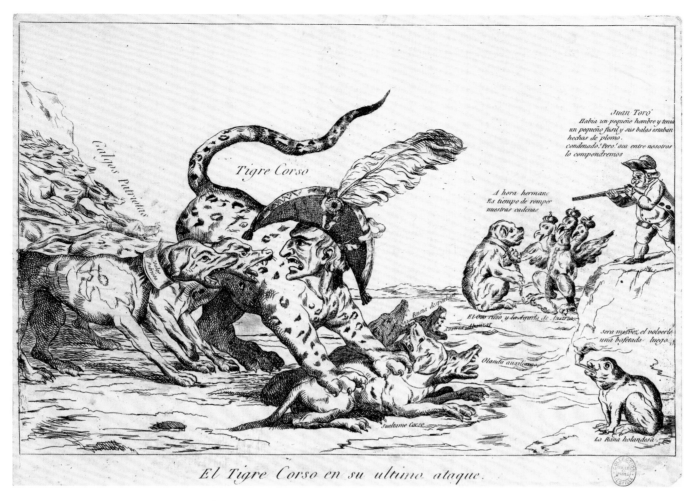

Fig. 13 Anonymous after Thomas Rowlandson (1756–1827)
El Tigre Corso en su ultimo ataque, 1808
Etching; 255 x 340 mm.
Musée Carnavalet, Paris. G27473

may have served as the template for a Spanish copy, *El Tigre Corso en su ultimo ataque* (fig. 10), on which, with the exception of a slight adjustment to the title to improve the Spanish, the letterpress wording was copied precisely in etched text.[96] Ackermann was active in the export market for both political and commercial reasons (after 1816, Spain and Latin America became extremely important markets for him – in 1826 his son George was a member of the Mexico City Cricket Club) and it is possible that he had direct personal connections with a Spanish publisher, but the presence of Frere and the Gillray copies is strong circumstantial evidence of the hand of the Foreign Office in letting Spanish opponents of Napoleon know of British support for their cause as reflected in London caricatures.

In Russia newspaper advertisements and surviving examples provide clear evidence that English caricatures were imported and the many anti-Napoleonic caricatures

produced by Russian artists between 1812 and 1814 show clear stylistic debts to British models.[97] In July 1812, the governor general of Moscow, Count Fyodor Vasilyevich Rostopchin, instigated a political print campaign that portrayed the common people resisting the French. About twenty popular prints were displayed in front of churches and probably given away. Another forty prints appeared in Moscow and some 210 in St Petersburg early in 1813, celebrating the victory over Napoleon and stressing the role of the peasants in his overthrow. The whole of this campaign was state-inspired, a number of prints had British antecedents and several were copied in Britain and elsewhere. A set of adaptations of Russian prints was etched by George Cruikshank for Hannah Humphrey in 1813 (cat. 114). The unusual alliance between Cruikshank and Humphrey might suggest Foreign Office involvement. Whatever the explanation, the English versions celebrating

the Russian effort were lettered in English and Russian, one also in German and French,[98] indicating an intention to distribute them abroad. The lesson was presumably that if the Russians could resist and drive out Napoleon, so could others.

When Ackermann resumed trade with Germany after the Battle of Leipzig in October 1813, he imported German prints as well as exporting his own. In December Ackermann wrote again to Böttiger, boasting of how much his business had grown during Napoleon's blockade and of how little effect it had had on Britain.[99] With some pride he issued a number of prints based on German prototypes: a copy of the Henschel brothers' 'Corpse Head' that he described as *A Hieroglyphic portrait of the Destroyer* (cat. 133), another of the *Head Runner of Runaways*[100] and one of *The Devil's Darling*, copied from a German print entitled *Das ist mein lieber Sohn* (cats 120–122). Versions of these prints were published in almost every country in Europe. In his *List of caricatures suitable to the present times; just published by R. Ackermann*, they were presented along with twenty other caricatures of his Corsican bête noire, such as *The Two Kings of Terror; or Death and Bonaparte* (cat. 118). Also listed was a portrait of Ackermann's personal hero, 'a most striking Likeness and highly-finished engraving of Marshall Blucher, The Terror of Buonaparte'.

As Napoleon's grasp on power loosened, some English prints began to circulate in Holland with explanatory letterpress in Dutch. In December 1813, Ackermann celebrated the liberation of Holland with *The Sea is Open Trade Revives*,[101] with bilingual lettering in English and

Dutch. Copies of English prints even began to circulate in France with lettering in French. George Cruikshank's *The Corsican Shuttlecock* was copied as *Le Volant Corse* and the British Museum's impression is inscribed in French in a contemporary hand 'this caricature and the five following were made in England' (see cat. 124).

British production of caricature prints was driven by commercial considerations, but leading British printsellers proved keen to contribute to the national struggle against Napoleon – not least because his economic campaign against Britain inhibited their commercial activities. Figures within government circles appreciated the propaganda value of caricatures and intervened at various times to employ caricature to promote their viewpoint both at home and abroad. Napoleon was acutely aware of this and took his own measures to counter the British view with printed visual propaganda of his own.

1 *Nouvelles des arts, peinture, sculpture, architecture et gravure*, III (1803), p. 282.
2 G.F.A. Wendeborn, *A View of England towards the close of the Eighteenth Century*, London 1791, I, pp. 190–2 and II, pp. 213–4.
3 Clayton 2010, p. 10.
4 Clayton 1997, pp. 274–9; A. Griffiths, 'English Prints in Eighteenth-century Paris', *Print Quarterly*, 22 (2005), pp. 375–96; Roy 2008, pp. 167–92.
5 *London und Paris*, II (1798), pp. 161 and 387.
6 The catalogue, discovered by Peter Fuhring, was described by Griffiths in

Griffiths 2005, op. cit. n. 4, p. 388.
7 T.S. Raimbach (ed.), *Memoirs and Recollections of the late Abraham Raimbach Esq., Engraver*, London 1843, pp. 104–5.
8 *The World* (3 February 1787), quoted in Wolf 1991, p. 12.
9 *Monthly Mirror* (1809), II, p. 7.
10 J. Caulfield, *Calcographiana*, London 1814, p. 6.
11 Bagot 1909, I, pp. 177–81.
12 Obituary in *Gentleman's Magazine*, 85 (1815), p. 380.

13 Donald 1996, p. 147.

14 For Holland see Alexander 1998; on his trial, pp. 34–8; on pamphlets and song-books, pp. 17–8.

15 *Gentleman's Magazine*, 63 (1793), p. 773.

16 Built as the Duke of Beaufort's London palace, the building later became the Fountain Tavern where Van Dyck's society of Virtuosi had gathered and where William Shipley had established his drawing academy.

17 See Ford 1983.

18 S. O'Connell, 'Humorous, Historical and Miscellaneous: Mezzotints, One Shilling Plain, Two Shillings Coloured', *Publishing History*, LXX (2011), pp. 83–100.

19 Donald 1996, p. 3.

20 Gatrell 2006, pp. 248–51.

21 *Public Advertiser* (1 January 1779); British Library Add MS 27,337; see BM Satires 7125 *The Scotch Arms* (1787).

22 *London und Paris*, 18 (1806), p. 7 in Banerji and Donald 1999, p. 245.

23 Alexander 1998, p. 23; British Library Add MS 27,337.

24 Letter in the Bodleian Library Oxford, Curzon Collection, b.2 (176) transcribed in Broadley 1911, pp. 36–7; the prints referred to are BM Satires 7380, 7381 and 7422.

25 In April 1781 William and Thomas Reeves were awarded the Silver Palette of the Society of Arts for the invention of the watercolour cake, see Simon, British artists' suppliers, 1650–1950 – R, and trade cards in British Museum, Banks 89.33 and Heal 89.122-132.

26 *London und Paris*, 18 (1806), pp. 7–10; see also Banerji and Donald 1999, p. 246.

27 *London und Paris*, 1 (1798), p. 23; Banerji and Donald 1999, p. 45.

28 *Letters to the Right Honourable Lord Hawkesbury* (1802), pp. 17–8; 26–8.

29 Alexander 1998, p. 19.

30 *Morning Post*, 26 November 1803.

31 British Museum PD 1851,0901.635 and 1851,0901.644; for a view of Holland's exhibition room, see British Museum PD 1876,0510.764.

32 *Caledonian Mercury*, 26 July 1792.

33 *Aberdeen Journal*, 5 August 1799, p. 1.

34 Alexander 1998, p. 19. At the time that he wrote on Newton, Alexander had not seen an example of one of Holland's collections with his title pages, but such a collection has since come to light.

35 Ibid., p. 43. The contents of the large collection of caricatures valued at £156 12s. 6d., sold to the Prince of Wales by William Holland are listed in TNA HO 70/20. See Heard 2014, pp. 33–49.

36 Alexander 1998, p. 44.

37 See, for instance, British Museum PD 1868,0822.7136.

38 *Morning Post*, 8 March 1814, sale by Harry Phillips.

39 See, for example, British Museum PD 1865,1111.2008; Gatrell 2006, p. 634, n.40; British Museum PD 1935,0522.8.164; 1948,0214.668.

40 See biographical note on p. 245.

41 See cats 76, 105, 112 and 118.

42 *The World*, 20 August 1789; for screens pasted with caricatures see Heard 2014, pp. 246–9.

43 *A Catalogue of Prints* (1805) and SLUB Handschriftenabteilung, Nachlaß Böttiger, h.37, 4°, Bd. 2, u.a. Ackermann (1803–1829, 80 Nrs.), nr.6; 'New publications by Thomas Tegg' in *Chesterfield Travestie; or a school for modern manners* (1808); ('only at 1s. each, equal to any, and superior to most, published at double the price.')

44 Holland's *Catalogue of humorous Prints, &c.* reproduced on p. 128 in S. Turner, 'William Holland's Satirical Print Catalogues, 1788–1794', *Print Quarterly*, XVI (1999), pp. 127–36. The catalogue was found in the collection formed by Lars von Engeström (1751–1826) in a volume called 'A Collection of various papers that serve to give an idea of the manners and habits of the English People collected in the years 1794 and 1795'. A number of advertisements are discussed in Alexander, 1998. A further series appeared in the society newspaper *The World* (1787–94).

45 *London und Paris*, XVIII (1806), pp. 7–10; see Donald 1996, p. 4.

46 Banerji and Donald 1999, p. 246; Hill 1965, p. 77 from British Library, Add MS 27,337 f. 20ff.

47 *The Aberdeen Magazine, Literary Chronicle and Review*, Aberdeen 1790, p. 542, in Cillessen et al. 2006, p. 8.

48 Heinrich Luden (ed.), *Nemesis*, 1 (Weimar 1814), p. 379, in Cillessen et al. 2006, p. 8.

49 Jacques-Marie Boyer de Nîmes, *Histoire de caricatures de la révolte des Français*, 2 vols (Paris 1792), I, p. 10, in Cillessen et al. 2006, p. 8.

50 A. Aspinall, *Politics and the press, 1780–1850* (1949), p. 421, cited by Alexander 1998, p. 60.

51 Robert Wilkinson, successor to John Bowles in Cornhill, published most of Gillray's serious prints.

52 BM Satires 8132, 8141, 8145, 8147, 8286, 8300, 8304, 8316, 8318, 8320.

53 C-M Bosséno, 'La guerre des estampes – Circulation des images et des thèmes iconographique dans l'Italie des anèes 1789–1799', *Mélanges de l'Ecole française de Rome, Italie et Méditerrannée*, 102 (1990), No. 2, p. 381; Cillessen et. al. 2006, pp. 166–7.

54 On this issue, see Eirwen Nicholson, 'Consumers and Spectators: The Public of the Political Print in Eighteenth-Century England', *History*, 81 (January 1996), pp. 5–21.

55 Note by Sarah Sophia Banks on the verso of her impression of the print, British Museum PD J.4.50.

56 S. O'Connell, *The Popular Print in England*, London 1999, pp.140–2.

57 *Ibid.*, pp.142–3; *Jackson's Oxford Journal*, 15 December 1792.

58 *London und Paris*, I, p. 23; Gatrell 2006, p. 494.

59 See Maxted http://bookhistory.blogspot.co.uk/2007/01/london-1775-1800.html.

60 Hill 1965, pp. 61–3.

61 George, BM Satires, VIII, pp. xii–xiii.

62 The National Archives PRO 30/8/229/2, f.209.

63 British Library Add MS 27,337 f.73 to Frere (27 October 1800).

64 G. Canning, *Poetry of the Anti Jacobin*, London 1799, p. 4.

65 Bagot 1909, p. 173.

66 British Library Add MS 27,337 f.81 to Canning (27 October 1800).

67 Canning's handling of Gillray seems to match Burrows's assessment of the way the government handled French journalists, Burrows 2000, pp. 129–30.

68 Bagot 1909, p. 143; BM Satires 9156.

69 BM Satires, VIII, xii–xiv; Hill 1965, p. 81n etc.

70 Hill 1965, p. 56.

71 Burrows 2000, p. 92.

72 BM Satires, VIII, xii–xiii.

73 Cobbett 1802–35, IV, no. 20 (19 November 1803), pp. 706–17.

74 *The British Critic and Quarterly Theological Review*, 22 (1803), p. 214.

75 Oxford, Bodleian Library, Curzon.b.9(59). This volume of 'patriotic papers' compiled by Broadley contains 148 pieces.

76 *Morning Post* (26 November 1803).

77 Samuel Taylor Coleridge, *Morning Post*, reprinted in Samuel Taylor Coleridge, *Essays on his own Times*, 2 vols, London 1850, II, p. 351.

78 *Le Journal de l'Empire* (21 March 1814), p. 4: 'For the monstrous and almost barbarous execution of English caricatures our artists have substituted a more natural design which while losing none of the grotesque physiognomy of the faces, which is essential, introduces a more realistic and wittier element.' See also Banerji and Donald 1999, pp. 36–44.

79 A. Griffiths and F. Carey, *German Printmaking in the Age of Goethe*, London 1994, p. 170.

80 Burrows 2000, p. 128.

81 Lucas Diary, vol. 20 (1802), p. 65.

82 Cillessen et. al. 2006, pp. 20–1.

83 Ibid., pp.14–6.

84 Ibid., pp. 21–2, 257 and 185–6; Donald and Banerji 1999, pp. 11–4.

85 Cillessen et. al. 2006, p. 22; Donald and Banerji 1999, p. 14.

86 SLUB Mscr. Dresd. h.37, 4°, Bd.4, Nr. 117 (24 March 1805) in Cillessen et. al. 2006, p. 23.

87 Cillessen et. al. 2006, pp. 24–32.

88 See Clayton 2010, pp. 11–7.

89 J. Ford, 'Rudolph Ackermann' in *Oxford Dictionary of National Biography*; Ford 1983, p. 32. Ford speculates that Ackermann's naturalization in 1809, 'having given testimony of his Loyalty and Fidelity to Your Majesty', may have been one result of government approval. SLUB Handschriftenabteilung, Nachlaß Böttiger, h.37, 4°, Bd. 2, nos. 7-9, dated from Vienna, Prague and Hamburg.

90 *Gazeta de Madrid*, vol. 4 (25 October 1808), p. 1364.

91 Hill 1965, p. 116; Madrid, Museo Municipal 1.A.1509; Paris, Musée Carnavalet G27354. We are grateful to Jesusa Vega whose paper 'English Satirical Prints, the Peninsular War and the new image of Spain' informed our research and to Philippe de Carbonnières and Pascal Dupuy for their help in Paris.

92 BM Satires 11061.

93 Hill 1965, p. 116 of BM Satires 11061; see the note by Antony Griffiths in *Print Quarterly*, XI (1994), pp. 48–50; *Gazeta de Madrid* (18 November 1808), p. 1510; British Museum PD 1878,0112.34.

94 *Gazeta de Madrid* (18 November 1808), p. 1526.

95 Paris, Musée Carnavalet G27355.

96 Oxford, Bodleian Library, Curzon b. 4(178); Paris, Musée Carnavalet G27473.

97 For Russian caricatures against Napoleon, the government's role in them and their relationship with English examples, see Peltzer 1985 and 2008.

98 BM Satires 12025.

99 SLUB Handschriftenabteilung, Nachlaß Böttiger, h.37, 4°, Bd. 2 [u.a. Ackermann (1803-1829, 80 Nrs.), nr. 11, 5 December 1813.

100 BM Satires 12192.

101 BM Satires 12119.

Napoleon and the print as propaganda

It is well known that from his earliest days as a general in Italy, Napoleon took a serious interest in self-promotion and the ways in which the arts could serve the greater glory of France and its leader.[1] 'We have all been enlisted,' wrote the painter Anne-Louis Girodet to his friend the singer Julie Candeille, 'even if we don't wear a uniform – paintbrush to the right, pencil to the left, forward march – and we march.'[2] Much work has been devoted to Napoleon as a patron and controller of painting, sculpture, medals, architecture, museums, music, writing, newspapers, the theatre, science and archaeology. It is remarkable, therefore, that so little has been written about Napoleon's interest in printmaking, the medium through which his interest in other visual arts was communicated to the wider world, and to posterity.[3] This is certainly not because Napoleon took no interest in prints – nothing could be further from the truth – and there is abundant evidence in his correspondence that having things engraved or etched and published was an urgent priority for him, so urgent that he wished to have plates distributed instantly, paying scant regard to the time required to engrave and print them.

On 13 May 1796 he wrote to thank Guillaume-Charles Faipoult, the French representative at Genoa, for the prints that he had sent which 'will give much pleasure to the army. Please send, on my behalf, 25 louis [roughly £24] to the young man who made them; commission him to engrave the astonishing crossing of the bridge at Lodi.'[4] It was Faipoult who introduced the painter Antoine Jean Gros to Josephine, and she took him to Milan where he stayed with the Bonapartes while he painted Napoleon's portrait, finishing it by 4 February 1797. Napoleon urged Gros to get it engraved and when Gros said he lacked the money, the general commissioned Giuseppe Longhi, the best engraver in Milan, to engrave it – remarkably fast by the standards of the time – at the cost of 250 louis, about £240 (fig. 14). Bonaparte gave the plate to Gros so that he could profit from sales, along with a 3,000 zecchini gratuity (about £1,440), although the plate remained in Milan with the engraver. *Bonaparte at the Battle of Arcola the 27 Brumaire Year V* was advertised in the *Moniteur* on 3 February 1799 at 12 francs (just under 10s.), but it became both rare and expensive until in 1801 the printseller Jacques-Louis Bance secured a regular supply to be sold at the original price of 12 francs. Bance also offered it framed at 21 francs (17s.).[5]

The portrait became iconic, but Bonaparte was fulfilling Josephine's wish to promote Gros as much as he was promoting his own image, for this was happening anyway. Such was the impression made by the slight young hero that his picture was in demand throughout Europe. Portrait prints proliferated in 1796–7: the earliest to be issued in Paris may have been the one advertised by the printseller François Bonneville in July 1796, but the drawing by Hilaire Ledru that was published by Jean-Louis Potrelle had been copied in London by May 1797; both of these belonged to a series of portraits of generals. A fine colour print by Pierre-Michel Alix after Andrea Appiani was advertised in March 1797.[6] Another influential portrait was drawn at Milan, and published there by Federico Agnelli, possibly as early as 1796, and copies were made in Augsburg and Nuremberg.[7] The portrait by Francesco Cossia (cats 2 and 3), painted in March 1797 and in circulation as a print by September 1797, was one of the earlier authentic portraits. Other early and influential images included an equestrian portrait by Philippe Auguste Hennequin that was engraved in August 1797, and one by Jean Guerin, engraved first by Elizabeth Herhan in September 1798, then by Franz Fiessinger, which was widely copied abroad.[8] Allegorical prints and 'history prints' immortalizing his moments of triumph also promoted Bonaparte's image. In May 1798 the Jacobin painter Hennequin published *The Liberty of Italy, Dedicated to Free*

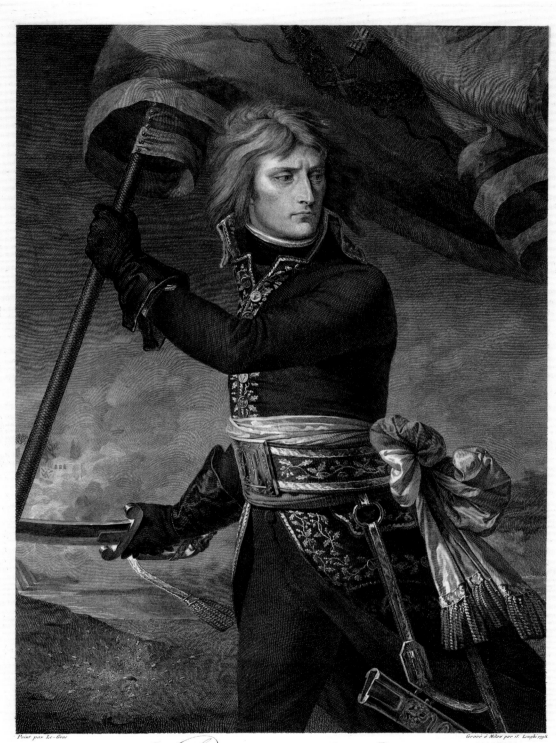

Fig. 14
Giuseppe Longhi
(1766–1831) after
Antoine Jean Gros
(1771–1835)
*Bonaparte à la
bataille d'Arcole le
27 Brumaire an V*
1798
Etching and
engraving; 497 x
343 mm
1917,1208.3789
From the collection
of Amabel, Lady
Lucas; presented
by Nan Ino Cooper,
Baroness Lucas of
Crudwell and Lady
Dingwal

Peint par Le-Gros

Gravé à Milan par il. Longhi 1798.

Bonaparte

à la bataille d'Arcole le 27 Brumaire an v.

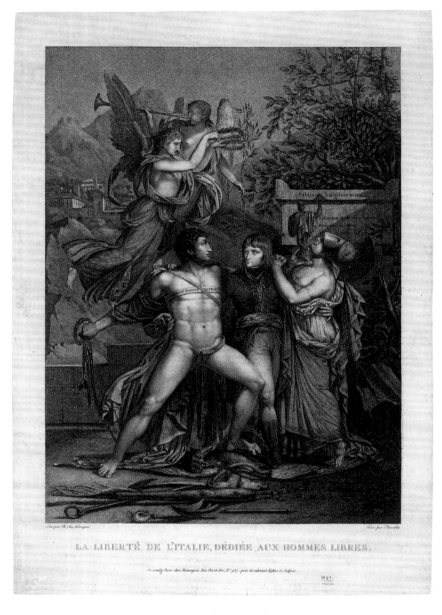

La Liberté de l'Italie, dédiée aux hommes libres.

Fig. 15 Antoine Monsaldy (1768–1816)
after Philippe-Auguste Hennequin (1762–1833)
La Liberté d'Italie. Published by Philippe-Auguste Hennequin, 30 May 1798
Etching with stipple, roulette-work and engraving; 552 x 390 mm
1861,1012.169. Presented by Henry W. Martin

Men (fig. 15).[9] The advertisement in the *Moniteur* explained what it showed: 'The French people call Italy to independence, breaking his chains and presenting him to Liberty, which he embraces. General Bonaparte is in the centre as the intermediary that France has employed to free Italy.'

General Bonaparte's fame was spread round the streets of Paris and to country towns and villages by a significant number of popular prints. *General Bonaparte Makes Peace with the Pope in the Name of the French Republic*, showing the

slim youth's triumph at Tolentino, was published in 1797. Huet-Perdoux of Orléans published *Heroic Exploit of General Buonaparte*, a version of Gros's portrait of Bonaparte planting the French flag beyond the Bridge at Arcola. In 1798 Latourmi of Orleans issued a two-sheet woodcut, *Bonaparte at the Head of his Army Accompanied by his General Officers and his Grenadiers Marching to Invade England 1798*, apparently re-using an old block.[10] The most famous dynasty of producers of French popular prints, the Pellerins of Epinal, was founded in 1800 by Jean-Charles Pellerin. His first catalogue of 1814 listed some twenty woodcuts celebrating the glorious achievements of the previous dozen years. Religious imagery included Saint Napoléon, added to the Gregorian Calendar by Pope Pius VII at Napoleon's request for 15 August (Napoleon's birthday). Pellerin was denounced and imprisoned in 1816 by Royalists who confiscated a portrait of the emperor and other prints from his daughter's bedroom, but he nevertheless continued to demonstrate Bonapartist credentials. By 1830 the business was in full flow again, run by his son-in-law, a sous-lieutenant of the 16th *chasseurs-à-cheval* who had lost a leg and won the cross of the *Légion d'honneur* at Essling in 1809.[11]

With Napoleon's encouragement, his soldiers played a major part in recording the triumphs of the army for posterity. Foremost among them were *ingénieurs-géographes*, a branch to which Bonaparte himself had once belonged. Louis Bacler d'Albe had fought with Napoleon at Toulon in 1793, and from 1799 to 1814 was head of his personal topographical office. Bacler was Bonaparte's closest military confidant, working alone with him over the map when planning marches. He was a first-class cartographer, but before the Revolution he had been a painter of landscapes and portraits of mountaineers, working in the Alps with the printseller Chrêtien de Mechel, and learning how to publish prints.[12] In Milan in 1797, Bacler published a large view of the Crossing of the Po and a companion showing the Battle of Lodi, as well as a portrait of Bonaparte, which were reissued in Paris in 1800. They were etched by Michelangelo Mercoli, who was described as a pupil of Bacler when he exhibited the Po view at the Salon of 1800. In January 1802 Bacler published *The Passage of the Great Saint Bernard by the French Army of Reserve Commanded by General in Chief Alex. Berthier, Under the Orders of First Consul Bonaparte* (fig. 16). Rudolphe Gautier of Geneva who designed the print under Bacler's supervision was another landscape painter with the rank of captain in the engineer-geographers attached to the general staff under Berthier.[13] This large print celebrated the crossing of the snowy Alps by 45,000 men and fifty cannons in order to outmanoeuvre the Austrians.

Louis Berthier, Bonaparte's brilliant long-term chief of staff, was himself an *ingénieur-géographe*. His father Jean-Baptiste Berthier had been head of the department at time of the War of American Independence and had

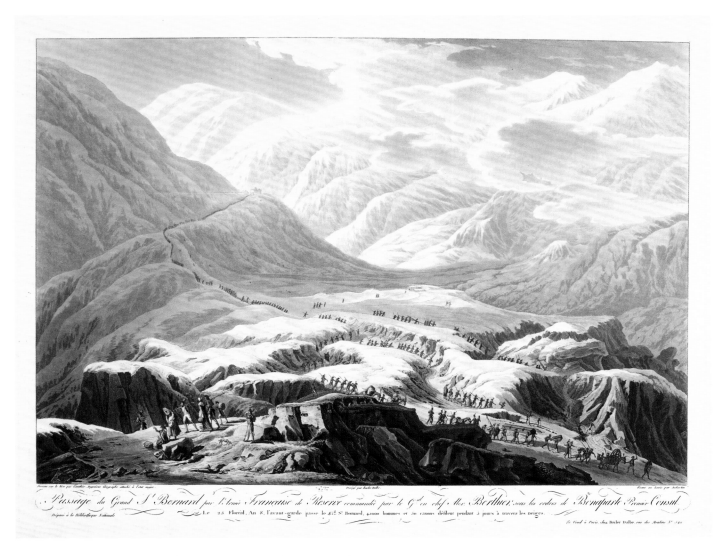

Fig. 16 François Aubertin (1773–1821) after Rudolphe Gautier (active 1800–10)
Passage du Grand St Bernard par l'Armée Française de Reserve
Published by Louis Bacler d'Albe, 28 January 1802
Aquatint and etching with hand colouring; 450 x 600 mm
1958,0712.684. Bequeathed by Robert Wylie Lloyd

included the best battle-painters in his staff when he went out to America. They had produced a series of prints of French successes in that war. Berthier and his brothers, who had the same training, all took a keen interest in battle painting which was shared with Napoleon, and Berthier greatly expanded the department. Louis-François Lejeune, who had trained as an artist before volunteering in 1792, was an aide-de-camp to Berthier from 1800–12. His *Battle of Marengo*, painted in 1802, was engraved by Jacques Joseph Coiny 'by order of the government' and exhibited at the Salon of 1806 (fig. 17). Bonaparte showed his appreciation in concrete terms: in April 1804 he wrote to Berthier: 'You want an honorarium for Lejeune, officer in the engineers, author of the battles of Lodi and Marengo. I would prefer that these battles were engraved at the expense of the government and sold for his benefit.' When Napoleon saw Carle Vernet's *Battle of Marengo* he gave him too a post at the *Dépôt de la Guerre*.[14]

Carle Vernet came to prominence through the *Historical Pictures of the Italian Campaigns*.[15] A prospectus for these was first mentioned as imminent in the *Moniteur* on 15 September 1798, to be had at 88, rue Saint-Lazare, chaussée d'Antin, the address of Auber[t], printmaker and publisher, who in 1794 had taken over responsibility for, and now owned, the earlier series, *Historical Pictures of the Revolution*. The battle scenes were drawn by Carle Vernet and etched by Jean Duplessi-Bertaux (1750–1818), who had been professor of drawing at the Military College since 1770. According to the prospectus they were to be published by subscription

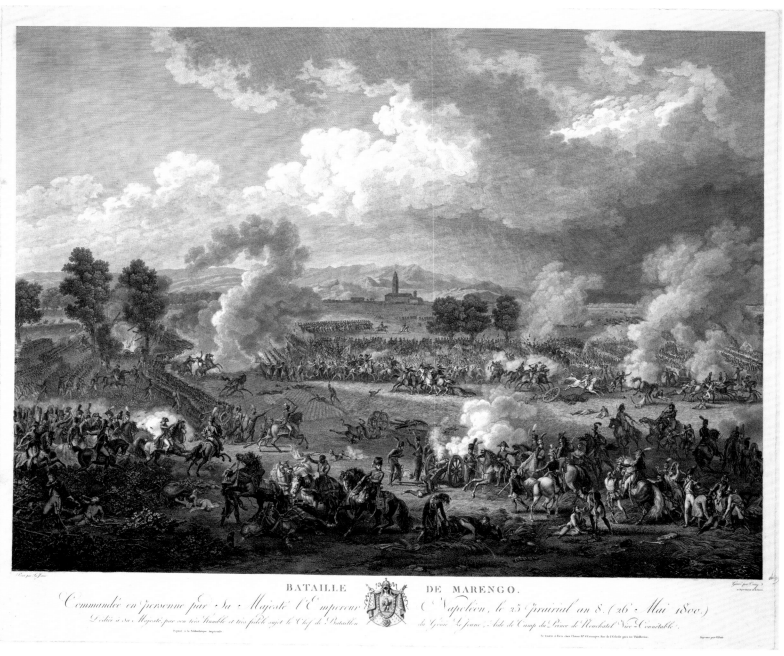

BATAILLE DE MARENGO.

Commandée en personne par Sa Majesté l'Empereur Napoléon, le 25 prairial an 8. (26.e Mai 1800.)
Dédiée à sa Majesté par son très humble et très fidèle sujet le Chef de Bataillon du Génie Lejeune, Aide de Camp du Prince de Neuchâtel Vice-Connétable.

Fig. 17 Jacques Joseph Coiny (1761–1809) after Louis François Lejeune
(1775–1848)
Bataille de Marengo. Government commission, distributed by Chaise, 1806
Etching with engraving; 528 x 766 mm. 1950, 1111.80

and delivered at the rate of a print per month from
20 April 1799. At the Salon in August, Vernet exhibited
five drawings with an announcement of the publication,
and the first three of a projected twenty-four prints were
exhibited by their engraver, Louis Joseph Masquelier, at
the Salon of 1800.[16] The prospectus promised that each
plate would be accompanied by letterpress written by an
anonymous man of letters who had travelled through Italy
with different parts of the army for two years and, it further
claimed, one of the publishers had followed the army from
the Genoa river across the mountains and fortresses of
Piedmont as far as Mantua, and was present at the crossing
of the Po, the bridge of Lodi and the entry into Milan.
Wherever there was a striking action he garnered details
to complete or correct the official account and at the same
time a skilled artist drew with the greatest care the positions

occupied by the respective armies. Auber and his colleagues also promised subscribers a sheet with prints of the medals commissioned either by Bonaparte or by the Cisalpine Republic and designed by Appiani. By February 1799 they were offering a portrait of Bonaparte as frontispiece. There was some interruption since only three numbers had appeared by 1802 when a fourth was promised for October.[17] In 1806 ownership of the plates passed to Bance who extended the series with prints of the campaigns of 1800 onwards after drawings by Jacques Swebach (1769–1823) into what ultimately ran to fifty-two plates ending with the embarkation for St Helena. These later prints appear to have been published individually or in small groups, relatively soon after the battles they described – Austerlitz and Jena were registered with the imperial library for copyright on 3 February 1807. Each historic picture showed Napoleon somewhere in the action, but Bance's were dedicated to the *Grande Armée*, stressing that Napoleon's battle prints were of a new kind with the army as hero, and the general as one figure among many. They seek at once to describe the whole action with documentary topographical accuracy and to stress the participation of all. Several of them were copied by George Cruikshank to illustrate William Henry Ireland's *Life of Napoleon Bonaparte* (1828).

In Britain, prints and plans of battles were usually left to private enterprise, informed and often stimulated by officers who had been involved (see cat. 21). In France, although commercial plans and views like Auber's *Historical Pictures of the Italian Campaigns* appeared along with cheaper prints issued by publishers like André Basset, Bonaparte and the *Dépôt de la Guerre* published official records of the war, issuing views, plans and printed descriptions of various conflicts. The *Dépôt de la Guerre* also projected a series of sixty-eight huge prints of battles from watercolours of the Italian campaigns by Giuseppe Bagetti (1764–1831), formerly a court and military landscape painter at Turin, who was made a captain in the *ingénieurs-géographes*, and two prints after Lejeune of the battles of Aboukir and Mont Tabor. In 1807, the emperor had Bagetti's watercolours of the Italian campaign exhibited at Fontainebleau and a printed catalogue

Fig. 18 Jacques Joseph Coiny (1761–1809) after Giuseppe Bagetti (1764–1831)
Vue de la bataille de Marengo au moment de la victoire
Government commission, published by the Dépôt de la Guerre before 1809
Etching with engraving. Bibliothèque nationale de France, Paris

VUE DE LA BATAILLE DE MARENGO,
au moment de la Victoire.

made. He took a deep personal interest in this work: orders to execute views came straight from headquarters and it was his order to have them all engraved. The artists were given plans and written accounts to help them turn their views of the locations into finished battle pictures and Bagetti proved particularly adept at doing this. His magnificently convincing *View of the Battle of Marengo* at the moment of victory was an entirely official product (fig. 18).[18] Many more sketches and watercolours by Bagetti, Gautier, Lejeune and others had not been engraved at the time the regime collapsed.

The main business of the printmakers of the *Dépôt de la Guerre* was maps and plans, however, and Napoleon was very keen to have plans of his engagements in circulation immediately. 'Mon Cousin,' he wrote to Jean-Jacques-Régis de Cambacérès, Second Consul and then Archchancellor, on 25 March 1807:

> Three plates of the battle of Eylau should have been sent to the dépôt de la guerre at Paris, which give a clear idea of that battle. Take care that in three times twenty-four hours these three plates have been etched and distributed in Paris. You can also order that a pamphlet is made from the bulletins that covered that battle and the account of it by a French officer to go with these three plates. You will send it to Prince Eugene at Milan who will have it translated into Italian and to the King of Holland who will have it translated into Dutch.[19]

Three weeks later he wrote to General Henri Clarke at Berlin that he had not yet seen examples of the German translation that Clarke was supposed to have produced.[20] Ten days after that he was sending Cambacérès the plan of Danzig to be engraved and published 'so that the public can follow the operations of the siege'.[21] The resulting pamphlet was presented with typography of the highest quality and the plans with it were extraordinarily precise in appearance, utterly convincing by their style.[22] Not long afterwards he was pestering Géraud Duroc, Grand Marshal of the Palace, to make sure that Dominique Vivant Denon, who handled art commissions, had taken care of the fifteen or so prints he had asked for covering the events at Tilsit where treaties were signed with Russia and Prussia in July 1807.[23]

As First Consul and afterwards as emperor, Napoleon used state patronage to create a grander type of visual propaganda, moving beyond portraiture and the battlefield. In a letter to Pierre Daru, *intendant-general* of the Imperial Household, on 6 August 1805 he made clear that he wanted the arts to be encouraged and was prepared for large sums to be devoted to that purpose with the particular intention of perpetuating the memory of all that had been achieved since the Revolution.[24] Jacques Louis David's huge canvas of the coronation (nearly ten metres long) is perhaps the most impressive painting produced as part of the promotion of

the regime, but the annual Salon was regularly used as an opportunity for the prominent display of paintings intended to convey Napoleon's point of view. The Salon of 1804 displayed Antoine Gros's painting of Bonaparte, commander in chief of the army of the Orient, at the moment when he touched a plague sore while visiting the hospital at Jaffa. This was a direct response to the allegations in Robert Wilson's *History of the British Expedition to Egypt* that Napoleon had ordered the poisoning of plague victims among his own soldiers (see cat. 68); Wilson's highly coloured account was a key element of the 'Black Legend' of Napoleon's misdeeds promulgated by the British government. The antiquarian and geographer, John Pinkerton, a Briton who had been detained in France in 1803, saw the Salon and was struck by Gros's painting of the plague-stricken soldiers that the British said Bonaparte had poisoned. In his account of the experience published after his release in 1805, he wrote:

> It was also said that Desgenet[te]s, a physician, who appears in this picture with Bonaparte (and the strict resemblance was acknowledged by all Paris), was the very person who had reported that the General of the East had been guilty of this cruelty. It seems, however, little probable that in such a case the subject should have been permitted to be thus exposed to public observation and inquiry…. The reader will, however, judge for himself; but those who have the best hearts will be the last to be persuaded of the truth of the accusation.[25]

Gros's painting was placed opposite one by Philippe Auguste Hennequin with an even clearer anti-British message. It showed the Battle of Quiberon in 1795 when a British-backed Royalist invasion had been definitively defeated by the Republican army. Both paintings were given long descriptions in the catalogue, the one for Quiberon beginning 'Everyone knows the motive for this English expedition, the perversity of ordering it and its hideous treasonous nature cast the British cabinet into eternal obloquy. In this expedition the unique object of England was to make Frenchmen cut each other's throats.'[26]

The principal fine art publishing feat of the Consulate and Empire was the *Galerie du Musée Napoléon*, a project to record the vastly increased national art collection, augmented by acquisitions through treaties (or booty, as the British had it) and by commissions from contemporary artists, such as the *Battlefield at Eylau* by Gros. The old royal palace of the Louvre had opened as a national museum with free public access in 1793 and was renamed the Musée Napoléon in 1803. The publishing project was conceived by 1800 with the first prints appearing in 1804; it was issued in 120 parts, making a series of 718 small prints (numbered 1–720, but with plates 552 and 553 missing) reproducing paintings and sculptures, designed to be bound in volumes with letterpress descriptions.[27]

Fig. 19
Raphael Morghen
(1758–1833) after
Jacques Louis David
(1748–1825)
*Napoleon on
Horseback Crossing
the Alps at the St
Bernard Pass,* 1813
Etched proof
(unfinished);
732 x 520 mm
1843,0513.1062

Some projects were undertaken entirely at Napoleon's expense. In 1803 Appiani began work on the Feats of Napoleon, a series of thirty-five monochromes for the royal palace in Milan. When he completed these in 1807, Napoleon ordered the frescoes to be engraved, which was achieved by 1816 under the supervision of Appiani and Longhi. The series was first published in Milan in 1818.[28] The extravagant coronation ceremony was likewise recorded in a sumptuous publication of engravings (see cat. 84).

Through the painter François Gérard, two English printmakers came to be closely associated with Napoleon. John Godefroy was English by birth and training: his parents were French but he had trained under a French artist, Peter Simon, in London, and his style was more London than Paris. He worked especially after contemporaries, notably Gérard, and engraved the *Dream of Ossian* that Napoleon had commissioned from Gérard for Malmaison in 1800; James McPherson's epic poem of ancient Scotland – *Ossian* – was a particular British literary favourite of both Napoleon and Josephine. Godefroy exhibited his print at the Salon of 1804 and he was selected to engrave Gérard's *Austerlitz* (cat. 95). William Dickinson had moved to Paris by 1802, probably on a permanent basis since he does not seem to have been arrested along with other English visitors in 1803. He was chosen to engrave Gros's official portrait of Napoleon in mezzotint (cat. 135) and went on to engrave at least six of Gérard's paintings in the same technique, known in France as '*la manière anglaise*', including another portrait of Napoleon. There may be a suggestion here that both Gérard and Napoleon admired the unaffected simplicity and naturalism associated by French critics with the fashionable English style, but Napoleon would also have enjoyed the propaganda value of having highly regarded English artists working for him.

Napoleon did his best to be seen to be connected with the best of contemporary artists. In 1810, Jacques-Louis David's famous *Oath of the Horatii* was finally engraved and published with a dedication to Napoleon.[29] Denon tried to persuade the most famous Italian engraver, Raphael Morghen, to settle in Paris by giving him the commission to engrave David's painting of Napoleon crossing the St Bernard Pass in May 1800. Morghen exhibited an engraving of Raphael's *Transfiguration*, then in the Louvre, at the Salon of 1812, and was paid 40,000 of the 60,000 francs (£1,600/£2,400) he was offered to engrave David's painting, but he never finished it because Napoleon fell from power before it was completed.[30] Large, fine line engravings took years to complete and the regime did not last long enough to see some of its most impressive commissions reach fruition.

The most immediate propagandist imagery was caricature. Napoleon's interest in caricature dated at least as far back as 1800: in the Bulletin of the army of Italy for 4 June 1800 he told his soldiers that the Austrian minister Baron Thugut had issued caricatures showing French cavalry mounted on donkeys with infantry consisting of old men and children armed with sticks and bayonets, but that they were now being forced to change their views; a month later he asked Talleyrand, his Minister for Foreign Affairs, to have a caricature made showing Thugut between the Doge of Venice and a Cisalpine director, the idea being that he was despoiling one because of the Treaty of Campo-Formio, and imprisoning the other because he did not recognize the same Treaty;[31] in 1805 he told Joseph Fouché, his Minister of Police, to have caricatures made, and also articles written 'informing the Germans and Hungarians of the extent to which they are being fooled by the English intrigues' (see cats 96–98); in 1806 he commented on prints of the oath sworn at the tomb of Frederick the Great (see cat. 102); he told him in 1809 to 'Get all that said in the newspapers; have caricatures made, songs, popular Christmas carols; have them translated into German and Italian to spread them throughout Italy and Germany.'[32] Further verbal instructions were no doubt given, but these surviving documents are sufficient evidence to demonstrate that Napoleon took an active interest in caricature as a means of countering the efforts of his enemies in this vein and of promoting the French view of events.

French caricature peaked, like its English counterpart, after the collapse of the peace of Amiens, which was blamed by the French on the intransigence of George III and his ministers. During the peace there had been mild social satires turning on the elegance of the French and the alternatively haughty or oafish inelegance of the British. After the rupture anti-English caricatures were appearing every day. A particularly well-drawn one showing English politicians holding an orgy to celebrate the renewal of hostilities was deposited with the national library on 12 August 1803 by an engineer named Toscani (fig. 20).

The many invasion prints were supplemented by more subtle threats. Napoleon had the Bayeux Tapestry, showing the successful French invasion of England in 1066, brought to Paris where it was exhibited in the Gallery of Antiquities at the Louvre from November 1803 to February 1804. Ennio Quirini Visconti, the Keeper, wrote a pamphlet about the tapestry, illustrated with prints of it, drawing particular attention to the coincidence between the comet seen at Harold's coronation and the one in the skies over England and France in December 1803.[33] A play came out simultaneously.[34]

French caricaturists gloried in the flight of the Duke of Cambridge from Hanover as the French army gathered for invasion in 1803. They made much of the British-backed attempt to assassinate Bonaparte (see cat. 80), and the flight of the British agent Francis Drake from Munich, caught trying to organize insurrection in the Rhineland. Before and during the Austerlitz campaign, the French mocked the Austrians for taking British money and then losing; they

Les Ministres Anglais fiers d'avoir rompu leurs traités, dans une Orgie se font Servir un Pâté d'Amiens qui renfermait un coq vivant

Fig. 20 H.E. Toscani (?) *Les Ministres Anglais fiers d'avoir rompu leurs traités, dans une Orgie se font Servir un Pâté d'Amiens qui renfermait un coq vivant* Published by Aaron Martinet, 12 August 1803. Hand-coloured etching; 275 x 396 mm. Bibliothèque nationale de France, Paris. De Vinck 7593

attacked Queen Louise of Prussia as a trouser-wearing, war-mongering whore who dominated her husband in pursuit of her lust for Alexander of Russia. They rejoiced in the death of Pitt who, until then, along with George III, had been the dominant figure in anti-English caricatures.

The French prints throw into relief the rare appearances of George III in English caricature in the years leading up to 1803. Although the King still had significant influence in the direction of foreign affairs and of the army, the British government preferred not to view its cause as the defence of monarchy and aristocracy, whereas in French prints, England is very much identified as a monarchy. In France, George is sometimes the Devil, or at least in the hands of devils, armed with bags of gold and ready to bite. *Georges édenté* (fig. 21), one of the fiercest, shows a grenadier of the guard removing teeth one by one from a hideously caricatured George for

presentation to an uncaricatured Napoleon. Napoleon is modest in his signature greatcoat; George in full regalia, his legs tied by a 'blocus continental', has already lost his Neapolitan, Austrian, Prussian and Hessian teeth, and the motto states that: 'When he has no more teeth he will no longer bite.' 'Leave me at least one, he pleads, 'they were very expensive.'

Very few caricatures showing hostility to the British were published between 1808 and 1814. It is far more likely that this was a result of the Continental blockade than of loss of interest. With hostile caricatures, chiefly from Britain, unable to circulate on the Continent for most of these years there was no need for counter-attack: the chief battle-ground, beyond the domestic market, was educated public opinion in the various states of Europe. During the Hundred Days in 1815 there was a brief but substantial wave of triumphalism

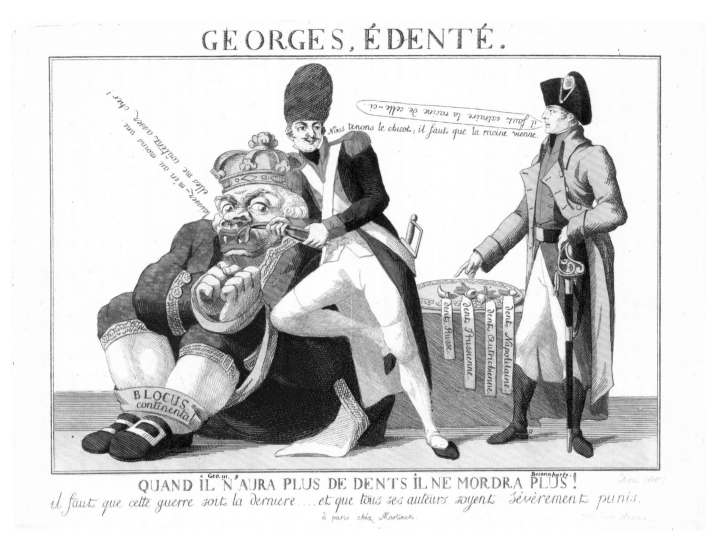

Fig. 21 Unknown artist. *Georges édenté*
Published by Aaron Martinet, 1807
Hand-coloured etching; 204 x 273 mm. 1868,0808.7610

and mockery of Royalists with prints such as *Using the Royal Extinguisher*, *Spring or the Return of the Violet* or *Quick! Quick! Leave Ghent and Lets Cross the Channel! Here come the Braves!* [35]

The vast majority of Bonapartist caricatures seem to have been published by Aaron Martinet, those that appear to have received the direct input of government included; but there are many without a publisher's address. It seems that in France, as in England, many caricatures were designed by their publishers. The publisher Paul-André Basset was said to have 'served his country by drawing caricatures against the Aristocrats … from skinny and pale like the abbé of our day, he turned fat and podgy like the abbé of old'.[36] A notable propagandist Carl François Badini also deposited caricatures at the national library. Badini originated from Piedmont but had lived in Britain for forty years before being deported

early in 1803 for writing too virulently in favour of Bonaparte in *Bell's Weekly Messenger*. He was alleged to have been in Bonaparte's pay while in London and once in Paris became the editor of the *Argus*, the Consul's English-language newspaper.[37] Other caricaturists represented in the present exhibition are recorded as sometime soldiers: Jean-Louis Argaud de Barges (1768–1808), who was also a theatrical writer, and Godisart de Cari (active 1803–29).

Napoleon used prints as he used all the arts in order to promote France and French culture and commerce, the image of the French army and his own image. In so far as the main rival to France in the field of printmaking and visual publication was Britain, Napoleon's commitment to prints can be seen as part of a war of images fought between the two countries throughout Napoleon Bonaparte's career in power.

1 See, among other literature, Holtman 1950; Jourdan 1998; Jourdan, Bertaud, and Forrest 2004.

2 Quoted in D. O'Brien, *After the Revolution: Antoine-Jean Gros, Painting and Propaganda under Napoleon Bonaparte*, Penn State University Press 2004, p. 2.

3 Hanley 2008; and C-M Bosséno, 'La guerre des estampes – Circulation des images et des thèmes iconographiques dans l'Italie des années 1789–1799', *Mélanges de l'Ecole française de Rome, Italie et Méditerrannée*, 102 (1990), No. 2, pp. 367–400, grapple with the early phase and P. Dwyer, *Napoleon: the Path to Power 1769–1799*, London and New Haven 2008, makes a noble attempt to incorporate prints into his account of Bonaparte's image, but there has been no substantial study by a print historian; see also Holtman 1950, pp. 165–8 on caricatures.

4 *Correspondence de Napoléon I^{er}*, I, p. 276 to Faipoult 13 May 1796. The subject of the first print is unclear but Napoleon's first victory at Montenotte took place on 12 April. From the speed of production and the reward these prints must have been slight.

5 A reissue by Bance was advertised in *Journal typographique et Bibliographique*, 6 March 1801 and in the *Moniteur*, 27 April 1801. Later he gave Desnoyers the plate of the coronation portrait (cat. 84).

6 Hanley 2008, chapter 4.

7 Agnelli British Museum PD 1926,0412.95; Haid British Museum PD 1926,0412.94.

8 British Museum PD 1889,0603.228, de Vinck 6815.

9 Print registered by Hennequin on 30 May 1798; see de Vinck no. 6817 for a transcription of the advertisement in the *Moniteur* on 9 *Prairial* Year VI; indicating that the print cost 12 francs.

10 Arcola illustrated in Sadion 2003, p. 42; de Vinck nos. 7638-9.

11 Anne Cablé, 'Une imagerie séditieuse', in Sadion 2003, pp. 21–7 and Henri George, 'Saint-Napoléon', in Sadion 2003, pp. 15–19.

12 See Christian Rümelin, *Die Verzauberung der Landschaft zur Zeit von Jean-Jacques Rousseau*, exh. cat., Geneva 2012.

13 Advertised in the *Moniteur*, 9 Pluviôse Year X (29 January 1802); legal deposit 28 January 1802, price 10 francs in black and 18 in colour. De Vinck no. 7509. After 1815 Bacler made his living as a lithographer.

14 *Correspondence de Napoléon I^{er}*, IX, p. 318 (5 April 1804), to Berthier; H.M.A. Berthaut, *Les ingénieurs géographes militaires, 1624–1831*, 2 vols, Paris 1902, I, p. 256.

15 See A. Duprat, 'La construction de la mémoire par les gravures: Carle Vernet et les tableaux historiques des campagnes d'Italie' in J-P Barbe and R. Bernecker (eds), *Les intellectuels Européens et la campagne d'Italie 1796–8*, Münster 1999, pp. 198–207.

16 *Explication des ouvrages de peinture, sculpture, architecture, gravure, dessins, modèles etc des Artistes vivans exposée dans le Salon du Musée centrale des Arts, le 15 Fructidor An VIII de la République* (Paris 1800), p. 86, no.630.

17 British Library 1879b1, collection of prospectuses for prints and books made by Dawson Turner, volume I, *Ouvrage complet des Tableaux historiques de la Révolution française*.

18 See Berthaut 1902 op. cit. n. 14, I, pp. 285–94, and Anne Godlewska, 'Resisting the Cartographic Imperative: Giuseppe Bagetti's Landscapes of War', http://www.geog.queensu.ca/napoleonatlas/Bagetti/jhg_paper.htm.

19 *Correspondence de Napoléon I^{er}*, XIV, p. 522, to Cambacérès, 25 March 1807.

20 *Correspondence de Napoléon I^{er}*, XV, p. 67, to Clarke, 13 April 1807.

21 Ibid., p. 139, to Cambacérès, 23 April 1807.

22 *Bataille de Preussich-Eylau gagnée par la Grande Armée, commandée en personne par S.M. Napoléon I^{er}, Empereur des Français, Roi d'Italie, sur les armées combinées de Prusse et de Russe, le 8 Février 1807*, Paris: Dépôt de la Guerre 1807.

23 *Correspondence de Napoléon I^{er}*, XVI, p. 85 to Duroc.

24 *Correspondence de Napoléon I^{er}*, XI, pp. 65–7 to Daru.

25 J. Pinkerton, *Recollections of Paris in 1802, 3, 4 and 5*, London 1806, pp. 244–8, as cited by D.G. Grigsby, *Extremities: Painting Empire in Post-Revolutionary France*, New Haven and London 2002, p. 100.

26 *Explication des ouvrages de peinture, sculpture, architecture, gravure, dessins, modèles etc des Artistes vivans exposée au Musée Napoléon, le 1^{er} jour Complémentaire, an XII de la République française*, Paris 1804, p. 41, no. 228.

27 Meyer 2005, pp. 82–3. See George D. McKee, *The Musée Français and the Musée Royal: A History of the Publication of an Album of the Engravings, with a Catalogue of Plates and Discussion of Similar Ventures*, dissertation, University of Chicago, 1981.

28 See *Mito e storia nei 'Fasti di Napoleone' di Andrea Appiani*, Rome, 1986.

29 British Museum 1950,1111.66.

30 P. Bordes, *Jacques Louis David: Empire to Exile*, New Haven and London 2005, pp. 42–3; Camilla Murgia, 'Raphael Morghen and Paris', *Print Quarterly*, XXVIII, 2011, pp. 18–33.

31 *Correspondence de Napoléon I^{er}*, VI, p. 337, Bulletin de l'armée d'Italie, 4 June 1800; *Correspondence de Napoléon I^{er}*, VI, p. 395 to Talleyrand 4 July 1800.

32 Lecestre 1897, I, p. 51, 30 May 1805 to Fouché; *Correspondence de Napoléon I^{er}*, XIII, p. 405; Kaenel 1998, p. 39; Lecestre 1897, I, p. 260 to Fouché, 1 January 1809.

33 E.Q. Visconti, *Notice historique sur la tapisserie brodée par la reine Mathilde* (an XII, 1803/4), p. 12; see Cillessen et al. 2006, p. 121.

34 Radet Barré and Desfontaines, *La Tapisserie de la reine Mathilde*, Paris 1804, in Bertaud 2004, p. 62.

35 Paris, Bibliothèque nationale in Gallica. De Vinck 10295,9405,9465.

36 J. Adhemar, *Imagerie populaire francaise*, Milan 1968, p. 92 in Kaenel 1998; on Basset, see S. Roy, 'Paul-André Basset et ses contemporains, l'édition d'imagerie populaire pendant la Révolution: piratage ou entente tacite', in *Nouvelles de l'Estampe*, no.176, May to June 2001, pp. 5–19.

37 Burrows 2000, p. 90. See L. Goldsmith, *The Secret History of the Cabinet of Bonaparte*, London 1810, p. viii.

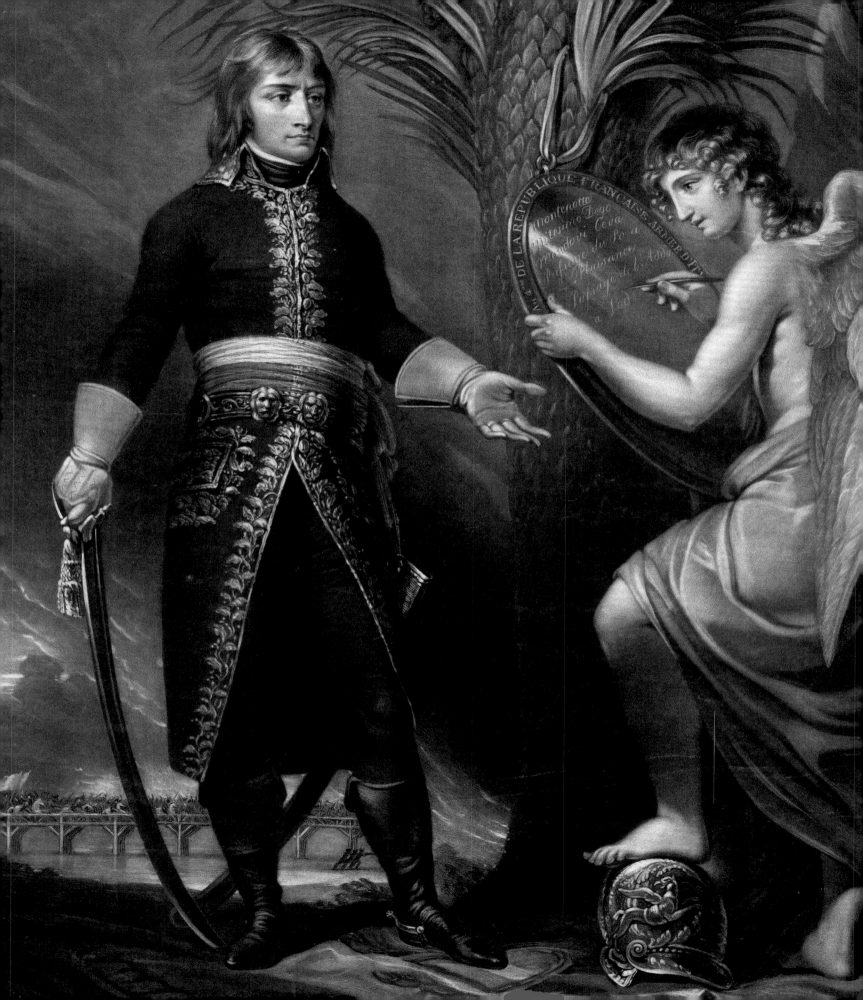

I

The young general

Napoleon Bonaparte came to the attention of the British public in 1796 as a result of his military successes in Italy, which admirers saw as its liberation. A determined propagandist from the start (see pp. 38–40), Napoleon was keen to have his portrait made and distributed in the form of prints, and Britons were among the first to commission paintings of the young hero. By early 1797 he was also appearing as an enemy general in English satirical prints. The 1790s were fraught years in Britain: King George III and William Pitt's government were afraid that revolution would spread across the Channel from France and brought in repressive measures against political dissent. Pitt had to introduce unpopular taxes to support an expensive war of questionable necessity, at a time when successive harvest failures sent bread prices rocketing. On foreign affairs, however, most satirical prints supported the government and mocked the Opposition – notably Charles James Fox and Richard Brinsley Sheridan – who were presented as Republican supporters of the French.

1

John Raphael Smith (1751–1812) after Andrea Appiani
(1754–1817)
Buonaparte, First Consul of France
Published by John Raphael Smith, 1800
Mezzotint; 651 x 457 mm
1917,1208.3792
From the collection of Amabel, Lady Lucas; presented
by Nan Ino, Baroness Lucas of Crudwell in memory of
her brother Auberon, Baron Lucas of Crudwell

When this print was published in 1800, Napoleon was First
Consul, but when the portrait was painted in 1796 he was merely
a general of the Republican army. He stands with the winged
figure of Fame who is writing on a shield the names of his
triumphs in Italy during the spring of 1796. In the background is
the battle on the bridge at Lodi on 10 May. The lettering in the
lower margin records that the mezzotint reproduces 'a Picture
painted at Milan by A[ndrea] Appiani, in the Possession of the
Right Honorable the Earl Wycombe'. This is the first record of
Earl Wycombe's ownership of the painting (now in the Rosebery
Collection at Dalmeny House, near Edinburgh), but it is possible
that he commissioned it when living in northern Italy during 1796.
He was an admirer of Napoleon, writing from Lausanne on
26 May of the following year to his friend Lord Holland (see
cat. 156): '[Bonaparte] has indeed no Model but in Antiquity.
Fortunate young man; he should himself desire to vanish from the
earth, that the honours of an apotheosis may be conferred upon
him whilst his fame is still recent and that he may cease to be an
object of jealousy and apprehension to inferior men.' Smith's
print was advertised in the *Morning Chronicle* on 27 January 1800 at
1 guinea (plain), 2 guineas (coloured) and 3 guineas (coloured in
oils). Smith was one of the leading mezzotinters and publishers
of his day, exporting widely until the wars of the 1790s hindered
international trade. For Appiani, see cat. 39.

BUONAPARTE first CONSUL of FRANCE,

Engraved from a Picture painted at Milan, by A. Appiani, in the Possession of the Rt. Honble. the Earl Wycombe, by J. R. Smith, Engraver in Mezzotinto to his Royal Highness the Prince of Wales, & published by him Jany. 25. 1800. Nst King Street, Covent Garden, London.

2
Francesco Cossia (active 1797)
General Napoleon Bonaparte, 1797
Oil on panel (originally on canvas);
303 x 276 mm (including frame)
Sir John Soane's Museum

This portrait of the young Bonaparte was commissioned by the English artist Maria Cosway (1760–1838) and painted in Verona by the otherwise unknown Francesco Cossia. Cosway spent the first nineteen years of her life in Florence until the death of her father, a prosperous English hotelier, after which she and her mother moved to London. Two years later, in 1781, she married the fashionable artist Richard Cosway (1742–1821). The couple maintained a cosmopolitan circle of friends that included the great French painter Jacques-Louis David whom they met in Paris in the early 1780s, and the Corsican leader Pasquale Paoli, exiled in London, who might well have inspired Maria's interest in Bonaparte.

Cossia described the making of the portrait in a letter of 17 March 1797 to a Signor Borghini of Milan. This was sent to England with the painting and subsequently published along with the first sympathetic account of Bonaparte to be published in Britain. Borghini had evidently passed Cosway's commission to Cossia along with a package for Napoleon from Josephine.

On 14 March the French army had arrived in Verona, at the beginning of the climactic march on Vienna. Cossia delivered Josephine's package and asked permission to paint the general; he was invited to dine that night and allowed half an hour before and after dinner. Cossia was received with charm and Bonaparte apologized for the difficulty in fulfilling the wishes of a lady for whom he had great esteem and said that for her he would bend time and make the impossible possible. 'At a quarter past two o'clock I had laid in the Head and figure,' wrote Cossia, 'and at three o'clock the Dinner being finished, I again began to paint, with good Spirits – because I saw that they were much pleased with the work already done.' He felt that he had succeeded in giving Napoleon 'that thoughtful expression which you know is so striking in his countenance'. After dinner he asked to accompany Napoleon on his journey north, 'in order to improve the head, and give it a finished appearance'. He travelled in Bonaparte's carriage and, after a sleepless night caused by the constant to and fro of messengers, continued over breakfast with the general

3

Luigi Schiavonetti (1765–1810) after
Francesco Cossia (active 1797)
Buonaparte
Published by John Shlunt
Stipple with etching; 263 × 201 mm
1871,0812.4127

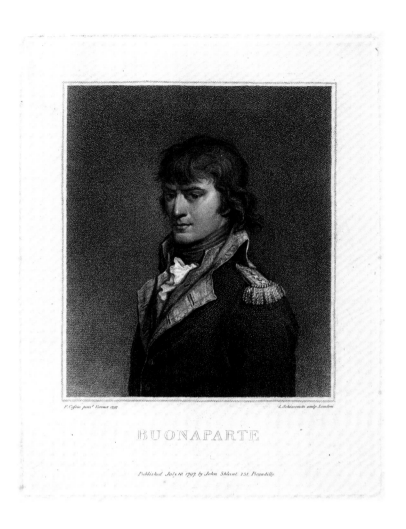

BUONAPARTE

Published July 10 1797 by John Shlunt, 231, Piccadilly

'very gay and affable', and then Napoleon gave him a chaise and escort in which to return to Verona.[1]

The painting was shipped to 'Madame Cosway/Londres' on 26 March and the print shown here was published in London as early as 10 July. It was made by Luigi Schiavonetti, a well-respected printmaker from Bassano del Grappa who had been established in London since 1790 and was a partner in Colnaghi & Co. from 1793 to 1796;[2] by 1802 he had moved to Berlin where he was a 'principal printseller'. The name of the publisher, John Shlunt, is not otherwise known and may be fictitious. His address, 231 Piccadilly, is one that was used by French émigrés: Jaques Chasseloup de Beaujeu insured the property with the Sun Fire Office on 26 December 1793, and it was given as the publication address for books published by Jean Peltier (see cat. 60) in 1796–8 and by Monsieur Beauvalet in 1797. The print was sold in Paris as well as in London and was advertised in the *Journal de Paris* on 18 September 1797 at 5 livres (4*s*. 9*d*.).

In 1798 John Landseer made another print of the portrait with an allegorical border designed by William Craig. Craig produced a pamphlet that explained the allegory and gave a translation of Cossia's letter together with an admiring account of Bonaparte's career.[3] He emphasized particularly Bonaparte's honourable behaviour towards Paoli and gave a Protestant view of

the value to humanity of his destruction of the Papal dominions.

Maria Cosway got to know the Bonaparte family during her stay in Paris from 1801 to 1803 when she undertook a project to make prints of the display of paintings in the Louvre; a presentation copy of the series lists both Napoleon and the Prince of Wales as subscribers.[4] Her portrait of the young Napoleon was probably a gift to Sir John Soane who was one of the friends who helped to organize sales of her husband's collection after his death in 1821. Much of the proceeds were used to support Cosway's pioneering school for girls at Lodi.

1 X.F. Salomon and C. Woodward, 'How England first saw Bonaparte', *Apollo* (October 2005), pp. 52–8.
2 *London Gazette* (20 September 1796).
3 Craig 1799, *passim*.
4 S. Lloyd, *Richard and Maria Cosway* (Edinburgh and London 1995).

4

Charles Howard Hodges (1764–1837)
after Hilaire Ledru (1769–1840)
Generaal Buonaparte
Published by Evert Maaskamp, 1797
Mezzotint; 382 x 279 mm
2010,7081.2532; de Vinck 6814
From the collection of the Hon. Christopher
Lennox-Boyd, acquired as part of a
group of over 7,000 mezzotints with
the assistance of the National Heritage
Memorial Fund, the Friends of the British
Museum, the Art Fund, Mrs Charles
Wrightsman, the Michael Marks Charitable
Trust, and numerous individual donors

Charles Hodges, a pupil of John Raphael Smith, had an established reputation in London as a mezzotinter when he moved permanently with his family to the Netherlands in 1792. William Humphrey, brother of James Gillray's publisher Hannah (see p. 20), helped to establish him there, did business with him in exporting and importing prints and visited him in 1802. Hodges also continued to produce mezzotints and portraits in pastel and oil of leading members of society including Napoleon's brother Louis, who was King of Holland from 1806 to 1810. In 1815 Hodges was one of the commissioners sent to Paris to identify and recover the pictures appropriated from Dutch collections.

The lettering below the image identifies the painter of the portrait on which the print is based as 'J T Rusca'. Marcel Roux named him as the obscure Jacopo Rusca (1718–1808), but it seems unlikely that an artist approaching eighty years of age would have been given the opportunity to paint Napoleon in 1797 and in fact the portrait is clearly adapted from a drawing by Hilaire Ledru which was the basis for an influential full-length print of the long-haired young general (1796–7) of which several copies were made.[1]

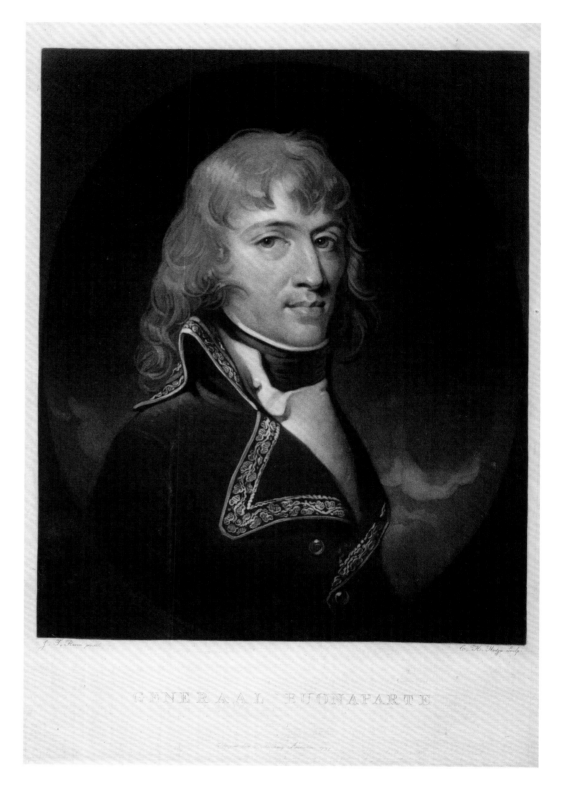

GENERAAL BUONAPARTE

1 De Vinck 6819. See above, p. 36.

5

John Godefroy (1771–1839) after Antoine Denis
Chaudet (1763–1801), Pierre François Léonard
Fontaine (1762–1853) and Charles Percier
(1764–1838)
Fan-leaf with a portrait of Napoleon Bonaparte
Published by Gamble *fils* and Dubus *père*,
29 March 1798
Stipple; 357 x 564 mm, 1891,0713.641
Presented by Lady Charlotte Schreiber

The print was made for a fan presented to Josephine Bonaparte
by the City of Paris; an impression printed in blue on silk is
preserved at the Château of Malmaison. It was recorded in the
legal depository of prints on 29 March 1798 (9 *Germinal* Year VI
in the Republican calendar): 'Citizens Gamble *fils* and Dubus
père have deposited as publishers and proprietors two proofs of a
fan representing Buonaparte crowned by victory and peace.' It
was exhibited at the Salon of 1799. Printed fans were extremely
fashionable in France in the 1790s and this one served as the
model for most artistic fans of the Napoleonic period; for a British
fan of Wellington, see cat. 115.

The names of three men who were to be responsible for
putting into effect many of Napoleon's most ambitious artistic
projects are given as designers: the sculptor Chaudet, and the
architects and designers Fontaine and Percier (see cat. 85).
Josephine had met Fontaine and Percier in 1798 and it seems likely
that she encouraged them to design a fan with the portrait of
her young husband to celebrate his successes in Italy. Dubus *père*
is otherwise known only as a printer, but Gamble *fils* was the son
of James Gamble (active 1774–1807), a top London copperplate

printer, also a printseller, who claimed to be the inventor of colour
printing[1] and had moved to Paris by 1791. The engraver, John
Godfrey, was born in London of French parents and had come
to France in 1797, where he was under surveillance as a British
spy, and only given the right to remain in France in 1800 (see cat.
95). Gamble and Dubus paid him 800 francs (£32) to engrave the
plate.

An advertisement in the *Moniteur* on 8 June 1798 explains
that the celebrated artists had condescended to design a fan only
out of respect for the hero and his glorious achievements; it was
always pleasing to see in a lady's hand an ornament that honoured
both the subject and the lady and the image of a great man could
only enhance the hand that carried it.[2]

1 Trade card in British Museum, Banks,100.52; Roy 2008, n. 93.
2 De Vinck 6824; Meyer 2005, p. 82; Roy 2008, pp. 167–192.

6

Isaac Cruikshank (1764–1811)
Buonaparte at Rome Giving Audience in State
Published by Samuel William Fores, 12 March 1797
Hand-coloured etching; 288 x 388 mm
1868,0808.6606; BM Satires 8997
From the collection of Edward Hawkins

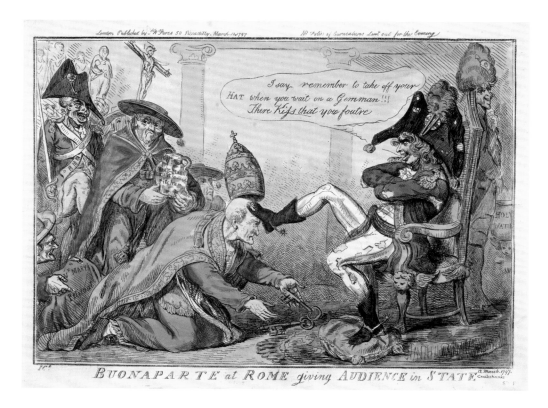

British satirical prints naturally show Napoleon – a general of the enemy army – in quite a different light from the images that he had himself approved. This is his first appearance in such a print and he is shown as a foul-mouthed, ragged Republican; at this point he has no distinct personality, being merely the most frightening of the Jacobin generals.

His victory over the Pope, however, was enjoyed by British Protestants. As William Craig put it in the pamphlet cited on p. 55:

> One great and important benefit has resulted to mankind from these victories of Buonaparte, in the destruction of the Papal Dominion … the lovers of Pure Christianity will rejoice to see hurled from the rock of its fancied security a power which has for centuries debased the minds of surrounding nations by its fetters, and blasphemed the deity by its superstitions and hypocrisy.[1]

On 19 February 1797 Napoleon had forced Pope Pius VI to accept painful terms in the Treaty of Tolentino. Full details were not published in London until the end of March, but it was clear that they would be humiliating for the Pope: as well as severe financial reparations, the papal city of Avignon was ceded to France and the Italian Romagna became part of the new Cisalpine Republic. The treaty also allowed for the transfer of works of art from Rome to France (see cat. 9).

The soldiers led by the uncouth brigand are literally *sans culottes*, one of whom is urinating into a holy water font. (In French sans-culottes were the radical workers who wore *pantalons* rather than knee breeches (*culottes*), but to British caricaturists the term obviously meant people wearing no trousers.) There is also mockery of Roman Catholicism – familiar to a British audience – in the cardinals carrying relics of Mary Magdalen and the Virgin Mary to lay before the conqueror, and the Pope himself offering the keys of St Peter. The image of the Pope's tiara being kicked off his head is an inversion of an illustration to Foxe's *Book of Martyrs* showing Pope Celestine kicking the crown from the head of Emperor Heinrich VI (1165–97) who kneels at his feet;[2] copies of the *Book of Martyrs* were to be found in every Anglican church at this time.

Isaac Cruikshank was one of the most active caricaturists in the early Napoleonic period; his son, George, only five years old in 1797, was to become the most successful in the last years of the emperor's career. For the publisher Samuel William Fores, see p. 20.

1 Craig 1799, p. 17.
2 British Museum 1994,0515.12.

7

Isaac Cruikshank (1764–1811)
The French Bugabo Frightening the Royal Commanders
Published by Samuel William Fores, 14 April 1797
Etching; 271 x 499 mm
1851,0901.857; BM Satires 9005
Presented by William Smith

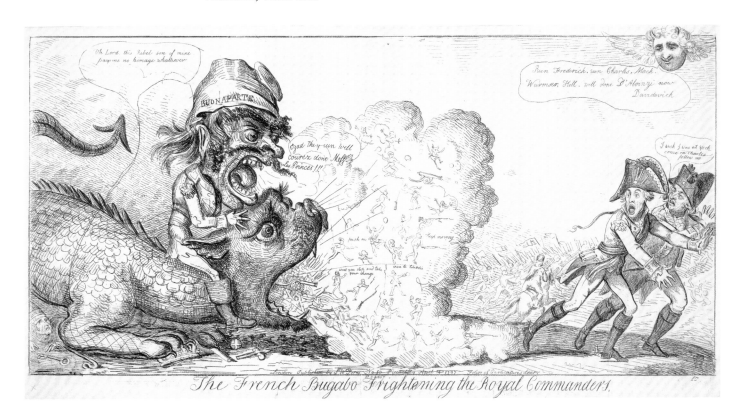

Cruikshank portrays Napoleon as a mustachioed Jacobin bandit, *sans culottes*, wearing a cap of liberty, and riding a scaly monster that has crushed the Pope and breathes out soldiers, guns and demons in a cloud of smoke, forcing the Austrian troops to flee. The Archduke Charles, brother of Emperor Francis, and the Duke of York, commander of British forces, retreat in terror. In the upper right-hand corner the head of Charles James Fox, Napoleon's most prominent British political supporter, smiles down, telling the allied commanders to run. Bonaparte's army had driven the Austrian forces and their allies from Italy in March 1797.

The British consul in Bologna reported in February 1797 that it is impossible to 'convey an adequate idea of the impression of terror and astonishment which accompanies the Republic's armies in their conquest of Italy; where they are venerated as a superior order of beings to whom nothing is impossible, and are looked upon in much the same way as the followers of Cortez were by the Mexicans.'[1]

1 Desmond Gregory, *Napoleon's Italy*, New Jersey 2001, pp. 30–1.

8

Richard Newton (1777–98)
*Buonaparte Establishing French
Quarters in Italy*
Published by Richard Newton,
9 November 1797
Hand-coloured etching; 241 x 349 mm
2001,0520.31

From the collection of Kenneth
Monkman, one of forty prints by
Richard Newton purchased with the
help of the Friends of the British
Museum

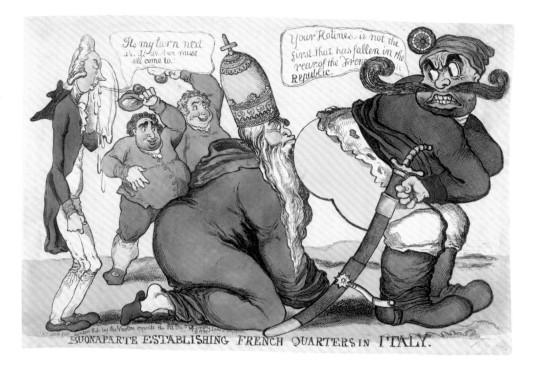

By the time this print was published news had arrived in London
of the signing of the Treaty of Campo Formio on 17 October
1797 that concluded Bonaparte's victorious Italian campaign.
Austria gave up Milan (which became the capital of the Cisalpine
Republic) and Flanders and recognized the Rhine as the 'natural
border' of France. The print shows not only the humiliation
of the Pope, but also suggests that the British government,
represented by Pitt, would be the next to succumb to France;
Fox and his ally Richard Brinsley Sheridan are cheering at the
prospect. In October the French government had announced
the creation of an Army of England to be led by Bonaparte and
relations with Britain had deteriorated to the point where a day
after this print was published Bonaparte's newspaper, the *Courrier
de l'armée d'Italie*, threatened to annihilate the English government:
'No peace with Pitt: Carthage must be destroyed'.[1]

Richard Newton was only twenty years old when he made
this, his second print of Bonaparte: his first *Buonaparte the Modern
Alexander on his Journey Round the World*, published in April,[2] had
shown the general as a colossus, taking Vienna in one stride,
spitting aristocrats and extinguishing kings. Newton had set up his
own shop in March 1797 and published prints that were savagely
critical of Pitt and the royal family, of a kind that William
Holland, who had published most of Newton's work, no longer
dared to issue. Holland had been imprisoned for a year in 1793–4
for selling a pamphlet by Thomas Paine and subsequently avoided
contentious political subjects.

Bonaparte remains a cipher, a generic Republican bandit, not
an individual, whereas the British politicians are unmistakeable
portraits, although not named.

1 Bertaud 2004, p. 37.
2 De Vinck 6917; Alexander 1998, p. 156, n. 242.

9

Jean Jérôme Baugean (1764–c. 1827)

Depart de Rome du troisieme Convoi de Statues
et Monumens des Arts, 1798

Etching; 450 × 606 mm

1992,1003.8

Depart de Rome du troisieme Convoi de Statues et Monumens des Arts pour le Muséum national de Paris le 21 Floreal An 5 de la République

Dedie au

DIRECTOIRE EXECUTIF DE LA RÉPUBLIQUE FRANÇAISE

Par les Citoyens Marin et Baugean

La Vue est prise du lieu appellé la Tarmaine on voit dans le lointain la Coupole de S.te Pierre, le Vatican et le Muséum; sur la droite s'eleve le Mont
Mario et le Tibre baigne a la gauche les bords du chemin qui conduit a Ponte Mole

The Treaty of Tolentino of February 1797 allowed for the transfer to France of more than one hundred paintings and other works of art from the Vatican and other Roman collections including the *Transfiguration* by Raphael, the Laöcoon group, the Apollo Belvedere and the marble bust of Marcus Brutus from the Capitol; further treaties in 1798 extended the provision to other Italian states. Bonaparte even suggested moving the Roman arena from Verona to Paris, stone by stone. This print shows the slow progress along a road by the Tiber of wagons drawn by oxen taking the treasures from Rome. The painter Antoine Gros accompanied this convoy carrying the most important antique statues including the Laöcoon and the Apollo Belvedere. The works arrived at Paris on 15 July 1798 and a huge four-day public festival was held to celebrate.[1]

'His love for the arts has been proved by his wish to obtain their most valuable productions for his adopted country.... The great consideration with which he has uniformly treated all professors of the arts and sciences is universally known,' wrote the painter William Craig.[2] Sir William Hamilton, British minister plenipotentiary to the Bourbon court at Naples and a great art collector, took a different view. He sent this print to William Grenville, the British Foreign Secretary with a note on the verso in which he complained bitterly: 'Lord Grenville will see by the enclosed print just published at Rome and which Sir William Hamilton has the honour of presenting to His Lordship that the *soi disant Grande Nation* glories in its iniquities and robberies, and is desirous of handing down to posterity the memory of them.' Creases show where the print was folded for dispatch to London.

1 Hanley 2008, chapter 4.
2 Craig 1799, pp. 18–9.

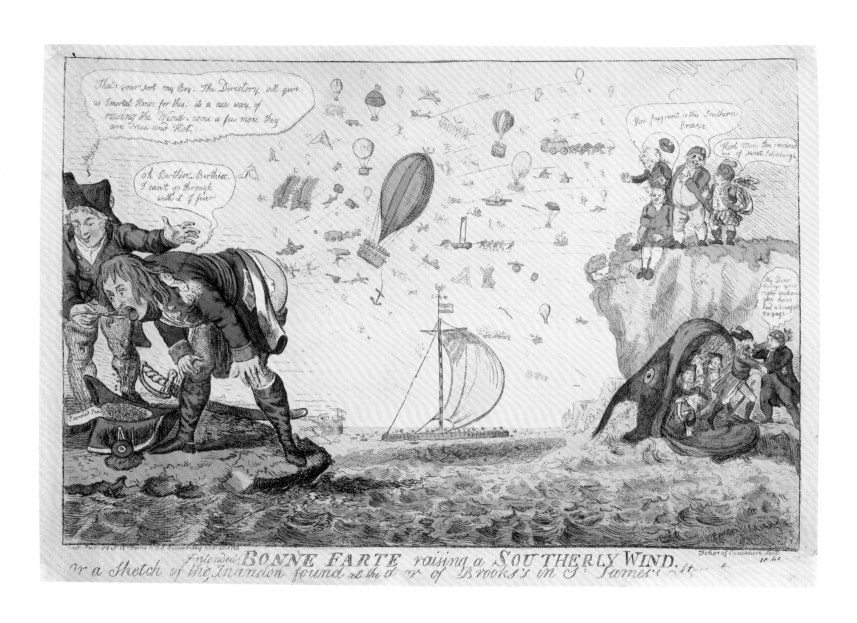

10

Isaac Cruikshank (1764–1811)
Bonne Farte Raising a Southerly Wind
Published by Samuel William Fores, February 1798
Hand-coloured etching; 275 x 390 mm
1868,0808.6698; BM Satires 9172
From the collection of Edward Hawkins

After his successes in Italy, Napoleon was ordered to prepare for a cross-Channel invasion to annihilate the British. In 1797 this looked promising, with great discontent in Ireland, some support in Britain and a series of naval mutinies that promised to paralyse the enemy fleet. Isaac Cruikshank appeals to the British taste for scatological humour and puns in playing on Napoleon Bonaparte's name – 'bonne farte'. On the French coast, his chief of staff, General Berthier, spoons dried peas into Napoleon's mouth helping him to break sufficient wind to blow balloons, parachutes, guns, soldiers, tents, wagons and a guillotine towards the cliffs of Dover where Fox, Sheridan and their friends wait to welcome them. The sub-title, 'Sketch of the intended invincible invasion found at the door of Brooks's in St James's Street', repeats the assertion made in earlier prints that the Foxite Whigs, frequenters of Brooks's club, were Republican supporters of Napoleon and the French. Fear of widespread support in Britain for the invading French underlies the humorous imagery. At the foot of the cliff a party of Frenchmen step from the jaws of a sea monster and an English Jacobin wearing a red cap of liberty embraces their leader, the mathematician Gaspard Monge. Monge was credited with designing a giant raft for the invasion of England, an example of which is shown in the middle of the Channel. Stories of the extraordinary armoured raft abounded. On 31 March (once Napoleon's invasion plan had been safely abandoned) a musical interlude entitled 'The Raft or both sides of the Water', was played at Covent Garden; cannons were fired from the raft and answered by batteries and gunboats, the raft blew up.

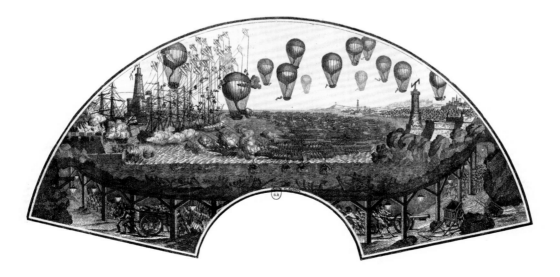

Fan-leaf entitled *Descente en Angleterre*: a French view of the transport of troops to the British coast
Published by Boulet, 17 February 1798
Etching, printed in brown ink; 151 x 428 mm
IFF 18, Boulet 3
Bibliothèque nationale de France, FOL-IB-4 (2)

THE FINANCIAL CRISIS

The government made continual requests for vast sums of money from the Bank of England in order to fund the war with France. From 1793 to 1815 total military spending was £830,000,000; in the same years Britain paid out £65,830,228 in subsidies to Austria, Russia, Prussia, Sweden, Portugal, Spain, Hanover, Sicily and smaller states in order to support their armies.[1] Government spending, together with panicky hoarding of gold by the public, brought the national gold reserves so low that in 1797 the Bank Restriction Act was passed according to which the Bank of England stopped paying out coin for its notes and made the first large issue of £1 notes. This caused immense concern to a populace whose confidence in the monetary system depended on being able to exchange notes for gold and who deeply mistrusted those that could not be exchanged. The Restriction period lasted until 1821.

1 Knight 2013, pp. 386–8.

11

James Gillray (1756–1815)
Midas Transmuting All into Paper
Published by Hannah Humphrey;
9 March 1797
Hand-coloured etching; 354 x 250 mm
1851,0901.852; BM Satires 8995
Presented by William Smith

The Bank of England had suspended payment of gold on 27 February 1797, three months before the Restriction Act was passed. James Gillray's immediate attack on Pitt shows him as a colossal, although as always very thin, figure bestriding the Rotunda of the Bank. His body is bursting with gold coins, but he vomits and defecates paper notes. Around his feet a number of tiny men hold up their hands in dismay at the shower of paper; among them is a John Bull, the English Everyman, as a farmer wearing a smock.

Gillray reverses the myth of King Midas who was granted a wish that everything he touched would turn to gold: for Pitt gold becomes paper. On the right, Pitt's allies, Lord Grenville, William Windham and Henry Dundas, as naked *putti*, fly towards him with a scroll summarizing his speech of the day following the suspension: 'Prosperous state of British finances and the new Plan for diminishing the National Debt – with hints on the increase of Commerce.' Below the title Gillray reminds his audience of another of Midas's mistakes when he judged the music of Marsyas superior to that of Apollo:

> The great Midas having dedicated himself to Bacchus [a reference to Pitt's heavy drinking] … Apollo fixed Asses-Ears upon his head, for his Ignorance – & although he tried to hide his disgrace with a Regal Cap, yet the very Sedges which grew from the Mud … whisper'd out his Infamy, whenever they were agitated by the Wind from the opposite Shore.

Ass's ears extend from the paper crown on Pitt's head and on the left are large reeds in which Fox and his followers can be seen. Agitated by the wind that blows a mass of soldiers across the Channel, and keen to malign Pitt's judgement, the Foxites whisper 'Midas has Ears'.

This is the first of many prints in the exhibition by Gillray, the greatest of the caricaturists. His intelligence and artistic skill made him a powerful political weapon and he was soon to be suborned into supporting the government, but politicians could never be certain that his satire did not attack his masters as well as their enemies, see pp. 26–8. From autumn 1791, he was employed almost exclusively by Hannah Humphrey, who became the leading caricature printseller of the day. This print was published from her shop in Bond Street shortly before she moved to 27 St James's Street, an even more fashionable address close to St James's Palace and to the political clubs, Brooks's (see cat. 10) and White's.

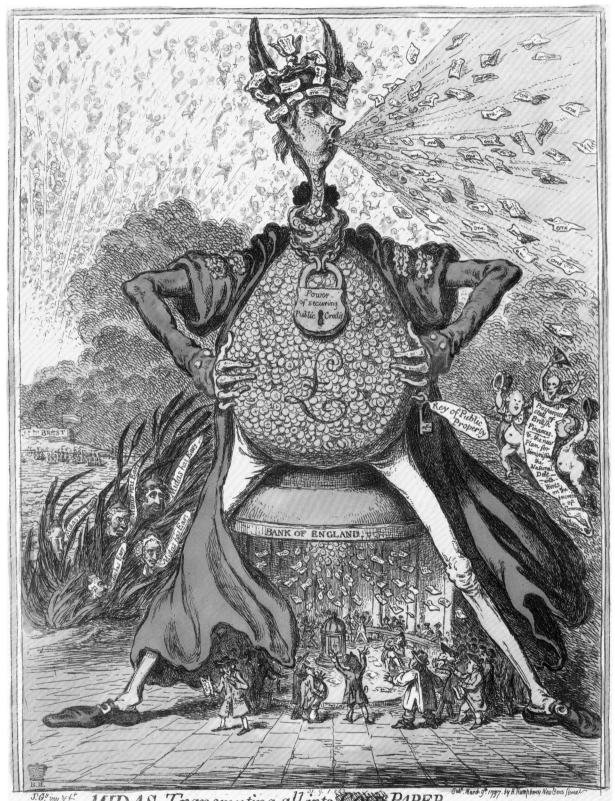

MIDAS, Transmuting all, into GOLD PAPER.

History of Midas, —— The great Midas having dedicated himself to Bacchus, obtained from that Deity, the Power of changing all he Touched
Apollo fixed Asses Ears upon his head, for his Ignorance —— & although he tried, to hide his disgrace with a Regal Cap, yet the very Sedges which
from the Mud of the Pactolus, whisper'd out his Infamy, whenever they were agitated by the Wind from the opposite Shore —— Vide Ovids Metamorphose—— P. 13

12

Banknote for £1, serial number 19220
Issued by the Bank of England,
14 November 1803
Engraving; 195 x 115 mm
1980,0223.1

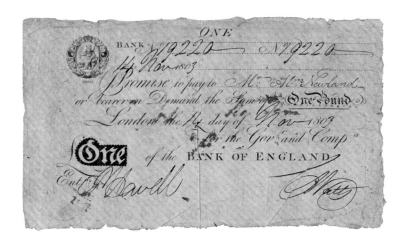

By 1803 when the note shown here was issued, the need for paper money was so great that the Directors of the Bank agreed at their meeting on 18 August to increase the quantity of paper required from the manufacturers, Portal and Bridges of Freefolk, Hampshire, from 7,400 to 10,000 reams, which would require two vats to be worked all year.

Currency was eased not only by an increased supply of bank notes, but also by the issue of dollar-size coins, mostly Spanish 'pieces of eight' (coins of *ocho reales*), countermarked with the head of George III on top of that of Charles IV of Spain. In February 1797 the Bank of England held silver bullion in foreign dollars amounting to £241,000. Much had been purchased on the market, but since the previous October when Spain had declared war on Britain, Spanish silver coin had also been taken on captured vessels. Coins were stamped at the Royal Mint with the small oval punches used for hallmarks on silver plate, and were issued on 6 March at the price of 4s. 6d. (22½p). A recent rise in the price of silver, however, meant that the coins could be bought for less than their bullion value and they were re-valued three days later at 4s. 9d.; then from June onwards the price of silver fell, and false countermarks began to appear on Spanish coins that were now worth more than their bullion value. In September, the coins – more than two million had been issued – were recalled by the Bank. In January 1804, with war-time inflation raging, there was another issue of countermarked dollars, this time with an octagonal stamp; they were valued at 5s., which was 3½d. above their bullion value and once again the stamps were forged. In June, after 266,000 coins had been issued, they were recalled. The solution was found in Birmingham where the steam-powered presses developed by Matthew Boulton and James Watt at the Soho Mint were able to re-strike dollars with a completely new design. These over-stamped dollars were issued from 1804 until 1811.[1]

While the Bank and the Mint were struggling to combat forgery, commercial companies and other organizations solved their immediate problems by issuing tokens for small sums that could be exchanged for goods or, when sufficient numbers had been accumulated, for bank notes. The three tokens shown here represent a range of organizations.

The Rev. Daniel Collyer, of Wroxham, Norfolk, was the local landowner and proprietor of large marl pits along the river Bure. Marl is a mixture of clay and limestone that was much in demand in the eighteenth-century agricultural revolution in order to improve the water-holding capacity of soil. Many thousands of tons of material were dug out before the pits near Wroxham closed in the 1870s; the cuttings were afterwards planted with conifers and the area is now known as Little Switzerland. A memorial in the church at Wroxham shows a more direct link to the Napoleonic war: Daniel's son Captain George Collyer of the Royal Engineers was killed at the age of 24 at the Siege of San Sebastian on 31 August 1813, 'after having with courage and judgement led a column to the attack [he] was killed in the breach'.

Samuel Fereday owned a number of coalmines and iron works, as well as a local bank in Bilston, Staffordshire. He was reputed to employ nearly 5,000 men and every Friday would send a carriage to Edward Thomason's factory in Birmingham to collect the tokens with which they were paid. Thomason claimed in his memoirs that he manufactured over two million copper tokens for Fereday. However, even an entrepreneur on such a large scale was vulnerable to the post-war slump and Fereday was declared bankrupt in 1817.

The workhouse in Lady Lane, Leeds was founded in the late seventeenth century to allow the local authorities to comply efficiently with the laws giving them responsibility for the care of the poor and infirm. In 1812, although the growth of the industrial town meant that it housed about 200 people, the workhouse was judged to have been well run by the standards of the time for more than thirty years by Joseph Linsley, described as a 'benevolent yet economical guardian of the poor'.[2] The token bears the coat of arms of Leeds with the fleece referring to the wool industry to which the city owes its prosperity.

1 H.E. Manville, 'The Bank of England Countermarked Dollars, 1797–1804', *British Numismatic Journal*, 2000, LXX, pp. 103–17.
2 John Mayhall, *The Annals of Yorkshire*, Leeds 1862, p. 245.

13
Peso de ocho reales with oval
countermark
Silver, 1797
1919,0918.498
Presented by T.H.B. Graham
1920,0907.396
Bequeathed by F.W. Hasluck

16
Token for threepence
Issued by D. Collyer of Wroxham,
Norfolk, proprietor the Marle Pit
'to pay workmen and promote
agriculture', 1797
From the collection of Sarah
Sophia Banks
SSB,195.172

14
Peso de ocho reales with octagonal
countermark
Silver, 1804
1926,0817.328
Presented by Miss Ruth
Weightman

17
Token for twopence
Issued by Samuel Fereday, Bilston,
Staffordshire, for Bradley, Bilston
and Priestfield Collieries and
Ironworks, 1811
1906,1103.4209

15
Peso de ocho reales overstruck using
Boulton and Watt steam press
Silver, 1804
1919,09018.501
Presented by T.H.B. Graham
E.4082

18
Token for one shilling
Issued by the Leeds Workhouse, 1812
Silver
1870,0613.12

NEW TAXES

Pitt attempted to avoid borrowing to finance the war by increasing taxes. On 24 November 1797 his budget speech announced a tripling of assessed taxes on inhabited houses, male servants, carriages, and so on. There were abatements for those on low incomes; the taxes were targeted at luxuries and the rich would be hit heavily. There was widespread evasion. In 1799, an even less popular measure was introduced: income tax. Rates began at 2d. per £1 (a little less than 1%) on incomes of £60 a year and were increased incrementally to 10% on incomes over £200. This allowed the government to raise an additional £6,000,000 a year. Further changes were made in 1803 when tax was levied at different rates according to the source of income, income from land being more severely taxed than that from farming, public annuities, self-employment or salaries.[1]

1 J. Jeffrey-Cook, 'William Pitt and his Taxes', *British Tax Review*, Issue 4, 2010.

19.
Charles Williams (active 1797–1830)
The Stratagem Alias the French Bug-a-bo
Published by Samuel William Fores,
1 January 1799
Hand-coloured etching; 249 x 403 mm
1868,0808.6811; BM Satires 9337
From the collection of Edward Hawkins

This print uses a favourite emblematic device of satirical printmakers of the period: a monster breathing fire and threat. In cat. 7 Napoleon rides another 'French bugabo' breathing out soldiers and guns; here Pitt carries a monster representing '*La Grande Nation*' (that is, France), this time breathing skeletons. The prime minister threatens an anxious and rather shabby John Bull imperiously: if he does not pay up his 10% income tax then the monster will be let loose. On the wall behind 'A Schedule of Farmer John's Income and Expenses' shows that after expenses and the new tax, only £24 a year will be left to support his family.

 The print has been attributed to Charles Williams, a prolific etcher working for Fores in the 1790s and later for other printmakers. There are ten prints by him in the present exhibition. Nothing is known of him beyond his prints, but his skilled draughtsmanship suggests that he was formally trained as an artist and he was probably the Charles Williams bound to the engraver Nicholas Goodnight on 17 July 1793.[1] His name has been used as something of a catch-all for anonymous prints and etchings attributed to him on stylistic grounds are often signed with pseudonyms, for instance, Argus, Timothy Squib or Tom Truelove.

1 A piece of information kindly supplied by David Alexander.

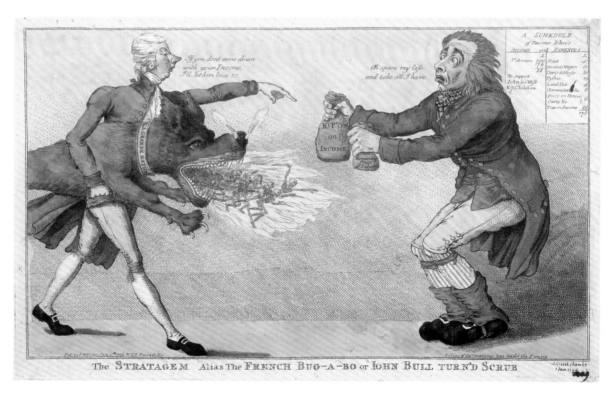

20

Isaac Cruikshank (1764–1811) after
George Murgatroyd Woodward
(c. 1760–1809)

John Bull Troubled with the Blue Devils

Published by Samuel William Fores,
23 May 1799

Hand-coloured etching; 387 x 226 mm

1935,0522.11.197; BM Satires 9391

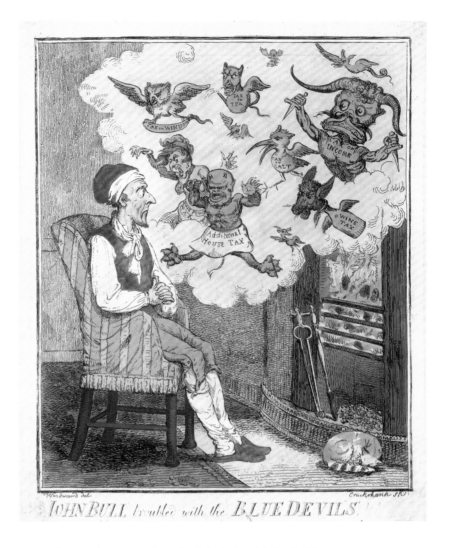

An anxious and shrunken John Bull sits before his fire in his
nightcap and slippers transfixed by a swarm of menacing blue
devils emerging in a cloud of smoke. 'Blue devils' was a cant term
for spleen or melancholy. Here they are personified in the form of
Pitt's taxes, introduced to pay for an unpopular war. The largest,
with a dagger in each hand, is the new 'Tax on Income'. Earlier
taxes also threaten: the 'Tax on Windows' that was introduced
in 1784 to compensate for the reduced 'Tax on Tea'; the 'Hair
Powder Tax' (in 1795 a 1 guinea licence was introduced for those
wearing powder and lists of licence-holders were posted on the
doors of parish churches); the 'Wine Tax' of 6d. a bottle imposed
in 1796; 'House Tax' the duty payable on inhabited houses that
was increased in 1797; the 'Tax on Salt', doubled in 1798.

Isaac Cruikshank based this print on a drawing by George
Murgatroyd Woodward who was the designer of more than 500
caricatures. He was not a skilled draughtsman but his inventive
humour had a ready market and the publishers who employed
him (Fores, Holland, Ackermann and Tegg) relied on Cruikshank,
Rowlandson and other printmakers to refine his vigorous sketches.

EGYPTIAN SKETCHES,

extracted from the Portfolio
of an ingenious young Artist, attached
to the Institut National at CAIRO, which
was found on board a Tartane intercepted
on its Voyage to Marseilles.

The Situations in which the Artist
occasionally represents his Countrymen
are a sufficient proof of an Impartial-
-ity and Fidelity, which cannot be too
much commended;—indeed, we must sus-
-pect that his view of the flagitious absurdi-
-ties of his Countrymen in Egypt, is
nearly similar to ours, and that he
took this method of pourtraying
them, under the seal of
confidence to his
Correspondent
at PARIS.

J? Gillray fec?

London, Publish'd March 12? 1799. by
H. Humphrey N: 27 S? Jamess St

2
Egypt

Bonaparte quickly realized that the French navy was in no condition to support an invasion of Britain and after inspecting the ports he suggested alternatives: an attack on Hanover and Hamburg, colonial conquests, or a landing in the Levant. In March, the Directory governing France decided on the Eastern Mediterranean, threatening Britain's routes to India while opening up their own. They were now wary of Bonaparte's popularity and this plan got him out of Europe while offering him the appealing role of a second Alexander the Great, a chance to emulate the ancient conqueror of lands stretching from Europe as far as the borders of India. On 19 May 1798, Bonaparte sailed from Toulon. The British had no idea what the French were up to and feared an attack on Portugal or Ireland as much as easterly targets. Admiral Nelson scoured the Mediterranean in vain until the French took Malta and then landed in Egypt. This was part of the Ottoman Empire, but had been ruled for centuries semi-autonomously by the Mamelukes, a caste of high-status military slaves. Napoleon defeated them at the Battle of the Pyramids and captured Cairo on 24 July, but on 2 August Nelson destroyed his fleet off Alexandria at the Battle of Nile.

Nelson became a national hero, a figure who united popular opinion in a way that neither William Pitt nor George III was able to do. Bonaparte marched into Syria but his progress was halted at Acre by Sir Sidney Smith and Achmet Pasha (known as 'Djezzar', that is, the Cutter or Butcher), the local governor, and their Albanian mercenaries. At Acre Napoleon suffered the first serious reverse of his career (see cat. 68).

21

Thomas Hellyer (active 1790s–1800s) after James Weir
(1757–1820)
Battle of the Nile
Published by John Brydon, 4 June 1800
Stipple and etching; 495 x 725 mm
1872,0511.363

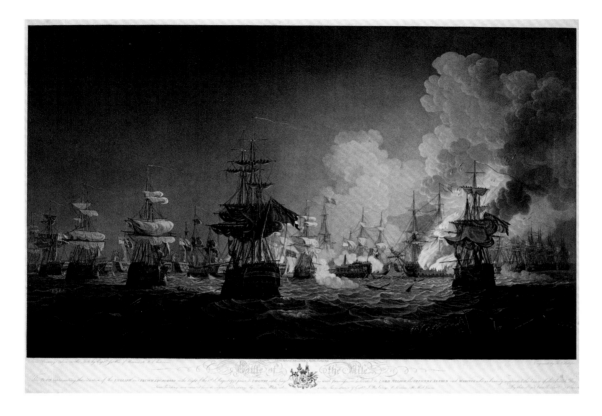

Within three weeks of landing in Egypt, Napoleon's army had defeated the Mameluke regime, but on the night of 1 August his ships moored at the mouth of the Nile were destroyed by Nelson's fleet. The French did not expect an attack just before sunset on ships anchored in a shallow bay on a lee shore protected by artillery, and had not even prepared their guns on the inshore side. Nelson sailed straight in, relying on the skill of his sailors and gunners, having previously explained his plans for all contingencies to his captains. The leading ship steered daringly inshore of the French line using the best (French) chart, and the British attacked from both sides, anchoring where they chose. The flagship *L'Orient* blew up; another ship was burned to destruction; nine were captured. Only two ships and two frigates escaped, leaving the French army practically marooned in Egypt. This was the achievement that turned Nelson from a popular admiral into a national hero.

There was a huge market for prints detailing the events of this particular battle. This fine stipple is one of a set of three prints by Thomas Hellyer showing different moments in the action based on drawings 'made on the spot' by James Weir, a Captain of Marines serving on the *Audacious*. Like many military and naval officers Weir was an accomplished draughtsman; his views of Elba and Malta (he went on to command Marine Corps

on both islands) were also published as prints. There was an established tradition in Britain of fine prints of naval battles, often showing the performance of ships in meticulous detail, and most captains wanted their successful actions preserved for posterity by at least a drawing. Thomas Whitcombe (1763–*c*. 1824), an artist who specialized in naval subjects, developed Weir's original drawings into paintings or watercolours under the supervision of John Boscawen Savage, who had been Captain of the Marines on board the *Orion* at the battle of the Nile where he was bruised by a cannon ball that passed between his arm and side. The set of prints based on Whitcombe's compositions, plus a key showing the disposition of the ships, was advertised in the *Sun* on 30 April 1799 by John Brydon of Charing Cross, and Amabel, Lady Lucas subscribed to the set. Brydon's business had expanded from frame-making to selling prints and looking-glasses, and he would later offer also to arrange funerals, before going bankrupt in 1801. He states on the prints that Nelson had given permission for them to be dedicated to him; Nelson certainly gave him his patronage, writing to Emma Hamilton on 8 February 1801: 'I hope Mr Brydon has executed the frames to your satisfaction'.[1]

1 Simon, British picture framemakers, 1610–1950 – B.

22

Charles Williams (active 1797–1830)
*Anticipation – Ways and Means – or
Buonaparte Really Taken!!*
Published by Samuel William Fores,
13 August 1798
Hand-coloured etching; 293 x 389 mm
1868,0808.6763; BM Satires 9241
From the collection of Edward Hawkins

Like many political satires this provides an incidental view of a familiar scene in Georgian Britain: a booth at a country fair where a 'monster' (Bonaparte) is displayed to the curious public. The strange creature's likeness appears on a banner, the sad clown (Fox) draws the attention of gullible passers-by, and the gouty mountebank (Pitt) lures them with a tall story to part with their cash.

In London, vague rumours abounded as to what might be happening in the Eastern Mediterranean but confirmed information was lacking. On 8 July, Lady Lucas wrote in her diary: 'A Report had been prevalent yesterday from some Stories told by Neutral Ships to one of Ours that Nelson had defeated Buonaparte & even taken him prisoner. But the Circumstance of Buonaparte's being in Possession of the Harbour of Malta by the 11th of June too clearly proves these Stories to be Fables.'[1] On 14 September the news arrived that Bonaparte had landed in Egypt in the first week of July, but the dispatch reporting Nelson's great victory on 2 August was captured by the French, and it was not until 2 October that news reached London.

This print imagines Pitt spreading the rumour of Bonaparte's capture, but it communicates scepticism both about the likelihood that he will be defeated, however much money Pitt raises in taxes, and about the image the government was putting about of the Frenchman: 'an undoubted likeness' is plainly sarcastic even though it refers to earlier caricatures of Bonaparte as a moustachioed brigand.

1 Lucas diary, XVII, p. 185.

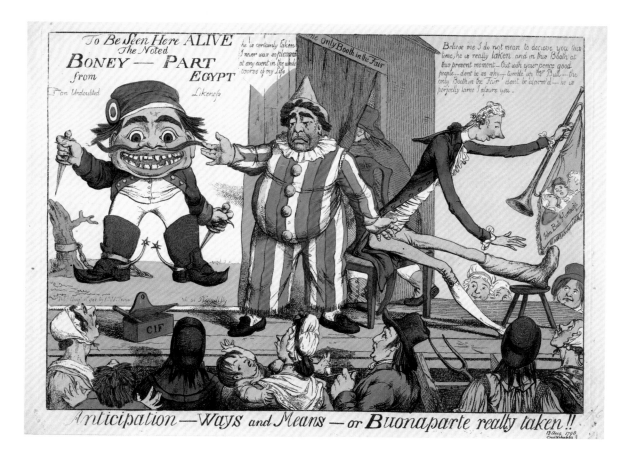

23

Battle of the Nile on Real Water
Published by Charles Dibdin, about 1804
Wood-engraving with letterpress; 372 x 519 mm
Y,6.159
From the collection of Sarah Sophia Banks

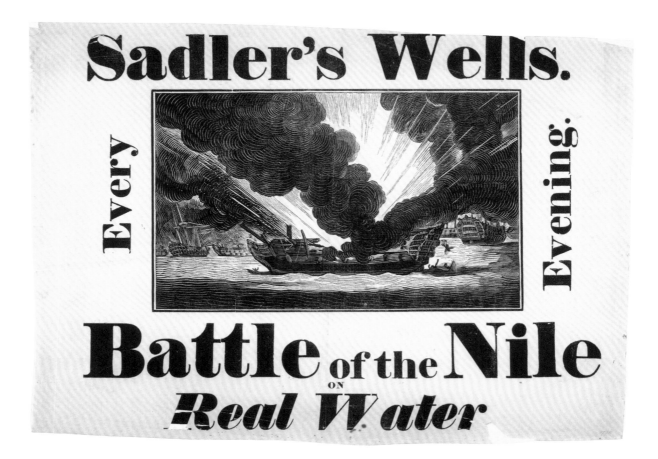

The most dramatic moment of the battle of the Nile was the
explosion of the 120-gun French flag-ship *L'Orient*, then with her
sister ship *Océan* the largest warship in the world. Spectacular
images appeared in many prints but the re-enactment at Sadler's
Wells Theatre must have been the most bizarre sight. The
impresario Charles Dibdin installed a water tank at the theatre in
1804 and was able to stage such extravaganzas as 'realistic naval
battles and Newfoundland dogs rescuing drowning children'.[1]

1 M. Kilburn, 'Dibdin, Charles Isaac Mungo (1768–1833)', *Oxford Dictionary of*
 National Biography, Oxford 2004: http://www.oxforddnb.com/view/article/7586.

24

Isaac Cruikshank (1764–1811)
The Gallant Nelson Bringing Home Two Uncommon
Fierce French Crocodiles
Published by Samuel William Fores, 7 October 1798
Hand-coloured etching; 261 x 378 mm
1868,0808.6774; BM Satires 9251
From the collection of Edward Hawkins

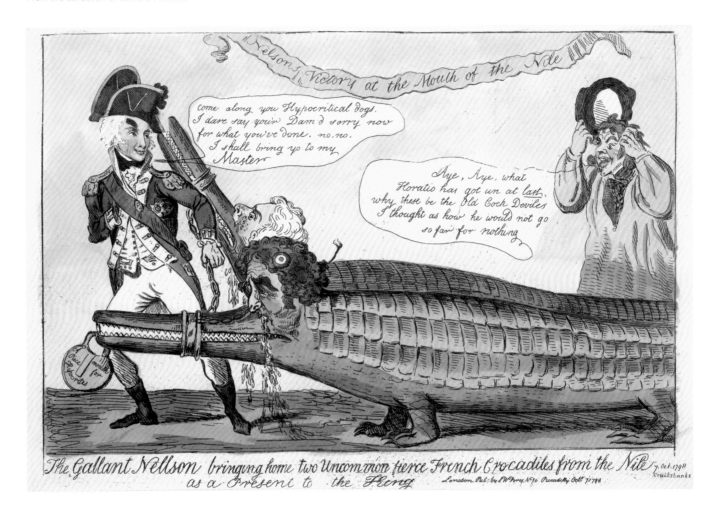

News of the Battle of the Nile, which reached London on
2 October, five days before this print was published, caused an
outbreak of unconfined joy: 'at Night Illuminations in every Street
& the Mobs throwing Squibs', wrote Lady Lucas in her diary.[1]

Although presented as a celebration of Nelson's victory,
the target of this satire is really the Opposition who had always
argued for an accommodation with Revolutionary France. The
two crocodiles led by Nelson in this print have been fitted with
the easily recognized heads of Fox, with his bushy eyebrows, and
Sheridan, with his red nose and blotchy cheeks. Their tears over
the defeat of the French are now crocodile tears. John Bull, a
farmer in a smock, is glad to see that the Opposition has been
foiled.

1 Lucas diary, XVII, p. 225.

25

James Gillray (1756–1815)
John Bull Taking a Luncheon
Published by Hannah Humphrey, 24 October 1798
Hand-coloured etching; 262 x 362 mm
1868,0808.6778; BM Satires 9257
From the collection of Edward Hawkins

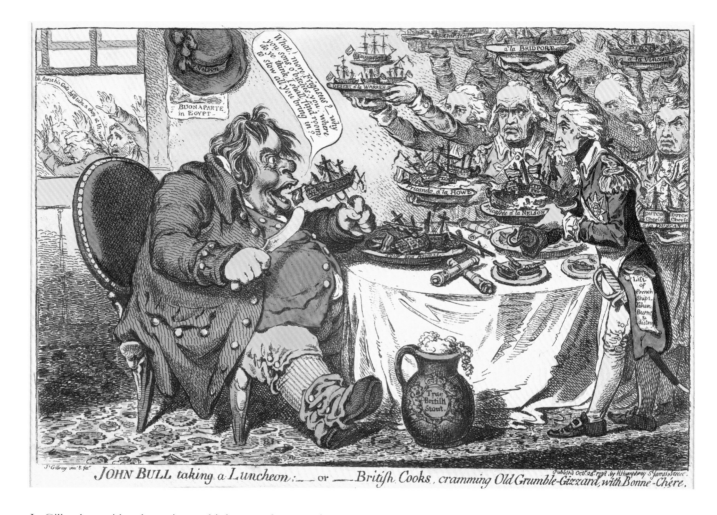

JOHN BULL taking a Luncheon: — or — British Cooks, cramming Old Grumble-Gizzard, with Bonne-Chère.

In Gillray's considered reaction to this latest and greatest in a string of naval victories, a grossly fat John Bull gorges on the offerings of British admirals who are, by contrast, portrayed with due respect – as careworn as they really were – although dressed in waiters' aprons over their uniforms. Bull's 'luncheon' consists of captured French ships and he complains that they have given him so many that he cannot manage to eat any more. His hat hangs on the wall, obscuring a print of 'Buonaparte in Egypt'. Nelson is in the foreground, his face scarred and his right hand, lost the previous year at Tenerife, replaced by a hook. Through an open window leaders of the Opposition are seen running off with upraised arms; Fox is crying, 'Oh, Curse his Guts! he'll take a Chop at Us, next.'

26

James Gillray (1756–1815)
Buonaparte Hearing of Nelson's Victory
Published by Hannah Humphrey,
8 December 1798
Hand coloured etching; 335 x 255 mm
1868,0808.6801; BM Satires 9278
From the collection of Edward Hawkins

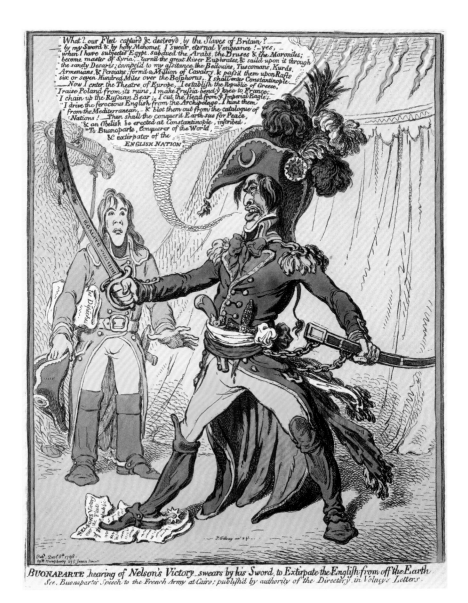

In this print Gillray purports to be depicting Bonaparte's reaction
to news of the Battle of the Nile, but in fact the speech is a parody
of an article by the French scholar, Constantin Volney, that had
appeared in the *Moniteur* on 20 November 1798 and was translated
in the *London Chronicle* on 1 December. The flamboyant general
(his visual image still not fixed by the caricaturists) swaggers
furiously. His words are closely based on Volney's but the tone has
changed so that rather than aiming at peace and a new balance
of power in Europe, he now wishes to 'subject' and 'subdue', to
force countries to 'bend the knee to France', to chain up, to cut off
heads, and finally for an obelisk to be 'erected in Constantinople
inscribed "To Buonaparte Conqueror of the World & extirpater
of the English Nation'". In Volney's original article, that
inscription was to read, 'To Bonaparte, member of the National
Institute, peacemaker of Europe.'

NAPOLEON'S SAVANTS AND THE BIRTH OF EGYPTOLOGY

When Alexander the Great set out to conquer the East he took with him a band of learned men and philosophers to explore the lands they passed through. Napoleon envisaged himself as a second Alexander and modelled his expedition to Egypt on antiquity. Already a member of the *Institut National* as a mathematician, he recruited fellow members to join his expedition and many prominent scholars, archeologists and artists travelled with the army. On reaching Cairo he created an Institute of Egypt from which a new science of Egyptology could evolve. The scholarly expedition was recorded in Dominique Vivant Denon's *Voyage dans la basse et la haute Egypte* (1802).[1]

The French were rapidly disillusioned by the reality of Egypt and some of their unhappy letters home dated July–September 1798 were intercepted on boats captured by British ships. George Canning, then Undersecretary for Foreign Affairs, masterminded the publication of a selection of letters – some of which may have been invented – in order to 'undeceive Europe' as to the motives of the French. The two juiciest revealed that an anguished Napoleon believed his wife was having an affair. Canning cunningly showed these to the Opposition, with the result that the *Morning Chronicle* revealed the scandal by demanding on 26 November 1798 what 'Madame Bonaparte's chastity has to do with her husband's Expedition through Egypt'.[2] Selections of the letters were published in 1798 and 1799 in French, English and German. Canning's introduction to the publication disparaged the savants who accompanied Napoleon's expedition: 'To promote the farce (for such we are persuaded it was), artists of all kinds, chymists, botanists, members of the pyro-technical school in prodigious numbers, and we know not what quantities of people calling themselves Savans, were collected from every part of France, and driven to Toulon in shoals'.[3]

1 Forrest 2011, p. 103.
2 S. Burrows, 'Britain and the Black Legend: The Genesis of the Anti-Napoleonic Myth', in Philp 2006, pp. 150–2.
3 *Copies of original letters from the army of General Bonaparte in Egypt: intercepted by the fleet under the command of Admiral Lord Nelson*, London 1798, p. vi.

27
James Gillray (1756–1815)
Siege de la Colonne de Pompee
Published by Hannah Humphrey, 6 March 1799
Hand-coloured etching; 500 x 415 mm
1851,0901.959; BM Satires 9352
Presented by William Smith

After an elaborate wooing with both carrot and stick and a final meeting with George Canning on 14 November 1797, Gillray accepted a government pension of £200 a year. From that date he sometimes worked with a group of Canning's associates including John Hookham Frere, George Ellis, William Gifford, Charles Bagot and John Sneyd; the latter had first introduced Gillray to Canning. This print was a product of that fertile collaboration. The idea was dreamed up of a series of imaginary intercepted drawings to run in comic parallel to the intercepted letters. The text at the bottom of the print sets the scene at the Roman column outside Alexandria known as Pompey's Pillar.

> It appears by an Intercepted Letter from General Kleber, dated 'Alexandria, 5 Frimaire, 7th Year of the Republic' [27 November 1798 – no letter of that date was actually intercepted], that, when his Garrison was obliged to retire into the New-Town at the approach of the Turkish Army under the Pasha of Rhodes, a party of the Scavans, who had ascended Pompey's Pillar for Scientific Purposes were cut off by a Band of Bedouin Arabs, who having made a large Pile of Straw and dry Reeds at the foot of the Pillar, set Fire to it, and rendered unavailing the gallant Defence of the learned Garrison, of whose Catastrophe the above Design is intended to convey an idea.

The design of this print follows in exact detail a set of instructions that survive in a collection of papers of Gillray and the Humphrey family in the British Library.[1] The sketch, mentioned in the first line, is now missing.

> A Sketch of the Principal Group is sent herewith, to give a more detailed Explanation of the Idea. The figures 1 & 2, having attempted to escape in the Air Balloon (which as it appears by its title had been meant as a regular vehicle to Abissynia) are brought down by a Shot, from the Turk on the left of the foot of the Pillar, which tore the Balloon, the hole is represented in the space marked x; – xx is the boat which has broke away from the Balloon in its fall. – Fig. 2 clings to the Parachute
>
> Fig: 3 contemplates with Dread the catastrophe of his comrades & the height he himself is likely to fall from. – Fig: 4 is on tiptoes about to take wing, he turns his back on his friends, & sets off in full confidence of the success of his Invention. - Fig: 5 is in frantic Despair & gnaws Savary's Book by which they were mislead to their Egyptian Expedition SAVARY is to be written on the Back of the Book. – Fig. 6 is addressing the Arabs with a view to obtain a cessation of hostilities – on the Scroll in his right is written *Vive Mahomet*

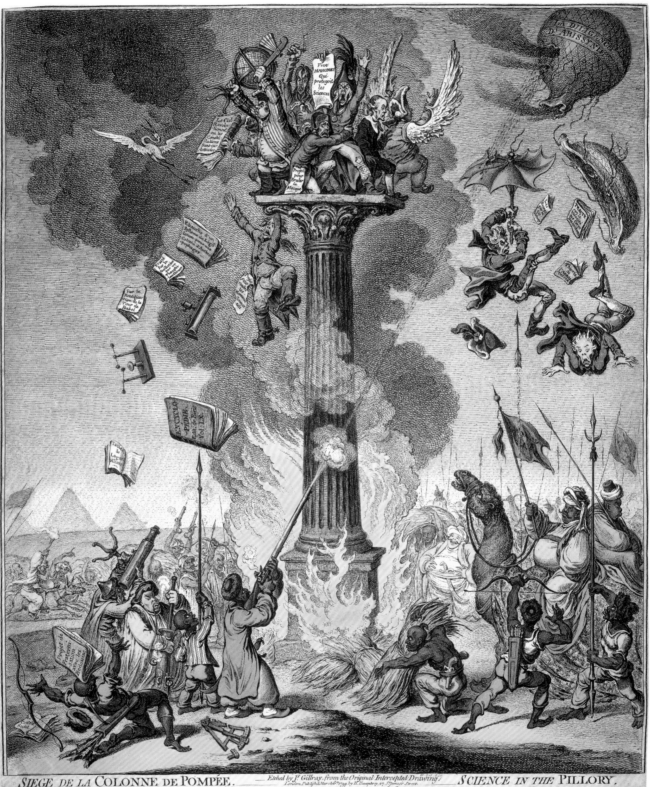

SIEGE DE LA COLONNE DE POMPÉE. — *Etched by J^s Gillray, from the Original Intercepted Drawing.* — SCIENCE IN THE PILLORY.

London, Publish'd March 6th 1799, by H. Humphrey, 27, S^t James's Street.

It appears by an Intercepted Letter from General Kleber, dated "Alexandria, 5 Frimaire, 7th Year of the Republic," that, when his Garrison was obliged to retire into the New Town at the approach of the Turkish Army under the Pacha of Rhodes, a Party of the Savans, who had ascended Pompey's Pillar for Scientific Purposes, was cut off by a Band of Bedouin Arabs,

who, having made a large Pile of Straw and dry Reeds at the foot of the Pillar, set Fire to it, and rendered unavailing the gallant Defence of the Learned Garrison, of whose Catastrophe the above Design is intended to convey an Idea.

To study Alexandria's store
Of Science, Amru deem'd a bore;
The Man was Ignorant 'tis true,
So sought one comprehensive view
Of the Light shed by Learning.

Your modern Arabs, grown more wise,
French vagrant Science duly prize;
They've fairly bit the biters,
They've learnt the style of Hebert's Jokes,
Amru to Books confin'd his Hoax,
These Bedouins roast the Writers.

Egypt 79

qui protegoit les Sciences. – Fig 7, is clinging to the orator (Fig. 6) that he may obtain Mercy for him; His principal cause of fear arises from his having in his Pocket a plan for burning Mecca; – on this Scroll protruding as it appears out of his Pocket is to be written *Projet pour bruler la Mecque.*

Fig 8 looks down with contempt on the pusillanimity of Fig: 7 who might find a resource in suicide which he means to resort to himself – In his right hand he holds a Razor inscribed *Tone*, in his left a Phial inscribed *Louvet*, & on its Label is *Opium*. In a girdle round his waist, to the right is a pistol inscribed *Roland*, & to the left is a knife inscribed *Romme* – as these were the means of suicide of the above mentioned revolutionary heroes. Fig: 8 is meant to be a lean melancholy figure.

Fig: 9 is furious & making a desperate defence hurling down a Globe from his right hand & a Trigon[2] from his left. He has already flung down a Book inscribed *Encyclopedie Edit: de Paris: Vol: LX*, (which an Arab Boy is catching on his Lance), an Electrical Universal Discharger, an Air Lea […] & a Telescope. Fig: 10 has fallen off the Pillar in the general scramble […] caught by his right hand, & in his despair[?] has caught at the legs of a crane (which is flying by, & which he has [missed with?] his left hand from which falls a scroll on which is written *Projet pour render les homes immortels.* of the books falling to the right of the Pillar in the first page of one is written *Les Ruines par le Cit: Volney*, of the second *Traité sur la Guillotine par un Theophilanthrope*, & of the third *Traité sur la Velocité des Corps descendens*, & on the back of the fourth *Théorie de l'aerostation.*

Of the Arabs to the right of the Pillar, of the two on the Dromedary the one whose face is turned to the Tail must have a heavy Countenance as in the Design for an obvious reason. – the Arab with a Bow has shot his arrow at Fig *2*; & the next with a Spear & on foot is waiting to pierce Fig. *1*, when he falls; the next, on the high ground is looking up at the Scavans, & laughing at them.

To the left of the Pillar the Arab nearest it has just shot the Balloon. The next, a Boy, is catching the 60th. Vol. of the Encyclopedie on his Lance, & is much astonished at it. The next, on his knee, is shooting his arrow at the Group on the Pillar. Those without Turbans are bringing Straw & dry Reeds. Another is loading his gun, & shooting. Above is an Arab who affects knowledge, & is looking as at the group on the Pillar with a Telescope flung down by the Scavans; he holds it upside down & looks thro' the wrong end. The two arabs arm'd with bows have quivers fastened on with cross Belts.

It is immediately evident that whoever wrote the instructions had entered into the spirit of Gillray's caricatures to a remarkable degree and, equally, that Gillray responded to the lively imagination of the as yet unidentified writer of the instructions (they are not in Canning's hand). The originator of the design probably had access to Charles Norry's *Relation de l'expédition d'Égypte*, published in Paris in 1799, which included 'a particular description and measurement of Pompey's Pillar'.

1 British Library, Add. MS 27,337, ff.191-93.
2 A surveying instrument.

28

James Gillray (1756–1815)
Frontispiece to *Egyptian Sketches*
Published by Hannah Humphrey,
12 March 1799
Hand-coloured etching; 243 x 349 mm
1851,0901.960; BM Satires 9355
Presented by William Smith

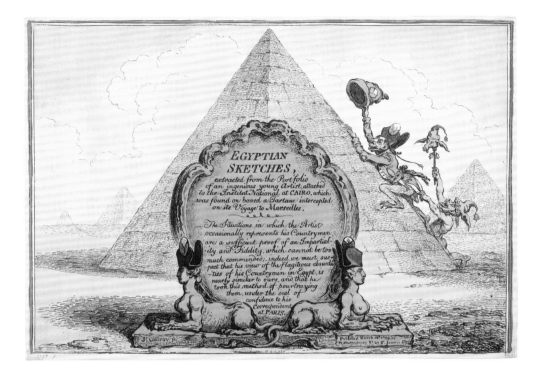

29

James Gillray (1756-1815)
L'Insurrection de l'Institut Amphibie
Published by Hannah Humphrey,
12 March 1799
Hand-coloured etching; 250 x 356 mm
1868,0808.6826; BM Satires 9356
From the collection of Edward Hawkins

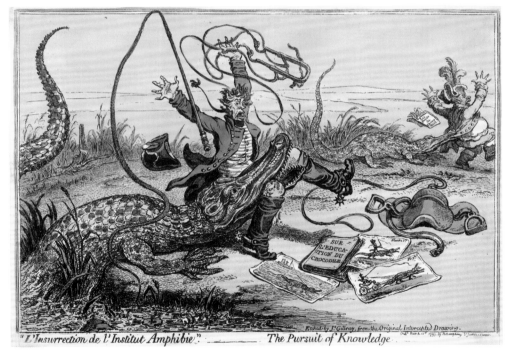

The large single-sheet 'intercepted drawing' was followed a week later by the frontispiece and a set of six further prints claiming to be based on drawings that were 'extracted from the Portfolio of an ingenious young Artist, attached to the *Institut National* at Cairo, which was found on board a Tartane intercepted on its Voyage to Marseilles.'

The set was designed to appeal to the type of British audience that would find Napoleon's encouragement of scholarship unconvincing or pretentious, or both. A savant from an imaginary Amphibious Institute has hoped to bridle a crocodile that has promptly seized his leg between its huge jaws. A large book, *On the Education of the Crocodile* lies on the ground together with three illustrations showing the savant's futile plans: a crocodile gallops forward with a rider on its back; a pair of crocodiles draw a fashionable chaise; a crocodile draws a boat across a large stretch of water. In the background, a second savant runs off dropping a book entitled *The Rights of the Crocodile* as another crocodile sinks its teeth into the tail of his coat.

30

Wooden figure of a man, originally
painted, c. 1850–1750 BC
Height: 360 mm
EA 2320
Purchased from Henry Salt, 1823

31

Painted wooden figure of a funerary
deity, Ptah-Sokar-Osiris,
c. 700–300 BC
Height: 455 mm
EA9773
Purchased from Henry Salt, 1823

[9773]

Few European travellers ventured to Egypt before 1798 and there
was a huge interest in the objects that were to be found there.
The most fascinating was part of a stela discovered by French
soldiers digging the foundations of a fort at el-Rashid (Rosetta) on
which the same text was inscribed in hieroglyphic and in Greek,
as well as in cursive demotic script. The Rosetta Stone was one
of a number of antiquities destined, like treasures from other
countries taken over by Napoleon (see cat. 9), for Paris. When the
French army finally capitulated to combined British and Turkish
forces on 30 August 1801, these antiquities became the property
of George III.[1] The importance of the Rosetta Stone was well
understood and the scholar Edward Clarke and the diplomat
William R. Hamilton were particularly charged with ensuring
its safety. A letter of 13 September 1801 to Clarke from General
John Hely Hutchinson, Commander of the British army in
Egypt, asks him to copy the inscription from the stone and
continues: 'Tell Colonel [Hilgrove] Turner that not only the
stone but every thing which we get from the French should be
deposited in some place of security. I do not regard much the
threats of the French sçavants [to burn their papers], it is better
however not to trust them.'[2]

The savants were given permission to keep their personal
collections and papers which were returned to France, and
allowed for the eventual publication of the series of large and
lavish volumes of the *Description de l'Égypte* (1809–28). The most
important scholarly outcome occurred in the 1820s when the
French linguist and historian, Jean François Champollion
published his decipherment of hieroglyphics and began the
systematic study of ancient Egypt.

In 1802 the King presented the antiquities acquired from the
French army to the British Museum, but the great British interest
in Egypt only began with the arrival at the British Museum of
spectacular works excavated by Henry Salt, British consul general
in Egypt from 1816. The first to attract widespread enthusiasm
was the bust of Ramesses II (now in Gallery 4); even before its
arrival, William R. Hamilton's description had inspired Shelley to
write his sonnet, *Ozymandias*, which ends:

> Look on my works, ye mighty, and despair!
> Nothing beside remains. Round the decay
> Of that colossal wreck, boundless and bare
> The lone and level sands stretch far away.

The parallel with Napoleon, by then on St Helena, cannot be
avoided.

Several hundred Egyptian antiquities in the British
Museum acquired indirectly as a result of Napoleon's invasion
are represented in this exhibition by two small figures from a
collection of more than 200 objects purchased from Henry Salt
(after several years' delay by the trustees) in 1823.

1 M. Bierbrier, 'The Acquisition by the British Museum of Antiquities discovered
 during the French Invasion of Egypt' in W.V. Davies (ed.), *Studies in Egyptian Antiquities:
 a tribute to T.G.H. James*, British Museum Occasional Paper, No. 123, London 1999.
2 British Museum, AES 2008,1006.1.

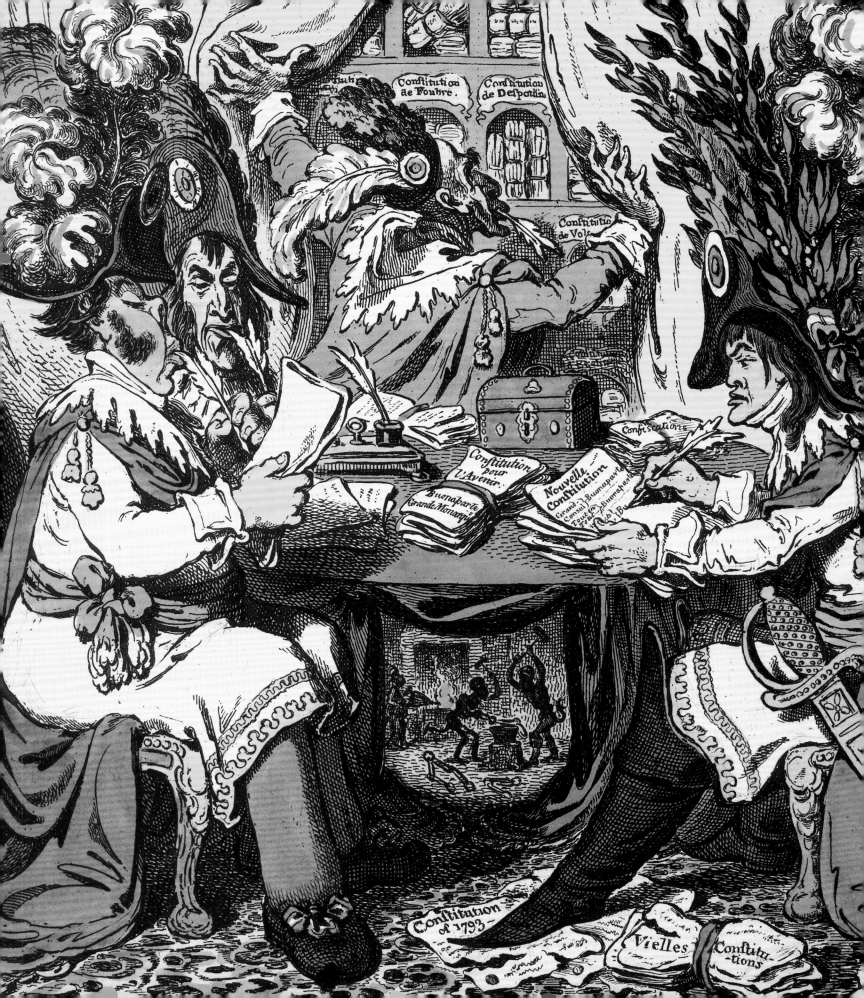

3
Consul and peacemaker

Napoleon had left Egypt for France on 23 August 1799. He was aware
that the rule of the Directory was unpopular and ineffective, and
angry that his military successes in Italy were being reversed. He may
also have known that two of the five Directors, Emmanuel Joseph
Sieyès and Roger Ducos, were planning to stage a coup d'état.

France's most popular general was greeted with enthusiasm by
the people, and within days of his arrival in Paris on 16 October,
he was involved in the plans for the coup. The intention was to oust
neo-Jacobin factions in the legislative assemblies and to create a new
constitution that would preserve equality for all before the law and
secure property, consolidating a bourgeois revolution.

The coup began on 9 November (18 *Brumaire*) with the hurried
move of both the Council of the Ancients and the Council of the
Five Hundred from the Tuileries to the Château of Saint-Cloud to
avoid a rumoured Jacobin attack. On the same day the notoriously
corrupt Paul Barras was persuaded to resign from the Directory
and the two neo-Jacobin Directors, Louis Gohier and Jean François
Moulin, were confined in the Luxembourg Palace. Thousands of
soldiers under Bonaparte's command ensured tranquillity in Paris.

On 10 November Bonaparte arrived at Saint-Cloud. His
confrontation with the Council of the Five Hundred in the Orangery
is shown in the following three prints. Accounts of the event vary, but
Napoleon met with an angry response and possibly some violence.
His brother Lucien, president of the Council, unable to make himself
heard, closed the session and left the building. Napoleon led his loyal
troops into the Orangery and Council members fled through the
windows.

Remaining members of the Councils voted to replace the defunct
Directory with a three-man Consulate of Bonaparte, Sieyès and
Ducos, who were charged with creating a new constitution within
six weeks.

32

Giacomo Aliprandi (1775–1855)
after Francisco Vieira (1765–1805)
*The Sitting of the Council of Five
Hundred*, 1 November 1802
Stipple; 360 x 452 mm
1871,0812.5279

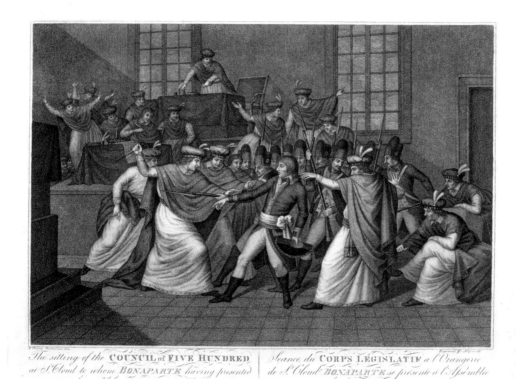

The sitting of the **COUNCIL** of **FIVE HUNDRED** at S.^t Cloud to whom **BONAPARTE** having presented himself he **DISSOLVED** Nov. 10.th 1799.

Seance du **CORPS LEGISLATIF** a l'Orangerie de S.^t Cloud **BONAPARTE** se présente à l'Assemblée et la **DISSOUD**, le 19 Brumaire 1799.

The print showing Napoleon's troops protecting him from attack
by Council members is one of a series prints of Revolutionary
and Napoleonic subjects by Giacomo Aliprandi, all copied from
other prints. Descriptive texts in the lower margins are in English
and French. Some carry lettering suggesting that they were
published in London, but in reality they were published in Italy,
merely made to look English because English prints had been
highly fashionable on the Continent since the 1780s.[1] The source
for this print is a large stipple of 1800 by Francesco Bartolozzi
(see cat. 40) based on a drawing by Francisco Vieira, a Portuguese
artist who worked in London from 1797–1801. By 1812, Aliprandi
had established himself as a printseller in Livorno, but at this
stage he was probably working for Santo Tessari, an important
Italian printseller based at Augsburg and Liège, who had been a
partner in Colnaghi & Co. in London until 1796.

1 Clayton 1997, pp. 261–82; T. Clayton, 'The export of English prints to Germany
 1760–1802' in A. Milano (ed.), *Commercio delle stampe e diffusione delle immagini nei secoli
 XVIII e XIV*, Rovereto 2008; Roy 2008, *passim*.

33

James Gillray (1756–1815)

Exit Libertè a la Francois!

Published by Hannah Humphrey,
21 November 1799

Hand-coloured etching; 250 x 353 mm

1851,0901.1003; BM Satires 9426

Presented by William Smith

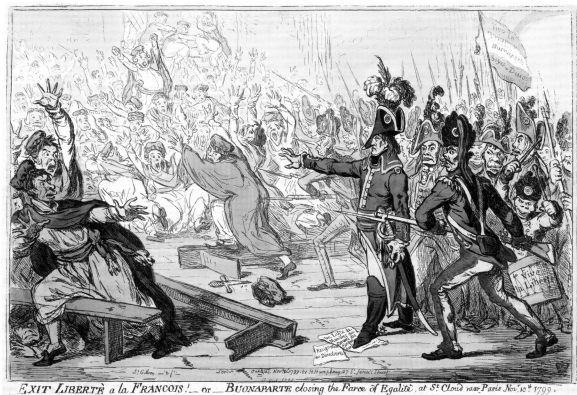

EXIT LIBERTÈ a la FRANCOIS! ___ or ___ BUONAPARTE closing the Farce of Egalitè, at St. Cloud near Paris Nov.r 10.th 1799.

Gillray's representation of events in the Orangery, although burlesqued, is more dramatic than Vieira's and Bonaparte is a more obviously powerful figure; there is no doubt that he will succeed in 'closing the Farce of Egalite'. The Council members flee in wild confusion from his outstretched arm. Gillray's Bonaparte has developed from the ruddy-faced caricature of Egypt into a more recognizable facial portrait, closest to the portrait by Hilaire Ledru (1769–1840) of 1796 that was widely copied in prints (see cat. 4).

The print was published only eleven days after the coup, and three days after news appeared in the London newspapers. Gillray has been careful to show the reported wounds on Napoleon's face and his left arm, and a bloody dagger lying on the floor. He tramples on 'A list of Members of the Council of Five Hundred' and 'Resignation of the Directors'.

34

Anonymous

The Corsican Crocodile Dissolving the Council of Frogs!

Published by William Holland, November 1799

Etching with hand-colouring; 255 x 347 mm

1868,0808.12565; BM Satires 9427

From the collection of Edward Hawkins

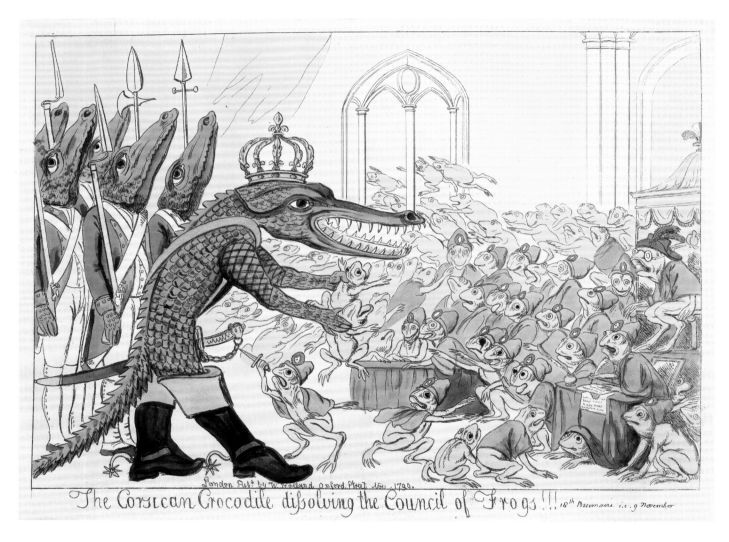

Holland's treatment of the event injects further irony. His print was inspired by Aesop's fable *The Frogs Who Wanted a King*, in which 'the commonwealth of frogs, a discontented variable race, weary of liberty, and fond of change, petitioned Jupiter to grant them a king'. Jupiter gave them a log, but they became contemptuous of the log and petitioned again, whereupon he sent them, according to alternative versions, either a crane or a crocodile, which ate them all up. Here Bonaparte, a crowned Egyptian crocodile, supported by crocodile grenadiers, seizes the nearest of the Council of Five Hundred who are depicted as frogs wearing red liberty caps. It has been argued that it was from the application of this fable to the French Revolution and from prints such as this, that to the British, the French first became 'frogs'.[1]

The British saw in Bonaparte the equivalent of Cromwell in their own seventeenth-century revolution and the event recalled Cromwell dissolving the Long Parliament. Many thought, like Pitt, that Bonaparte's coup would lead eventually to the restoration of monarchy either through his own seizure of royal power or through a Bourbon restoration.

1 D. Bindman, 'How the French became Frogs: English caricature and stereotypes of nations' in P. Kaenel and R. Reichardt (eds), *Interkulturelle Kommunikation in der europäischen Druckgraphik im 18. und 19. Jahrhundert – The European print and cultural transfer in the 18th and 19th centuries – Gravure et communication interculturelle en Europe aux 18e et 19e siècles*, Hildesheim 2007, pp. 427–9.

35

James Gillray (1756–1815)
The French Consular-Triumvirate Settling the New Constitution
Published by Hannah Humphrey,
1 January 1800
Hand-coloured etching; 350 x 250 mm
1851,0901.1007; BM Satires 9509
Presented by William Smith

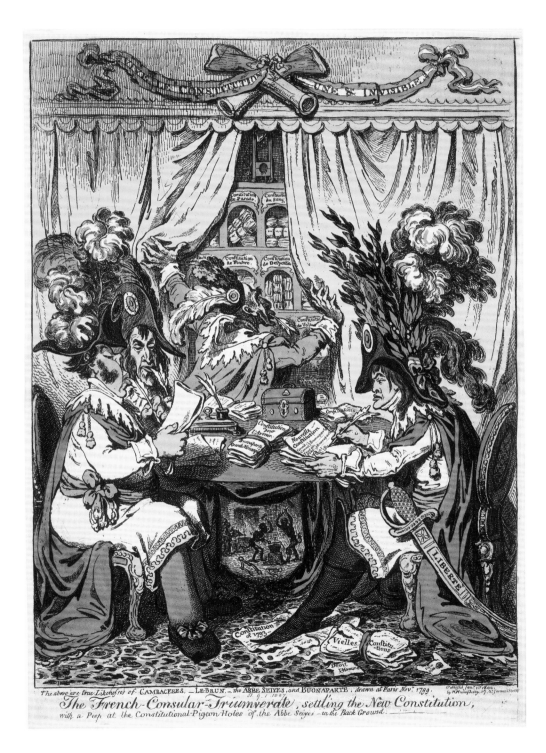

The above are true Likeness[es] of CAMBACÉRÉS, – LE-BRUN, – the ABBÉ SEIYES, and BUONAPARTE ; drawn at Paris Nov.r 1799.

The French-Consular-Triumverate, settling the New Constitution,
with a Peep at the Constitutional-Pigeon-Holes of the Abbé Seiyes –in the Back Ground.

This print bears the mark of George Canning's intimate familiarity with the details of French politics in the period after the coup, and it may be supposed that a briefing from him or someone in his circle lay behind it.[1]

Napoleon characteristically wasted no time in devising a new constitution in which he became First Consul. The other interim consuls, Sieyès and Ducos, handed over to Jean-Jacques Regis de Cambacérès and Charles François Lebrun, here seen dithering and sucking their pens. Sieyès appears in the background looking out a suitable constitution from his stock – a thought taken from Edmund Burke's *Letter to a Noble Lord* of 1796: 'Abbé Sieyès has whole nests of pigeon-holes full of constitutions ready made, ticketed, sorted, and numbered; suited to every season and every fancy'. This passage had been reprinted in *The Times* of 7 December 1799, three weeks before Gillray's print was published, with the further remark that 'The New Constitution proposed for France is said to come from the pigeon-holes of the Abbe Sieyes but it has more the appearance of being hatched in the Egyptian ovens of Bonaparte.' It is significant that a fold in the banner at the top changes the words of the Revolutionary constitution of 1793 from '*une et indivisible*' to '*une & invisible*'.

The figures have to be identified in the lower margin, for only Bonaparte is faintly recognizable as a portrait. The appearance of the other consuls was presumably unfamiliar either to Gillray, or to his audience.

1 Hill 1965, p. 81 n, pp. 125–6.

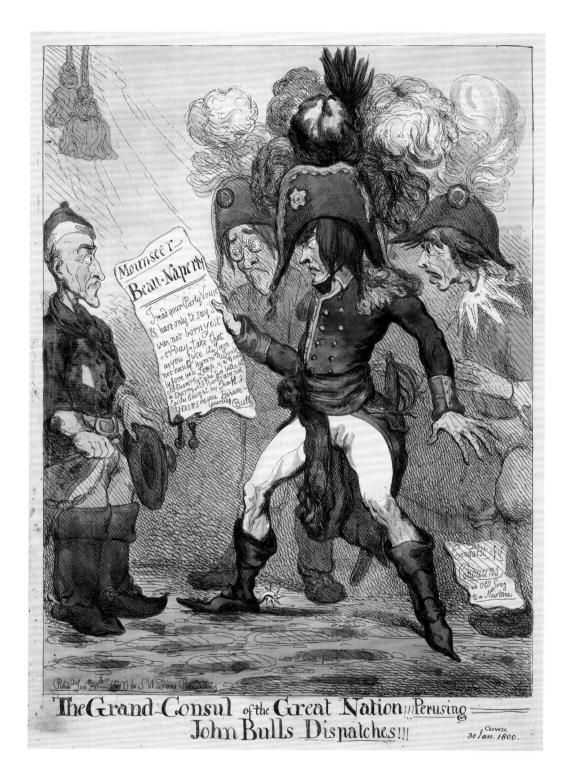

36

John Cawse (1778–1862)
The Grand-Consul of the Great Nation perusing John Bulls Dispatches
Published by Samuel William Fores,
30 January 1800
Hand-coloured etching; 350 x 251 mm
1868,0808.6847; BM Satires 9512
From the collection of Edward Hawkins

On 25 December 1799, Napoleon wrote to George III proposing peace: 'The war which for eight years, has ravaged the four quarters of the world, must it be eternal? Are there no means of coming to an understanding?' The haughtily dismissive reply sent by Lord Grenville, the Foreign Secretary, is translated by the caricaturist into the words of an oafish John Bull: 'Mounseer– Beau. Naperty I read your Parly Vouse & have only to say I was not born yesterday, take that as you like it, I am not easily humm'd, – Look before you Leap is a Good old Proverb, take two bites at a Cherry, old Birds are not Easily Caught by Chaff, Yours as you Behave yourself – Bull.'

The ballad sheet that falls to the floor 'The Conquest of ye Chouans an Old Song to a New tune' alludes to the ongoing revolts of the Royalist Chouans in western France that were finally suppressed in January 1800. After that date Chouan leaders, notably Georges Cadoudal (see cat. 41), turned from open rebellion to conspiracy.

John Cawse made a number of caricatures as a young man in 1799 and 1800, working mainly for Fores. The distinctive lettering used for the title at the foot of this print appears on many of his prints and is clearly in his hand. He went on to develop a career as a portraitist and designer of book illustrations.

37

James Gillray (1756–1815)
Democracy, or a Sketch of the Life of Buonaparte
Published by Hannah Humphrey, 12 May 1800
Hand-coloured etching; 293 x 456 mm
1851,0901.1030; BM Satires 9534
Presented by William Smith

Dr Johnson's Dictionary (1755) defined 'Democracy', in a way that would be recognized today, as the form of government 'in which the sovereign power is neither lodged in one man, nor in the nobles, but in the collective body of the people', but in the 1790s the term had sinister connotations for those who trusted the existing British constitution. It suggested uncontrolled Republicanism and mob rule.

This sequence of designs sums up the first thirty years of Napoleon's life in eight 'Democratic' scenes: his family, actually minor nobility, are shown as living in desperate poverty; as a ragged child he is received at the École Militaire; on 13 Vendémiaire (5 October 1795) he commands the 'Regicide Banditti' defending the Convention against a Royalist insurrection; after the conquest of Egypt, he

accepts Islam, and therefore circumcision for himself and his officers; he deserts his army in Egypt; he overturns the French Republic and puts to flight members of the Council of Five Hundred; he is enthroned as Grand Consul of France; his ill deeds come to haunt his sleep.

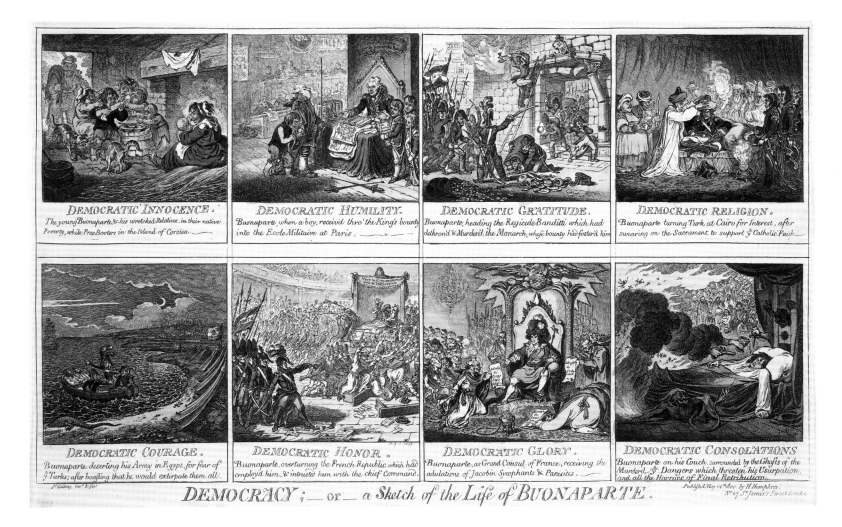

THE SECOND ITALIAN CAMPAIGN: MARENGO

The war had been going badly for France in 1799. However, with Napoleon's return the balance shifted. In May 1800 he undertook one of the most spectacular feats of his career, marching his army over the Great St Bernard Pass – crossing the Alps like Hannibal two thousand years earlier. He re-occupied Milan and defeated the Austrians at the battle of Marengo on 14 June. Success was only narrowly achieved, but Napoleon's propaganda machine mythologized Marengo into a triumph, consolidating his position as Consul.

By the terms of their subsidy from Britain, the Austrians could not make a separate peace before 1 February 1801, but following a much more crushing defeat by an army led by General Moreau at Hohenlinden on 3 December 1800, they were forced to negotiate at the earliest permissible moment. They had to make concessions whereby the Cisalpine Republic was enlarged, Tuscany became a separate kingdom and France gained control of Luxembourg and the southern Netherlands, as well as all the German lands west of the Rhine. Napoleon had achieved the ancient territorial aspirations of Louis XIV.

38
Anthony Cardon (1772–1813) after
Joseph Boze (1745–1826) and
Robert Lefèvre (1755–1830)
Bonaparte and Berthier at Marengo
Published by Anthony Cardon and
Joseph Boze, 1 September 1802
Stipple, printed in colour; 689 x 556 mm
1867,0309.1212
From the collection of Sir Charles Rugge Price

This fine stipple is printed in colour using the English method where the plate was dabbed with different coloured inks before each impression was printed, a skilful and time-consuming procedure, which doubled the cost of the print. It shows Napoleon and General Louis Alexandre Berthier, his chief of staff, overlooking the battle while a dragoon holds Napoleon's mare, La Belle. The print was dedicated by Joseph Boze to Louis Guillaume Otto, ambassador of France to England, of whom Cardon had also engraved a portrait for Boze in January.

A subscription for the print, priced at 4 guineas, was launched in June 1801. The painting was exhibited in London that summer, then in Bath and Bristol, and again in London in summer 1802. Otto reported to Talleyrand on 6 October 1801: 'There is not one man of leisure here who does not wish to see Paris, and above all the First Consul, and the portrait painted by Boze has created a great sensation.'[1]

That portrait (now in the collection of the Fondation Napoléon, Paris) was the subject of a very public dispute between Boze and Robert Lefèvre, both successful French portrait painters who had worked for the *Ancien Régime* and for major Revolutionary figures. When Boze exhibited the painting as his own work in Amsterdam and then in London Lefèvre published articles in the *Journal des Arts* and in the *Moniteur Universel* (2–8 and 9 August 1801) claiming that he had painted the portraits of the two main figures and that Carle Vernet had been responsible for the horses and other subsidiary elements. Vernet confirmed Lefèvre's accusation. A similar dispute had occurred over a portrait of Mirabeau (1789–90) when Lefèvre accused Boze of having painted only the head, while he, Lefèvre, had been responsible for the rest of the work.

Cardon was the son of the leading engraver in Brussels but, with the threat of French invasion in autumn 1792, he had been sent to London to learn fashionable English methods.

1 Quoted in R. Morieux, '"An Inundation from Our Shores": Travelling across the Channel around the Peace of Amiens', in Philp 2006, p. 221.

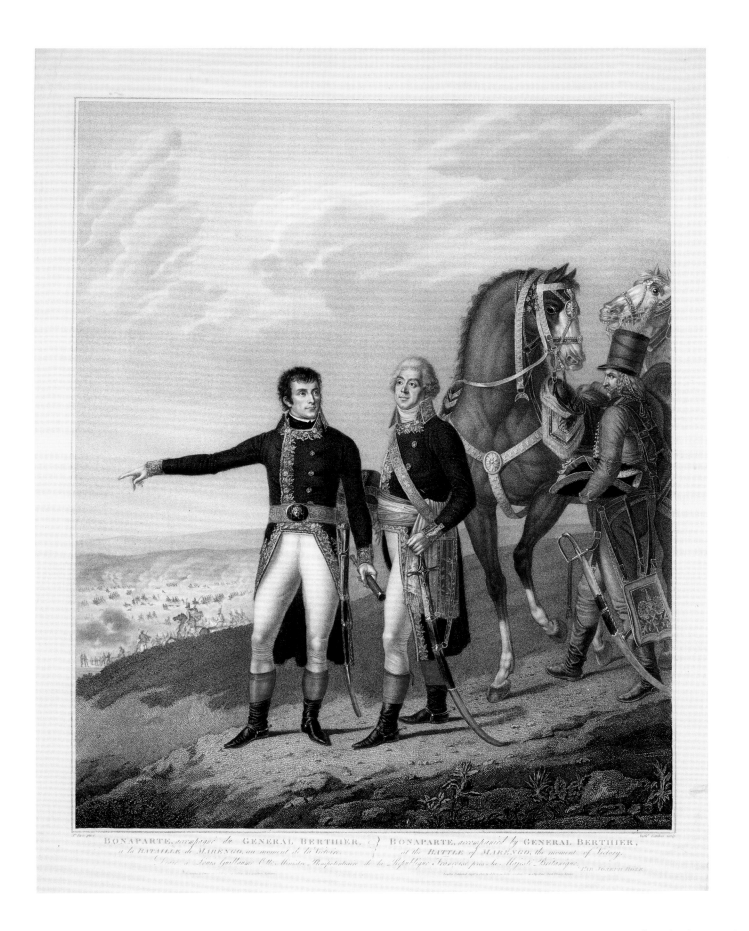

BONAPARTE, *accompagné du* GENERAL BERTHIER, BONAPARTE, *accompanied by* GENERAL BERTHIER,
a la BATAILLE *de* MARENGO, *au moment de la Victoire.* *at the* BATTLE *of* MARENGO, *the moment of Victory.*

Andrea Appiani (1754–1817)
Napoleon
Black chalk with watercolour;
400 x 309 mm
1926,0412.80

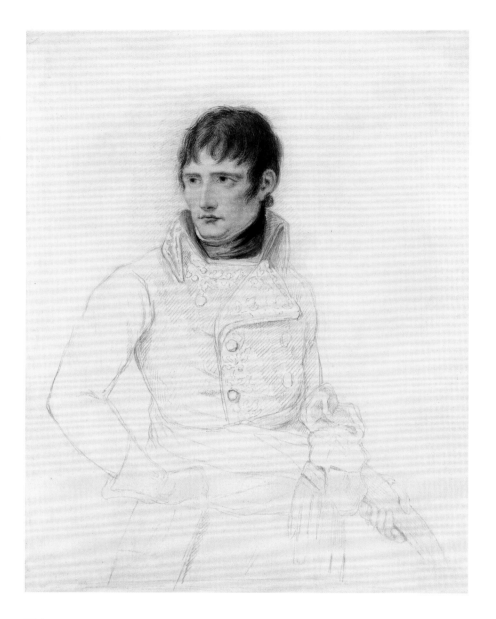

This drawing is a study for a painting owned by
Napoleon's brother, Joseph (now in a private collection
in Montreal). Napoleon is shown wearing the uniform
of a general in which he was portrayed by artists
celebrating his exploits in the second Italian campaign
of 1799–1800; the uniform is preserved in the Musée de
l'Armée, Paris. The drawing was brought to London
by William Vincent Barré (about 1760–1829) and was
reproduced as the frontispiece to his *History of the French
Consulate, under Napoleon Bonaparte*, 1803. Barré had
fought with Napoleon in Italy and acted as his personal
interpreter (he had been born in Germany and fought
as a young man in the Russian army) until, as his own
story has it, he fell from favour after writing satirical
verses and was obliged to flee from France to England.
His *History* was extremely hostile to Bonaparte, claiming
inter alia that he had massacred the population of Toulon

in 1793, had been arrested as a Jacobin after the fall
of Robespierre (actually he was released after the
fall of Robespierre), had massacred Parisians in 1795
and was homosexual. Barré had been employed to
translate Robert Wilson's history of the Egyptian
campaign with its atrocity stories (see cat. 68) and he
quoted them at length.

Appiani was already well established when he first
encountered Napoleon in 1796 and painted his portrait
as the victor of Lodi (see cat. 1). He soon became
a favoured artist and was commissioned to make
portraits and design medals as well as being charged
with overseeing works of art to be requisitioned and
transferred to France. His most extensive work for
Napoleon, the *Fasti*, a series of large grisailles in the
Palazzo Reale, Milan, survive only as engravings.

40

Francesco Bartolozzi (1728–1815) and after
Andrea Appiani (1754–1817)

N Bonaparte

Published by Gaetano Bartolozzi, 10 June 1802

Stipple and etching; 493 x 422 mm

1917,1208.3790

From the collection of Amabel, Lady Lucas;
presented by Nan Ino, Baroness Lucas of
Crudwell in memory of her brother Auberon,
Baron Lucas of Crudwell

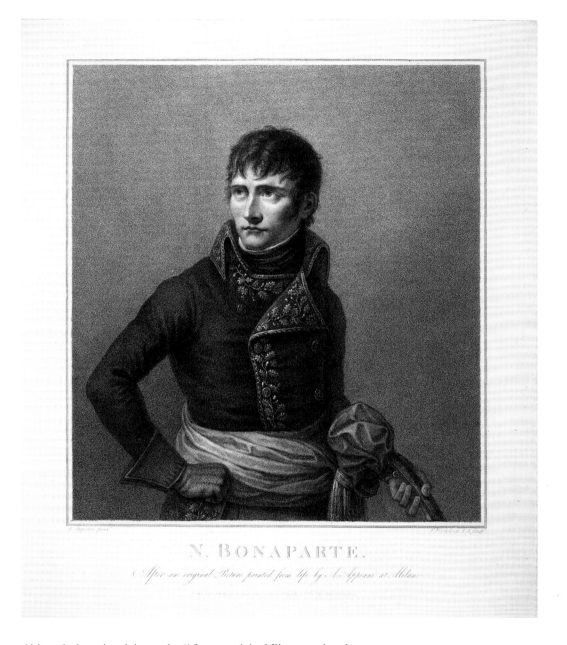

N. BONAPARTE.

After an original Picture painted from life by A. Appiani at Milan

Although the print claims to be 'After an original Picture painted from life by A. Appiani at Milan' it was probably made after the drawing which had been brought to London by William Vincent Barré (see cat. 39). Bartolozzi would have been eager to exploit the market for portraits of the young Consul at the height of his popularity with the British.

The print was also published in Paris by Julien Fatou and sold at 24 francs (£1). A notice in *Journal des arts, des sciences et de littérature* on 8 August 1802 stated that although the features of the sitter were broadly recognizable, the portrait was not very faithful. Gaetano Bartolozzi, son of Francesco, presented an impression to Jean Antoine Chaptal, Minister of the Interior, whose letter of thanks was published in the *Journal de Paris*.

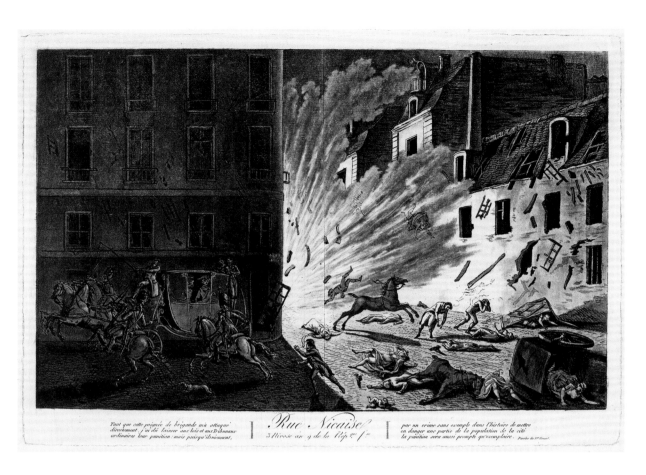

Tant que cette poignée de brigands m'a attaqué
directement, j'ai dû laisser aux loix et aux Tribunaux
ordinaires leur punition : mais puisqu'ils viennent

Rue Nicaise
3 Nivose an 9 de la Rép.e 1.er

par un crime sans exemple dans l'histoire de mettre
en danger une partie de la population de la cité
la punition sera aussi prompte qu'exemplaire. *Paroles du 1.er Consul.*

41

Anonymous
Rue Nicaise
Published 1801
Etching and aquatint with roulette
work; 260 x 371 mm
1925,0615.140

On 7 September 1800 Napoleon wrote to Louis XVIII informing him that he would never support a Bourbon restoration. French Royalists funded by the British government, and directed by the comte d'Artois, future King Charles X, already had plans in place for assassination. British ministers knew of these, and evidently had no objection. After the failure of an attempt to catapult missiles into Bonaparte's carriage on the road to Malmaison and another to kidnap him while hunting, a third plot was activated to blow up his coach on Christmas Eve. The men chosen to assassinate Bonaparte were Chouans (see cat. 36) controlled by Georges Cadoudal: Joseph Picot de Limoëlan who arrived from London on 16 November, Pierre Robinault de Saint-Régeant and François-Joseph Carbon.

They acquired a horse and cart containing a wine barrel full of explosives and paid a fourteen-year-old girl to hold the horse. Napoleon was travelling with Generals Berthier, Lannes and Lauriston to attend the first performance of Joseph Haydn's *Creation* at the Opéra. Limoëlan was to watch for the carriage leaving the Tuilleries and signal Saint-Régeant to light the fuse, but he panicked and failed to signal, so Saint-Régeant lit the fuse when the first horse grenadier came in sight. Napoleon and his companions were unharmed, but twenty-two people were killed, about 100 wounded, and forty-six houses were destroyed. Carbon and Saint-Régeant were captured and executed; Limoëlan escaped to the United States. By attributing the plot to Republican extremists, although he knew that the conspirators were actually Royalists, Bonaparte took the opportunity to exile or imprison 130 Jacobin opponents.

42

Die engraved by Henri Auguste (1759–1816)
Machine Infernale, 1800–1
Struck bronze; Diameter: 49 mm
Laskey 19; Bramsen 76
1898,0102.26
From the collection of John Coryton,
presented by Adela Kepple Taylor
M.6755

The simple design of this medal compared with the exquisite
neo-classical productions made to commemorate major events
in Napoleon's career (see cats 64–67) suggests that it was issued
quickly to be distributed as soon as possible after the attempt
on Napoleon's life. According to the lettering on the obverse,
it was struck as a mark of the love of the French people for the
First Consul. The reverse is lettered with a sentimental appeal
from Napoleon himself telling citizens that they should not rush
towards him, but to those who had been hurt by the 'infernal
machine'.

 The profile head is identified on a print published on
25 February 1801 as based on a miniature by Joseph Point
(active 1778–1811). The die-cutter Henri Auguste had been
Goldsmith to the King before the Revolution, and subsequently
produced a number of lavish commissions for Napoleon including
the table service for the coronation.

THE PEACE OF AMIENS

By early 1801 when Austria made peace with France, Britain was isolated in Europe. Difficulties at home were exacerbated by harvest failures in 1799 and 1800 and relations were strained between Pitt and George III, who felt that foreign policy was being made without his participation. Matters came to a head over Roman Catholic emancipation (seen by Pitt as a political necessity after the Act of Union with Ireland); the king declared that he would consider any proponent of emancipation as his personal enemy. Pitt resigned on 14 March 1801.

With Denmark and Prussia occupying Hanover, and France making preparations for the invasion of Britain, Pitt's successor, Henry Addington, announced in his first speech that he would open peace negotiations. His hand was strengthened by the assassination of Tsar Paul on 21 March by conspirators at least some of whom had British Secret Service connections,[1] and by Nelson's victory at Copenhagen on 2 April. Louis-Guillaume Otto, the French ambassador, signed a preliminary treaty in London on 1 October, just before news arrived of the French capitulation in Egypt. Peace was greeted on both sides of the Channel with relief and joy, and in Britain – to the consternation of conservatives – with adulation of Napoleon.

Amabel, Lady Lucas noted that the illuminations on the night of 10 October were very general and that 'the mob not only huzza'd Buonaparte's aide-de-camp this morning, but drew him and M. Otto along the street, a deviation from old British spirit which I never thought to have seen.'[2] William Cobbett (at that date still vehemently anti-Bonapartist), did not illuminate his windows and they were broken by the mob. In an open letter to Lord Hawkesbury (now Foreign Secretary) Cobbett recorded that 'nineteen transparencies out of every twenty were expressive of attachment to Buonaparte's person or to the cause of France!'[3]

The treaty of Amiens between Britain and France was signed on 25 March 1802.

1 Sparrow 1999, pp. 223–40.
2 Lucas diary, XX, p. 63.
3 W. Cobbett, *Letters to the Right Honourable Lord Hawkesbury*, 1802, p. 17.

43

William Dickinson (1746–1823) after Antoine Jean Gros (1771–1835)
Napoleon Bonaparte
Published by William Dickinson and Jacques-Louis Bance, 15 October 1803
Mezzotint; 715 x 480 mm (uncut impression)
1850,0211.146

This is a fine impression of a rare mezzotint after the portrait in the Musée national de la Légion d'honneur showing Napoleon as First Consul, his hand resting on papers referring to notable events in his career, most prominently a plan of the battle of Marengo and a list of treaties up to Amiens. The print must have been damaged at some early stage with the result that the corners and lower margin were removed reducing it to an oval which was carefully attached to a backing sheet before it was purchased by the British Museum in 1850.

William Dickinson was a pupil of the radical painter Robert Edge Pine (1730–88) who emigrated to the United States for ideological reasons in 1784, and it is possible that Dickinson shared his democratic views. In 1778 he took over a fashionable print shop in Bond Street but sold his stock of copper plates in 1794. This did not save him from bankruptcy in 1797 when part of his stock in trade of prints was sold. He was still working in London in 1798 and probably went to Paris in 1802. It is not known whether he stayed deliberately or whether he settled there after Napoleon had arrested English people stranded there by the renewal of hostilities. However, this print demonstrates that his services were coveted at a high level since the portrait was commissioned from Gros by Napoleon and it can be assumed that the print was also authorized by government. It was sold for 36 francs (£1 10s.) with proofs costing 72 francs (£3), with prices on the English scale and very high for France.

Dickinson continued to make important prints in France, engraving several paintings from the Musée Napoléon (that is, the Louvre) and a number of prints after François Gérard, the favoured establishment painter. Indeed, with the line-engravers Auguste Desnoyers and John Godefroy, he was Gérard's favoured interpreter and he exhibited at the Salons of 1808, 1810 and 1812. Dickinson lived first in the Faubourg Saint-Denis and then in rue Werthinghen with a shop on the rue du Bac. Paul Colnaghi visited Dickinson's daughter in Paris in 1806, where she was living as companion to Madame Talleyrand, of whom Dickinson made a full length mezzotint after Gérard. His son Thomas joined him in Paris in 1809.

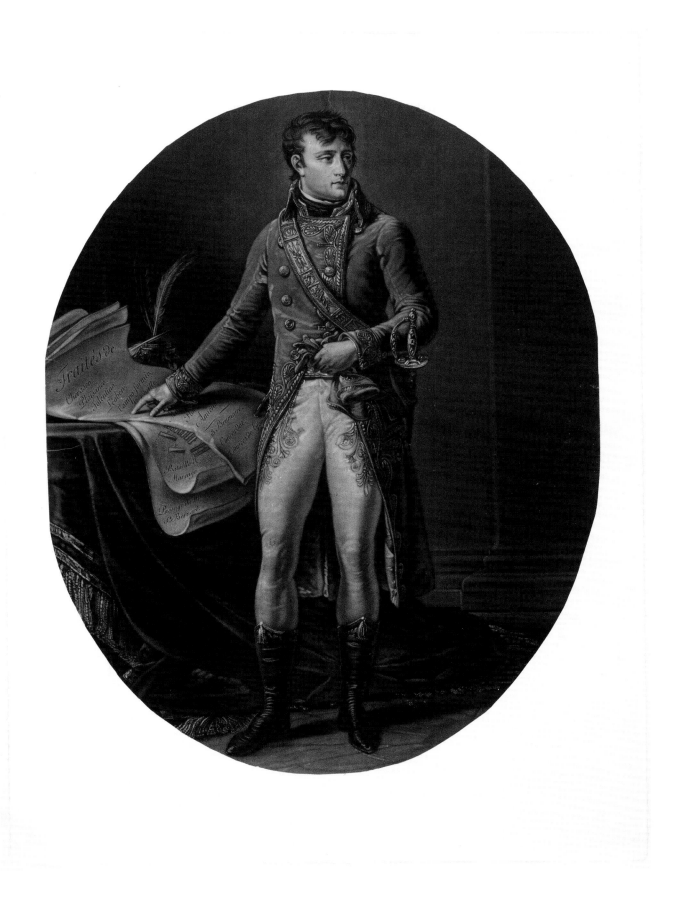

44

Charles Turner (1774–1857)
after John James Masquerier
(1778–1855)
*Bonaparte Reviewing the
Consular Guards*
Published by Charles Turner
and John James Masquerier,
1 January 1802
Mezzotint; 610 x 710 mm
1891,0414.200
From the collection of Mrs Savery,
daughter of the printmaker

The print shows a review of the Guards at the Tuileries, a favourite ceremony introduced during the Consulate. The focus is on the Consul and his entourage: Bonaparte, calmly in control, is the centre of the composition while General Lannes and the Mameluk bodyguard Roustan Raza struggle to restrain their horses, distracted by the excitement of the event.

Like Cardon's print of Bonaparte at Marengo (cat. 38), this mezzotint reproduces a painting that was exhibited widely – in this case in Piccadilly and Fleet Street in London, and later in Liverpool – but was not quite what it was made out to be. The market for images of Bonaparte was so lucrative that it was clearly tempting to make exaggerated claims. In the pamphlet that accompanied Masquerier's exhibition of the painting (admission 1s.) he claimed that he was in Paris during December and January 1800–1 and obtained permission to paint Napoleon, making the painting the 'Only Likeness, in London,

painted from the Life'. Charles Turner, however, annotated this statement in his own copy of the pamphlet as follows:

> False!!!! Masquerier obtain'd the composition of this Picture by giving the valet of Isabey the Painter a premium to let him trace his drawing of the same subject from which tracing a small picture was made here, and the large one painted from that. The head of Napoleon was from a small china bust; all the officers were copied from prints he brought over. He never saw Buonaparte or any of his Generals. The large Picture was painted in my Room in Warren Street, and I painted all the Bridles, Saddles; and Mr H B Chalon the horses. We clear'd a Thousand Pounds by the picture one third was my share.[1]

The drawing by Jean Baptiste Isabey must have been the one that was acquired in 1820 by

George IV and is still in the Royal Collection.[2] Although Masquerier's composition is greatly simplified he has clearly used the drawing as the basis for the calm figure of Napoleon and for Lannes on his prancing stallion, as well as for the perspective view of the Tuileries with court ladies watching the review from the balcony. Turner noted the development of the project in his diary from 22 November 1800 to 16 March 1801 from his 'engagement with Mr. Masquerier for a Whole height Portrait of B[onapar]te ...' to the exhibition at Piccadilly.[3] The subscription for the print opened in May 1801 and the print was sold to subscribers at 2 guineas, with proofs before letter at 4 guineas.

1 *Description of the Great Historical Picture painted by I. J. Masquerier, of the First Consul Buonaparte, reviewing the Consular Guard* (Charles Turner's annotated copy in the British Museum, Department of Prints and Drawings, Tt.5.43).
2 Royal Collection RCIN 451894.
3 Diary, British Library, Add. Mss. 37525, quoted in A. Whitman, *Nineteenth Century Mezzotinters: Charles Turner*, London 1907, no. 794.

45

Piercy Roberts (active 1795–1824)
John Bull's Prayer to Peace
Published by Piercy Roberts, 1801
Hand-coloured etching; 262 x 353 mm
1868,0808.6980; BM Satires 9737
From the collection of Edward Hawkins

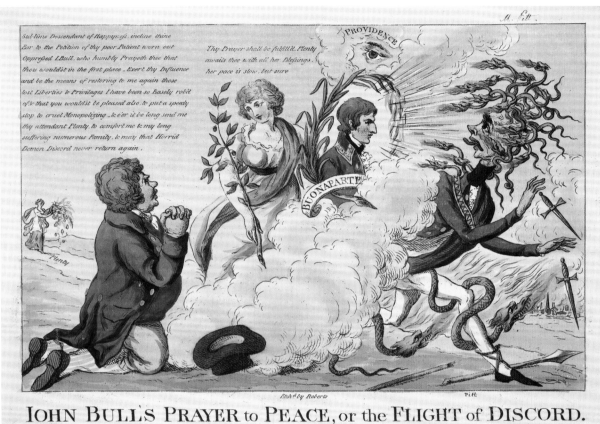

IOHN BULL'S PRAYER to PEACE, or the FLIGHT of DISCORD.

This print shows just how unpopular Pitt was in many circles and how great was the desire for peace. It celebrates the resignation of Pitt and the prospect of peace, anticipating the repeal of the repressive domestic policies that constituted 'Pitt's terror'. John Bull kneels to pray to the personification of Peace who holds a portrait of Bonaparte. Pitt, shown as snake-haired Discord, is branded a warmonger and supporter of the monopolizers who had profited from years of war.

For most of his career Piercy Roberts worked as a printmaker for William Holland and other publishers, but the boom in satirical prints of the Napoleonic period must have encouraged him to set up on his own account. He ran his business at 28 Middle Row, Holborn, from 1801 to 1806, when his stock was taken over by the great cheap print entrepreneur Thomas Tegg (see p. 21).

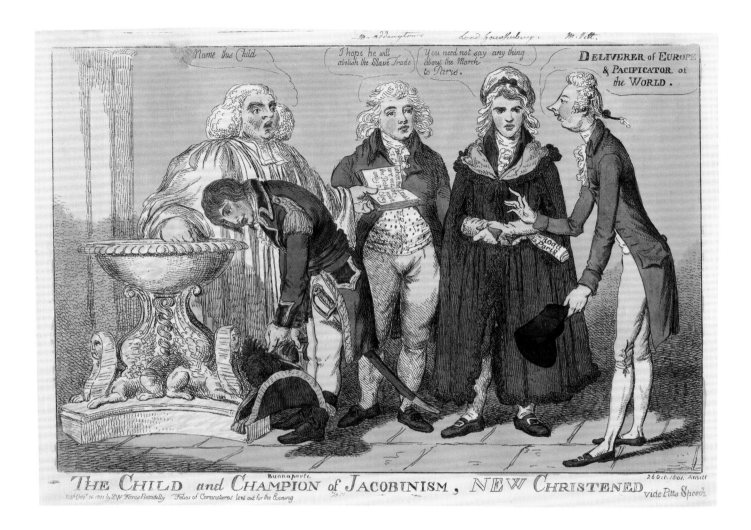

The Child and Champion of Jacobinism, New Christened

46

Charles Williams (active 1797–1830)
The Child and Champion of Jacobinism New Christened
Published by Samuel William Fores,
26 October 1801
Hand-coloured etching;
247 x 347 mm
1868,0808.6965; BM Satires 9733
From the collection of Edward
Hawkins

This is an ironical jibe at the hypocrisy of those in power who had to find a way to deal with the problem of how to interpret Napoleon after the Peace: was he still to be seen as a revolutionary, or was he now to be treated with respect as a quasi-monarch? Bonaparte is being baptised at a font supported on bewigged sphinxes by the High-Church Tory Samuel Horsley, Bishop of Rochester (a faithful instrument of government who had pronounced during a debate in the Lords on the Treasonable Practices Bill in 1795 that 'when the Laws are made the People have only to Obey' and had likened the French Republic to the beast of the apocalypse). The 'god-parents' are William Wilberforce (hoping for an ally in his campaign against the slave trade) and Lord Hawkesbury, then Foreign Secretary, who is anxious to hush up the bullish demand he had made in 1794 that the army should march on Paris. The main weight falls

on Pitt, who in February 1800 had used all his powers of irony to ridicule the idea of Bonaparte as 'pacificator of Europe' in speeches explaining the government's refusal to negotiate with France. He had asked how the Opposition could believe that 'the Jacobinism of Robespierre' and the others had disappeared, simply 'because it has all been centred and condensed into one man who was reared and nursed in its bosom, whose celebrity was gained under its auspices, who was at once the child and champion of all its atrocities and horrors. Our security in negotiation is to be this Buonaparte, who is now the sole organ of all that was formerly dangerous and pestiferous in the Revolution.'[1]

1 W. Pitt, *Speeches*, London 1817, III, p. 124 and pp. 152–3 and 17 February.

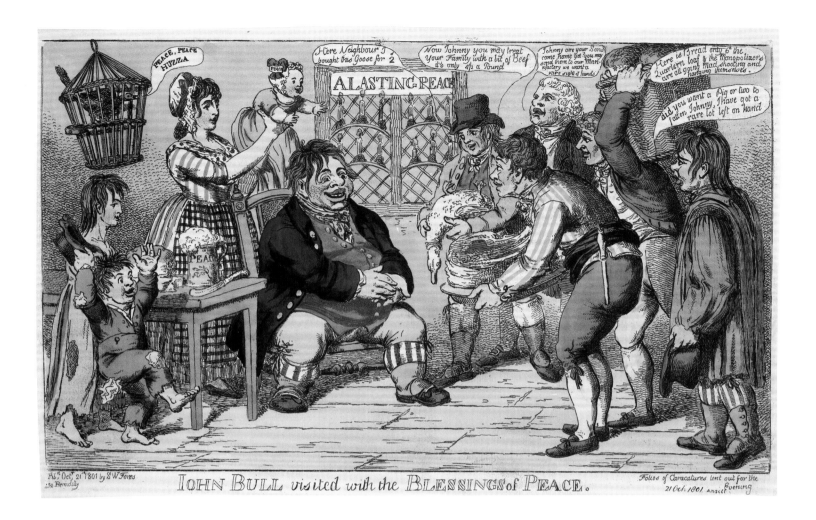

IOHN BULL visited with the BLESSINGS of PEACE.

47

Charles Williams (active 1797–1830)
John Bull Visited with the Blessings of Peace
Published by Samuel William Fores,
21 October 1801
Hand-coloured etching; 249 x 389 mm
1868,0808.6964; BM Satires 9732
From the collection of Edward Hawkins

John Bull and his family – the ordinary people of Britain – enjoy the prevailing optimism at the prospect of peace. A butcher, a baker and farmers ply them with plentiful supplies of food at lower prices – the price of bread fell steadily through 1801 from 15½d. in May to 10½d. in October, though there was still some distance to go before a quartern loaf (about 1½ kilograms) was 6d., as shown in the print. A factory owner offers work to John Bull's sons when they return from the war. Twelve lighted candles burn in his window, a humble version of the elaborate illuminations in great houses and shops in the towns on 10 October (see cat. 118).

48

James Gillray (1756–1815)
The First Kiss this Ten Years!
Published by Hannah Humphrey, 1 January 1803
Hand-coloured etching and aquatint; 354 x 254 mm
1868,0808.7071; BM Satires 9960
From the collection of Edward Hawkins

Following on from the naïve delight at the Peace of Amiens
depicted in prints published by Roberts and Fores, Humphrey,
Gillray and the anonymous designer of this print express a more
wary view. Britannia is fat and good-natured but the lean and
sardonic 'Citizen François' who bends forward to kiss her is
certainly not a man to be trusted with his promise of 'everlasting
attachment'. Bonaparte and George III appear in oval portraits
high on the wall; they regard each other with mutual hostility and a
suspicion which reflects the truth of the bilateral relationship more
accurately than the affection demonstrated by the couple below.
The print appeared at the beginning of 1803 when return to war
seemed ever more likely.

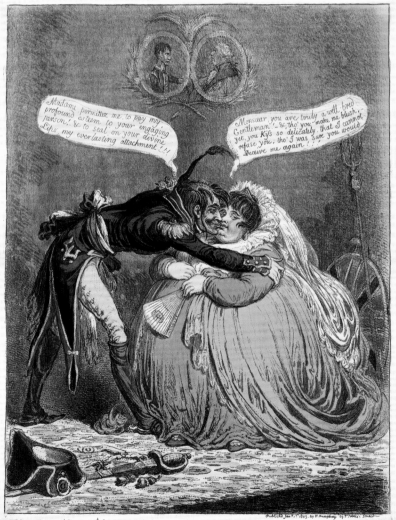

The first Kiss this Ten Years! _ or _ the meeting of Britannia & Citizen François

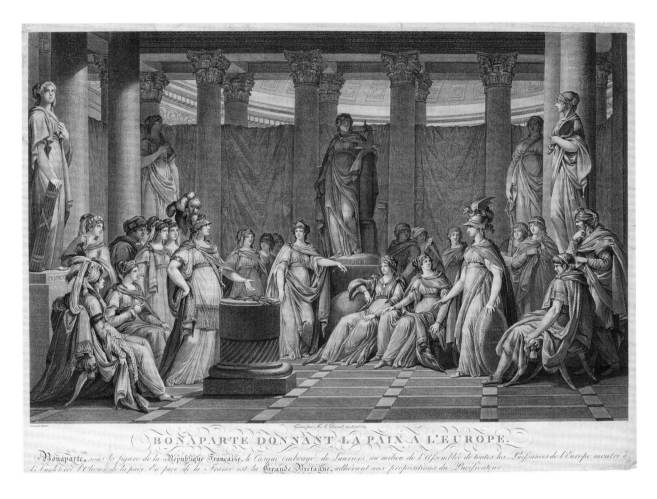

BONAPARTE DONNANT LA PAIX A L'EUROPE.

Bonaparte, sous la figure de la République Française, le Casque ombragé de Lauriers, au milieu de l'Assemblée de toutes les Puissances de l'Europe, montre à l'Angleterre l'Olivier de la paix. En face de la France est la Grande Bretagne, adhérant aux propositions du Pacificateur.

49

François Anne David (1741–1824)
after Charles Monnet (1732–1808)
Bonaparte donnant la Paix à l'Europe
Published by François Anne David,
18 August 1804
Etching; 440 × 590 mm
2013,7030.2
Purchased with funds from the
Friends of Prints and Drawings

This celebration of Bonaparte as the peacemaker is based on a design by Charles Monnet, one of many French artists who had flourished under the *Ancien Régime* and adapted readily to life after the Revolution. He had been *peintre du roy* to Louis XV but became professor of drawing at the *Ecole militaire* under Bonaparte and that appointment may have been the impetus for the present allegory. The figures in classical and oriental robes represent the powers of Europe and their allies. The text below explains that the statuesque female figure on the left is Bonaparte representing the French Republic who points to an olive branch lying on an altar as she addresses Great Britain. Bonaparte's helmet is encircled with a laurel wreath while Britain's is topped by a warlike winged dragon.

It was characteristic of Bonaparte's propaganda that he had to be seen as giving peace, rather than just making peace. A piece of French theatre called *La Fête de la paix* announced similarly in July 1802:

> Peace stills the flails of the human race
> France grants peace and Albion accepts it
> When he might triumph, Bonaparte forgives.[1]

1 Bertaud 2004, p. 50.

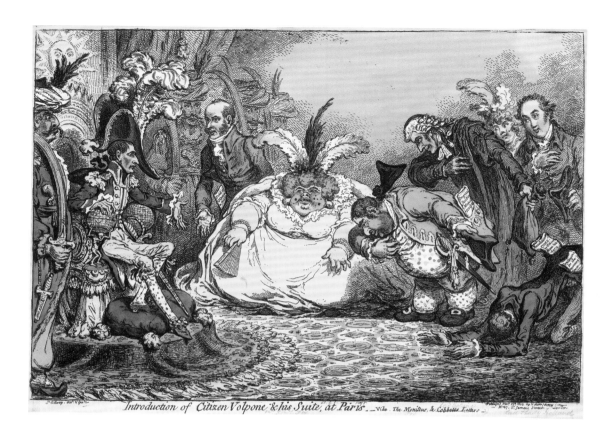

Introduction of Citizen Volpone & his Suite, at Paris — Vide. The Moniteur, & Cobbetts Letters -

50

James Gillray (1756–1815)
Introduction of Citizen Volpone & his Suite at Paris
Published by Hannah Humphrey, 15 November 1802
Hand-coloured etching;
250 x 355 mm
1851,0901.1098; BM Satires 9892
Presented by William Smith

Wealthy Britons flocked to enjoy the various delights of Paris after the Peace of Amiens. Here Bonaparte, enthroned and flanked by burly mamelukes, is shown receiving the homage of Charles James Fox ('Volpone', the old fox) and his wife Elizabeth (a famous beauty in her days as a courtesan, here portrayed as almost spherical, but with none of the coy charm of Britannia in cat. 48). They were in Paris from 29 July to 17 November and Fox intended to use at least some of his time there researching the life of King James II, whose papers were then in the French archives; playing on words, Gillray has placed 'Original Jacobin Manuscripts' protruding from Fox's pocket. To the left, Arthur O'Connor, prominent in the United Irishmen rebellion on 1798 and now a general in the French army, bows as if introducing the party. To the right is the radical lawyer, Thomas Erskine, as well as Lord and Lady Holland (see cats 156–160 and 162) and the diplomat Robert Adair, grovelling abjectly. Gillray has given his own interpetation to an event which did occur: Fox's party, which included Lord Holland and Adair (but not the ladies, who were instead introduced to Josephine), was presented to Bonaparte on 3 September and Fox met the Consul again on 7 October. Fox and Erskine met O'Connor by chance at the house of Thérésa Tallien (see cat. 86) and were strongly criticized for associating with a self-confessed conspirator against the British state.

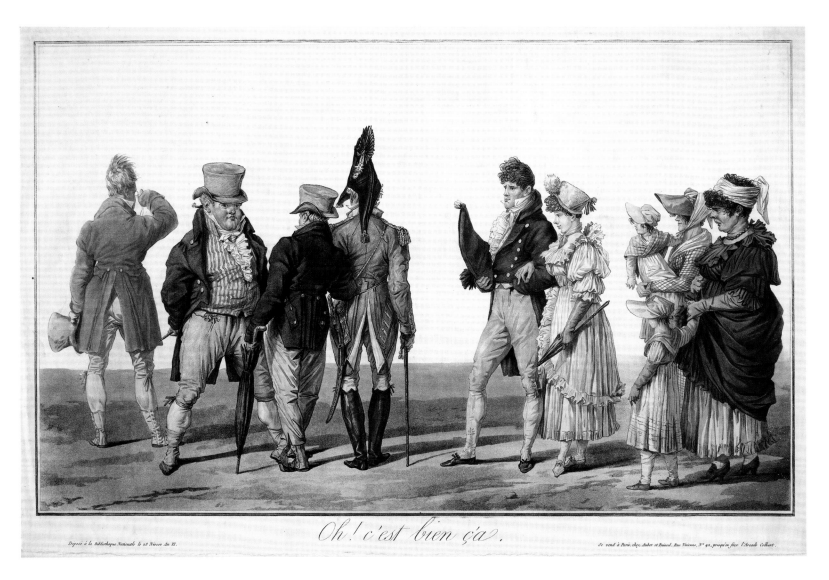

Oh! c'est bien ça.

Déposé à la Bibliothèque Nationale le 28 Nivôse An XI.

Se vend à Paris, chez Auber et Boissel, Rue Vivienne, Nº 42, presqu'en face l'Arcade Colbert.

51

Philibert Louis Debucourt
(1755–1832) after Carle Vernet
(1758–1836)

Oh! C'est bien ç'a

Published by Auber & Boissel,
10 January 1803

Etching and aquatint; 390 x 573 mm

2003,0531.30

Purchased with funds from the
Arcana Foundation

This appears to be one of the earliest satires on the uncouth dress sense and awkward clumsiness of the English; the vast majority belong to 1814 and 1815. Philibert Louis Debucourt executed a number of satires on fashion at this time but the majority picked on French victims. Auber & Boissel appears to have been a branch of the important business of Auber (see pp. 41–3).

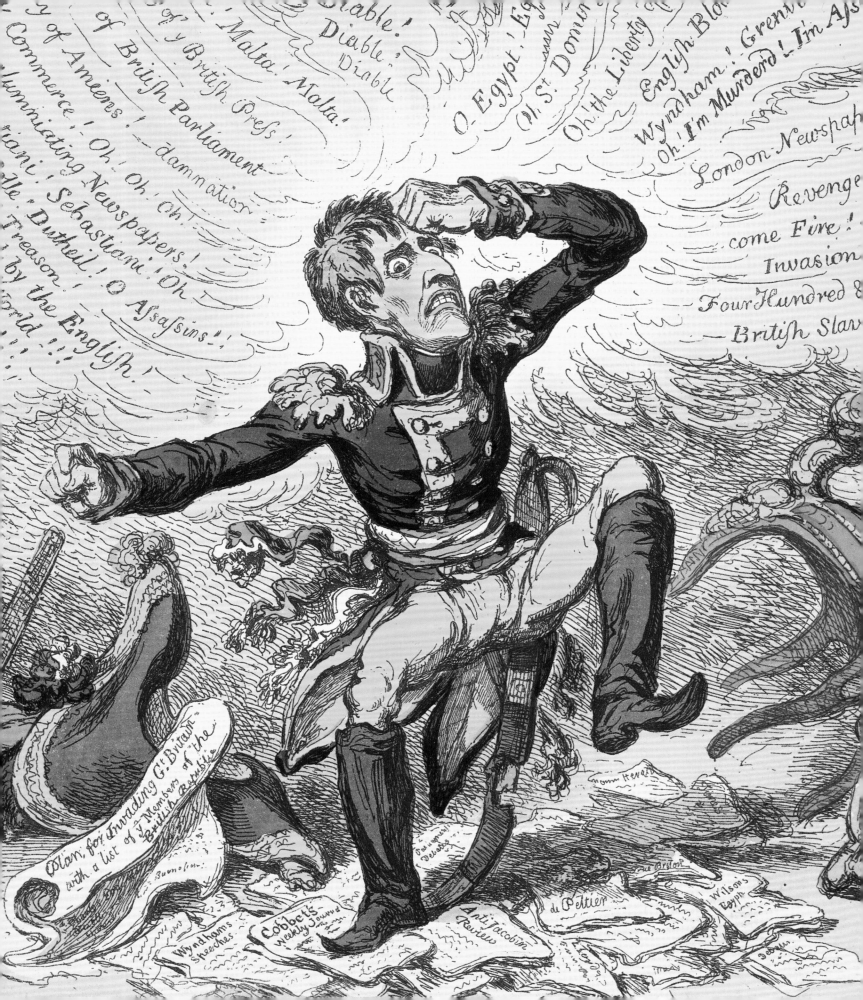

4
Little Boney and the invasion threat

Though welcomed with wild enthusiasm by the populations of
London and Paris, the Peace of Amiens was fragile from the start.
Neither side trusted the other, for while Napoleon immediately used
the peace to annexe Piedmont, put down rebellions in France's rich
West Indian islands and settle affairs in Switzerland, the British were
in no hurry to honour their treaty obligation to evacuate Malta
and Egypt. The British government constantly denounced French
aggression and they and French Royalists invented the 'Black Legend'
of Napoleon as the cruel murderer who would sacrifice countless
lives to his ambition. Diplomacy broke down on 12 May 1803 and
the British ambassador left Paris. Three days later George III issued
letters of marque to British privateers giving them permission to
attack French ships; the French government ordered fifty invasion
craft, and on 5 June a French army marched into the city of Hanover.

A flood of caricatures justifying the renewal of hostilities inundated
the print shops. Napoleon's anti-British propaganda at this period
focused on the king and his detested minister Pitt, who came back to
office on 10 May 1804. George III returned to British caricature as a
positive figure, having almost disappeared since 1797 when printsellers
had been warned off. The enemy was no longer Republican France in
general, but Napoleon Bonaparte himself. He became 'Little Boney',
caricatured as a diminutive, bad-tempered bully.

Napoleon used a large part of the proceeds from the sale to the
Americans of Louisiana – the central third of the present United
States – to finance the construction of invasion barges and based his
Armée des Côtes de l'Océan at a huge camp in Boulogne. By the summer
he had 170,000 men there. The British responded with extraordinary
measures for the defence of the realm.[1]

1 Knight 2013, pp. 251–284.

52

James Gillray (1756–1815)
German-Nonchalence, or the Vexation of Little Boney
Published by James Gillray, 1 January 1803
Hand-coloured etching and aquatint; 255 x 357 mm
1851,0901.1101; BM Satires 9961
Presented by William Smith

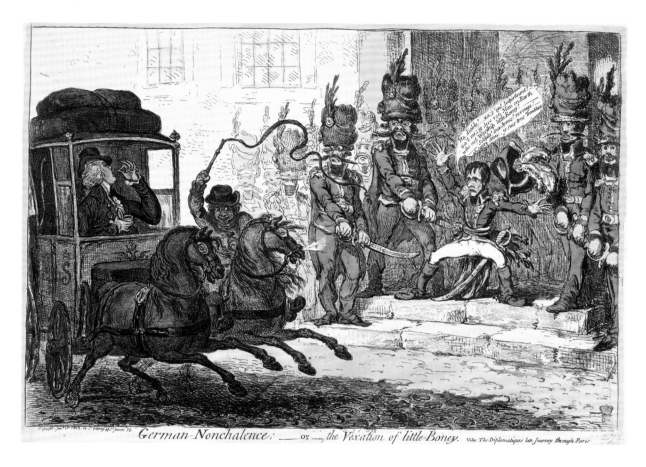

German-Nonchalence; — or —, the Vexation of little Boney. Vide The Diplomatique's late Journey through Paris.

This seems to be the first appearance of the soubriquet 'Little Boney' by which Napoleon was known contemptuously in Britain thereafter; in fact his height appears to have been about 5 *pieds* 2 *pouces*, the equivalent of a little over 5 feet 6 inches (167.5 cm), which was above average height at the time. He appears at the gate of the Tuileries, a small, angry man surrounded by large grenadiers, shouting insults in *franglais* at Count Starhemberg who drives past in a post-chaise, languidly taking snuff.

Starhemberg, Austrian ambassador to Britain from 1793 to 1807, was suspected of being the author of a satirical pamphlet entitled *Le Grand Homme*, published in London in 1800. The pamphlet, whose content certainly suggests that it was written by an Austrian, sought to change the public perception of Bonaparte, who was then widely admired, by portraying him as a cruel despot who had betrayed the king who had educated him and massacred Parisians with grapeshot. He had been given Josephine by Director Barras and was aware that her daughter Hortense was also part of the bargain. He had massacred thousands in Egypt,

but his wars were won for him by General Berthier and although he imitated Oliver Cromwell, he was all cunning and intrigue and did not have Cromwell's stature. The pamphlet defended Grenville's dismissive response (see cat. 36) to the peace proposals made by the 'little crowned Corsican'.

Late in 1802, when passing through Paris on the way to London, Starhemberg was ordered leave the country immediately. Accounts vary as to whether French officials treated the ambassador with courtesy or ignominy, but the event was reported in the British press as a shocking breach of diplomatic protocol by Napoleon.

Starhemberg was himself a collector of satirical prints and owned several thousand British caricatures, which were only dispersed in the 1950s. The gentleman in the post-chaise is a close likeness, not caricatured. It may well be that Gillray and Hannah Humphrey produced this print as a flattering thank you to one of their best customers; there were at least three impressions in Starhemberg's collection.

53

Anonymous
John Bull Teazed by an Ear-Wig
Published by William Holland, 6 April 1803
Hand-coloured etching; 327 x 248 mm
1868,0808.7094; BM Satires 9976
From the collection of Edward Hawkins

The supposedly small stature of
Napoleon now becomes his main
identifying characteristic for the satirists.
Here he is shown as a tiny creature
irritating a bloated John Bull who
wants to be left alone to enjoy his bread
(labelled 'Malta') and cheese ('Ceylon').

The valuable Dutch island of Ceylon
(Sri Lanka) with its strategic harbours had
been ceded to Britain according to the
terms of the Treaty of Amiens and was
not in dispute. Malta was a much more
contentious issue: the island had been
restored by the Treaty to the order of
St John of Jerusalem and was to remain
neutral, but its position and the quality
of Valetta's fortified harbour meant
that it was a crucial strategic base in
the Mediterranean, coveted by both the
French and the Russians. Napoleon was
demanding its immediate evacuation by
the British, but Britain refused to leave.

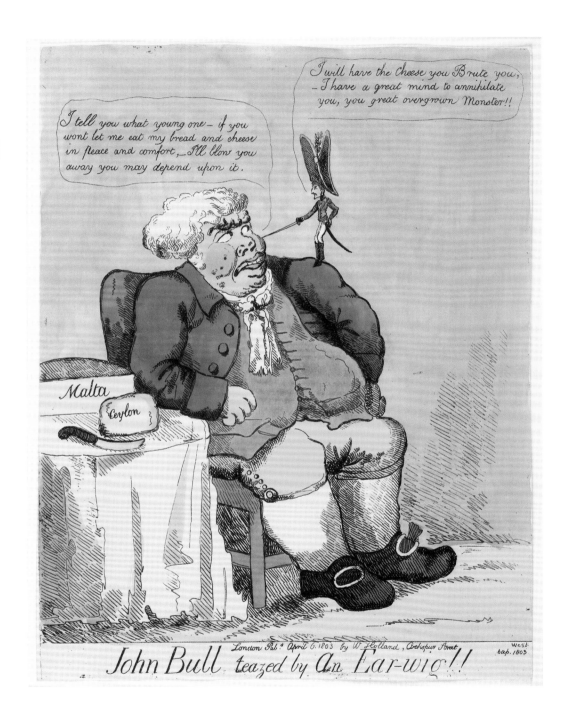

54

Anonymous
An Attempt to Swallow the World!!
Published by William Holland, 6 April 1803
Etching; 327 x 250 mm
1868,0808.7095; BM Satires 9977
From the collection of Edward Hawkins

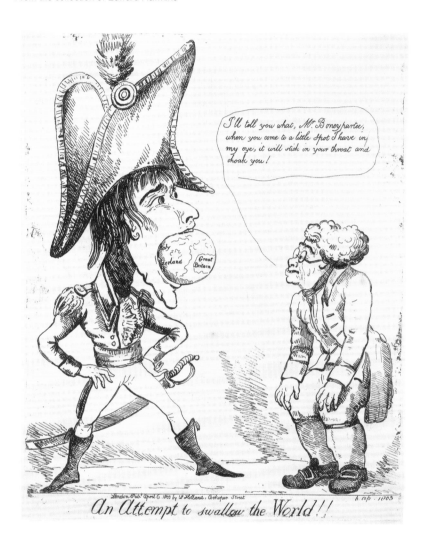

Napoleon is shown as a cocksure youth with the globe wedged
in his gaping mouth: Italy and Switzerland are about to be
swallowed but Great Britain is being watched by an elderly John
Bull who is confident that he can protect his country.

The theme of British caricatures in the spring of 1803 was
the increasingly aggressive posturing of a Bonaparte keen to
conquer the world, or as much of it as he could bite off.

55

Charles Williams (active 1797–1830)
The Governor of Europe Stopped in his Career
Published by Samuel William Fores, 16 April 1803
Hand-coloured etching; 352 x 249 mm
1868,0808.7101; BM Satires 9980
From the collection of Edward Hawkins

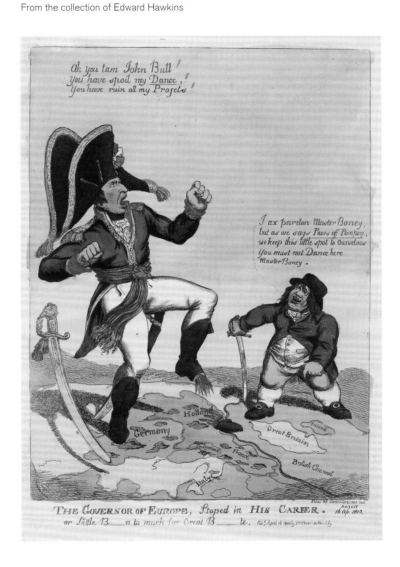

An advertisement placed by a shopkeeper called John Cooke in the *Exeter Flying Post* on 7 July 1803 demonstrates how these prints were used to rally the population, and at the same time how patriotism was used to sell prints:

> Usurpation may have conquered some Part of Europe, but I have a Caricature in my Shop Window of the statues of Bonaparte and John Bull, the former is treading on Germany and Holland, and striding toward Great Britain, the latter cuts off one of Boney's Feet and says, '*I ask pardon, Master Boney,*' but as we say, '*Paws off Pompey, we keep this little spot to ourselves you must not Dance here Master Boney.*' – Boney

says, '*Oh you tam John Bull, you have spoil my Dance, you have ruin all my Projects.*' And I have seen another Caricature, where Boney has a Consultation on his Disorder, and his Physician tells him his Case, '*your Heart lies in your Small-Cloathes.*'

As in *An attempt to swallow the world*, the relative proportions of the antagonists are reversed: Napoleon towers over a small but sturdy John Bull. Insult is added to injury in the phrase: 'Paws off, Pompey' – a reference to the popular eighteenth-century novel, *The History of Pompey the Little, or the Life and Adventures of a Lap-Dog.*

TRANSFER-PRINTED POTTERY

Among the many inventions of the brilliant entrepreneurs in the Midlands during the second half of the eighteenth century were techniques for mass-producing images on ceramics, allowing a huge expansion of the trade in decorated wares. Designs painted on to ceramics had long been copied from prints, but the direct transfer of etched or engraved images from a copper plate to pottery was far more efficient. The most successful technique, 'bat' printing on glazed ceramics, was perfected by Josiah Spode in the early years of the nineteenth century for use both on earthenware and bone china. An image was printed in oil on to a thin sheet or 'bat' of gelatinous animal glue which was pressed on to a glazed pot; the bat was peeled off, leaving the image in oil which was then dusted with finely powdered enamel; the powder adhered to the oil and when fired again it fused with the underlying glaze.[1]

Humorous and patriotic subjects were especially popular and there are many examples of anti-Napoleonic images, chiefly based on prints by the major London publishers. They would have been acquired by the pottery manufacturers within days of publication and copied with amendments to suit the shape and size of the pots to which they were to be transferred. The production of pottery was already a factory-based operation performed by a team of workers, each with a specialist task, enabling economies of scale so that the unit cost of transfer-printed ware was low. The prints reproduced on the pots shown here would have been sold at about 2s., or twice that if hand-coloured, whereas earthenware mugs and jugs could be bought for a few pennies; bone china would have been three times the price, but still around the price of a print published by Tegg rather than Humphrey or Holland.

1 D. Drakard, *Printed English Pottery: history and humour in the reign of George III 1760–1820*, London 1992, pp. 30–2 and Chapter 11.

The Governor of Europe Stopped in his Career, 1803
Earthenware mug, transfer-printed in black and painted with additional overglaze colours and rim painted blue;
Height: 90 mm
Private collection

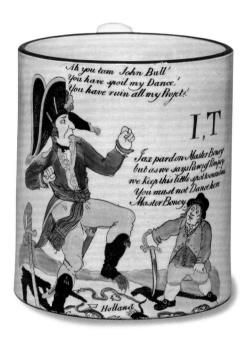

Williams's print (cat. 55) was used as the basis for copies by a number of potters. The copy used for the jug shown here is densely engraved with a variety of tones created by more or less close cross-hatching and parallel lines, while the mug – probably made by a different factory – is printed chiefly in outline with just the blacks created by dense cross-hatching, the colours being added by hand. The bold letters 'I, T' suggest that this may be the work of I. Topham, a decorator who signed four pieces of Spode in 1804.

The jug was printed on the other side with *The Apotheosis of Bonaparte*, after a print published on 10 August 1803 by John Badcock, a Paternoster Row bookseller, in which John Bull kneels at prayer while Napoleon's body swings from a gallows.

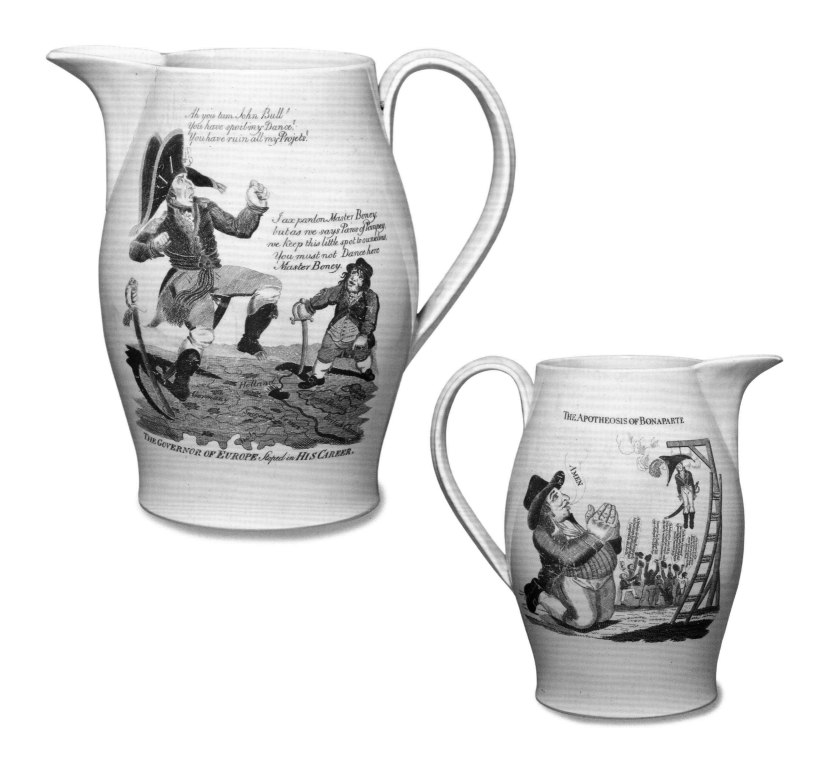

57
*The Governor of Europe Stopped
in his Career*, 1803
Earthenware jug, transfer-printed
in red; Height: 190 mm
Private collection

*John Bull Peppering Buonaparte in the Front and the
Rear*, 1803
Earthenware mug, transfer-printed in red;
Height: 91 mm
Drakard, ill. 508
1988,0502.1

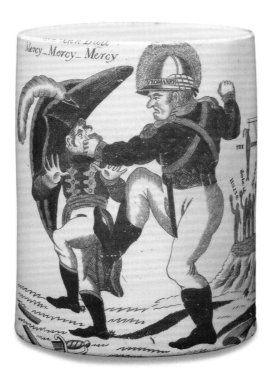

This mug carries another image that was used by a number of
pottery manufacturers. John Bull, portrayed as a member of
one of the volunteer regiments, seizes Napoleon by the nose and
prepares to punch him in the face while kicking his backside at
the same time. The image is based on a print by Isaac Cruikshank
published by William Holland entitled *John Bull Peppering
Buonaparte in the Front and Rear*. In a version on another pot the
image is accompanied by text in the form of dialogue and stage
directions:

> Damn ye you black hearted treacherous Corsican. If you
> were not such a little bit of a fellow, in spite of your large
> cocked hat, I'd crack your skull in an instant with my fist.
> (Seizes him by the nose). If your beggarly Soldiers come
> among us they'll soon have enough of it and damn me if any
> ten of ye shall have my person or property. So be off. (Kicks
> his A[rse]).

59

The Bone of Contention
Spode, 1803
Bone china jug, transfer-printed in black, and painted in
red with a band around the rim, and with painted black
lines at the rim, on the handle and near the foot;
Height: 180 mm
Private collection

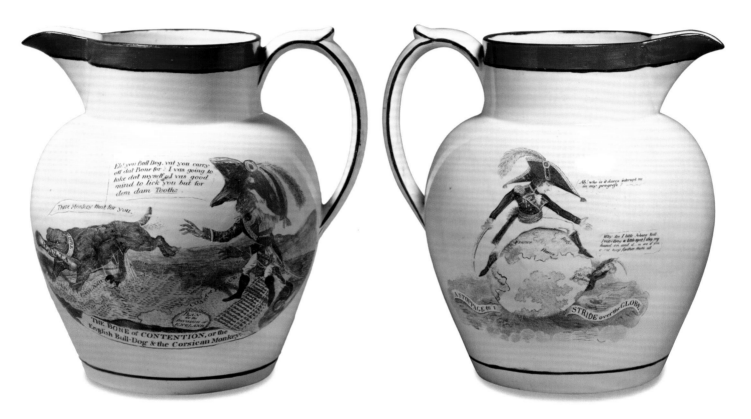

The Bone of Contention was published as a print by Samuel William
Fores on 14 June 1803[1] and copied, no doubt shortly afterwards,
by an engraver employed by the Spode factory. The English
bulldog and the 'Corsican Monkey' stand on either side of the
Channel: the monkey Napoleon nervously treading on his 'Plan
for Invading England', the bulldog raising his leg to urinate on
the French ships. The dog holds a bone labelled 'Malta' between
his teeth, indicating Britain's determination to keep a garrison on
the island.

 The other side of the jug is printed with *A Stoppage to a Stride
over the Globe* based on a print published by Piercy Roberts on
16 April 1803.[2] A youthful Napoleon seated astride the globe,
stretches his legs from Switzerland to Italy, but is prevented from
reaching 'Old England' by a determined 'little Johnny Bull'; as
in *The Governor of Europe …* (cat. 55), the usual contrast of size
is reversed.

1 BM Satires 10015.
2 BM Satires 9981.

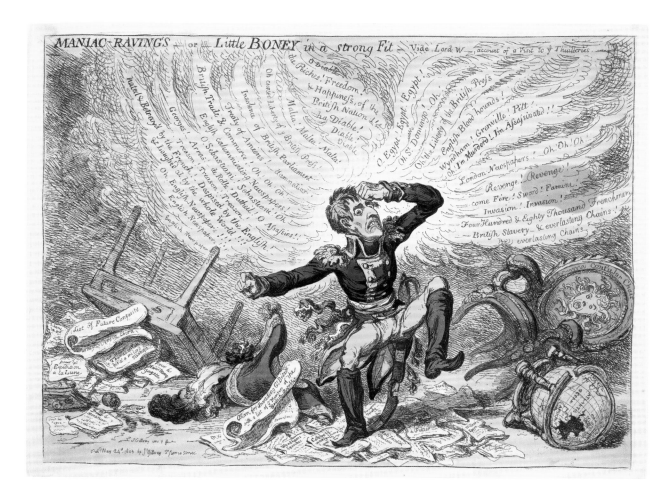

60

James Gillray (1756–1815)
Maniac Ravings
Published by James Gillray,
24 May 1803
Hand-coloured etching;
260 x 352 mm
1868,0808.7120;
BM Satires 9998
From the collection of
Edward Hawkins

According to the lettering on the plate, Gillray published this print himself, which was most unusual: of over 800 prints that he etched, fewer than a dozen carry his name as publisher as well as printmaker, and in almost all those cases there are indications of one kind or another that the plates were funded by interested parties (see pp. 26–8). The examples in this exhibition (see also cats 52 and 69) demonstrate a very detailed knowledge of current international politics. Although the signature 'inv & fec' suggests that *Maniac Ravings* was all Gillray's invention, the subject was probably suggested and information provided by someone at the centre of political affairs. There are references to the official correspondence that had been laid before Parliament on 18 May – the day that hostilities commenced – only six days before publication of the print and it is unlikely that such a complex composition could be devised and produced in such a short time. At this point both George Canning and William Pitt were out of office, but it is possible that this plate and *The Hand-Writing upon the Wall* (cat. 69) may in some way have been subsidized by the government.

The subject derives from an interview on 13 March between Napoleon and the British Ambassador Lord Whitworth when the Consul demanded loudly why Britain wanted to go to war, why they could not honour the Treaty of Amiens by evacuating Malta and why they were rearming. He did not threaten to invade England with 'Four Hundred & Eighty Thousand Frenchmen' as the lettering on the print suggests, but he did promise other ambassadors in Whitworth's hearing that if the British drew their sword first he would sheath his last. Napoleon's display of ill-temper was calculated to ruffle diplomatic feathers, although it was not the sort of tantrum Gillray depicts here.

As well as the names of émigré Royalists and British politicians, Gillray shows him screaming, 'Sebastiani! Sebastiani!' Horace Sebastiani had been sent on a diplomatic mission to negotiate with both British and local officials concerning the British refusal to evacuate Malta and Alexandria; Sebastiani's report, published in the *Moniteur* disparaged the British army and claimed that with 6,000 men

it would be possible for France to regain control of the area. It was not a coincidence that the publication of this report followed the laudatory review in *The Times* on 18 January 1803 of Sir Robert Wilson's *History of the British Expedition to Egypt* with its allegations of the massacre at Jaffa (see cat. 68) and other atrocities by Napoleon; Napoleon's right foot is raised to stamp on 'Times' and 'Wilson's Egypt'.

A 'Plan for Invading Gt. Britain with a list of ye members of the British Republic' falls from Napoleon's hand; the name 'Charles Fox' is legible. Hated publications are trampled underfoot: Canning's *Anti-Jacobin*, Cobbett's *Weekly Journal*, 'Wyndham's Speeches' (William Windham was fiercely anti-Napoleon and was one of the few in the House of Commons who opposed the Peace of Amiens) and Peltier's *L'Ambigu*. In February 1803, the émigré Jean Peltier was tried for a libel against Napoleon before the Court of King's Bench, the principal charge being that his journal, *L'Ambigu*, had called for Bonaparte's assassination; he was found guilty, but never sentenced because Britain was soon at war with France.

61

James Gillray (1756–1815) after
Thomas Braddyll (1776–1862)
The King of Brobdingnag, and Gulliver
Published by Hannah Humphrey,
26 June 1803
Hand-coloured etching and aquatint;
357 x 256 mm
1861,1012.46; BM Satires 10019
Presented by Henry W. Martin

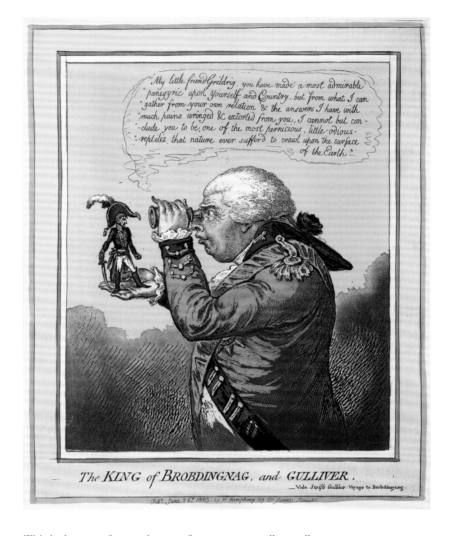

This is the most famous image of an exaggeratedly small
Napoleon. George III holds the Consul on the palm of his
hand, inspecting him through a spy-glass. The print is one of
several prints by Gillray based on drawings by Thomas Braddyll,
a wealthy young Coldstream Guards officer. George III takes
the role of the King of Brobdingnag in *Gulliver's Travels*. He
describes Napoleon in Jonathan Swift's words as 'one of the most
pernicious, little odious reptiles, that nature ever suffer'd to crawl
upon the surface of the Earth'. As usual with Gillray, the message
has a certain ambiguity: in Swift's original text the description was
applied by the king to the tiny Gulliver, an Englishman, after he
had given a shocking description of his country's warlike ways.

George III's reaction to the print suggests that Gillray's satire
passed him by: the Opposition politician Lord Holland recorded
that on seeing the print, the king's only comment was that there
was an error in the dress in which he had been portrayed: 'quite
wrong, quite wrong, no bag [wig] with uniform!!!' [1]

1 Quoted by D. George, BM Satires 10019.

62

Anonymous
A British Chymist Analizing a Corsican Earth Worm!!
Published by William Holland, July 1803
Hand-coloured etching and aquatint;
325 x 245 mm
1868,0808.7161; BM Satires 10031
From the collection of Edward Hawkins

This print was published within a few days
of Gillray's *King of Brobdingnag* and must have
been inspired by it. George III again sits in
profile, wearing a military uniform and bag-wig,
staring myopically through a glass at a tiny
Napoleon, this time scowling back from inside
a chemist's retort. In the king's hand is a small
bowl containing a liquid distilled from the
apparatus which he analyses: 'I think I can now
pretty well ascertain the ingredients of which
this insect is composed – viz, – Ambition, and
self sufficiency, two parts – Forgetfulness one
part, – some light Invasion Froth, on the surface
and a prodigious quantity of fretful passion,
and conceited Arrogance! in the residue!!'
The words mock the language of recent texts
investigating the composition of matter by
French chemists, including Antoine Lavoisier
whose work was available in translation.

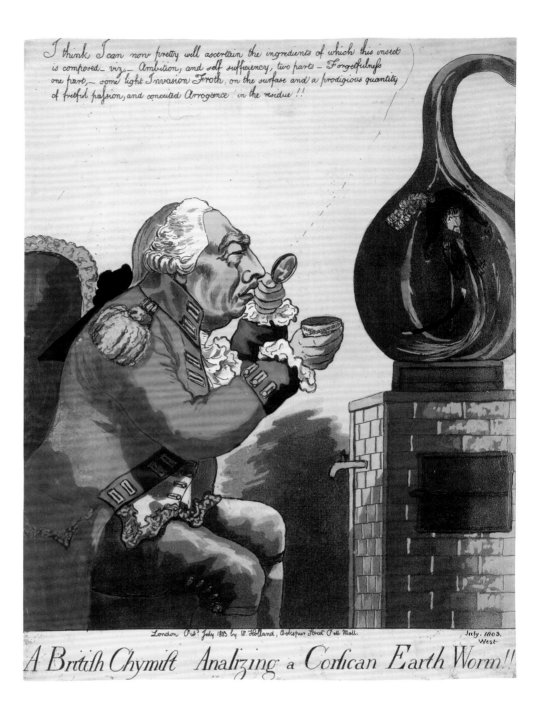

63

Jean Louis Argaud de Barges
(1769–?1808)

*Gare à ta couronne, et déffens
tes côtes*

Published by Aaron Martinet,
1 July 1803

Hand-coloured etching;
210 x 276 mm

1868,0808.7186;
BM Satires 10086

From the collection of
Edward Hawkins

The renewal of war was not expected to be popular on either side of the Channel and Napoleon came up with his own violent rhetoric, stressing Britain's failure to comply with treaty obligations, its government's use of Chouan terrorists (see cat. 36) and of hired Royalist hacks to write offensive lies in their 'free press':

> A treaty of peace means nothing to you. You either violate or execute only those parts that suit you[r] interest. What has been England's conduct since the peace? What vile means has she not employed to defame France and injure her First Magistrate? Every brigand that the Republic vomited forth has been welcomed in England and incited by her to commit new crimes. The cabinet of Saint-James has caused rivers of blood to flow. There is no part of the globe that she has not washed with tears, covered in mourning garb and crimes. The cabinet of Saint-James encourages treason, rewards cowardice and pays crime.[1]

More than sixty caricatures were published in France to justify the renewal of conflict, awaken animosity and threaten invasion during 1803 and early 1804. In this example Napoleon wrestles George III, warning him to take care both of his coasts and his crown. The depictions of the two rulers are, naturally, quite different from those in British prints: there is no attempt at caricature, and the figures are recognizable chiefly from their clothes. The print was registered in the legal depository on 12 *Messidor* Year XI (1 July 1803) with three other prints designed by Citizen Argaud de Barges.[2]

Jean Louis Argaud de Barges was a junior officer in the army, wrote for the theatre and was the designer of some twenty prints registered between 1801 and 1805, including a dozen caricatures in May, June and July 1803. 'The public mood remains very good', noted a police report of 16 June. 'The groups which gather around the printsellers who display caricatures against England have been observed with care … these caricatures are selling very well.' On 30 June the *Gazette de France* remarked that 'Not a day passes without the appearance at M. Martinet's of some new caricature designed to repair the historical omissions committed by England.'[3]

1 J. Diacon, *Guerre à l'Angleterre ou réflexion sur la mauvaise foi du gouvernement anglais*, Paris 1803, p. 7 in Bertaud 2004, p. 52.
2 British Museum PD 1868,0808.7106.
3 De Vinck 7594.

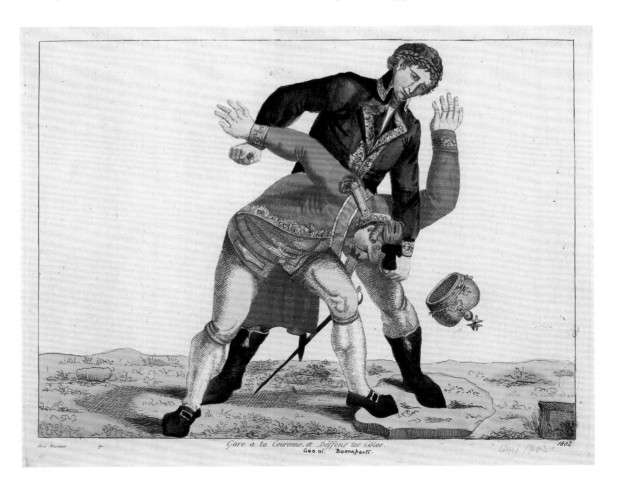

Gare à ta Couronne, et Déffens tes Côtes.
Geo. III. Buonaparte.

NAPOLEONIC MEDALS [1]

One aspect of Napoleon's comprehensive use of the visual arts as propaganda was his production of medals of the highest quality. Medals had been produced since the Renaissance as deliberate echoes of the coins of ancient Rome, which had been struck to record the images of great rulers and their achievements for posterity. It was thought that such objects, which were excavated widely, would outlive the written word. In the seventeenth century, King Louis XIV had beautiful and durable medals struck as a series, with his head appearing in standard form on the obverse, and on the reverse a design recording an event in his reign for which he wished to be remembered.

From his first victories in Italy in 1796–7 onwards, Napoleon had ordered medals on a meticulously controlled basis to commemorate events as they occurred. In September 1803 he instructed Dominique Vivant Denon, to whom he had entrusted virtually all aspects of state involvement in the arts, to produce an *Histoire Métallique* to record the history of his career in a series of medals. Denon suggested the subjects and chose the manner in which they should be represented, using classical allusions and allegories. The designs were produced by the leading artists of the day, and the dies cut by the best engravers. By the time of the final fall of Napoleon in 1815, the Paris Mint was able to produce a series of 141 medals, mostly those produced under the auspices of Denon, but also including others that had been produced for specific occasions before 1803.

The first medal shown here celebrates the Treaty of Amiens, the others censure Britain for the return of war and anticipate its imminent defeat.

1 A. Griffiths in *The Medal*, 16 (1990), pp. 16–30; 17 (1990), pp. 28–38; 18 (1991) pp. 35–49; and in Mark Jones (ed.), *Designs on Posterity: drawings for medals*, London 1994, pp. 106–16; for an earlier medal, see cat. 42.

64

Die engraved by Rambert Dumarest (1760–1806)
The Peace of Amiens, 1802
Struck bronze medal; Diameter: 49 mm
Laskey 22; Bramsen 195
1898,0102.29
From the collection of John Coryton, presented by
Adela Kepple Taylor
1977,0106.22
Presented by Rosemary Waterfield

The obverse shows a profile of Napoleon as 'Premier Consul', wearing the laurel wreath of peace. On the reverse, victorious Mars offers an olive branch to a supplicant Britannia, resting on the subdued British lion.

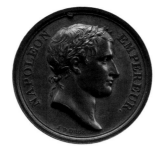

65
Die engraved by Romain Vincent Jeuffroy (1749–1826)
after Antoine Denis Chaudet (1763–1810)
The Treaty of Amiens broken by England and *Hanover occupied by the French Army*, 1803
Struck bronze medal; Diameter: 40 mm
Laskey 27; Bramsen 271
1977,0106.27
Presented by Rosemary Waterfield
1898,0102.33
From the collection of John Coryton, presented by
Adela Kepple Taylor

The medal couples Britain's renewal of
hostilities on 18 May 1803 with the French
response three weeks later in occupying
Hanover, the German territory of which
George III was elector. On the obverse the
British bulldog tears up the Treaty of Amiens.
On the reverse Victory, holding out her laurel
wreath, clings to the white horse of Hanover.
The lettering states that the medal was struck in
silver taken from the mines of Hanover in the
fourth year of Bonaparte's rule, although this
example is bronze.

66
Die engraved by Jean Pierre Droz (1746–1823)
Hercules subdues the lion, 1804
Struck bronze medal; Diameter: 40 mm
Laskey 36; Bramsen 320
1898,0102.37 and 38
From the collection of John Coryton, presented by
Adela Kepple Taylor

On the obverse is the head of Napoleon as
'Empereur', the title he took on 18 May 1804
on the anniversary of Britain's renewal of war.
The reverse shows Hercules about to strangle
the Nemean lion, which represents Britain. The
lettering proclaims that 2,000 ships were built in
the twelfth year of the Revolution. These were
to be used in the invasion of Britain that, in the
event, never occurred.

67
Die engraved by Romain Vincent Jeuffroy (1749–1826)
Invasion of England, 1804
Struck bronze; Diameter: 40 mm
Bramsen 364
M.5210

The obverse of this medal shows the head of
Napoleon. The reverse shows Hercules wrestling
a figure that is half man, half fish; this refers to
the monstrous nature of Britain and to its naval
power. The lettering, '*Descente en Angleterre /
Frappée a Londres en 1804*', reveals that the medal
was designed in advance, and was intended to
be struck in London after Napoleon's conquest
of the country. As the invasion did not happen,
the medal was suppressed. The die was later
recut with the names of Denon and Jeuffroy,
the date 1806, and '*Toto Divisos Orbe Britannos*'
(Britannia, separated from all the world), a
quotation from Virgil referring here to the
Continental blockade intended to isolate
Britain. Napoleon himself refused to allow the
second version of the reverse to be issued, but
the die survived and found its way to England
after 1815, where medals struck from it had a
ready market among collectors.

68

After Robert Ker Porter (1777-1842)
Buonaparte Ordering Five Hundred & Eighty of his Wounded Soldiers to be Poisoned at Jaffa
Published by John Hatchard, James Asperne and John Ginger, 12 August 1803
Etching; 435 x 288 mm
1866,0407.984

Sir Robert Wilson had served with distinction in the early stages of the Revolutionary Wars and was in Egypt for the last few months of French occupation in 1801. The following year he published his best-selling *History of the British Expedition to Egypt*. The book's popularity derived from its charges of cruelty against Napoleon. After Nelson's victory at the Nile in 1798 Napoleon had led his army northwards towards Syria. Wilson gives an account of alleged atrocities at Jaffa. The first occurred on 7 March 1799 after the city had been stormed by French troops:

> Buonaparte, who had expressed much resentment at the compassion manifested by his troops, and determined to relieve himself from the maintenance and care of three thousand eight hundred prisoners, ordered them to be marched to a rising ground near Jaffa; where a division of French infantry formed against them. When the Turks had entered into their fatal alignment, and the mournful preparations were completed, the signal gun fired. Vollies of musquetry and grape instantly played against them; and Buonaparte, who had been regarding the scene through a telescope, when he saw the smoke ascending, could not restrain his joy, but broke into exclamations of approval.

The second event described by Wilson took place when Napoleon returned to Jaffa in late May and found a number of his soldiers stricken with the plague:

> He entered into a long conversation with [a physician] respecting the danger of contagion, concluding at last with the remark, that something must be done to remedy the evil, and that the destruction of the sick at present in the hospital was the only measure which could be adopted…. Opium at night was administered in gratifying food; the wretched unsuspecting victims banqueted and in a few hours 580 soldiers, who had suffered so much for their country, perished thus miserably by the orders of its idol.[1]

These wild exaggerations of actual events naturally infuriated Napoleon and must have been the reason for his commissioning Antoine Gros to paint the famous *Bonaparte Visiting the Plague Victims of Jaffa* (Louvre) exhibited at the Salon of 1804.

Wilson's allegations formed the core of the 'Black Legend' that was effectively spread by British propagandists. The print shown here is one of a group of four based on drawings by the young painter Robert Ker Porter that were published with government encouragement by John Hatchard and John Ginger, both of Piccadilly, and James Asperne of Cornhill in the City of London. At the time of the invasion threat these three publishers were largely responsible for numerous 'Patriotic Papers' – broadside letterpress sheets with such titles as 'Britons the Period is now arrived, when it is to be discovered whether you are to be Freemen or Slaves! Signed Taurus' – that sold for a penny or twopence; clergymen and local gentry were encouraged to buy in bulk at a discount rate to distribute among their parishioners. The four prints based on Ker Porter's drawings were clearly aimed at those who would be able to pay for more carefully produced propaganda.

The present print shows the physician who was said to have refused to dispose of the plague-stricken French soldiers by administering opium; the task was allegedly later performed by an apothecary. The other three prints in the series are *Napoleon Massacring Three Thousand Eight Hundred Men at Jaffa*, *Buonaparte Sends a Flag of Truce and at the Same Instant Commences an Assault on Acre*, an incident alleged to have occurred in May 1799, and *Buonaparte Massacreing [sic] Fifteen Hundred Persons at Toulon*, an accusation with no foundation that harks back to Napoleon's first military success as a young officer in 1793.[2] Bonaparte had no part in the executions at Toulon; the other three allegations had some basis in truth, but ignored significant mitigating circumstances.

1 R. Wilson, *History of the British Expedition to Egypt*, London 1802, pp. 74–7.
2 British Museum PD1866,0407.983, 985 and 982.

From a Design by Mr R.K.Porter.

BUONAPARTE

Ordering Five Hundred & Eighty of his wounded Soldiers to be poisoned at

JAFFA.

London Published as the Act directs, Aug.st 12, 1803, by J. Hatchard, Piccadilly, J. Ginger, Piccadilly, & J. Asperne, Cornhill.

69

James Gillray (1756–1815)
The Hand-Writing Upon the Wall
Published by James Gillray,
24 August 1803
Hand-coloured etching and aquatint;
253 x 354 mm
1851,0901.1124; BM Satires 10072
Presented by William Smith

Napoleon feasts with his officers and their mistresses at a table laden with dishes moulded to represent significant London buildings, and the head of a bishop, labelled, 'Oh de Roast Beef of Old England'. He has dropped his wine glass and overturned three bottles as he turns in shock to see behind him the writing on the wall: 'Mene Mene, Tekel, Upharsin' ('God hath numbered thy kingdom, and finished it; Thou art weighed in the balances, and art found wanting; Thy kingdom is divided' Daniel, V, 25–8, Authorized Version). The arms of Jehovah emerge from clouds, one pointing at the words, the other arm holding a pair of scales on which a crown ('*Vive le Roi*') outweighs shackles and a red liberty cap ('Despotism').

Only Napoleon has seen the apparition, although three grenadiers with bloody sabres standing stiffly behind him turn their eyes apprehensively in that direction. Josephine, at his side, drinks avidly; in front of her is a plate with two '*Prunes Monsieur*' (a slang term for testicles) and a bottle of Maraschino. This is Josephine's first appearance in British satire and Gillray chooses with no justification to depict her as grossly fat (for a more attractive portrayal, see cat. 85). Napoleon's three sisters, Elisa, Pauline and Caroline stand behind her, their

breasts bare and their hair in ringlets. On the left is Arthur O'Connor, the Irish Republican (see also cat. 50), identified by the bottle labelled 'Maidstone', the town where he was tried for treason; he offers a dish of '*Pommes d'Amour*' to the woman at his side.

Marcel Roux suggests that the threat implicit in the print is the conspiracy to assassinate Napoleon led by Georges Cadoudal who had been landed on the French coast from a British brig just before the print was published.[1] The conspiracy was supported by the British government and if Roux is correct then the implication is that the print was devised by someone close to the government who had first-hand knowledge of what was being planned.

A print of 1785 by Henry Hudson of Rembrandt's *Belshazzar's Feast* (now in the National Gallery, then in the collection of Thomas Fullwood[2]) is likely to have been Gillray's inspiration for this composition, and for the figure of Napoleon in particular.

1 De Vinck 7716.
2 British Museum 1868,0808.2658.

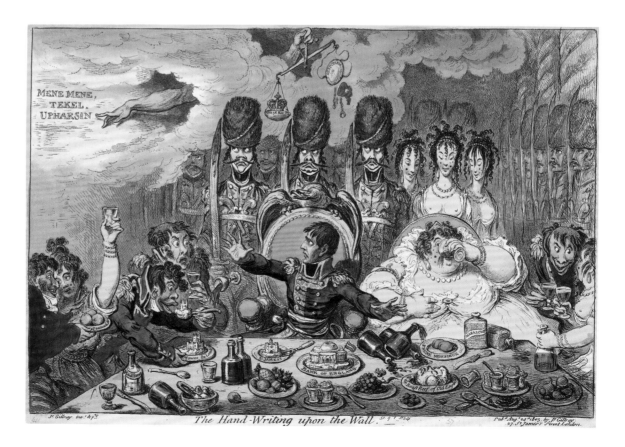

The Hand-Writing upon the Wall.

70

J.S. Barth (active 1797–1808)
after John Boyne (c. 1755–1810)
A Gallic Idol
Published by Robert Cribb, 20 August 1803
Hand-coloured etching and aquatint; 444 x 263 mm
1897,0615.15; BM Satires 10070

Robert Cribb, publisher of this symbolical bust, ran a small business in Holborn selling conventional portrait prints and making frames, but like many others he exploited the demand for Napoleonic subjects. This unusual example reproduces a drawing by John Boyne, another little-known member of the art world – according to Louis Fagan, writing in the 1880s, 'lack of application and a dissipated lifestyle worked against him.'[1] He is best known for a series of watercolour heads of Shakespearian characters that he exhibited at the Royal Academy.

Napoleon is dressed as a Roman emperor wearing a fantastic helmet wreathed with zodiacal devices, laurel leaves and snakes that hiss 'Rapine', 'Lust', 'Murder'; the Consul himself utters the word 'Invasion'. Boyne was clearly inspired by the 'Black Legend' (see cat. 68): perched on top of the helmet are the Devil playing a fiddle and the figure of Death, holding a cup of poison inscribed 'Jaffa'; the chest cavity is open revealing ribs and a wounded heart surmounted by a crown pierced by a dagger labelled 'Wilson's Narrative' and a spear labelled 'British Press'; fragments torn from the heart are lettered 'Acre', 'Egypt' and 'Ireland'. In the middle of the heart is a triangular patch: 'England'. The ironic explanation on the base quotes from Charles James Fox's declaration to Edmund Burke in 1791 that the French Revolutionary constitution would prove 'a stupendous Monument of Human Wisdom'.

Robert Cribb published a companion, *A Sacrifice to Ambition*, also by Barth after Boyne, with verses repeating Napoleon's alleged ruthless crimes as he makes a Faustian pact, 'Let me this world but govern while I live, I'll forfeit all futurity can give'.

An annotation on the verso of the print suggests that it formerly belonged to Adolphe Thiers (1797–1877) who published a 12-volume *Histoire de la révolution française* in the 1820s before establishing himself as one of the most influential politicians of the century.

1 *Oxford Dictionary of National Biography.*

A GALLIC IDOL.

Symbolical of the Effects produced by that Cause which the enlightened
Eighteenth Century sagaciously predicted would ultimately prove
A STUPENDOUS MONUMENT OF HUMAN WISDOM !!!

71

James Gillray (1756–1815)
The Arms of France
Published by John Hatchard, 6 September 1803
Hand-coloured etching; 360 x 252 mm
1868,0808.7189; BM Satires 10090
From the collection of Edward Hawkins

As with cats 60 and 69 there is reason to believe that this print was instigated by the government, or more specifically by George Canning. It is significant that Gillray does not claim to have invented the design, only to have drawn and etched it ('del. & ft.'); the publisher, John Hatchard, was one of those who regularly produced government propaganda. The price, 2s. coloured, as advertised in the *Morning Post*, 22 September 1803, was half the normal price charged by Humphrey, Holland or Fores for a print of this size and quality, suggesting subsidy.

Mock heraldic devices were a staple of popular print production, allowing for satirical messages or propaganda to be conveyed emblematically in a way that a wide audience was able to follow. Here Napoleon's alleged cruelty is linked to the violence of the Terror. His concordat with the Roman Catholic church in 1801 is exposed as the hypocritical opportunism of an atheist. He had gone so far as to ask the émigré clergy who had returned to France to pray for success in the war against Britain, infuriating the London press who reminded readers that these priests had been sheltered in England. The design is framed by *tricoleur* curtains with the names of 'French Worthies' headed by 'Robespierre' paired with 'Buonaparte'. In the centre, 'The Sun of the French Constitution' shines through a guillotine dripping with blood. The supporters on either side are a monkey wearing a fool's cap, sitting on the works of Rousseau, Voltaire and Thomas Paine and holding a flag lettered 'Atheism', and a rampant tiger whose flag is lettered 'Desolation'. This is a Canning-style joke: Voltaire had once said that the French could be 'divided into two species: the one of idle monkeys who mock at everything; and the other of tigers who tear'.[1] Below hangs an oval medallion with the head of Napoleon lettered, 'And God made Buonaparte, and rested from his labours'. Examples of 'Gallic Fraternity' are listed, 'Spain, Inchain'd – Holland, Plunder'd, – Switzerland, Ruin'd; – Italy, Destroy'd. – France, in Slavery.' Scrolls on either side proclaim 'Invasion – Plunder and Destruction.' On the ground below are heaps of bleeding heads: children, nuns (a veiled head rests on a rosary and a book lettered 'Ave Maria'), a bishop, a

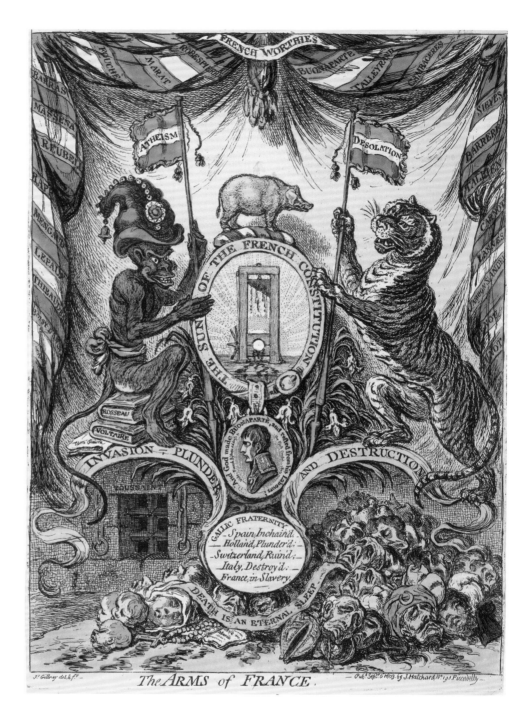

The ARMS of FRANCE.

turbaned Turk, and numerous unidentified men. On the left is a heavily barred prison window with the name 'Toussaint', a reminder of the death in prison earlier in the year of the leader of the rebellion in Haiti. A ribbon lettered 'Death is an eternal Sleep' refers to the words ordered to be inscribed over the gates of cemeteries in the first year of the Republic when France underwent 'dechristianisation'.

1 Letter from Voltaire to Madame Deffand, 21 November 1766, quoted in BM Satires 10090.

72

James Gillray (1756–1815)
The Corsican Pest
Published by Hannah Humphrey, 6 October 1803
Hand-coloured etching; 403 x 328 mm
1851,0901.1127; BM Satires 10107
Presented by William Smith

On 12 November 1803, William Cobbett
described what must be this print in Hannah
Humphrey's window: 'the Consul … with the
Devil, who has the little hero upon a toasting
fork, writhing before the flames of hell!'[1] The
depiction of devils and hell-mouth harks back to
medieval iconography with an overlay of cruel
schoolboy humour. Napoleon is toasted over
the fire; he defecates in terror and the childlike
attendant demons hold their noses. The print
is again drawn and etched but not invented by
Gillray, but there is none of the detailed topical
reference of cats 60 and 69. The verses below
describe the scene, with cheery choruses, 'Tol
de rol'. It is only on reading the annotations
within the image that the context becomes
apparent: 'Favourite French Wines of the
Consular Vintage' are the blood of the Swiss,
English and Dutch; the figures suspended from
the beam beyond the flames are Napoleon's
'*Armée D'Angleterre*'; the flames are fed with
papers lettered 'Poisoning 580 wounded
French soldiers', 'Massacre of 3800 Turks at
Jaffa', 'Murdering 1500 Women at Toulon',
'Assassination of captive Swiss', 'Destruction
of St Domingo', 'Extermination', 'Murder',
'Treachery', and so on.

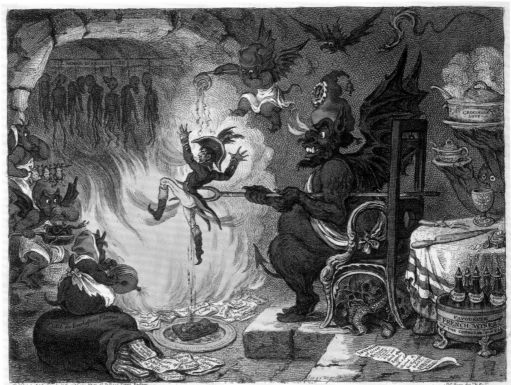

1 Cobbett, 1802–35, IV, p. 712, Letter to R.B. Sheridan Esq.

73

Anonymous
*John Bull Viewing the Preparations
on the French Coast!*
Published by William Holland,
13 October 1803
Hand-coloured etching and aquatint;
250 x 353 mm
1868,0808.7204; BM Satires 10110
From the collection of Edward
Hawkins

William Holland has produced a simple, and very clear, image of what the ordinary Englishman was afraid of in October 1803. John Bull gazes over the Channel towards the French coast where regiments of soldiers line the shore and boats are gathering at sea. He displays characteristic bravado, puffing on his pipe and declaring, 'You may all be Damned!!' The print was one of sixty-six on the invasion scare as advertised by William Holland in the *Morning Post* on 26 November 1803 (see p. 30).

Bonaparte had constructed a magnificent camp for his army at Boulogne complete with a monumental column, which survives today. He spent the cost of thirty-five ships of the line trying to convert Boulogne and other places into ports fit for military use, and was improving the roads to the coast. In Britain major defensive preparations were begun along the south coast including the strengthening of Dover castle, the building of over 100 Martello towers (inspired, ironically, by the round coastal fortress at Mortella in Corsica), and the digging of the Royal Military Canal on the edge of Romney Marsh.[1]

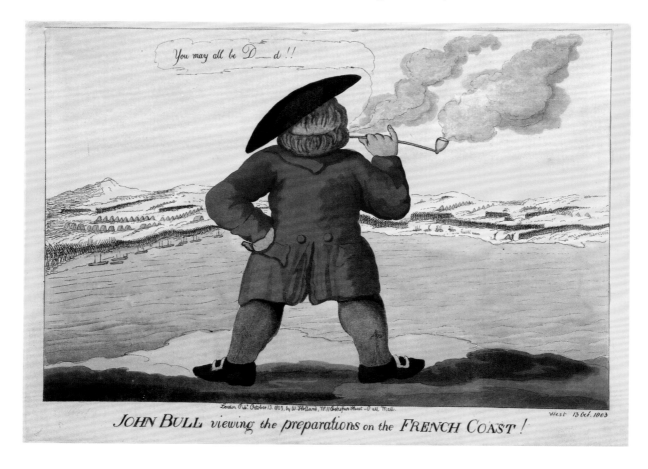

JOHN BULL *viewing the* preparations *on the* FRENCH COAST *!*

1 Knight 2013, pp. 276–80.

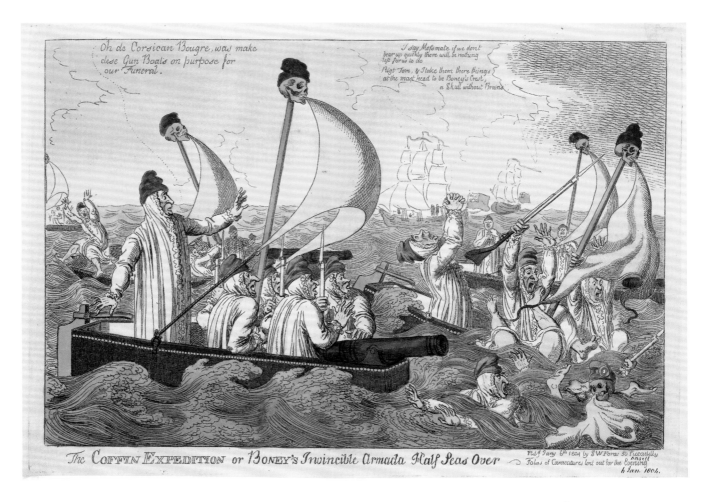

Oh de Corsican Bougre, was make dese Gun Boats on purpose for our Funeral.

I say Mesomate if we don't bear up quickly there will be nothing left for us to do

Right Tom, & I take them there things at the mast head to be Boney's Crest, a Skull without Brains.

The COFFIN EXPEDITION or BONEY's Invincible Armada Half Seas Over

Pub.d Jan.y 6.th 1804 by S.W.Fores 50 Piccadilly Ansell Folios of Caricatures lent out for the Evening
6 Jan. 1804.

74

Charles Williams (active 1797–1830)
The Coffin Expedition
Published by Samuel William Fores,
6 January 1804
Hand-coloured etching;
249 x 352 mm
1868,0808.7238; BM Satires 10222
From the collection of Edward
Hawkins

On 24 May Napoleon had ordered 1,050 invasion barges to be built and on 5 July he placed orders for 2,410 more. He was said to have claimed in June 1803 that three days of fog would make him master of London. Naval men in Britain (and in France) knew that the reality was rather different. It had never been possible to sail more than 100 craft on any tide at Boulogne and altogether at least five days were needed to embark and sail. During a trial in windy weather, thirty craft were wrecked and several hundred men drowned. A fair wind would cause a surf on English beaches in which the invasion craft could not land, but to row across the Channel would take two days, during which they would be at the mercy of an ever-vigilant, numerous and well-equipped Royal Navy.

This print reflects the optimistic view of British sailors of French prospects. Bonaparte's army is sailing in gunboats in the form of unseaworthy coffins, their masts topped by skulls wearing red liberty caps. The crews are already wearing shrouds, and again liberty caps (in fact no longer worn after 1799). In the distance British sailors comment, 'I say Messmate if we don't bear up quickly there will be nothing left for us to do' and 'Right, Tom, & I take them there things at the mast head to be Boney's Crest, a Skull without Brains.'

75

Anonymous
Vent contraire
Published by Aaron Martinet, November–December 1803
Hand-coloured etching; 180 x 162 mm
1868,0808.6807; BM Satires 9165
From the collection of Edward Hawkins

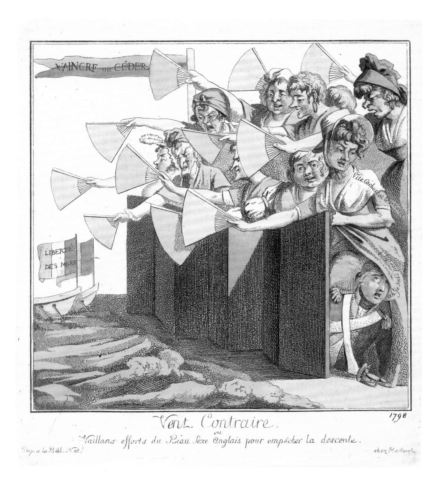

The defence of Britain has been left to a group of Englishwomen
(as unattractive as usual in French caricatures) who stand behind
a folding screen on the seashore waving their fans in an attempt to
make a contrary wind that will prevent the landing of the French
fleet. A terrified officer ('ah! I am lost') hides under the petticoats
of a woman who warns him that the French have arrived. Two
boats have reached land; their *tricoleur* flags proclaim 'Freedom
of the Seas': Napoleon claimed to be fighting on behalf of all
Europe against British insistence on searching neutral shipping.
An English pennant, flying behind the Englishwomen, is lettered:
'*Vaincre ou céder*' (Conquer or yield), a play on '*Vaincre ou mourir*',
the constant refrain of French armies under the Revolution and
Bonaparte.

 A previous owner annotated the print with the incorrect date
'1798', but it can be dated to November–December 1803 from the
impression in the Musée Carnavalet.[1]

1 Musée Carnavalet G27239.

76

James Gillray (1756–1815)
Buonaparte, 48 Hours after Landing
Published by Hannah Humphrey, 26 July 1803
Hand-coloured etching; 355 x 255 mm
J,3.30; BM Satires 10041
From the collection of Sarah Sophia Banks

William Cobbett was disgusted by this print: 'There was and yet is, to be seen the head of Buonaparté, severed from his body and exhibited upon the *pike* of a *Volunteer* with the blood dripping down upon the exulting crowd.'[1] But the historian Dorothy George sensed some ambivalence in Gillray's treatment of a subject that had, again, been provided to him for propaganda purposes: 'There is, however, a refinement in Napoleon's haggard head contrasting with the coarse features of the yokels, which tempers the naïveté of the patriotism.'[2]

Whereas conscription into the militia was most unpopular, volunteering, introduced in 1798, proved very acceptable. The volunteers remained in their local area, exempt from conscription. They dressed up, paraded round, seemed to be doing work of consequence and impressed the ladies. In 1798 and throughout the following years, the government had attracted some 100,000 volunteers but this seemed less than adequate in view of the present threat. Consequently a *Levy en Masse* Bill was introduced on 18 July 1803 for local conscription of men aged between seventeen and fifty-five whose role would be to resist invasion. The Act was passed on 27 July, but so many volunteers were coming forward – 300,000 in Britain and 70,000 in Ireland – that it was soon dropped as unnecessary. 463,134 men had volunteered in Britain and Ireland by 1804. Prints played an important part in encouraging volunteer recruitment, as publishers took advantage of the situation to sell pictures of them in their camps and sets of their uniforms, but apart from the many rallying broadsheets published by government printers, the prints were commercially motived. The large numbers of volunteers themselves constituted a substantial market.

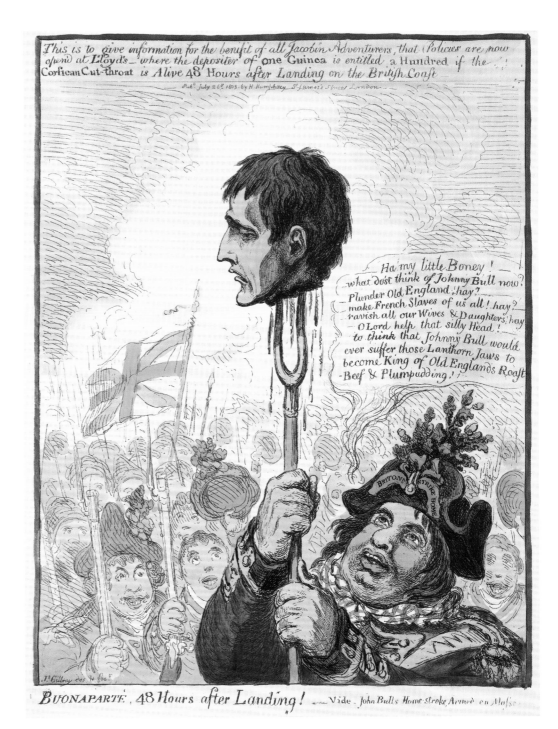

BUONAPARTE, 48 Hours after Landing! — Vide John Bull's Home stroke Armed en Masse

1 W. Cobbett, *The Political Proteus*, London 1804, Letter VIII, p. 188.
2 BM Satires 10041.

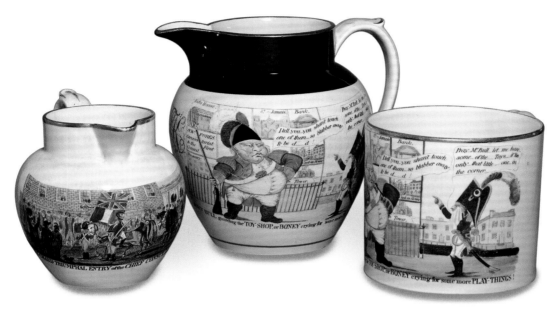

77

The Grand Triumphal Entry of the Chief Consul into London
Spode, 1803
Bone china jug, transfer-printed in black, painted with additional overglaze colours, rim gilt, and handle partly gilt;
Height: 120 mm
Drakard, ill. 568
Private collection

This jug carries a view based on a print published by Samuel William Fores on 1 October 1803[1] showing Napoleon subjected to ritual humiliation by Londoners. He has been forced to ride backwards on his horse through the streets. The cheering figure on the left who appears to be Charles James Fox does not appear in Fores's print and his presence suggests that Spode's copyist was not aware of Fox's more usual positioning as a supporter of Napoleon and opponent of war.

78

John Bull Guarding the Toy-Shop
Spode, 1803
Bone china jug, transfer-printed in black, painted with additional overglaze colours, a brown band near the rim, rim gilt, handle partly gilt and gilt line near the foot;
Height: 165 mm
Private collection

79

John Bull Guarding the Toy-Shop
Spode, 1803
Bone china mug, transfer-printed in black and painted with additional overglaze colours, rim gilt and handle partly gilt;
Height: 110 mm
Drakard, ill. 570
Private collection

Spode has used the same image on both a jug and a mug. A very large John Bull, dressed as a volunteer, stands guard outside a shop clearly labelled with a sign identifying it as that belonging to Samuel William Fores, the publisher in Piccadilly (where the shop remained until the 1930s). Fores's print of this composition appeared on 29 October 1803.[1] The shop window is filled with prints of London landmarks and the tiny Napoleon points at the view of the Bank of England crying as he asks, 'Pray Mr Bull, let me have some of the Toys. If 'tis only that little one in the corner.'

On the other side of the jug is a copy of a print published by James Asperne on 27 August 1803:[2] Napoleon, 'the little Corsican Monkey' is dressed in a harlequin coat and chained to a block at Gilbert Pidcock's famous menagerie at Exeter Change in the Strand. The Harlequin is a reference to David Garrick's pantomime, *Harlequin's Invasion*, written for the invasion threat of 1759 and containing the ever-popular song 'Heart of Oak', a pantomime revived in adapted form for 1803. The highly conservative Asperne – his shop sign was 'The Bible, Crown and Constitution' – was one of those involved in publishing cheap prints carrying the government's message.

1 BM Satires 10106.

1 BM Satires 10118.
2 BM Satires 12267.

80

Charles Williams (active 1797–1830)
*The Cold-Blooded Murderer or the
Assassination of the Duke d'Enghien*
Published by Samuel William Fores,
2 June 1804
Etching; 249 x 351 mm
1868,0808.7271

The kidnapping and execution of Louis-Antoine de Bourbon-Condé, Duke of Enghien was an event that shocked Napoleon's admirers as well as his enemies. It followed a Royalist conspiracy to assassinate Napoleon that had been backed with British support.[1] The chief conspirators were arrested early in 1804: Georges Cadoudal, who had also been involved in the *Machine Infernale* plot (cats 41–42), Jean Charles Pichegru, a former Revolutionary general, and General Jean Victor Moreau,

victor of the decisive battle of Hohenlinden in December 1800 and Bonaparte's principal military rival. It was revealed that the arrival in France of a prince of royal blood was to be the signal for the conspirators to act.

Bonaparte assumed that the prince in question would be the Duke of Enghien, who was at Ettenheim in Baden, only ten kilometres from the French frontier. He had him abducted by a force of dragoons and tried by a hastily convened tribunal. He was found guilty of having offered his services to the English, having conspired with English agents, having put himself at the head of a force of émigrés in English pay and having been one of the authors and conspirators in the English plot to assassinate the Consul. Condemned to death, he was shot in the ditch at the Château de Vincennes during the night of 21–22 March 1804.

On 10 June, Cadoudal and nineteen of his accomplices were also condemned to death;

Pichegru had already been found strangled in his prison cell; Moreau was exiled.[2] Bonaparte's journalists immediately accused Britain of sponsoring the plot. The *Moniteur* denounced criminal Albion, land of sanguinary barbarians and monsters making war with the assassin's knife. A nation of slaves determined to suppress the liberty of the entire human race, England was outlawed and doomed to destruction. One anonymous hireling wrote in 1804 that 'Proud Albion should tremble and dread that her last hour is about to toll'; the fleet and the army preparing for invasion at the camp in Boulogne 'will make terrible war and Albion will be annihilated'.[3]

1 Sparrow 1999, pp. 267–95.
2 Bertaud 2004, p. 55; J-P Bertaud, *Le Duc d'Enghien*, Paris 2001, p. 341.
3 Bertaud 2004, p. 56.

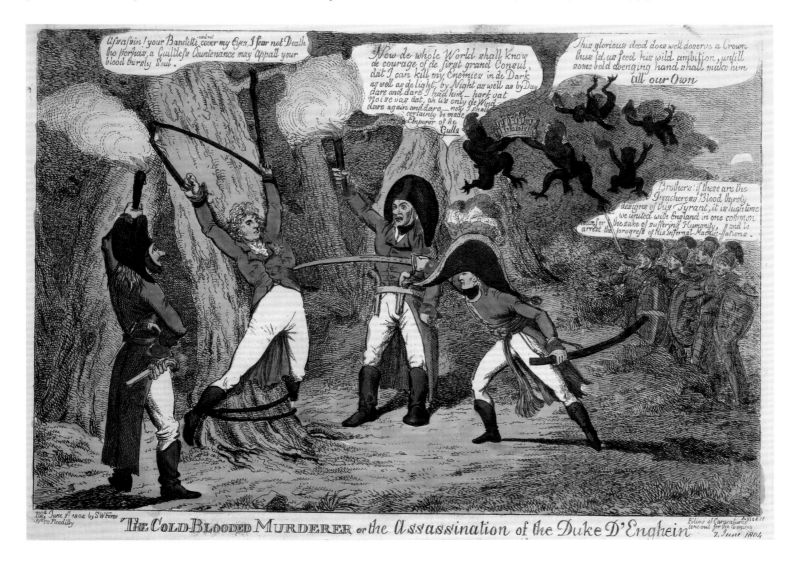

5
Emperor

Napoleon was proclaimed Emperor in May 1804 and crowned in December. His elevation followed war with Britain and the Royalist plots that had raised the First Consul's popularity and entwined his fate with the survival of Revolutionary changes. The Revolutionaries saw the consolidation of the First Consul's power as the only protection against attempts to restore the Bourbon monarchy.

Having an emperor was claimed not to be incompatible with being a Republic: in ancient Rome an Imperator was originally an individual invested with the power to command, usually a war leader acclaimed after victories, and the Roman Empire continued to be governed notionally by the Senate and People. 'The government of the Republic is entrusted to an emperor who takes the title of Emperor of the French' stated the new constitution of the Year XII.

For some time Bonaparte had been behaving like a monarch with all the trappings of royalty, and so the coronation merely made the distinction formal. The title was to be hereditary, but because Napoleon had no children and would have to adopt a successor this was readily agreed.

Prints in this section contrast British mockery with fine French printmaking and demonstrate Napoleon's appreciation of the role of works of art in promoting his dignity.

81

James Gillray (1756–1815) after T.B.-d-lle
The Genius of France Nursing her Darling
Published by Hannah Humphrey,
26 November 1804
Hand-coloured etching and aquatint;
345 x 254 mm
1868,0808.7303; BM Satires 10284
From the collection of Edward Hawkins

A savage embodiment of the Republican
Marianne has taken a baby Napoleon from
his cradle and dangles him on her hand. She
is shown as a distorted version of Britannia,
her spear dripping blood and her shield
painted with the bleeding head of Louis XVI.
Although the coronation was still some days
away, Napoleon is wearing a royal robe over
his military uniform, and he points towards the
crown on the rattle that the harridan shakes as
she sings:

> There's a little King Pippin
> He shall have a Rattle & Crown,
> Bless thy five Wits my Baby
> Mind it dont throw itself down!
> Hey my Kitten, my kitten &c &c.

King Pippin was the eponymous hero of
a widely read children's story, first published
by Francis Newbery in 1780,[1] but the reference
is also to Pepin the Short, the first Carolingian
king who was crowned in Paris by the Pope in
the year 754. The consecration of Napoleon
by Pius VII was intended to lend legitimacy,
but Jean Peltier's Royalist journal *L'Ambigu*
commented sarcastically that 'word from Paris
has it that the Holy Father will travel to France
to crown Napoleon the short, just as Pope
Zachary did for Pépin'.[2]

The phrase, 'Bless thy five wits' is footnoted
on the print. It refers to Edgar's speech to the
old king in Shakespeare's *King Lear* (Act III,
scene 4):

> False of Heart, light of Ear, bloody of
> Hand,
> Fox in Stealth, Wolf in Greediness, Dog in
> Madness,
> Lion in Prey....

A contemporary audience would also have
known that the final line of Marianne's verse
comes from a nursery rhyme that continues:

> Now we go up, up, up,
> And here we go down, down, down.[3]

1 For Thomas Bewick's illustrations of *King Pippin*, see British
 Museum PD 1882,0311.4652.
2 *L'Ambigu*, VII, p. 178.
3 For the nursery rhyme *Hey my Kitten*, see Robert Burns (ed.),
 The Scots Musical Museum, Edinburgh 1787.

82 and 83

James Gillray (1756–1815)

The Grand Coronation Procession of Napoleone the 1st Emperor of France from the Church of Notre Dame, Decr 2d 1804

Published by Hannah Humphrey, 1 January 1805

Etching (proof before letters); 235 x 770 mm

1863,0110.141; BM Satires 10362A

Published state: Etching and aquatint with hand-colouring; 237 x 778 mm

1868,0808.7312; BM Satires 10362

From the collection of Edward Hawkins

Gillray shows the chief members of the Bonaparte family and the imperial regime in a grotesque version of the procession that succeeded the coronation on 2 December 1804. The fine proof before lettering, printed in dark brown ink, is annotated in Gillray's hand with descriptions of those portrayed; these are only occasionally altered in the final published state, here shown in a hand-coloured impression.

The procession is led, on the right, by the theatrical figure of the emperor's younger brother, Louis Bonaparte, labelled 'Marboeuf' after his godfather, the Comte de Marbeuf, governor of Corsica under Louis XV, alleged lover of Napoleon's mother and sponsor of Napoleon's education at the military college at Brienne. He is followed by 'The Three Imperial Graces' who scatter roses: Napoleon's sister Pauline, the Princess Borghese; his stepdaughter, Hortense, wife of Louis Bonaparte, described as the '*cher amie of ye Emperor*'; and Julie Bonaparte, wife of his brother Joseph. Next walks Catherine, Madame Talleyrand, portrayed as a stout matron leading the four-year-old Napoleon-Charles Bonaparte, son of Louis, or as '*chere amie*' implies, of Napoleon. The renowned beauty put on weight as she reached middle age, but Gillray has exaggerated greatly. He alludes to her earlier marriage in Calcutta to George Grand and to her affair with Sir Philip Francis, both British civil servants, but his suggestion that she had a relationship with Nathaniel Halhed, the Orientalist and supporter of the millenarian Richard Brothers, is not necessarily accurate.

Talleyrand himself follows: on the proof Gillray describes him as 'Herald at Arms, Secretary of State, Prime Minister of ye Empire – Nominated King of Great Britain after ye Invasion'. He carries on his shoulder a genealogical table showing Napoleon's descent from a butcher, and other panels hang about him with images of the emperor's bloody career. Gillray draws attention to Talleyrand's damaged right foot by showing it supported by blocks under the shoe. Next walks the aged Pope Pius VII 'conducted by his old Faithful Friend', a devil disguised as a young acolyte. Beside him Cardinal Fesch, Napoleon's uncle, wafts clouds of incense inscribed with such phrases as, 'the admiration of fools', 'the congratulations of the frogs', and 'the obeisance of cowards'. Next come Napoleon (portrayed with the proportions of a plump child) and Josephine (grotesquely fat – compare to cat. 85), both crowned and carrying sceptres. The emperor's long cloak is held by his obsequious allies Spain, Prussia and Holland; Josephine's train is supported by three 'Ladies of Honor', ragged former fishwives with feathered coronets. Above them a fringed canopy is inscribed ironically with Virgil's tribute to the Emperor Augustus (*Eclogues*, Book IV) referring to the return of Saturn's (changed by Gillray to 'Satan's') reign. Behind them march 'the brave Train of Republican-Generals': Berthier, Bernadotte, Augereau, Masséna and Macdonald, all with their hands tied. Next walks 'Senator Fouché, Intendant General of ye Police, bearing the Sword of Justice', and armed with a dagger, followed by the 'Guard of Honour' consisting of gaolers, spies and poisoners bearing emblems of despotism. In the background are close ranks of French soldiers, a forest of caps, spears, pikes, muskets, bayonets and eagle-headed banners expressive of tyranny, doom, destruction and world domination, one of them parodying the Roman 'SPQR' (Senate and People of Rome).

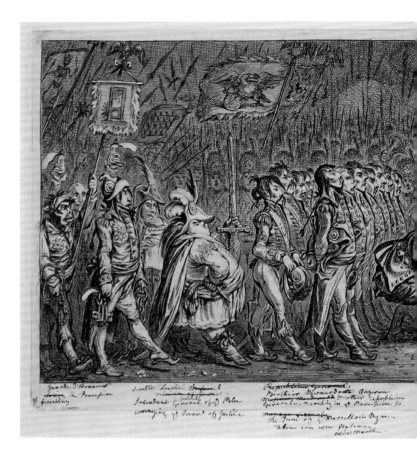

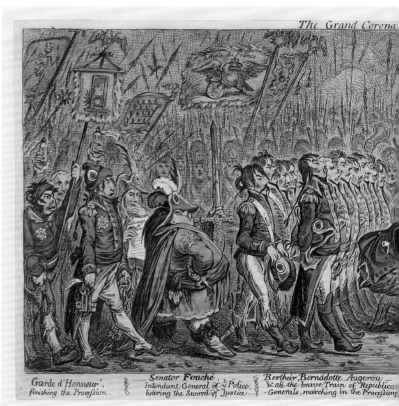

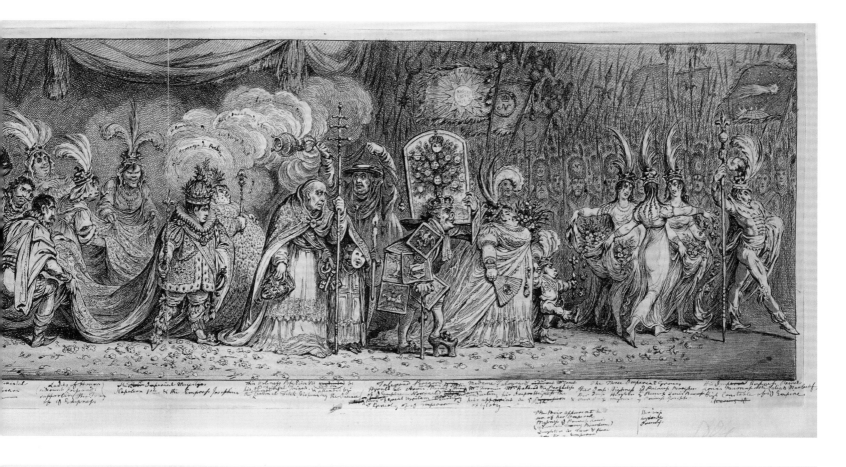

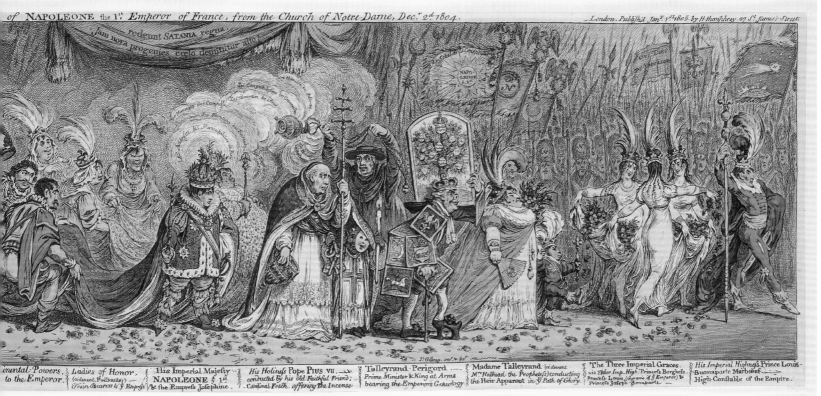

of NAPOLEONE *the* 1.st *Emperor of France, from the Church of Notre Dame, Dec.r 2.d 1804.*

London, Publish'd Jan.y 1.st 1805. by H. Humphrey, 27 St. James's Street.

J.t Gillray. inv.t & fe.t

| imental Powers to the Emperor. | Ladies of Honor. (ci devant, Poissardes) Train Bearers to y.e Empress | His Imperial Majesty NAPOLEONE y.e 1.st & the Empress Josephine. | His Holiness Pope PIUS VII. conducted by his old Faithful Friend; Cardinal Feςh, offering the Incense | Talleyrand - Perigord. Prime Minister & King at Arms bearing the Emperor's Geneology. | Madame Talleyrand. (ci devant M.rs Halhed, the Prophetess) conducting the Heir Apparent in y.e Path of Glory | The Three Imperial Graces. viz Their Imp. High. Princess Borghese Princess Louis (Sister of y.e Emperor) & Princess Joseph Bonaparte. | His Imperial Highness Prince Louis Buonaparte Marbœuf High Constable of the Empire. |

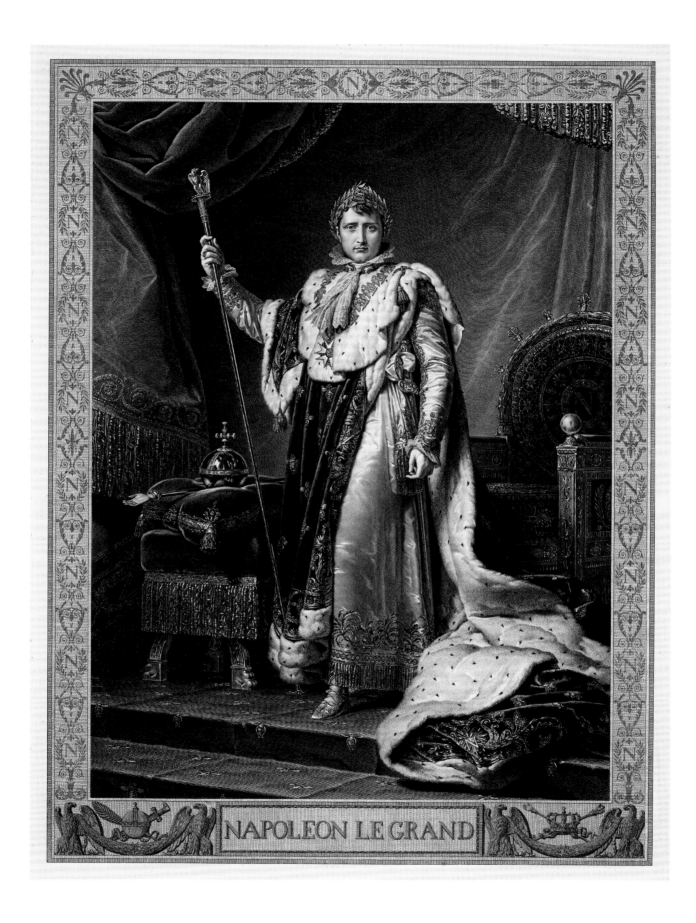

NAPOLEON LE GRAND

84

Auguste Gaspard Louis Boucher Desnoyers (1779–1857)
after François Gérard (1770–1837)
Napoleon le Grand
Plate commissioned by the French government, 1808
Etching and engraving; 687 x 513 mm
1868,0822.943
Bequeathed by Felix Slade

François Gérard was the leading portrait painter of the imperial period and a favourite of Napoleon. His portrait of Napoleon in coronation robes (the main version now at Versailles) was a major propaganda project, echoing, in neo-classical mode, a famous portrait of Louis XVI by Antoine François Callet that had been engraved by Charles Clément Bervic.[1] The emperor's awareness of the importance of employing artists of the highest quality led him to commission this print from the virtuoso engraver Auguste Desnoyers for a fee of 2,000 livres (about £80). After 600 impressions had been printed for the emperor's use, Desnoyers was given the plate and allowed to sell impressions for his own profit. The print was issued in three states for connoisseurs and was exhibited at the Salon of 1808 and again in 1810 and 1812. The present fine impression is a proof before the addition of the names of the artists.

1 British Museum PD 1927,1008.406.

TWO EMPRESSES

Napoleon was married twice: in 1796 to
Josephine de Beauharnais (1763–1814)
and in 1810 to Marie-Louise of Austria
(1791–1847). Josephine was the widow of
an aristocrat guillotined in the Terror;
her two children, Eugène and Hortense
de Beauharnais played important roles
in Napoleon's regime. He divorced her
in 1810 and she died while he was exiled
on Elba; it was said that he spoke her
name on his deathbed. The divorce
allowed Napoleon to marry Marie-Louise,
daughter of Francis I, Emperor of Austria,
and great-niece of Marie Antoinette. This
marriage into the Habsburg dynasty was
clearly intended to give legitimacy to the
French Empire, but the ensuing peace
with Austria lasted for only three years.
On 20 March 1811, Marie-Louise gave
birth to the longed-awaited son, Napoleon
François Charles Joseph. Mother and son
left France after Napoleon's abdication in
April 1814 and did not see him again.

85

Jean François Ribault (1767–1820) after Jean Baptiste
Isabey (1767–1855), Charles Percier (1764–1838) and
Pierre François Léonard Fontaine (1762–1853)
L'Impératrice en petit costume from *Le Sacre de l'empereur
Napoléon*
Commissioned by the French government, 1805
Etching and engraving; 505 x 325 mm
1868,0822.1052
Bequeathed by Felix Slade

By contrast with Gillray's distortions, Josephine
is shown here as a graceful woman (which,
indeed, she was) wearing an elegant gown.
The print is taken from the *Livre du Sacre*, the
sumptuous publication recording Napoleon's
coronation with thirty-eight plates illustrating
the events of the day and the costumes of the
chief participants. Portraits were designed
by Jean Baptiste Isabey, official designer to
the emperor, the architectural elements by
Pierre François Léonard Fontaine and the
refined neo-classical borders by Charles Percier
who together developed the Empire style of

decoration; sixteen leading printmakers worked
on the plates. Work on the publication was
not completed until 1815, by which time the
total cost had risen to 195,000 francs (about
£13,000).[1]

By then Napoleon had abdicated and,
initially at least, only a few books were issued,
but one was purchased by the Prince Regent
in 1816 from the dealer Samuel Woodburn.[2]
The prince would have been thinking about his
own forthcoming coronation; he was eventually
crowned in 1821 with characteristically
extravagant ceremony. Copies in the Royal

Library and in the British Museum[3] have
identical lavish bindings by the famous London
firm of Frederich Leberecht Staggemeier
(1759–1827) of red morocco tooled in gold with
eagles in the centre of each cover, repeating
patterns of capital 'N' inside medallions, and
turn-ins on each cover with bees, another of
Napoleon's symbols.

1 J. Tulard, *Le Sacre de l'empereur Napoléon: histoire et legend*, Paris 2004,
 passim.
2 Book bills of George IV, Royal Archives GEO/28589.
3 Royal Library, 1046682; British Museum PD 1855,0714.71-112.

86

James Gillray (1756–1815)
Ci-devant occupations
Published by Hannah Humphrey,
20 February 1805
Hand-coloured etching;
302 x 450 mm
1851,0901.1162; BM Satires 10369
Presented by William Smith

Propagandists used any means possible to undermine Napoleon's credibility as an emperor, including attacks on Josephine. These had begun in the early days of their marriage when Napoleon was said to be depressed by reports of his wife's infidelity.[1] Josephine's one-time lover Paul Barras, was a prominent member of the Directory who had observed Napoleon's military talent in October 1795 when the young general defeated a Royalist insurrection with what Thomas Carlyle was to call a 'whiff of grapeshot'.[2] Five months later, Napoleon married Josephine before leaving Paris to take command of the Army of Italy.

In this print, published shortly after the coronation, Gillray harks back nearly ten years:

Barras (then in Power) being tired of Josephine, promised Buonaparte a promotion, on condition that he would take her off his hands; – Barras had, as usual, drank freely, & placed Buonaparte behind a Screen, while he amused himself with these two Ladies, who were then his humble dependents, – Madame Talian is a beautiful Woman, tall & elegant; – Josephine is smaller & thin, with bad Teeth, something like Cloves, – it is needless to add that

Buonaparte accepted the Promotion & the Lady, – now, – Empress of France!

The notoriously dissolute Barras is shown as Bacchus watching two maenads dancing, while Bonaparte peers through a transparent curtain. Dorothy George described the print as 'A grossly libellous satire based on the facts of Napoleon's infatuation with Josephine in 1796 when she and Mme Tallien were protegées of Barras, and the command of the Army of Italy which he obtained through Barras as a result of his marriage in 1796.' The beautiful Spaniard, Thérésa Tallien, one of the *merveilleuses* of the 1790s, was renowned for wearing dresses of transparent muslin over the thinnest of chemises, a fashion denounced by Napoleon when he became First Consul. Gillray may also be deliberately recalling the *Attitudes* of Emma Hamilton, another victim of his satire.[3]

1 See p. 78.
2 T. Carlyle, *The French Revolution*, London 1837, chapter 3.7.VII.
3 See British Museum PD 1873,0809.139.

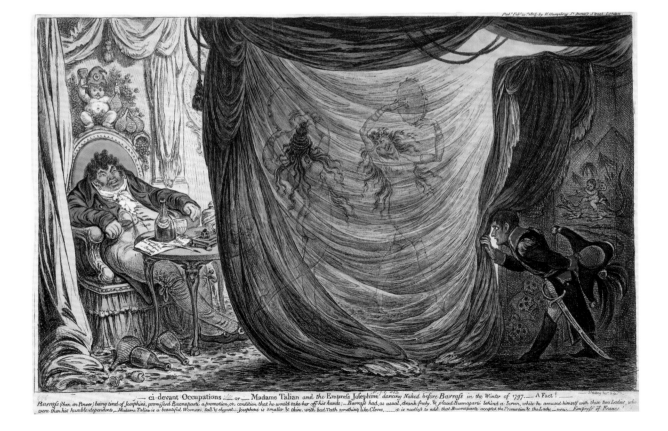

— ci-devant Occupations — or — Madame Talian and the Empress Josephine dancing Naked before Barras in the Winter of 1797.— A Fact !

Barras (then in Power) being tired of Josephine, promised Buonaparte a promotion, on condition, that he would take her off his hands; – Barras had, as usual, drank freely, & placed Buonaparte behind a Screen, while he amused himself with these two Ladies, who were then his humble dependents, – Madame Talian is a beautiful Woman, tall & elegant; – Josephine is smaller & thin, with bad Teeth, something like Cloves, — it is needless to add, that Buonaparte accepted the Promotion & the Lady, – now, – Empress of France!

87

John Roffe (1769–1850) and J.R. Hamble (active
1803–32) after Jean Baptiste Bosio (1769–1845)
and Pierre Paul Prud'hon (1758–1823)
*Maria Louisa, Arch Duchess of Austria, Empress
of France*
Published on 1 March 1811
Stipple and aquatint; 395 x 308 mm
1917,1208.3798; de Vinck 8508
From the collection of Amabel, Lady Lucas; presented
by Nan Ino, Baroness Lucas of Crudwell in memory
of her brother Auberon, Baron Lucas of Crudwell

The statement at the foot of the sheet claiming that this portrait of Marie Louise was based on 'a correct likeness by M. Prudon, Paris, in the possession of Her Grace the Duchess of St Albans' is deceptive. It suggests that the Duchess owned a painting or drawing of the empress by Pierre Paul Prud'hon, one of Napoleon's favoured artists and drawing master to Marie Louise. But Prud'hon did not paint the young empress. This print by John Roffe and J.R. Hamble is based on a larger print published in Milan and Paris. The story is a complicated one that reveals a good deal about the pragmatic world of the print trade.

A series of large portraits of Napoleon, his family and his allies published by the Ubicini brothers in Milan after drawings by Jean Baptiste Bosio, was advertised in the *Moniteur* on 18 April 1810, less than three weeks after the imperial wedding. It would have been essential that Marie Louise's portrait was included in the series. The publishers had relied on the tried and tested solution of having alterations made to an existing plate and a plate with a portrait of Princess Augusta Amalia of Bavaria that had already been made for the series was quickly sent to Paris so that a study of the Empress's head by Prud'hon could replace that of Augusta Amalia.[1] The series evidently sold well; it was certainly available in London – at least five of the prints were in the collection of Amabel, Lady Lucas.

Roffe and Hamble, printmakers who usually worked for others, clearly believed that the demand in Britain for likenesses of Marie Louise made it worth investing in publishing a portrait themselves. They must have persuaded Louisa Grace Manners, Duchess of St Albans to allow them to copy an impression of the Ubicini print that she owned and to use her name, so that the association with a prominent society figure, as well as the reference to Prud'hon, would add veracity to their portrait.

1 See British Museum PD 1925,1215.52 and 1925,1215.16.

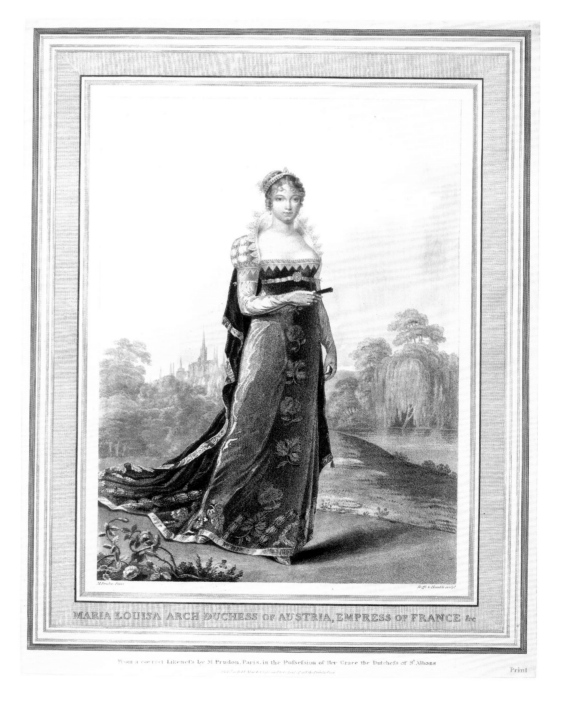

MARIA LOUISA ARCH DUCHESS OF AUSTRIA, EMPRESS OF FRANCE &c

From a correct Likeness by M. Prudon, Paris, in the Possession of Her Grace the Dutchess of St. Albans

Print

88

Thomas Rowlandson (1757–1827)
Nursing the Spawn of a Tyrant
Published by Thomas Tegg, 14 April 1811
Hand-coloured etching; 333 x 231 mm
1935,0522.12.47; BM Satires 11721

Marie Louise shrinks from her baby son, a
miniature version of his father who peeps from
behind a curtain on the right. The boy threatens
his mother with a dagger and is about to the
throw the orb at her. In her alarm she has
overturned his commode and a dish of food.
She complains: 'There's no Condition sure so
curst as mine – Day and Night to dandle such a
Dragon … the very spawn and spit of its Tyrant
Father – Nay now I look again he is the very
Picture of his Grandfather the Devil'. On the
left appears the head of a bishop who offers a
chalice inscribed 'Composing Draught' that is:
laudanum. This suggestion of helping the young
Napoleon to a permanent sleep is backed up by
the figure beside him who suggests: 'Send him
to his Grand Pappa as quick as possible'.

The print was clearly produced quickly so
that Tegg could catch the market with a print
of the newborn heir. There is no attempt at an
accurate portrayal of the young empress. She
is simply a typical Rowlandson young woman:
plump, pretty and innocently alarmed by the
situation in which she finds herself. There is
no comparison with Gillray's imaginative, and
cruel, images of Josephine and other women.

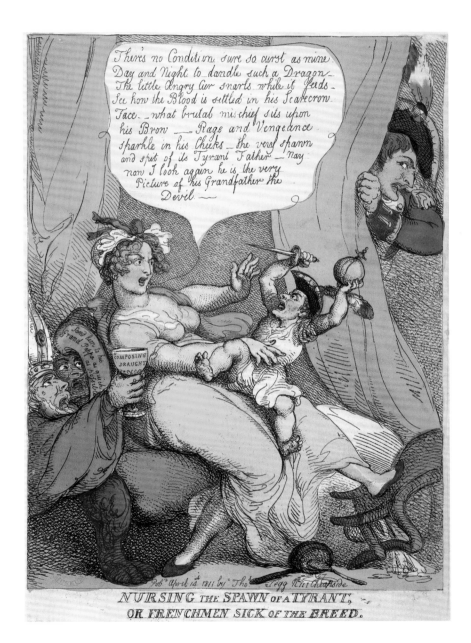

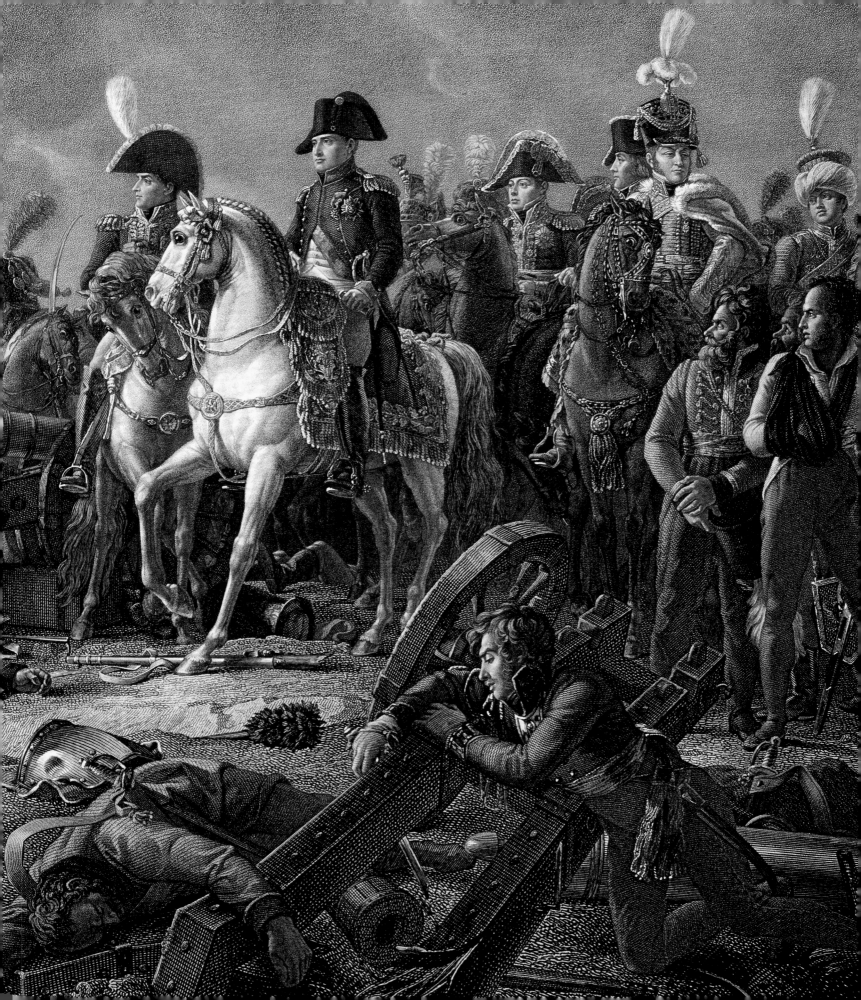

6

Trafalgar and Austerlitz: triumph and disaster

When war began again in May 1803, Britain was fighting Napoleon alone. A French army was camped at Boulogne and on 16 August 1804 Napoleon held his largest military festival there, distributing eagles to his regiments and 2,000 crosses of the *Légion d'honneur* (see cats 137 and 160). The Continental powers were suspicious of Britain's commercial and colonial ambitions and 'feared that London was prepared to shed their blood in a war to secure a monopoly in the Americas and India', a view fostered by Napoleon's propaganda.[1]

An undeclared British attack on frigates carrying bullion and civilians from America to Spain in September 1804 forced Spain into war against Britain. This doubled the size of Napoleon's fleet and sharpened British fears of invasion. On 26 May 1805 he crowned himself King of Italy, previously an Austrian sphere, using the Iron Crown of Lombardy and the trappings of Charlemagne. By August, Sweden, Russia, Austria and Naples were allied with Britain in a third coalition against France, Spain and their allies.

Hearing of Austrian preparations for war, and aware that the Russians would be joining forces, Napoleon broke up the camp at Boulogne on 24 August to march east. His army crossed the Rhine on 25 September. In July, the Franco–Spanish fleet had tried and failed to gain control of the Channel by decoying Nelson's navy to the West Indies; in October it left Cadiz to support a French attack on Naples, and off Cape Trafalgar it encountered Nelson's fleet.

1 Forrest 2011, p. 180.

89

James Gillray (1756–1815)
The Plumb-pudding in Danger
Published by Hannah Humphrey, 26 February 1805
Hand-coloured etching; 261 x 363 mm
1851,0901.1164; BM Satires 10371
Presented by William Smith

In this most famous image of Britain's war with France two greedy politicians, Pitt and Napoleon, carve up the globe. It is uncertain whether Gillray's government pension was renewed between 1804 and 1806, but his view here is unexpectedly even-handed. The treatment of Pitt appears to take account of the French view that while keeping the French busy in Europe the British were intent on colonial empire and a monopoly of world trade. The hungry prime minister surreptitiously carves himself almost half of the globe, including the lucrative West Indies and the Atlantic Ocean. Napoleon, with his fork in George III's Hanover, slices off most of Europe.

On 2 January 1805, Napoleon had made another offer of peace to George III, suggesting that 'your Majesty has gained more in ten years than the whole extent of Europe … the world is sufficiently large for our two nations to live in'. Pitt and the king, already trying to form an alliance with Russia against France, publicly rejected the idea as incompatible with 'the safety and independence of Europe'.[1] Gillray's conclusion in this print is that both men threaten the world with their insatiable appetites. His depiction of political greed is made timeless through evocation of Shakespeare's *The Tempest*, where the magician Prospero reveals all mortal ambition to be an illusion that will disappear like his spell:

> Our revels now are ended …
> The cloud-capp'd towers, the gorgeous palaces,
> The solemn temples, the great globe itself,
> Yea all which it inherit, shall dissolve
> And, like this insubstantial pageant faded,
> Leave not a rack behind.

Gillray refers to 'W-d-m's eccentricities, in ye Political Register.' William Windham, a Whig who had turned early against the French Revolution, was strongly in favour of 'eternal war'. In 1802 he had financed the founding of Cobbett's *Political Register* (see p. 204).

1 King's speech to Parliament, 13 January 1805. Cobbett 1802–36,
 VII (1805), p. 257.

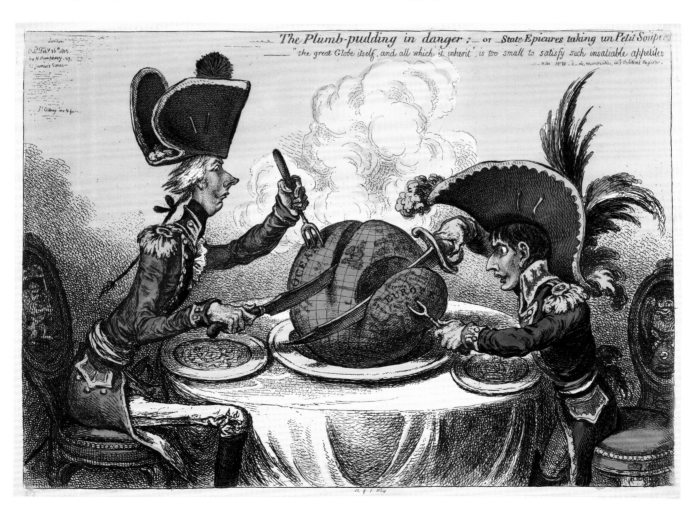

90

William Bromley (1769–1842) after
Arthur William Devis (1762–1822)

The Death of Nelson

Published by Boydell & Co, 1812

Etching, engraving and stipple;
500 x 620 mm

1917,1208.4601

From the collection of Amabel,
Lady Lucas; presented by Nan
Ino, Baroness Lucas of Crudwell
in memory of her brother Auberon,
Baron Lucas of Crudwell

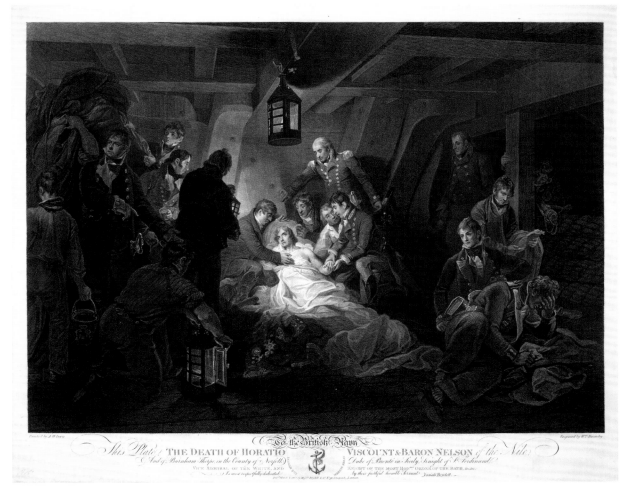

Off Cape Trafalgar in southern Spain on 21 October 1805, Nelson led his ships into battle against the combined Franco–Spanish fleet. He paid no regard to his own safety and within an hour a shot from a French sniper entered his left shoulder, shattering his spine. He was taken below and died three hours later, aware that he had won a significant victory. In fact the battle, and particularly the terrible storm that followed it, almost annihilated the French and Spanish fleets. Nelson's body was brought back to England for a state funeral.

Arthur William Devis, a bankrupt but highly ambitious painter, determined to win the prize of £500 offered by the print-publisher Josiah Boydell for the best representation of the hero's death. Devis joined the *Victory* when it returned to Portsmouth in December, and made studies of Nelson's body and of those who had been present as he lay dying. The portraits of the grieving sailors and officers were regarded as evidence of the veracity of the scene and a separate key, in which they were all named, was issued with the print.[1] An oil-sketch of the composition (now in the Royal Collection) was displayed at Josiah Boydell's showroom in Cheapside in 1807; the finished painting (now in the

Royal Museums Greenwich) was exhibited at the British Institution in 1809. Joseph Farington recorded in his diary on 4 December 1806 that Boydell had told him that Luigi Schiavonetti had offered to engrave the picture in three years for a fee of £1,500, and furthermore, since his health was poor, he would want to take the picture to France; 'this unreasonable & unsafe proposal Boydell rejected, and has since entered into an agreement with Bromley, the engraver, who is to undertake it, & to finish it in two years for £800'. The print – a virtuoso combination of etching, engraving and stipple with each head an expressive portrait – was not finished until 1812. In the description published with the key to the portraits, Boydell countered objections to the realism of the scene and the lack of 'epic representation' (a complaint by Benjamin West who had also painted the scene): he claimed that 'Mr Devis has adopted the plan of making Truth alone the object of his delineation; and has, consequently, depicted this awful scene, with respect to time, place, and persons present, exactly as it occurred.'

1 British Museum 1917,1208.4602.

91

Anonymous

Neptune Supporting his Favorite Son Admiral Lord Nelson

Published by Stampa & Son,
14 March 1806

Hand-coloured mezzotint;
255 x 352 mm

2010,7081.3048

One of 7,763 mezzotints purchased from the collection of the Hon. Christopher Lennox-Boyd with the assistance of the National Heritage Memorial Fund, the Friends of the British Museum, the Art Fund, the Friends of Prints and Drawings, Mrs Charles Wrightsman, the Michael Marks Charitable Trust, and numerous individual donors

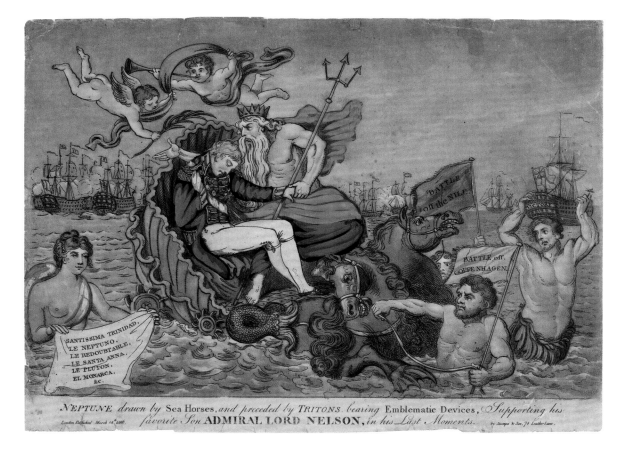

NEPTUNE *drawn by* Sea Horses, *and preceded by* TRITONS *bearing* Emblematic Devices, *Supporting his favorite Son* ADMIRAL LORD NELSON, *in his Last Moments.*

The nation was united in mourning the death of Nelson. The Royal Navy protected Britain from invasion and kept open trade routes on which prosperity relied; the jovial, brave sailor was a popular hero and Nelson was the sailor's idol. Memorials were produced for all levels of society, including many thousands of prints. This is an example of a genre that had been in fashion for the last three decades of the previous century: cheap mezzotints, known as 'posture prints' from their size, around 10 x 14 inches, and sold for 1*s*. plain, or 2*s*. highly coloured like this example.[1] Publishers dealing with this sort of material usually produced prints that would remain saleable for many years and so avoided topical subjects, but the huge market for prints of Nelson meant that even a small publisher could take a calculated risk that the subject would sell; in fact the Stampa family of Holborn produced several different posture prints of Nelson. They were wholesale carvers and gilders selling frames and mirrors for export as well as cheap prints and would have had access to the broadest decorative market. Here classical mythology is combined with contemporary references – Neptune supports the dying admiral while nymphs and tritons carry his ship the *Victory* and banners lettered with the names of his triumphs at the battles of the Nile (1798) and Copenhagen (1801), and of Spanish and French ships defeated at Trafalgar.

1 S. O'Connell, 'Humorous, Historical and Miscellaneous: Mezzotints, One Shilling Plain, Two Shillings Coloured', in *Publishing History* 70, 2011, pp. 83–100.

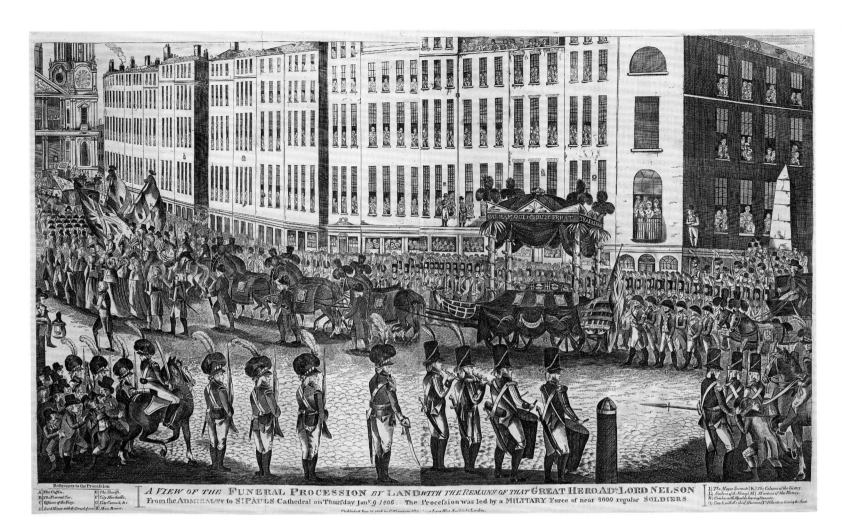

A VIEW OF THE FUNERAL PROCESSION *BY LAND WITH THE REMAINS OF THAT* GREAT HERO AD.L LORD NELSON
From the ADMIRALTY to S.t PAULS Cathedral on Thursday Jan.y.9.1806. The Procession was led by a MILITARY Force of near 8000 regular SOLDIERS

References to the Procession
A The Coffin. E The Sheriff.
B The Funeral Car. F City Marshalls.
C Officers of the Navy. G City Council, &c.
D Lord Mayor with the Sword of state H Mens Bearers.

I The Mayor Servants K The Colours of the Victory.
L Sailors of the Victory M Marines of the Victory.
N Coaches with the Royals bearing Banners.
O Coach with the chief Mourners M.r Felton late bearing the Sword.

Published June 27 1806 by G.t Thompson N.o ...Lane West Smithfield London.

92

Anonymous
The Funeral Procession of that Great Hero Admiral Lord Nelson
Published by George Thompson, 27 June 1806
Etching; 595 x 945 mm
1865,0114.741

Large prints are vulnerable to damage and this is a rare example of a two-sheet print produced for the cheaper end of the market. It was a pair to a print showing the funeral procession by water, published by George Thompson three months earlier on 27 March 1806.[1] It would have retailed for about a shilling, probably finding a place on the walls of taverns where sailors went to toast Nelson, their departed hero. Coarse, deeply bitten etchings of this type had taken over from traditional large woodcuts in the 1790s. They could be produced quickly to catch widespread interest in current events such as Nelson's funeral and were produced in large numbers by mass-market City of London publishers like George Thompson, and John and Thomas Evans, his neighbours in Long Lane, Smithfield, or John Marshall of Aldermary Churchyard. The funeral carriage was designed by the printseller Rudolph Ackermann who had been trained as a coachmaker.

1 Royal Museums Greenwich, PAH7325.

93

Anonymous

Ticket for the funeral of Lord Nelson, 1806

Etching with engraving; 152 x 171 mm

C.2,1832

From the collection of Sarah Sophia Banks

This ticket for a place in Nelson's funeral procession from the Admiralty in Whitehall to St Paul's Cathedral is made out to Charles Burney (1757–1817), the classical scholar and master of a school in Greenwich where he taught many future naval officers. Burney's sister, the novelist Fanny Burney, lived in Paris from 1801–15 with her aristocratic French husband, General Alexandre D'Arblay, a soldier who accepted Bonaparte's invitation to émigrés to return to France, as nearly all of them did, and in 1815 she was in Brussels at the time of the battle of Waterloo.[1]

The funeral ticket comes from the collection of 17,000 pieces of printed ephemera collected by Sarah Banks (1744–1818), the well-connected sister of the great naturalist Joseph Banks. They give glimpses of late Georgian daily life for an upper middle-class lady – invitations to balls and card-games, advertisements for auction-sales and menageries, tickets for sermons and state trials, bills from goldsmiths, milliners and coal-merchants.

[1] See P. Hughes et al. (eds), *The Journals and Letters of Fanny Burney (Madame D'Arblay)*, vol. VIII, 1815, Oxford 1980.

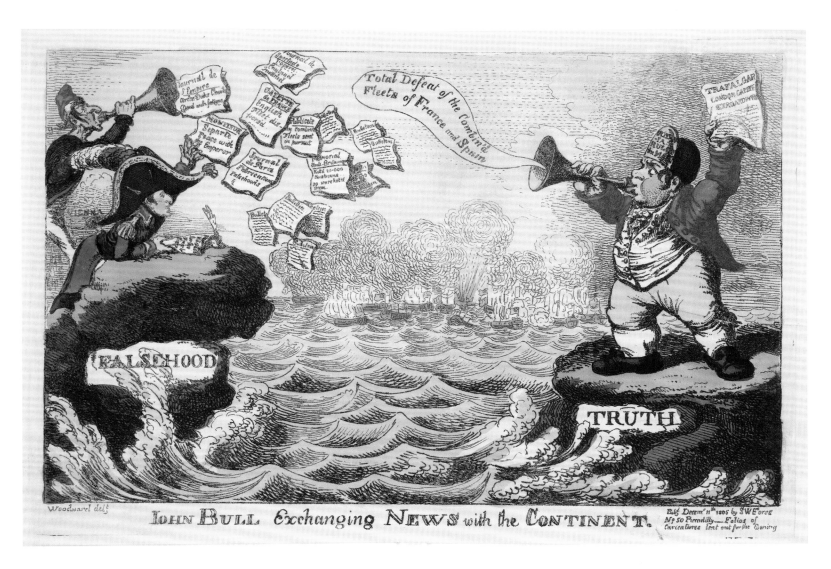

Total Defeat of the Combin'd Fleets of France and Spain

FALSEHOOD

TRUTH

JOHN BULL Exchanging NEWS with the CONTINENT.

94

Charles Williams (active 1797–1830)
after George Murgatroyd Woodward
(c. 1760–1809)
John Bull Exchanging News with the Continent
Published by Samuel William Fores,
11 December 1805
Hand-coloured etching;
236 × 356 mm
1868,0808.7398; BM Satires 10441
From the collection of
Edward Hawkins

Napoleon is here contrasted with John Bull, the archetypal Englishman. They face each other across the Channel, broadcasting war news. Napoleon leans against a rock lettered 'Falsehood', scattering his bulletins and official newspapers: the *Moniteur*, *Journal de Paris*, *Gazette de France*. The towers of a defeated Vienna appear behind him as he announces a peace treaty with the Austrian emperor, the death of Archduke Charles of Austria, the dispersal of the English Fleet pursued by those of France and Spain, and the invasion of England. On a rock labelled 'Truth' stands John Bull as a plump newsboy, his cap inscribed 'Britannia rules the Main', trumpeting the 'Total Defeat of the Combin'd Fleets

of France and Spain' as he holds up the *Trafalgar London Gazette Extraordinary*.

Reality was less clear-cut than suggested. The major claim by the Napoleon figure in the print was true: the French army had defeated the combined forces of Austria and Russia at Austerlitz and – although news did not reach London until after the publication of this print – Emperor Francis I had agreed peace terms. However, Archduke Charles was not dead, the English fleet was not dispersed and England was not invaded; the Royal Navy had triumphed at Trafalgar, and Britain continued to 'rule the waves'. But Napoleon now ruled the European mainland.

THE MILITARY TRIUMPH OF NAPOLEON

Napoleon's lightning campaign forced an Austrian army to surrender at Ulm on 19 October 1805 and he took Vienna. At Austerlitz on 2 December, he destroyed a combined Austro–Russian army in what has generally been regarded as his most brilliant victory. Austria was out of the war.

Britain figured in this campaign as a significant paymaster. It was a role that infuriated Napoleon and he did his best to persuade Europeans that the British liked to fight Continental wars by proxy while enriching themselves elsewhere. Britain's funding of the war effort was a constant refrain of French propaganda: many satires featured an Englishman with money bags. In his proclamation to the French Army on 29 September 1805, Napoleon called upon his soldiers 'to confound and dissolve this new league which has been formed by the hatred and the gold of England'.[1] René-Jean Durdent's *Austerlitz, ou l'Europe préservée des Barbares* published shortly after the battle put French animosity in poetic terms:

> But will this peace suit England's greed?
> For she buys princes, telling them to bleed
> And in her cunning follows up their soldiers
> With dark plots and fiendish murders.[2]

After the defeat of Austria Napoleon created the Confederation of the Rhine, a series of client states that formed a buffer between France and Austria and Prussia. Hanover became a matter of contention because George III desperately wanted to recover his ancestral domain. In less than a year Prussia, Russia and Britain formed a fourth coalition and mobilized. Napoleon struck, shattering the Prussian armies at Jena and Auerstädt and seizing Berlin on 25 October 1806. After a series of defeats Tsar Alexander changed sides and the treaty of Tilsit, signed on 7 July 1807, committed Russia to helping Napoleon in an economic war against Britain. British goods were to be excluded from Europe.

1 Published in translation in *The Gentleman's Magazine*, October 1805, p. 963.
2 R.J. Durdent, *Austerlitz (1806)* from Bertaud 2006, p. 213.

95
John Godefroy (1771–1839) after
François Gérard (1770–1837)
Bataille d'Austerlitz
Published by John Godefroy,
27 September 1813
Etching and engraving with stipple;
507 x 947 mm
1917,1208.3970; IFF 23
From the collection of Amabel,
Lady Lucas; presented by Nan
Ino, Baroness Lucas of Crudwell
in memory of her brother Auberon,
Baron Lucas of Crudwell

Austerlitz was considered Napoleon's most glorious victory and both the painting and the engraving of it had the highest importance set upon them. The painting was commissioned from François Gérard by Napoleon in March 1806 who, through Dominique Vivant Denon, gave him a series of instructions on its content.[1] It was to be ready for the Salon of 1808 and was destined for the ceiling of the room in which the Council of State met; it is now at Versailles. General Rapp is shown presenting the Russian commander Prince Nikolai Grigorievitch Repnine and 800 noble prisoners from the Russian Imperial Guard, together with captured standards and cannon. Napoleon insisted on immortalizing the *chasseur-à-cheval* on the left who galloped up to present the emperor with the flag he had just captured and then dropped dead at his feet. Denon wrote to Gérard on

2 November 1806 with a portrait of Rapp and some details about his costume and of what Gérard was to paint. One of his instructions was to 'put much magnificence into the costumes of the emperor's entourage, so as to contrast with the simplicity that he affects'.[2]

The painting was exhibited in an unfinished state in 1808, but at the Salon of 1810 it caused a sensation. Godefroy began work on the engraving in 1811 and exhibited it, unfinished in etched state, at the Salon of 1812. Not only did he employ an English style of engraving that he had learned from Peter Simon (c. 1764–1813) in London (Simon, also known as Jean Pierre, settled in France in 1802 and also produced portraits of Napoleon and his circle[3]), he also marketed the print English-style, issuing a series of proofs in various stages of completion and selling by subscription with the price raised for non-subscribers. The French government subscribed for 100 impressions and Paul Colnaghi had one on display in his London shop, from which Amabel, Lady Lucas bought most of her prints. A second edition was printed during the Hundred Days in 1815. After the restoration, Godefroy was warned that the authorities intended to seize and destroy the plate but this threat was averted, as an English review published in 1817 confirmed:

A fine engraving in a mixed style of line and dot, from one of the best commemorations of a battle that has been painted since Le Brun; by an Englishman, whose real name is Godfrey, formerly a pupil in London of Simons who was employed on Boydell's Shakespeare and other large plates. The excellence of the plate has obtained him permission from the present Government of France to sell them without restriction.[4]

A third edition was published in 1824.[5]

1 Denon to Gérard, Paris, 27 March 1806 in *Archives de l'Art Français*, II, 1852, pp. 185–6.
2 Denon to Gérard, Berlin, 2 November 1806 in *Archives de l'Art Français*, III, 1853, p. 144.
3 V. Meyer, 'Jean Pierre Simon, un graveur anglais à Paris sous le Consulat et l'Empire', in *Bulletin de la Société d'Histoire de l'Art Français*, 2001, pp. 167–93.
4 J. Elmes in *Annals of the Fine Arts*, I, 1817, p. 339.
5 For a key to this print, see British Museum PD 1917-12-8-3071; V. Meyer 2005, pp. 80–109.

BATAILLE D'AUSTERLITZ.

96

Anonymous

François II partant pour la guerre

Published by Aaron Martinet, 1805

Hand-coloured etching and aquatint; 210 x 262 mm

1868,0808.6905; BM Satires 9554; de Vinck 8058

From the collection of Edward Hawkins

97

Anonymous

François II revenant de la guerre

Published by Aaron Martinet, 1805

Hand-coloured etching and aquatint; 197 x 266 mm

1868,0808.6906; BM Satires 9555; de Vinck 8059;

From the collection of Edward Hawkins

FRANÇOIS II. PARTANT POUR LA GUERRE,

reçoit du peuple Anglais, le prix du sang de ses sujets.

A Paris chez Martinet, Rue du Coq

The bag of gold destined for Sweden establishes that this print refers to the Third Coalition of allied powers against France and the campaign of 1805, while the impression at the Musée Carnavalet of the first print is dated August 1805. Sweden had remained neutral with a pro-French bias until December 1804, when the execution of the Duke of Enghien inspired King Gustav to join the ranks of Napoleon's opponents, formally joining the Third Coalition in August 1805, along with Russia, Austria and Naples. These prints may have been the direct result of Napoleon's instruction to Joseph Fouché, his Minister of Police, in a letter of 30 May 1805: 'Have caricatures made – an Englishman purse in hand, entreating the various powers to take his money, etc. That is the real direction to give this business; and the great attention that the English give to gaining time by spreading false news, all these indications together must be understood as of extreme importance.'[1] The latter sentence about English fabrications demonstrates that British complaints over Napoleon's false reports (cat. 94) were reciprocated.

The central character in each print is John Bull, as seen through French eyes: an untidy boor who believes that he can pay others to fight his wars while he gorges at the table. In the first print the elegant Austrian emperor is the unfortunate recipient of a bag of British cash to fund his army, while other money bags are prepared for the rulers of Russia and Sweden. Pitt peeps through a curtain, confident that Continental armies will preserve British commerce. In the second print, the emperor returns wounded and defeated; John Bull greets him with disdain and Pitt despairs.

FRANÇOIS II. REVENANT DE LA GUERRE

demande sa solde de retraite au peuple Anglais.

A Paris chez Martinet, Rue du Coq.

1 Lecestre 1897, I, p. 51.

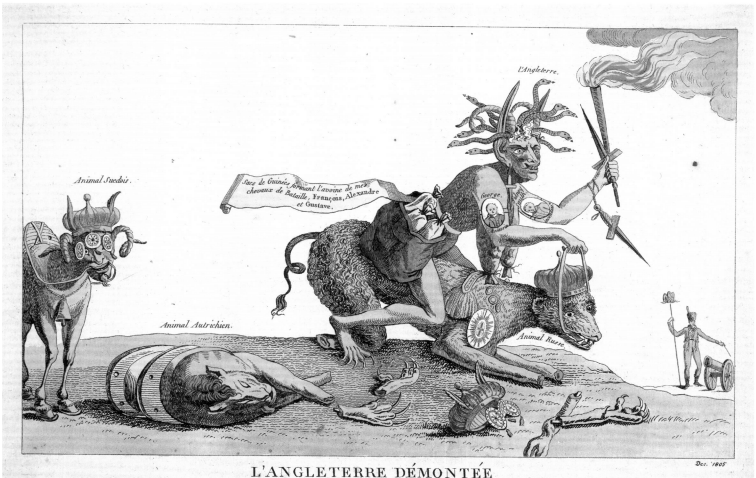

L'ANGLETERRE DÉMONTÉE

Par la perte de ses deux meilleurs chevaux de Bataille, François II.^e et Alexandre I.^{er}. – L'Animal Autrichien François 2 tient un peu du chien et l'animal Russe tient a la fois de l'ours
et du cochon. Les mamelles de l'Angleterre sont formées par 2 sacs remplis de Guinées qu'elle est toujours prête a offrir à tous les traitres, à tous les assassins et à tous les incendiaires.
Se vend à Paris, rue J. J. Rousseau, N.^o 10 en face l'Hôtel des Postes.

98

Anonymous

L'Angleterre démontée

Published by Charles Bance,
December 1805

Hand-coloured etching and aquatint;
264 x 381 mm

1868,0808.7399; BM Satires 10451;
de Vinck 8068;

From the collection of Edward Hawkins

A warlike monster representing England rides a grotesque and injured Russian bear. Money bags at the monster's waist are labelled with the names of the emperors of Austria and Russia and the king of Sweden. On her arms are portraits of Georges Cadoudal, guillotined in 1804 for leading the conspiracy to assassinate Napoleon, and Sidney Smith, a hated adversary, in both open and covert operations, since 1793 when he had been responsible for setting fire to the French fleet at Toulon where Napoleon as a young artillery captain was besieging Royalist rebels and foreign troops.

A dead horse in the foreground represents Austria, defeated at Austerlitz. Another grotesque animal (Sweden) stands to one side: a Swedish expedition was planned to liberate Hanover and the Netherlands but Prussian reluctance to allow the troops to cross their territory delayed their advance on Hanover.

99

Dominque (?) Leleu (active 1780s–1800s)

Rêve de Pitt

Published by Aaron Martinet, 12 December 1805

Hand-coloured etching and aquatint; 248 x 332 mm

BM Satires 10520; de Vinck 8062

1868,0808.7400

From the collection of Edward Hawkins

RÊVE DE PITT.

A. *Bravo compere François.*

B. *Courage Milord ; Il aime qu'on le berce.*

C. *Chût.... Il fait quelque beau Rêve.*

Impressions of these prints were deposited at the *Dépôt légal des estampes* by the printmaker L.D. Leleu (probably Dominique Leleu of 20 rue du Bouley who exhibited a drawing at the Salon of 1801) on 12 December 1805, and the *Journal de Paris* of 16 December remarked on their impact in Martinet's shop window:

> Two new caricatures excite the curiosity of passers-by and stop them at the door of M. Martinet, rue du Coq-Saint-Honoré. The first shows Mr. Pitt, cradled by his supporters, and dreaming that he is a puppet master, directing the show as he wishes. In the second John Bull (the English people) has just learned of the success of the French grande armée. In his fury, he wakes Pitt who sees on opening his eyes the list of victories of the Emperor NAPOLEON; the terror he displays, the discomfiture of his accomplices, the confusion that this news causes, make this scene a comic picture worthy of the pencil of Callot.

Pitt's shock and distress at the news of Austerlitz appears to have been too much for his poor state of health: he died little more than a month later, aged only forty-six, on 23 January 1806.

100
Dominique (?) Leleu (active 1780s–1800s)
Reveil de Pitt
Published by Aaron Martinet, 12 December 1805
Hand-coloured etching and aquatint; 244 x 337 mm
BM Satires 10521; de Vinck 8063
1868,0808.7401
From the collection of Edward Hawkins

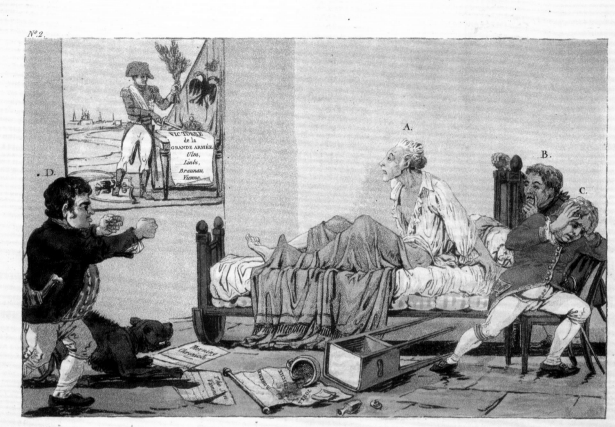

101

James Gillray (1756–1815)
Tiddy-Doll, the Great French-Gingerbread-Baker
Published by Hannah Humphrey,
23 January 1806
Hand-coloured etching;
257 x 377 mm
1868,0808.7410; BM Satires 10518
From the collection of
Edward Hawkins

Gillray portrays Napoleon as Tiddy Doll Ford, the famous London gingerbread-seller conspicuous in Plate 11 of Hogarth's *Industry and Idleness*. It is typical of Gillray to draw in his audience with a well-remembered character, and particularly one familiar through prints. The gingerbread men whom Napoleon is creating in his oven fuelled by cannon balls – that is, after his success at Austerlitz – are the new kings (previously electors) of Bavaria and Würtemberg, and the Grand Duke (previously Margrave) of Baden, former allies of the Austrian emperor, now subservient to France. On the left, Talleyrand ('hopping Talley' identified by his club foot as well as by a bishop's mitre and robes – he was briefly Bishop of Autun before being excommunicated in 1791) kneads the dough to which Napoleon will next turn his attention: 'Hungary', 'Poland', 'Turkey'. 'Hanover' is already being devoured by an eagle representing Prussia whose troops had just marched in at Napoleon's invitation. On the right is a chest on which 'little dough viceroys' wait to be baked. They are British Opposition politicians, including Fox and Sheridan, looking forward to preferment from Napoleon. In the ash-hole beneath the oven is piled the debris of fallen European states, including the 'Republique Francois' now the Napoleonic Empire. In the foreground a basket is full of 'True Corsican [gingerbread] Kinglings for Home Consumption & Exportation'. Gillray here foretells the advancement of Napoleon's family: his brother Joseph became King of Naples the following March, Louis became King of Holland in June, Jerome King of Westphalia in July 1807; his sister Elisa was already Princess of Piombino, Caroline would shortly become Grand-Duchess of Berg, and Pauline, Princess Borghese; his uncle Joseph Fesch had become a Cardinal in 1803. As a reward for dealing with diplomatic complexities after Austerlitz, Talleyrand was made Prince of Benevento in June 1806.

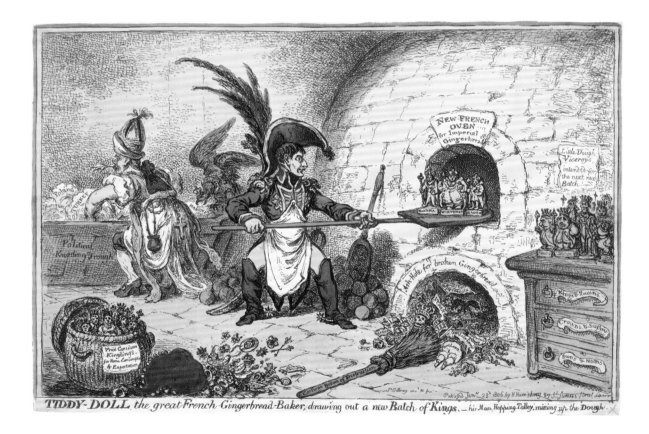

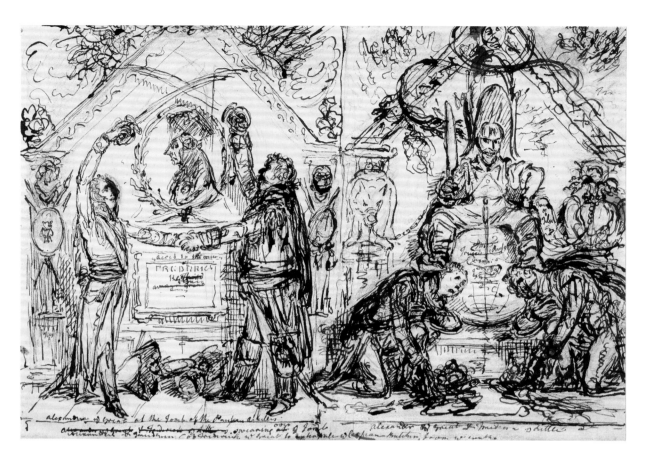

102

James Gillray (1756–1815)
Monuments of Truth and Honour
July–August 1807
Pen and ink with red chalk;
232 x 334 mm
1906,1016.16; BM Satires 10755

This fine example of Gillray's dynamic draughtsmanship is one of two studies for a print that was never published; the other, from which the title is taken, is in the Curzon collection at the Bodleian Library.[1] On the left, Tsar Alexander and King Frederick William III of Prussia stand at the tomb of Frederick the Great and swear 'to extirpate ye Corsican Butcher from ye earth'. The oath took place on the night of 5 November 1805 and famously Queen Louise of Prussia had been present, urging her uncertain husband towards war. In less than a month the Russian army was defeated at Austerlitz. The following October, Napoleon's forces overpowered the Prussians at Auerstädt and occupied Berlin. They advanced towards Russia and won another famous victory at Friedland in June 1807. The right-hand part of the drawing depicts Gillray's view of the state of affairs after Alexander and Frederick William signed the Treaties of Tilsit on 7 and 9 July: Napoleon, portrayed as a truculent young thug, sits astride the globe, his feet resting on the heads of the kneeling sovereigns and holding a Treaty in his hand.

Why did Gillray not make a print after working out his design in two drawings? The reason may be that his patron George Canning, since March 1807 Foreign Secretary, did not wish him to publish a print so offensive not only to Napoleon, but also to Prussia and Russia, who were potential allies; according to Cobbett, Canning arranged for Gillray's pension to be renewed in 1807.[2] But the reason may be more personal. Gillray was seriously unwell at this period and during August took a room in Margate for the sake of his health: he may not have had time to etch the plate before being taken ill. His career was coming to an end with failing eyesight, and perhaps already the beginnings of the mental collapse that overtook him by 1810.

1 Oxford, Bodleian Library, Curzon.b.4/164.
2 Cobbett 1802–3, 30 May 1818, p. 626.

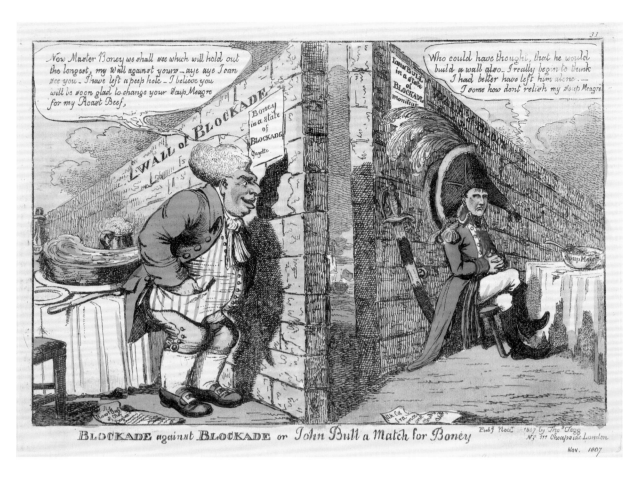

BLOCKADE against BLOCKADE or John Bull a Match for Boney

103

Charles Williams (active 1797–1830)
Blockade Against Blockade
Published by Thomas Tegg,
November 1807
Hand-coloured etching; 248 x 347 mm
1868,0808.7603; BM Satires 10773
From the collection of Edward Hawkins

This is a version of a long-standing stereotype dating back at least to Hogarth's *Calais Gate* of 1749: the hungry Frenchman with his meagre bowl of soup is contrasted with the Englishman (John Bull) enjoying plentiful roast beef. Here the anxious Frenchman is Napoleon who leans against the 'wall of Blockade'; John Bull believes that the wooden walls of the Royal Navy will prevail and Napoleon will be the loser.

British naval power after Trafalgar allowed the British government to commence economic warfare in May 1806 by blockading the French coasts. Napoleon escalated the process, issuing a decree on 21 November forbidding European states to trade with Britain; Britain in turn claimed the right to seize ships trading with France. States were bullied into compliance by one side or the other. When neutral Denmark refused an offer of alliance in 1807, British forces burned Copenhagen and forced the surrender of the Danish fleet. Portugal, a British ally, refused to comply with Napoleon's demands and in 1807 the French army invaded, thus triggering the lengthy Peninsular War. The effect on Britain was not as significant as the damage to the economies of French allies and neutral countries and, in the long term, to Napoleon's ambitions. British merchants simply found different markets, notably in Spanish and Portuguese America.

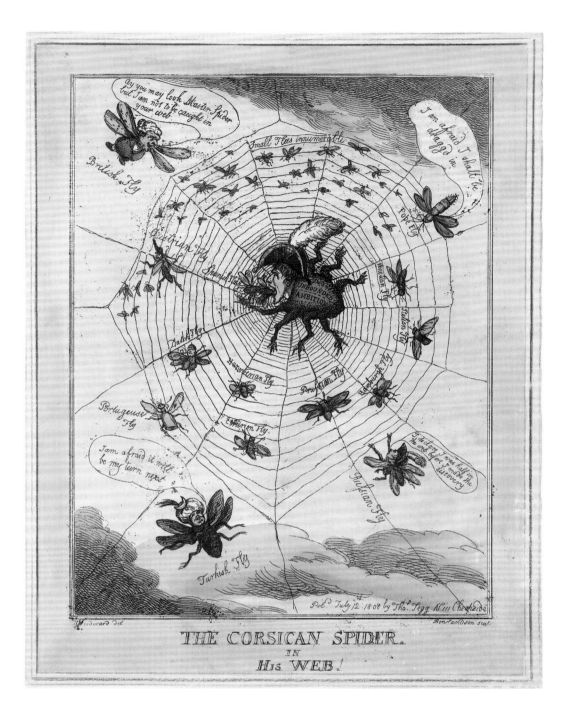

104

Thomas Rowlandson (1757–1827)
after George Murgatroyd Woodward
(c. 1760–1809)
The Corsican Spider in his Web
Published by Thomas Tegg,
12 July 1808
Hand-coloured etching;
345 x 270 mm
1868,0808.7652; BM Satires 10999
From the collection of Edward
Hawkins

The output of graphic satires on the war was limited during
the most severe period of the blockade from 1807–8. This print
suggests the anxiety that must have been felt in Britain, isolated
almost entirely from continental Europe and with Napoleon's
power apparently invincible. The emperor is a spider in the centre
of a web in which the European states are caught or into which
they are about to fly. The 'Turkish Fly' is afraid that 'it will be my
turn next', but John Bull still flies free, 'Ay you may look Master
Spider but I am not to be caught in your web'.

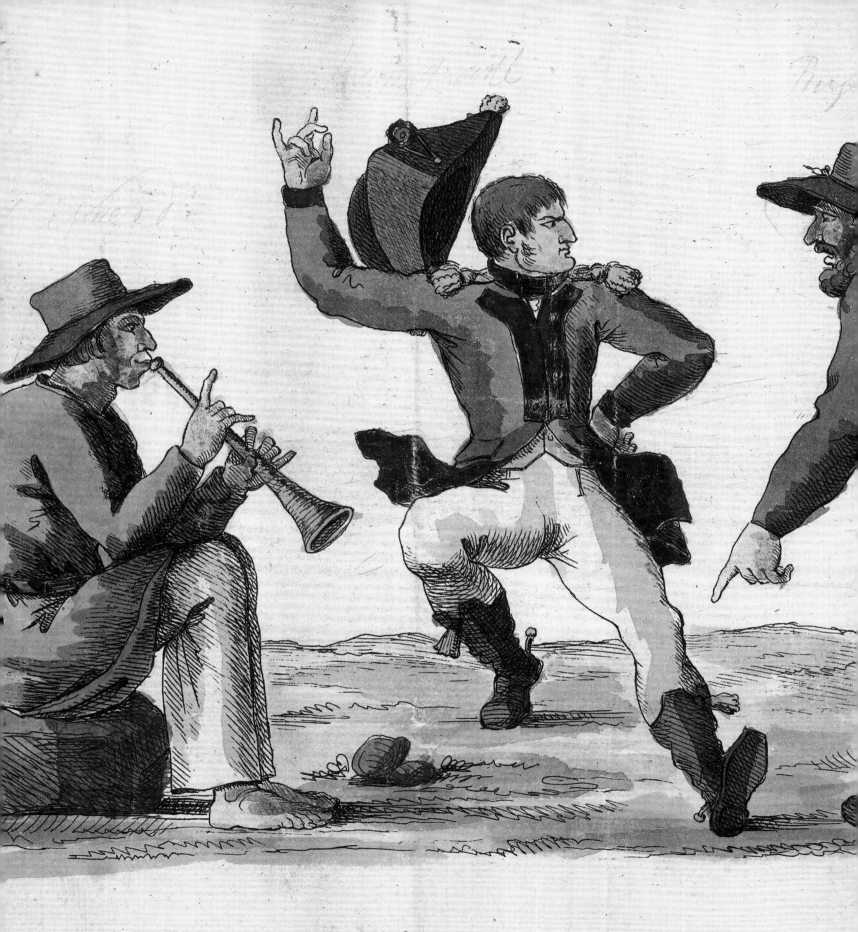

Не удалось тебѣ насъ переладить н

7
Spain and Russia

In November 1807 the French army marched though Spain into Portugal in order to enforce Napoleon's demand that Portugal should close its ports to British ships and seize all British goods. The Portuguese royal family fled to Brazil. In April 1808, after riots and a palace coup that forced him to abdicate in favour of his son Ferdinand, the unpopular King Charles IV left Spain. Charles appealed to Napoleon who met father and son in Bayonne and required both of them to abdicate. He summoned his brother Joseph from Naples to rule Spain instead. In May, after a riot in Madrid was savagely repressed by French troops, the Spanish rebelled and by June the country was in turmoil. The initial success of Spanish generals and requests for British help produced a burst of wild enthusiasm in Britain. Even Whigs were united in support of the cause: 'To assist the Spaniards is morally and politically one of the highest duties a nation ever had to perform', declared Lord Grey. [1]

A British army under Arthur Wellesley, the future Duke of Wellington, landed in Portugal and defeated the occupying French force. A second British army landed at Corunna in October. Spanish fever gripped Britain until the end of the year when defeats, disorganization, dissention and demands for money caused cynicism to set in. Wellesley held out in Portugal, however, and built a strong reputation.

The Peninsular War continued until 1813, and meanwhile Napoleon had suffered his crucial defeat in Russia.

1 Charles Earl Grey, letter to Henry Brougham, 29 September 1808, *The Life and Times of Lord Brougham Written by Himself*, London and Edinburgh 1871, p. 413.

105

James Gillray (1756–1815)
The Spanish Bull Fight
Published by Hannah Humphrey, 11 July 1808
Hand-coloured etching; 260 x 356 mm
J,3.64; BM Satires 10997
From the collection of Sarah Sophia Banks

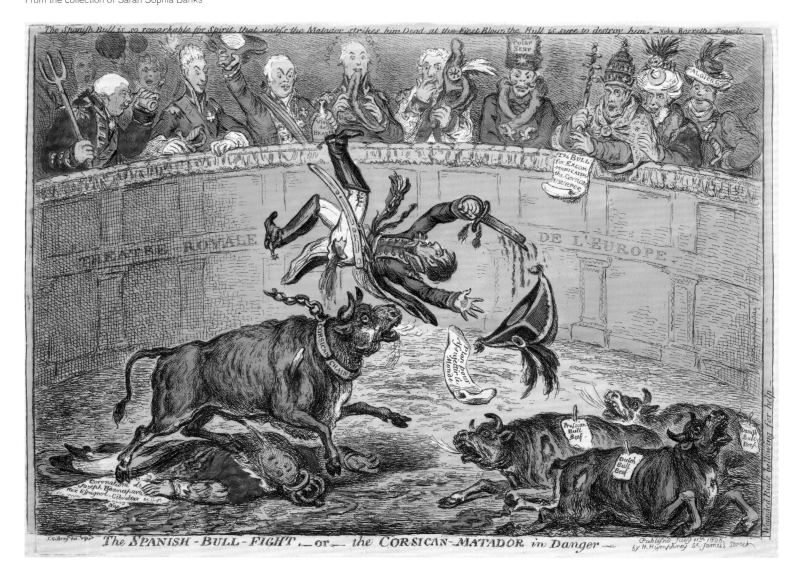

This print, designed but not thought up by Gillray, was published a few days before Joseph Bonaparte entered Madrid on 20 July to take the Spanish throne. Having already been crowned at Burgos, he was proclaimed King at Madrid on 25 July. In Gillray's print an angry bull tosses the matador Napoleon, ruining his plan to subject the world to his will; Joseph already lies under the bull's feet, the announcement of his coronation torn and trampled. Wounded Prussian, Dutch and Danish bulls bellow for help while an audience of European and Mediterranean rulers looks on with satisfaction. The metaphorical warning at the top of the print: 'The Spanish Bull is so remarkable for Spirit, that unless the Matador strikes him Dead at the First Blow, the Bull is Sure to destroy him' is taken from Giuseppe Barretti, *A Journey from London to Genoa, through England, Portugal, Spain, and France* (1770).

Gillray's design was warmly received in Spain. Three close copies were issued in October 1808 for circulation in Spain and on 4 November an allegorical print celebrating French setbacks in Spain and British victory in Portugal was published bearing a dedication 'to the English inventor of the Spanish bull' (see p. 34).

The copy in the Museo de Historia de Madrid illustrated opposite is the same size as Gillray's print and differs only in details of the inscription, such as the content of the paper carried by the Pope. It is not inconceivable that it was engraved in England. The version of which there is an example at the Musée

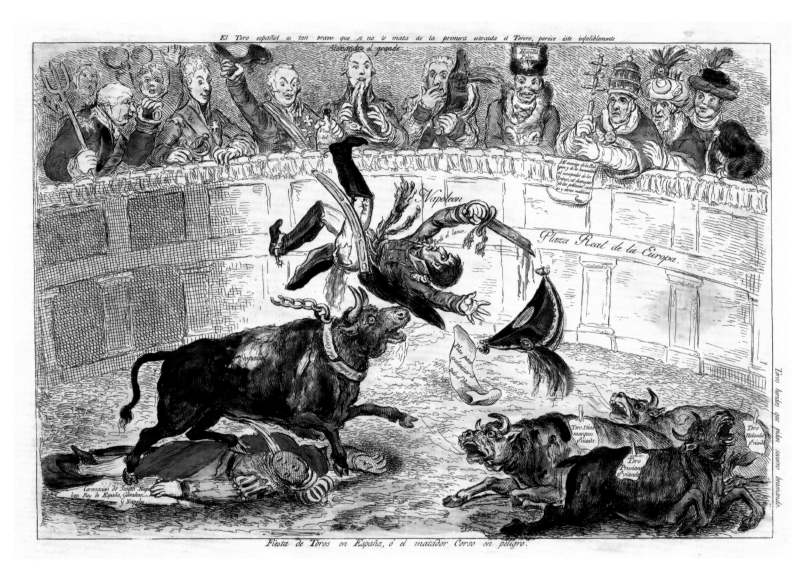

El Toro español es tan bravo que si no le mata de la primera estocada el Torero, perece este infaliblemente

Fiesta de Toros en España, ó el matador Corso en peligro.

Fiesta de Toros en España
Hand-coloured etching; 260 x 360 mm
Museo de Historia, Madrid, 4435-8784

Carnavalet was smaller (222 x 320 mm), simpler in its inscriptions and presumably cheaper. A third, cruder version also at the Museo de Historia de Madrid, omitted the Pope.[1]

It seems likely that Francisco Goya was influenced by Gillray's print when designing his *Tauromaquia* series (1815–16). Earlier bull-fighting scenes, notably the popular series by Antonio Carnicero published in 1790, were set in spacious outdoor arenas,[2] but Goya echoes the intensity of Gillray's enclosed space where the audience peers over a high barricade at the violent spectacle.

1 Hill 1965, p. 116, n. 5.
2 British Museum PD 1871,0812.4512.

106

Thomas Rowlandson (1757–1827)
after George Murgatroyd Woodward
(c. 1760–1809)

King Joe's retreat from Madrid

Published by Thomas Tegg,
21 August 1808

Hand-coloured etching; 235 x 341 mm

1868,0808.7666; BM Satires 11013

From the collection of Edward Hawkins

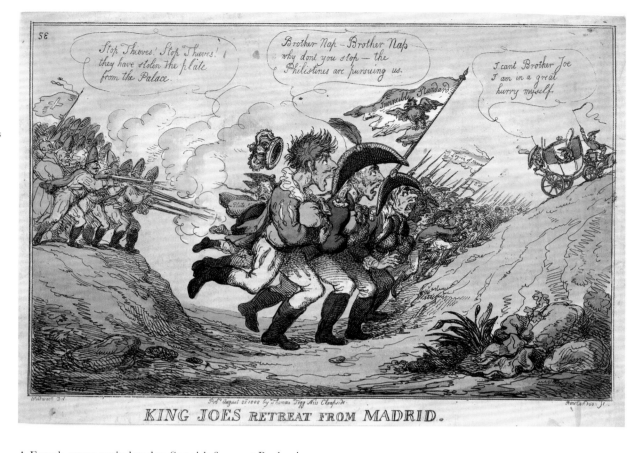

A French army capitulated to Spanish forces at Baylen in
Andalusia on 19–21 July 1808. The defeat caused a sensation at
a time when French troops were thought to be unbeatable. Ten
days later, Joseph Bonaparte and the French army evacuated
Madrid, little more than a week after his arrival, taking with them
the crown jewels and other treasure. Here Joseph flees with a long
line of soldiers holding tattered 'Invincible Standards' and sacks
of loot. He is identified as Spanish according to the convention
of British satirical prints by being dressed as a sixteenth-
century Spaniard. Spanish soldiers shouting, 'Stop Thieves!' are
accompanied by two monks; the clergy took a leading role in
anti-French guerrilla warfare. Napoleon disappears ahead of the
fleeing army and Joseph cries after him.

 The design of the print was the work of George Murgatroyd
Woodward (see cat. 20), who generally preferred humorous social
subjects to politics. Even here the attack is mild and Joseph is
treated as a figure of fun rather than anything more sinister:
Rowlandson's interpretation of Woodward's design portrays
'King Joe' as a youth running away after having been caught
misbehaving.

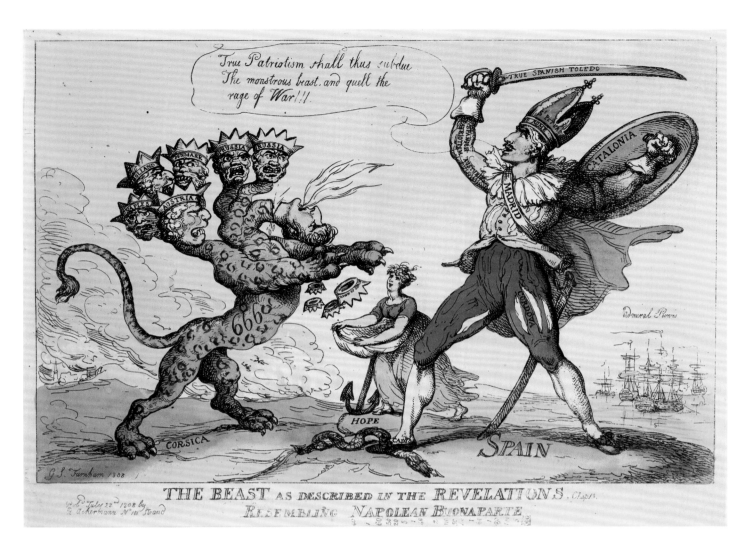

True Patriotism shall thus subdue The monstrous beast, and quell the rage of War!!!

THE BEAST AS DESCRIBED IN THE REVELATIONS. *Chap.*

RESEMBLING NAPOLEAN BUONAPARTE

107

Thomas Rowlandson (1757–1827)
after George Saulez (1779–1843)

The Beast as Described in the Revelations

Published by Rudolph Ackermann,
22 July 1808

Hand-coloured etching;
249 × 345 mm

1868,0808.7657;
BM Satires 11004

From the collection of
Edward Hawkins

This print by Rowlandson is based on a design by George Saulez, a young schoolmaster of French descent living in Farnham, Surrey.[1] It was not unusual for amateurs to provide designs for satirical prints and Rudolph Ackermann published at least three social satires by Saulez in 1805–6, but the half-dozen designs he provided over the next three years were all anti-Napoleon.

The design draws on current millenarian beliefs and imagery to portray Napoleon as the anti-Christ who has provoked the apocalyptic struggle preceding the Second Coming of Christ. His name is deliberately misspelt as 'Napolean' so that numbers ascribed to the letters of the alphabet can be added up to a total of 666, the number of the Beast (Book of Revelation, 13:18). The seven heads of the Beast shown in the print bear the names of Napoleon and the states that were then his allies. It is attacked by a soldier representing the Spanish provinces that were rising in revolt. He wears traditional Spanish dress of the sixteenth century and a mitre inscribed 'St Peters Rome' as a reminder of Spain's Roman Catholicism. It is a measure of British anxiety over Napoleon that the country's close links with the papacy

could be accepted now that Spain was resisting France; in earlier imagery the Pope had been identified as the anti-Christ.[2]

The figure of Hope rushes forward to catch the crowns of Portugal, Spain and France that fall from Napoleon's head as the soldier decapitates him. It was, in the event, to be five years before Napoleon lost control in those countries. In the background, British ships commanded by Admiral John Child Purvis stand off shore. Purvis was blockading Cadiz at the outbreak of the rebellion against Napoleon and his help was reluctantly accepted by the Spanish.

Napoleon was to return to Spain in November 1808. He reinstated his brother and instituted social and political reforms, but guerrilla warfare and British involvement in the Iberian Peninsula continued.

1 http://familytrees.genopro.com/IainTait/Tree_Compilation/default. htm?page=toc_families.htm; *The Gentleman's Magazine*, 102, 1807, p. 653.
2 Semmel 2006, pp. 83–6.

THE RUSSIAN CAMPAIGN

Relations between Napoleon and Russia deteriorated from 1810. Tsar Alexander was affronted by Napoleon's conduct in Europe as he sought to enforce a trade blockade against Britain that was proving to have a terrible effect on the Russian economy. Meanwhile Napoleon was frustrated by the failure of the blockade to subdue the British and by the long and dirty war in Spain and Portugal. He began to raise a huge army for a Russian campaign. Of more than 600,000 men in the front line and behind, only one third were French, the rest being Austrian, Prussian, German, Italian, Polish, Belgian, Dutch, Croatian, Swiss, Spanish and Portuguese. In June 1812 they crossed the river Niemen confident of victory. The Russians retreated and Napoleon pursued them, first to Smolensk, which was captured, and then to Moscow. The heat was intense, the lands stripped and burned by the retreating Russians; from the beginning the *Grande Armée* was plagued by dysentery. The bloody battle at Borodino on 7 September cost the lives of 30,000 from Napoleon's army and 44,000 Russians, but the Russians refused to make peace; instead they burned Moscow. Faced with a stalemate and without supplies, Napoleon began the famous retreat from Moscow on 19 October. Before long the temperature plummeted and it began to snow. The number of soldiers lost to battle, capture, desertion, disease and cold is still disputed, but it is certain that only a pitiful remnant of the *Grande Armée* crossed back over the Niemen on 16 December; Jean Tulard, doyen of French Napoleon scholarship, gives the number as 18,000.[1] Napoleon's reputation as an invincible military commander was destroyed.

1 Tulard 1984, pp. 301–4.

108

William Elmes (active 1804–16)
General Frost Shaving Little Boney
Published by Thomas Tegg, 1 December 1812
Hand-coloured etching; 345 x 245 mm
1935,0522.11.16; BM Satires 11917

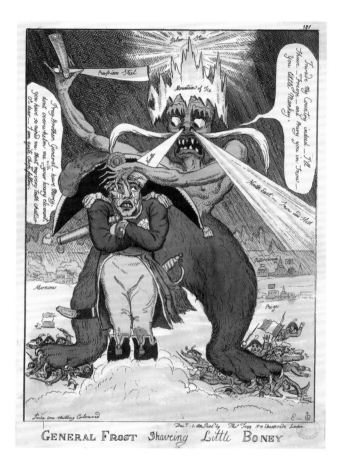

GENERAL FROST Shaving Little BONEY

The weather turned cold on 7 November. News reached Britain quickly: on 23 November Lady Lucas wrote, 'the Russians exult in the distressed condition of the retreating French army, and Emperor Alexander's proclamation on the subject is a little in the style of Napoleon himself.'[1] This early British representation shows the situation emblematically: General Frost towers above the shivering emperor threatening him: 'Invade My Country indeed – I'll Shave – Freeze – and Bury you in Snow – You little Monkey.' Frost has the legs of a Russian bear and his great feet are planted upon two groups of little French soldiers crushing them into the snow. In the background on the left is Moscow in flames.

William Elmes worked for Tegg as a caricaturist between 1811 and 1816, but was also a significant marine artist. He designed and etched a large number of aquatints of naval subjects for the publisher John Fairburn.

1 Lucas diary, vol. 28 (1812), p. 284.

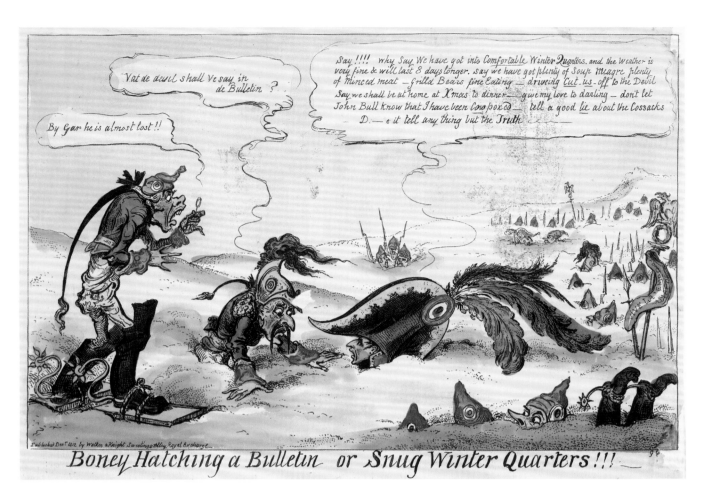

Boney Hatching a Bulletin or Snug Winter Quarters!!!

109

George Cruikshank (1792–1878)
Boney Hatching a Bulletin or Snug Winter Quarters!
Published by Elizabeth Walker and Samuel Knight, December 1812
Hand-coloured etching; 236 x 339mm
1868,0808.8038; BM Satires 11920
From the collection of Edward Hawkins

Napoleon had left Moscow declaring in one of his army bulletins that he was going into winter quarters: 'It is beautiful weather, the roads are excellent; it is the end of autumn; this weather will last eight days longer, and at that period we shall have arrived in our new position.'[1] Even in France 'to lie like a bulletin' had become proverbial and the British very much enjoyed the contrast between French official pronouncements and the reality as reported in their newspapers.

By December London knew the full extent of the calamity. George Cruikshank, aged twenty, was already established as a producer of graphic satire having worked with his father, Isaac, for several years. He designed and etched prints for Fores and Tegg, but his best prints of this period were produced for the partnership of Walker and Knight, one of many print-publishing enterprises of the period who are now little known. The history of the business, and changing partnerships is complex and chiefly understood by reference to the publication lines lettered on the prints themselves. In 1791, Elizabeth Walker had

taken over the established business of John Walker, carver, gilder and printseller, who had been publishing high-quality decorative stipples and mezzotints for fifteen years from 7 Cornhill in the City of London and other addresses. She was probably his widow – it was common practice for women to deal with the financial side of their husbands' businesses and to carry on running them when they became widows. Elizabeth Walker continued to produce decorative prints until 1805, when she began also to sell caricatures published by C. Knight in Lambeth. Most of these were designed by 'Argus', who has been identified as Charles Williams but may perhaps have been Samuel Knight, presumably a relative. During 1811 the name of the business changed to Knight & Walker. In the following year it took over, in addition to the premises in Cornhill, a tiny shop beside the Stock Exchange in Sweetings Alley that had previously been run by John Harris, another business associate.

1 27th Bulletin of the Grand Army, 27 October 1812, published in translation in Cobbett 1802–35, 5 December 1812, pp. 733–4.

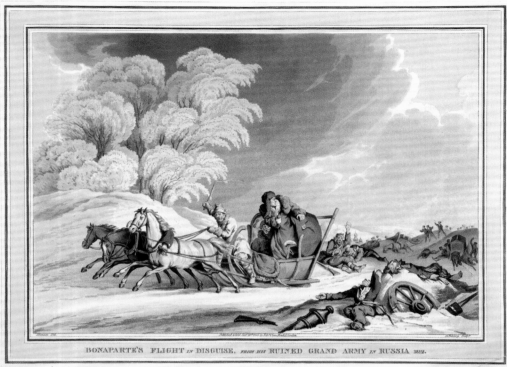

BONAPARTE'S FLIGHT IN DISGUISE, FROM HIS RUINED GRAND ARMY IN RUSSIA 1812.

Dedicated to all the patriotic Subscribers to the Fund for the relief of the brave Victorious but suffering Russians.
By Edwd Orme

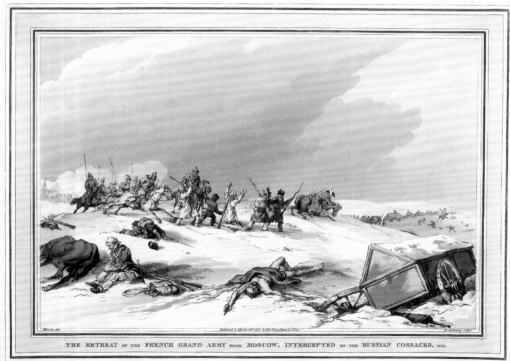

THE RETREAT OF THE FRENCH GRAND ARMY FROM MOSCOW, INTERCEPTED BY THE RUSSIAN COSSACKS, 1812.

Inscribed to the Wisdom, Valour & Valour, of the Russian Government & Army
By Edwd Orme.

110

Matthew Dubourg (active 1805–1838) after
John Augustus Atkinson (1775–1833)
*Bonaparte's Flight in Disguise from his Ruined
Grand Army in Russia*
Published by Edward Orme, 20 January 1813
Aquatint with hand-colouring; 282x 372 mm
1917,1208.3998; de Vinck 8780
From the collection of Amabel, Lady Lucas;
presented by Nan Ino, Baroness Lucas of
Crudwell in memory of her brother Auberon,
Baron Lucas of Crudwell

111

Matthew Dubourg (active 1805–1838) after
John Augustus Atkinson (1775–1833)
*The Retreat of the French Grand Army
from Moscow Intercepted by the Russian
Cossacks*
Published by Edward Orme, 30 January 1813
Aquatint with hand-colouring; 285x 378 mm
1917,1208.3997
From the collection of Amabel, Lady Lucas;
presented by Nan Ino, Baroness Lucas of
Crudwell in memory of her brother Auberon,
Baron Lucas of Crudwell

These two prints come from a set of four
aquatints depicting the retreat from Moscow.
The prints relish the predicament of Napoleon's
army. In the first, the emperor abandons his
dead and dying soldiers as he is driven off in the
comfort of a horse-drawn sleigh: Napoleon left
for France on 5 December in order to defend
his position against opponents at home. In the
other, a raiding band of Cossacks (exotic heroes
in British eyes) spears stragglers at the rear of a
retreating French column.

 The series was published only a month
or so after news of the horrors of the retreat
reached London and was dedicated to the
Russian people. John Augustus Atkinson, who
was responsible for the watercolours on which it
was based, had lived in St Petersburg as a child
and young man from the 1780s until 1802. He
had painted portraits of members of the court
and on his return produced a long series of the
Manners, Customs and Amusements of the Russians.
In 1815 he visited the field of Waterloo with
Arthur William Devis to make studies for a
large painting of the battle. Matthew Dubourg
specialized in aquatint, producing many views
of subjects connected with the Napoleonic wars.

 The publisher Edward Orme produced
several sets of prints that were aimed at the
Russian market. After making a great deal
of money, he began to develop property in
Bayswater, and named Moscow Road and
St Petersburgh Place in homage to the sources
of his wealth.

112

George Cruikshank (1792–1878)
Murat Reviewing the Grand army!!!!!!
Published by Elizabeth Walker and
Samuel Knight, January 1813
Hand-coloured etching; 358 x 400 mm
J,4.203; BM Satires 12002
From the collection of
Sarah Sophia Banks

George Cruikshank continued producing prints for Walker and Knight, evidently after his own designs, while also working for Hannah Humphrey (see cat. 114). The subjects are swift responses to news from the Continent, treated with ridiculous grotesqueness. Here Joachim Murat, who had been left in charge of the army when Napoleon returned to France, appears not in his usual guise of a flamboyant dandy, but in a state of terrified despair at the condition of his army. On 8 December, three days after the emperor's departure, he had marched what was left of the main army into its base at Vilnius, where there were sufficient supplies for the rest of the winter, and where he was supposed to remain. However, he became alarmed that they might be trapped there by the Russians and continued on to East Prussia.

Murat was Napoleon's greatest cavalry commander, his right-hand man in the defence of Paris in 1795, and married to the emperor's sister Caroline. Since 1808 he had been King of Naples but, having been forced to raise taxes to fund the Russian campaign and facing the threat of a British invasion from Sicily, he was anxious about his grip on his kingdom. He resigned his army command to Eugene de Beauharnais, Napoleon's stepson, and left for Naples on 17 January.

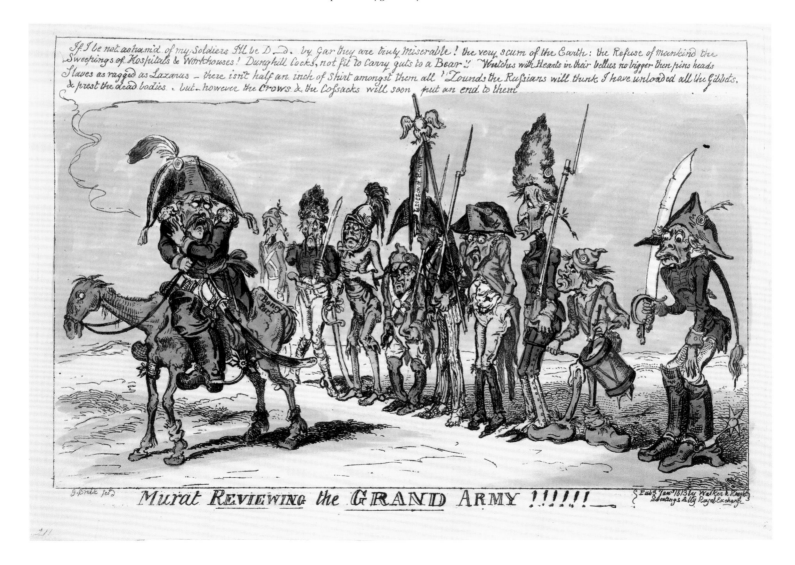

113

Ivan Ivanovitch Terebenev (1780–1815)
The Russian Dance
Published by Ivan Petrov Glasunov,
31 January 1813
Hand-coloured etching; 206 x 260 mm
1877,1013.1475

114

George Cruikshank (1792–1878) after
Ivan Ivanovitch Terebenev (1780–1815)
Russians Teaching Boney to Dance
Published by Hannah Humphrey,
18 May 1813.
Hand-coloured etching; 250 x 355 mm
1868,0808.12716; BM Satires 12046
From the collection of Edward Hawkins

In 1813, as Napoleon's power in Europe weakened, propaganda prints were distributed internationally and versions of the same designs appear in several countries (see also cats 119–124). Print publication was strictly controlled in Russia and political caricatures were suppressed until 1812 when the French invasion encouraged the development of patriotic graphic satire using elements of popular prints (*lubki*). After the French Revolution there had been anxiety among the Russian ruling classes, just as in Britain, that the people might rise in rebellion, but the threat provided by Napoleon changed attitudes. Propagandists appealed to Tsarist sentiments by presenting the Russian peasant as the brave defender of the country against the French. In this example, Napoleon dances the *gopak*, Cossack style, to the pipe of one peasant while another wields a whip. More than 200 such prints were published between 1812 and 1814, a large proportion of those by Ivan Ivanovitch Terebenev who was well-established as a sculptor. The main centre for production was St Petersburg, the great port city from which trading continued even during Napoleon's blockade, British ships sometimes sailing under flags of convenience. Publishers, encouraged by state authorities, aimed prints at an international market and examples published in Russia are lettered in several languages. German and Italian versions of the present example are known as well as Cruikshank's.[1]

Cruikshank's treatment is more caricatural than the original. Whereas Terebenev portrays Napoleon as a proud figure dancing with grim deliberation, in Cruikshank's print the emperor capers in fear of the Russian peasant brandishing his whip. The preliminary drawing for the print is part of the huge bequest made to the British Museum by Cruikshank's widow Eliza.[2]

Cruikshank made at least nine copies of Russian prints for Hannah Humphrey in the first half of 1813. Each gives the original title in Cyrillic script and a more or less literal translation, in this case: 'If you trespass on our grounds; you must dance to our tunes'. This seems to be the first time that Mrs Humphrey employed Cruikshank. Gillray was no longer able to work and the young printmaker's *Boney Hatching a Bulletin or Snug Winter Quarters!* (cat. 109), published the previous December, would have shown her that he could cope with Russian subjects with graphic vigour and wit. Cruikshank's satires are the liveliest productions of the later years of Napoleon's empire, although he never rivals Gillray's intellectual complexity.

1 BM Satires 12188.
2 British Museum PD 1891,1117.4.

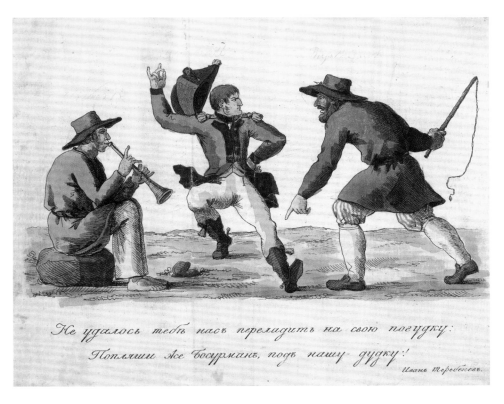

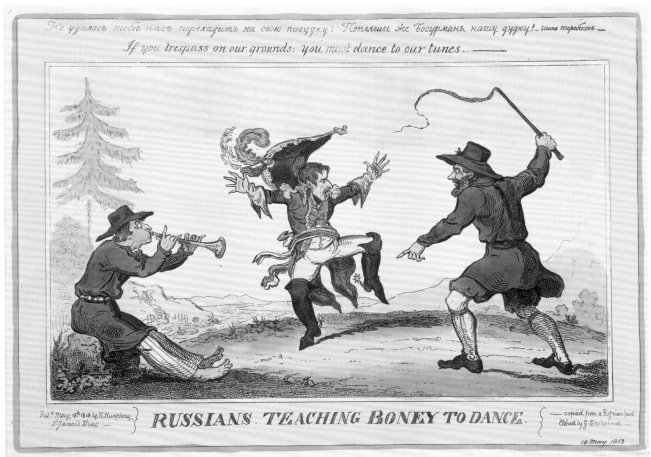

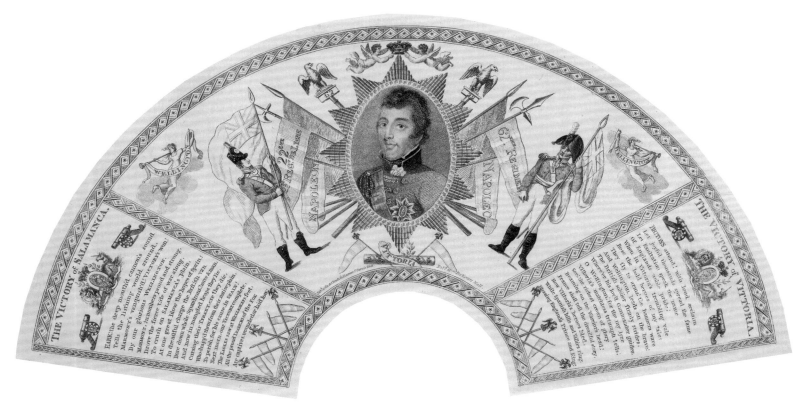

115

Anonymous, the portrait after Robert Home
(1752–1834)

Fan-leaf with a portrait of the Duke of Wellington

Published by Joseph Lauriere, 1813

Stipple and engraving, partly printed in colours;
125 x 359 mm

1891,0713.370

Presented by Lady Charlotte Schreiber

London publishers began to produce printed fans in comparatively
large numbers in the mid-1700s and by the end of the century
they were exported widely throughout Europe. Images related
to contemporary events were popular and the Peninsular War
generated a number of fans. This example, glorifying Wellington's
successes at Salamanca and Vitoria with triumphant verses, was
produced by Joseph Lauriere, a jeweller – presumably of French
descent – in fashionable St James's Street. The head of Wellington
is based on one of many versions of his portrait painted at the end
of his years in India by the expatriate British artist Robert Home.[1]

Printed fans were also published in London specifically for the
Spanish market. One publisher, Joseph Hadwen, even gives his
address in Spanish: cort de la Corona [Crown Court], Cheapside
London' on a fan lettered *La España Triunfara*.[2]

116

Henry Moses (1781–1870) and Frederick Christian
Lewis (1781–1856) after John Masey Wright
(1777–1866)

Victory of Vittoria

Published by John Hassell and Thomas Rickards,
1 June 1814

Hand-coloured etching and aquatint; 598 x 746 mm

1868,0612.2309

1 R. Walker, *National Portrait Gallery: Regency Portraits*, London 1985, p. 525.
2 British Museum PD 1891,0713.398.

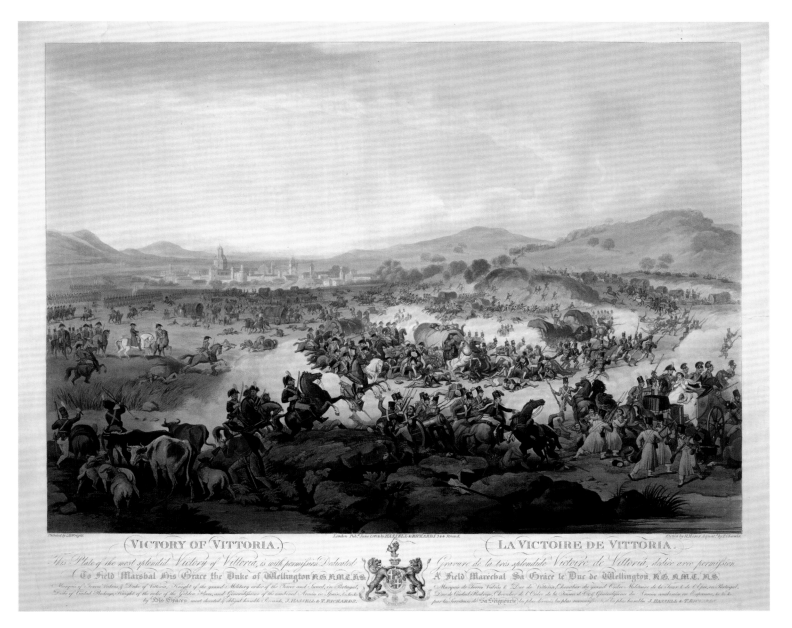

VICTORY OF VITTORIA. LA VICTOIRE DE VITTORIA.

The end of Napoleonic power in Spain finally came about in 1813 when Spanish, Portuguese and British forces led by Arthur Wellesley, the future Duke of Wellington, succeeded in driving the French army across the Pyrenees. The crucial battle was at Vitoria on 21 June. Although this print is dedicated to Wellington in honour of his victory, the view of the innumerable wagons surrounded by a riotous melee of infantry and cavalry was not one that he would necessarily have enjoyed. Many British troops broke ranks and, instead of pursuing the defeated French, took to looting King Joseph's baggage train. Wellington wrote angrily to Earl Bathurst, Secretary of State for War, on 29 June: 'We started with the army in the highest order,

and up to the day of the battle nothing could get on better; but that event has, as usual, totally annihilated all order and discipline. The soldiers of the army have got among them about a million sterling in money, with the exception of about 100,000 dollars, which were got for the military chest. The night of the battle, instead of being passed in getting rest and food to prepare them for the pursuit of the following day, was passed by the soldiers in looking for plunder.' On 2 July he famously despaired, 'We have in the service the scum of the earth as common soldiers'; nearly 3,000 men had gone astray since the battle, 'from irregularities, straggling, &c.… for plunder'.[1]

The print was not published until two

months after the Peace of Fontainebleau and Napoleon's abdication. The lettering is in both English and French in order to appeal to the international market that had reopened after years of blockade. It is a technical tour de force of colour-printing, *a la poupée*, inked on the copper plate in shades of brown, blue and grey, with stronger colours added by hand in watercolour. Hassell and Rickards published a print entitled the *Battle of the Pyrenees* as a pair, marking the next stage of Wellington's ascent into France.

1 J. Gurwood (ed.), *The Dispatches of Field Marshal the Duke of Wellington*, London 1838, X, pp. 472–73 and 495–96.

8
Leipzig and the collapse of empire

During the first months of 1813, a Sixth Coalition was built up against Napoleon consisting of Britain, Russia, Sweden, Prussia and Austria, together with Spain and Portugal. The French army was rebuilt from reserves and by calling up very young conscripts; the force was large but it lacked experienced soldiers. In May, Napoleon was victorious at Lützen and Bautzen in Saxony, but success at Vitoria in northern Spain (cat. 116) rallied the Coalition. At the huge 'Battle of the Nations' – so-called because so many nations were represented – fought from 16–19 October at Leipzig, the French and their Italian and Polish allies were defeated. Napoleon was forced into retreat to the Rhine as his German confederation unravelled. Meanwhile, Wellington had reached south-west France and Holland rose in revolt. The allied armies followed Napoleon into eastern France. He fought a brilliant campaign but the odds against him were too great. He was forced to abdicate on 4 April 1814.

117

George Cruikshank (1792–1878)
French Conscripts for the Years 1820, 21, 22, 23, 24 & 25.
Published by Samuel Knight,
18 March 1813
Hand-coloured etching; 250 x 350 mm
1948,0214.784; BM Satires 13486
From the collection of Francis Klingender

On 11 January 1813, with 120,000 twenty-year-old conscripts already on their way to fight, the Senate in Paris agreed to a further levy of 350,000 young men to compensate for losses in the Russian campaign. These included nineteen-year-olds, 'the class of 1814', who would not normally have been due for conscription for another year.[1] George Cruikshank's print was published two months later.

He takes the idea of young conscripts to a ludicrous extreme – envisaging the recruitment of an infant army consisting of the classes of 1820 to 1825. A ragged soldier with two wooden legs, an empty left sleeve, and missing eye and nose speaks doubtful words of encouragement: 'Come along my pretty little Heros….' One child, stretching up to hold a musket, replies in baby talk: 'I want to do home to my mamma.' But others are braver: in the background boys are already on the march past a signpost, 'To Russia', from which a skeleton dangles.

1 A. Pigeard, 'La conscription sous le premier empire' in *Revue du Souvenir Napoléonien*, 420, October–November 1998, pp. 3–20.

118

Thomas Rowlandson (1757–1827)
The Two Kings of Terror
Published by Rudolph Ackermann, November 1813
Hand-coloured etching and aquatint; 440 x 292 mm
J,4.206; BM Satires 12093
From the collection of Sarah Sophia Banks

News of the battle of Leipzig reached London in a fortnight, and the town was illuminated on 5 and 6 November 1813. This broadside reproduces the large transparency displayed in Rudolph Ackermann's printshop window in the Strand; he was a Saxon and deeply committed to the overthrow of Napoleon (see pp. 33 and 224–5). When London was illuminated, ordinary people put candles in their windows, but government buildings such as the Admiralty picked out mottos and designs in lights and people went out into the streets to see them. Ackermann's shop was one of the first buildings in London to be lit by gaslight and he made a point of mounting a spectacular display. He exhibited huge back-lit transparent designs, of which he sold smaller printed versions in his shop. Along with Edward Orme (cats 110–111), Ackermann was the leading publisher of transparent prints, in which all or part of the design was oiled and varnished so that light shone through when placed behind. This print of the Leipzig transparency has the skeleton figure of Death seated on a cannon facing Napoleon who, according to the punning text below 'is now placed in a situation in which all Europe "may see through him"'. In the background soldiers of the Russian, Prussian, Austrian and Swedish armies advance from the left in regular formation with bayonets levelled; the French army flees in wild confusion up and over the hill.

COPY

OF THE

𝕮𝖗𝖆𝖓𝖘𝖕𝖆𝖗𝖊𝖓𝖈𝖞

EXHIBITED AT

ACKERMANN'S REPOSITORY OF ARTS,

During the Illuminations of the 5th and 6th of November, 1813,

IN HONOUR OF THE SPLENDID VICTORIES OBTAINED BY

The ALLIES over the ARMIES of FRANCE,

AT LEIPSIC AND ITS ENVIRONS.

THE TWO KINGS OF TERROR.

THIS Subject, representing the two Tyrants, viz. the Tyrant BONAPARTE and the Tyrant DEATH, sitting together on the Field of Battle, in a manner which promises a more perfect intimacy immediately to ensue, is very entertaining. It is also very instructing to observe, that the former is now placed in a situation in which all Europe *may see through him.* The emblem, too, of the Circle of dazzling light from mere *vapour,* which is so soon *extinguished,* has a good moral effect; and as the Gas represents the dying flame, so does the Drum, on which he is seated, typify the *hollow* and *noisy* nature of the falling Usurper.

The above description of the subject appeared in the *Sun* of Saturday, the 6th of November. These pointed comments arose from the picture being *transparent,* and from a Circle, indicative of the strength and brotherly union of the Allies, which surmounted the same, composed of *gas* of brilliant brightness.

119

After a design by the Brothers Henschel
(active early nineteenth century)
Napoleon
Published by Rudolph Ackermann,
probably March 1814
Hand-coloured etching with letterpress text;
473 x 287 mm
1868,0808.12742; BM Satires 12202
From the collection of Edward Hawkins

This image was one of the most widely published caricatures of Napoleon: versions were produced in nine European countries, twenty-three in Germany alone. It was formerly thought that the earliest version of the image was one produced by the German artist Johann Michael Voltz (1784–1858) in 1814, but it is now known to have been designed some months earlier by the Brothers Henschel (Moritz, August, Friedrich and Wilhelm) in Berlin. They announced it in the *Berlinischen Nachrichten* on 9 December 1813 as a print for the new year: 'A surprising allegory in letter format with the inscription "Triumph des Jahres 1813. Den Deutschen zum Neuenjahr 1814" is recently published and coloured at our shop and can be had for 6 Gr[oschen]. current. Brothers Henschel, Werderstrasse 4.'

The caricature uses a conventional portrait of Napoleon by Gottfried Arnold Lehmann (active 1770–1815), redrawn as a composite figure made up of allusions to the thousands who died in the recent war. The Henschel brothers explained the meaning in a list of their publications issued in 1814:

> The hat is the Prussian eagle which has gripped the great man in his claws and will never again let him loose. The face is composed of some of the hundreds of thousands of corpses sacrificed in his quest for fame. The collar is the great stream of blood which had to flow for so long to satisfy his ambition. The coat is a part of the map of the dissolved Confederation of the Rhine. He lost battles at all the places mentioned. The place named on the red ribbon ['Ehrfort' – a reference to the Convention of Erfurt of 1808] needs no explanation. The large Order of the Legion of Honour is a spider's web whose threads spread over the whole confederation of the Rhine; from the epaulette the mighty hand of God reaches out to tear the web which ensnared Germany and destroy the spider which sits in the place where a heart should be.[1]

In Rudolph Ackermann's print, the fingers bear the initials of the countries allied against Napoleon: he evidently had no copy of the Henschel catalogue and did not entirely understand the complex meaning of the image. The letterpress below is a compilation of the accusations, justified or invented, that had been levelled at Napoleon since he came to prominence: '… Emperor of the Jacobins, Protector of the Confederation of Rogues, Mediator of the Hellish League …'[2]

1 Reproduced in Scheffler 1995, pp. 259–60.
2 Vetter-Liebenow 2007, pp. 124–5; Scheffler 1995, pp. 257–9.

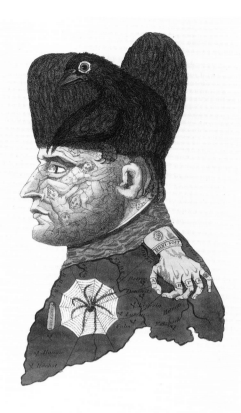

Pub.d by R. Ackermann, 101 Strand, London.

NAPOLEON

THE FIRST, and LAST, by the Wrath of Heaven Emperor of the Jacobins, Protector of the Confederation of Rogues, Mediator of the Hellish League, Grand Cross of the Legion of Horror, Commander in Chief of the Legions of Skeletons left at Moscow, Smolensk, Leipzig, &c. Head Runner of Runaways, Mock High-Priest of the Sanhedrim, Mock Prophet of Mussulmen, Mock Pillar of the Christian Faith, Inventor of the Syrian Method of disposing of his own Sick by sleeping Draughts, or of captured Enemies by the Bayonet ; First Grave-Digger for burying alive; Chief Gaoler of the Holy Father and of the King of Spain, Destroyer of Crowns, and Manufacturer of Counts, Dukes, Princes, and Kings; Chief Douanier of the Continental System, Head Butcher of the Parisian and Toulonese Massacres, Murderer of Hoffer, Palm, Wright, nay, of his own Prince, the noble and virtuous Duke of Enghien, and of a thousand others; Kidnapper of Ambassadors, High-Admiral of the Invasion Praams, Cup-Bearer of the Jaffa Poison, Arch-Chancellor of Waste-Paper Treaties, Arch-Treasurer of the Plunder of the World, the sanguinary Coxcomb, Assassin, and Incendiary......to

MAKE PEACE WITH!!!

This Hieroglyphic Portrait of the DESTROYER is faithfully copied from a German Print, with the Parody of his assumed Titles. The *Hat* of the Destroyer represents a discomfited French Eagle, maimed and crouching, after his Conflict with the Eagles of the North. His *Visage* is composed of the Carcases of the Victims of his Folly and Ambition, who perished on the Plains of Russia and Saxony. His Throat is encircled with the *Red Sea*, in Allusion to his drowned Hosts. His Epaulette is a *Hand*, leading the Rhenish Confederation, under the flimsy Symbol of a *Cobweb*. The *Spider* is an Emblem of the Vigilance of the Allies, who have inflicted on that Hand a deadly Sting!

PUBLISHED AT R. ACKERMANN'S, 101, STRAND, LONDON.

———————

Harrison & Leigh, Printers, 373, Strand.

120
Anonymous
Das ist mein lieber Sohn
Published in Germany, 1813/14
Hand-coloured etching; 121 x 107 mm
1989,1104.120
From the collection of Fernand Gabriel Renier

121
Anonymous
Le petit homme rouge berçant son fils
Published in France, 1814
Hand-coloured etching; 247 x 174 mm
1856,0712.646; BM Satires 12197

122
Thomas Rowlandson (1757–1827)
The Devils Darling
Published by Rudolph Ackermann, 12 March 1814
Hand-coloured etching; 327 x 231 mm
1868,0808.8116; BM Satires 12196
From the collection of Edward Hawkins

The German print shown here is the original of an image of which there are at least thirteen German versions and others with text in Dutch, English, French, Italian and Swedish. It is a measure of the strength of feeling in the post-Leipzig period that publishers felt free to use the biblical text: 'This is my beloved Son, in whom I am well pleased' (spoken by a voice from heaven after Christ's baptism) in such a context.

The French version is very close to the original, but Rowlandson's print made for Ackermann is in a larger English format and the Devil, huge, nude, dark, and hairy, holds the infant Napoleon with more vigour and realism. The biblical text is not used, but instead a popular English insult.

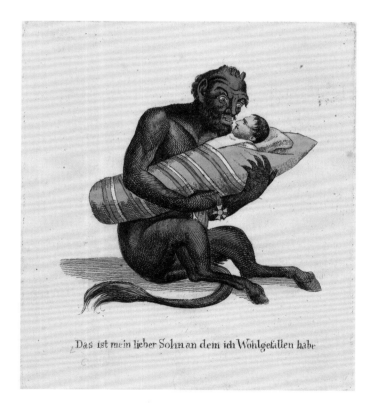

Das ist mein lieber Sohn an dem ich Wohlgefallen habe

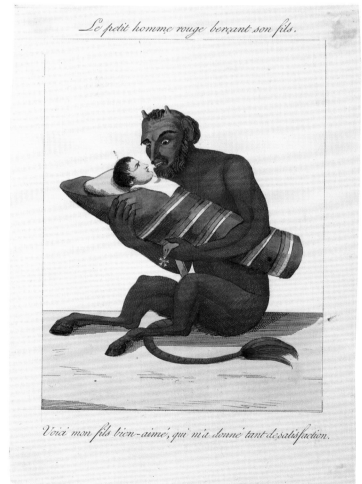

Le petit homme rouge berçant son fils.

Voici mon fils bien-aimé, qui m'a donné tant de satisfaction.

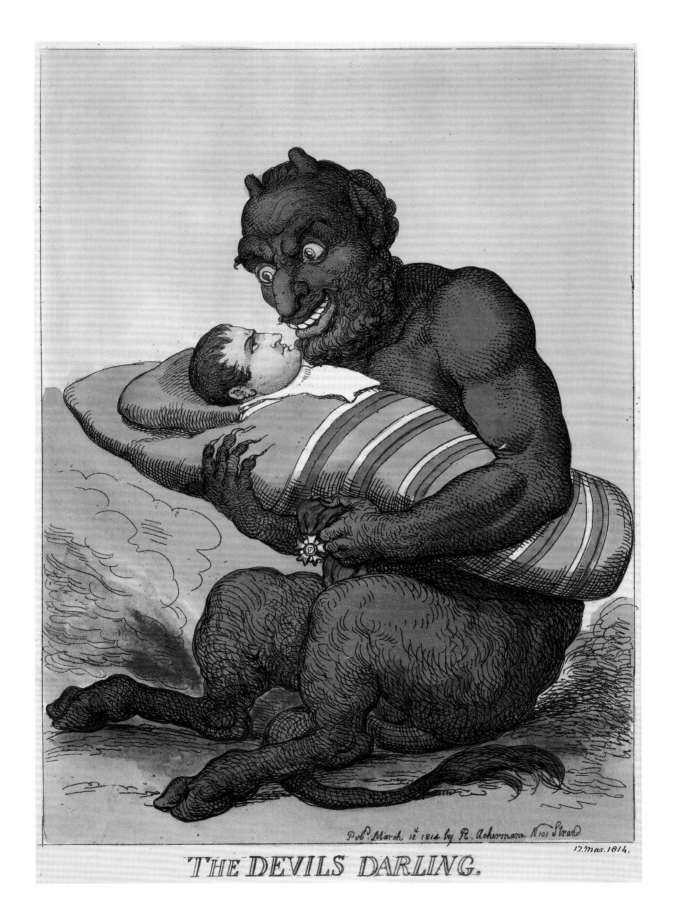

Pub.d March 12.th 1814 by R. Ackermann N.o 101 Strand

12. Mar. 1814.

THE DEVILS DARLING.

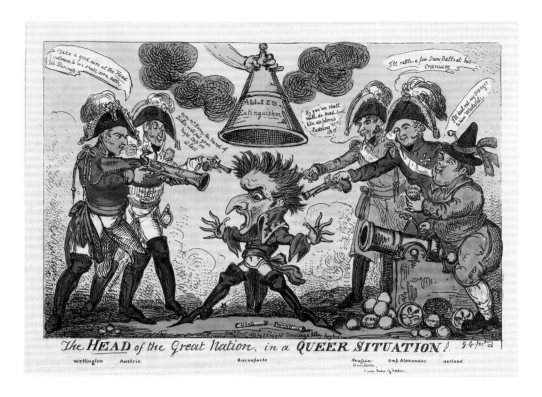

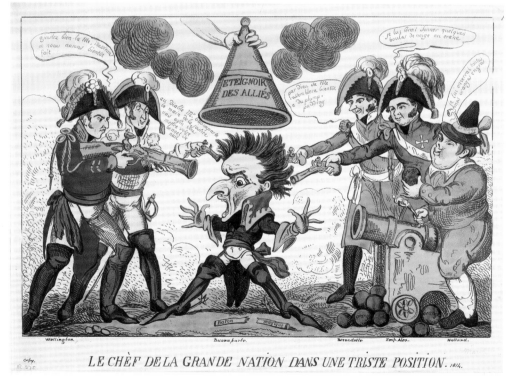

123

George Cruikshank (1792–1878)
The Head of the Great Nation in a Queer Situation
Published by Samuel Knight, December 1813
Hand-coloured etching; 250 x 350 mm
1868,0808.12745; BM Satires 12120
From the collection of Edward Hawkins

124

Anonymous, after George Cruikshank (1792–1878)
Le Chef de la Grande Nation dans une triste position, 1814–15
Hand-coloured etching; 251 x 330 mm
1868,0808.12763; BM Satires 12120.A; de Vinck 8985
From the collection of Edward Hawkins

This is one of many triumphalist satires produced as the wars reached a conclusion. Napoleon stands with legs astride and mouth open as if shrieking. An arm emerging from the clouds above him holds a conical 'Allied Extinguisher' and the leaders of the coalition armies threaten him with various weapons at point-blank range: Wellington is on the left and beside him Francis I, Jean-Baptiste Bernadotte, Crown Prince of Sweden and Tsar Alexander. On the extreme right a conventionally fat Dutchman in brown breeches and a conical hat celebrates the liberation of Holland by firing 'oranges' from a mortar. The extinguisher was a popular motif much favoured by French Royalists.

A number of close copies of anti-Napoleon prints by George Cruikshank appeared in 1813 and 1814 with very literal translations of the English texts.[1] It is likely that they were produced in England for export to France, one of the group is recorded there in May 1814. A contemporary annotation on one of the French versions reads (in French): 'This Caricature and the five following were made in England'.[2]

1 See also BM Satires 12023, 12217 and 12218, and Musée Carnavalet, de Vinck 8595.
2 British Museum PD 1868,0808.12762.

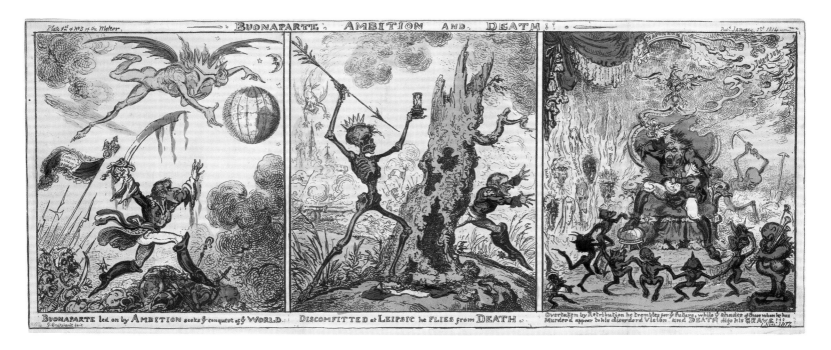

125
George Cruikshank (1792–1878)
Buonaparte! Ambition and death!!
Published by Thomas Hughes, 1 January 1814
Hand-coloured etching; 210 x 510 mm
1868,0808.12751; BM Satires 12171;
From the collection of Edward Hawkins

This scathing summing up of Napoleon's career was an illustration to *The Meteor; or, Monthly Censor. A Critical Satirical and Literary Magazine*, eight numbers of which appeared between 1 November 1813 and 1 July 1814, illustrated with etchings and woodcuts by George Cruikshank. In the first part of the print, Ambition is a demon that lures Napoleon over piles of bloody corpses as he strives to possess the world, shown as a globe floating in the air. In the second part Death appears beside a shattered tree holding up an hour-glass whose sands are running out; he prepares to hurl a javelin at Napoleon who leaps across a swiftly flowing stream (a reference to the disastrous retreat across the River Elster on 19 October 1813). In the background the towers of Leipzig rise beyond the smoke of battle, while high above Ambition falls headlong from the sky. In the third part, Napoleon is in a frenzy of despair. He sits on his throne clutching his son with one hand, and clapping the other to his head as flames lettered 'Justice' strike off his crown. To the left, the ghosts of victims rise from the ground: Johann Philipp Palm, John Wesley Wright, Jean Charles Pichegru, Toussaint l'Ouverture and Enghien; in the foreground two small devils play the fiddle and bagpipes while others dance merrily around the throne.

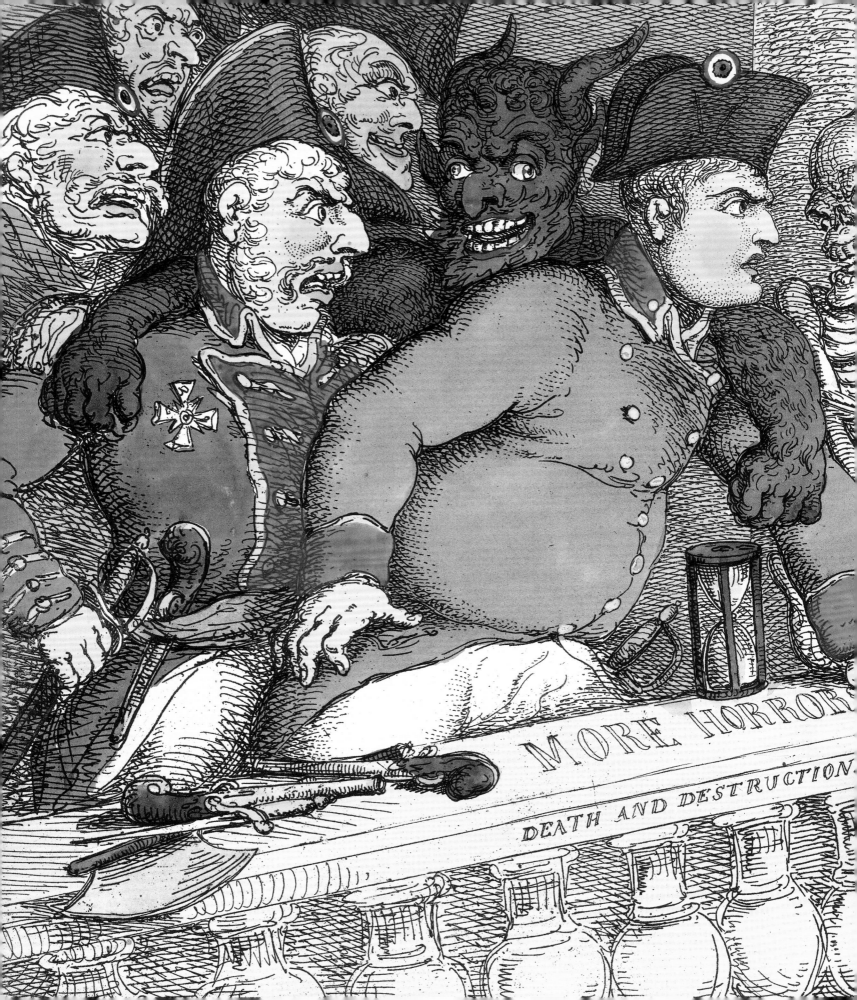

MORE HORROR

DEATH AND DESTRUCTION.

9
Peace of Paris, Elba and Waterloo

The Treaty of Paris, signed on 30 May 1814, brought peace at last. All of Europe celebrated and Napoleon was exiled to the island of Elba off the coast of Tuscany where he was given sovereignty and allowed to retain his title of Emperor. The states of Europe met in Vienna with the aim of creating a new balance of power. Louis XVIII was placed on the throne of France, but his government quickly made itself unpopular.

On 26 February 1815, Napoleon sailed from Elba with a tiny army, landed at Golfe Juan on the Mediterranean coast of France, and marched on Paris. Royalist laughter turned to anguish as first battalions then divisions deserted to the Emperor and he arrived in Paris on 20 March. Despite his pacific overtures, the Congress of Vienna declared its intention to overthrow him finally, and Britain, Russia, Austria and Prussia started the process of mobilizing troops.

In France, Napoleon's reception was mixed: he still commanded the love of the ordinary soldiers and the Bourbons were hated in most regions, but the people dreaded renewed war and there was much scepticism about his prospects. He claimed to have returned to his Republican roots, determined to save the values of the Revolution while offering concessions to liberals; he would drive out aristocrats and princes and defend France against foreign invaders. In Britain the ministry saw war as inevitable, but there was little enthusiasm for it and some voiced the opinion that if the French wanted to have Bonaparte for their ruler it was not Britain's business to stop them.

Britain reinforced its small army in the Netherlands where the Prussians under Prince Blücher joined the Duke of Wellington, and they waited for the Austrians and Russians to get into position for a simultaneous invasion of France. But Napoleon launched a surprise attack crossing the border into what is now Belgium on 15 June. The next day the main body of his army defeated the Prussians at Ligny while a left wing held off Wellington at Quatre Bras. Wellington retreated to a new position near the village of Waterloo, and the final battle was fought on 18 June 1815.

126

George Cruikshank (1792–1878)
*A Grand Manoeuvre! or, The Rogues March to the Island
of Elba*
Published by Thomas Tegg, 13 April 1814
Hand-coloured etching; 259 x 353 mm
1859,0316.72; BM Satires 12221

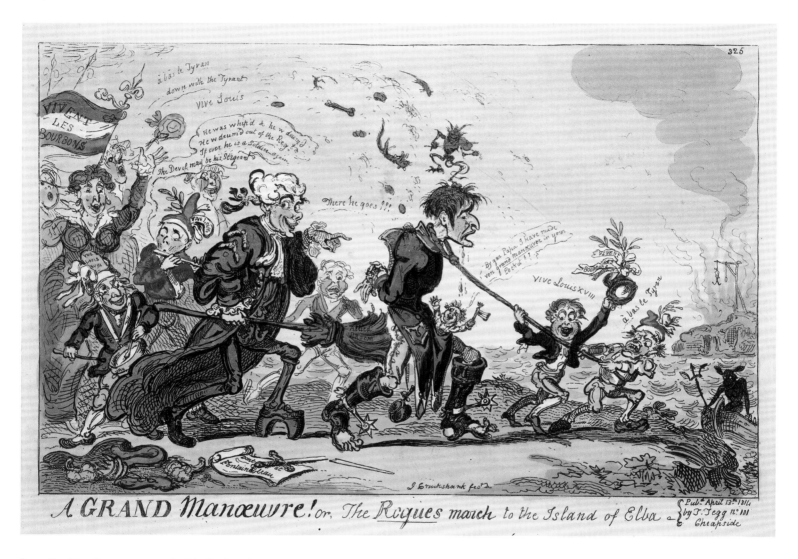

In reality Napoleon was treated with dignity after the abdication
on 6 April 1814 and retained his title as Emperor, but in this print
published only a week later (and another week before Napoleon
left Paris), George Cruikshank shows him dragged off by urchins
to a boat which a devil will row to Elba, a fiery island where a
gallows awaits him. His son is in his coat pocket and cries out,
'By gar Papa I have made von grand manoeuvre in your pocket!!'
Talleyrand, identified by the surgical shoe on his left foot, pushes
his former leader forward with a broom, and a rowdy crowd of
Royalists follows. Talleyrand had lost faith in Napoleon in 1807, left
government and intrigued with the Emperor's enemies. He led
the Senate that forced Napoleon's abdication and negotiated for
Louis XVIII at the Congress of Vienna.

The procession is the humiliating 'rogue's march' of the
disgraced soldier who is drummed out of the regiment, a halter
around his neck, his coat worn inside out and his hands tied
behind his back. The fifer behind Napoleon sings the song that
accompanied the ritual:

He was whipped and he was drummed
He was drummed out of the Regiment
If ever he is a Soldier again
The Devil may be his Sergeant.

127
Print made by George Cruikshank (1792–1878)
Little Boney Gone to Pot
Hand-coloured etching; 235 x 325 mm
Published by Thomas Tegg, 12 May 1814
1868,0808.12780; BM Satires 12261
From the collection of Edward Hawkins

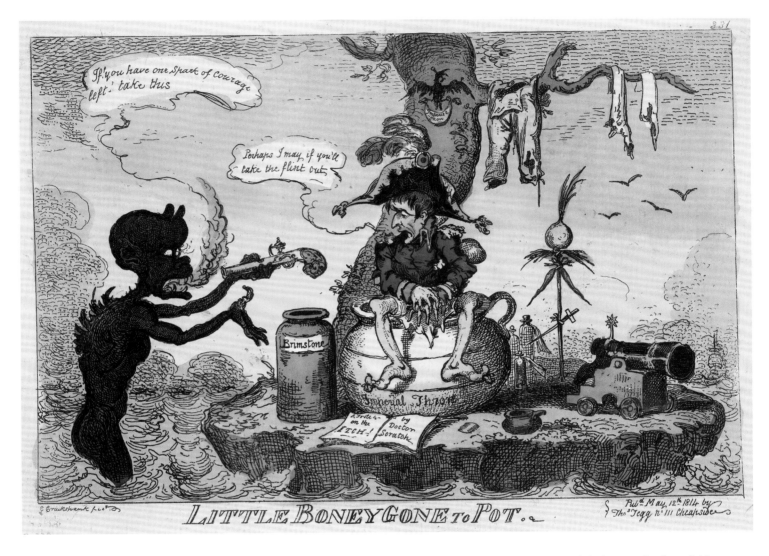

The fertile island of Elba is shown as a flat-topped rock emerging from the sea only a little above the waves. Napoleon, who in fact set about improving local administration and draining the marshes, sits on an 'Imperial Throne' consisting of a huge chamber-pot, contemplating suicide as a demon rises from the sea to offer him a large pistol. Napoleon had attempted suicide on the night of 12 April by taking poison that he had acquired in 1812 in case he was captured by Cossacks, but over two years it had lost its potency and merely made him ill.

Neither George Cruikshank nor Thomas Tegg could have known of a letter written by the eighteen-year-old Thomas Carlyle to a fellow student on 30 April 1814, but it expresses the same sentiments in similar terms:

Were I disposed to moralise, there is before me the finest field that ever opened to the eye of mortal man. – *Nap the Mighty*, who, but a few months ago, made the sovereigns of Europe tremble at his nod; who has trampled on thrones and sceptres, and kings and priests and principalities and powers, and carried ruin and havoc and blood and fire, from Gibraltar to Archangel – *Nap the Mighty* is – *gone to pot*!!![1]

1 Letter to Robert Mitchell, *The Carlyle Letters Online* [*CLO*]. Brent E. Kinser (ed.), Duke UP 14 Sept. 2007. carlyleletters.dukejournals.org.

128
Godisart de Cari (active 1803–29)
L'Arrivée
Published by Aaron Martinet, February 1815
Hand-coloured etching; 203 x 265 mm
1868,0822.7249; BM Satires 12361
Bequeathed by Felix Slade

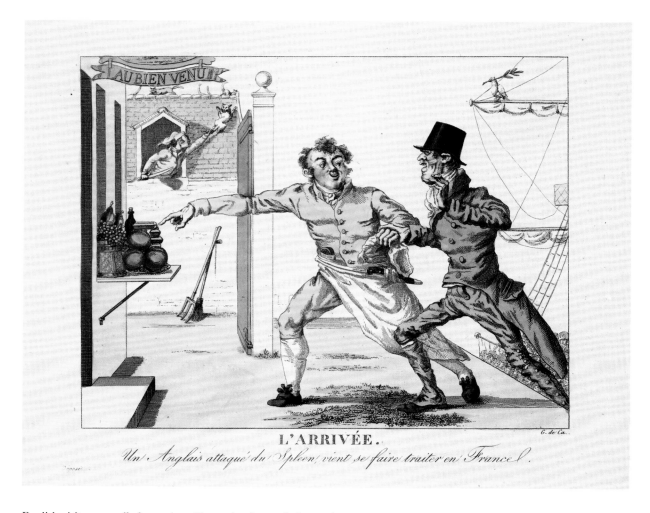

L'ARRIVÉE.

Un Anglais attaqué du Spleen, vient se faire traiter en France.

English visitors travelled eagerly to France in 1814 and 1815 as they had done in 1802. A market developed for prints mocking them for their gluttony, bad manners, gauche behaviour and terrible dress sense, and no doubt with some reason – even the earnest Benjamin Robert Haydon (see cat. 161) admitted that he and fellow artist David Wilkie got drunk and sang 'God save the King' in the streets.[1]

This pair of prints tells the story of an Englishman's life-changing encounter with French hospitality. He disembarks at Calais in a distressed state of mind, wearing clothes that hang around his angular person. A French cook directs him to a welcoming inn

129
Godisart de Cari (active 1803–29)
Le Départ
Published by Aaron Martinet, October 1814
Hand-coloured etching; 200 x 265 mm
1868,0822.7250; BM Satires 12362
Bequeathed by Felix Slade

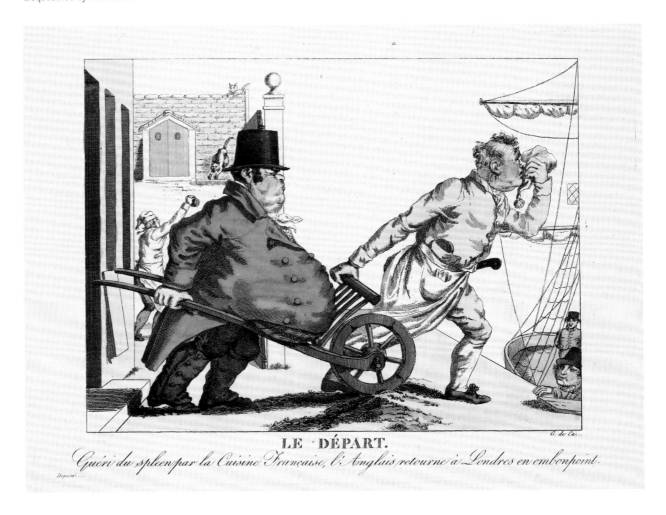

LE · DÉPART.

Guéri du spleen par la Cuisine Française, l' Anglais retourne à Londres en embonpoint.

where an array of peaches, grapes and pears is awaiting him. In the second print, he has been cured of his melancholy by '*la Cuisine Française*', but is now so grossly obese that his paunch has to be supported on a wheelbarrow as the cook leads him back to the boat for England.

The caricaturist, Godisart de Cari, was identified in 1803 as a former soldier.[2] The plates were listed in the *Bibliographie de la France* in reverse order, *Le Départ* in the issue for 12 November 1814 (p. 345, no. 744) and *L'Arrivée* in the 1 February 1815 issue (p. 91, no. 113) as '*chez Martinet*'.

1 Haydon 1926, I. p. 176.
2 De Vinck, no. 7616.

130

Jean Alphonse Roehn (1799–1864)
Amusements des Anglais à Paris
Published by Jean Roehn, 12 November 1814
Hand-coloured etching; 227 x 229 mm
1861,1012.386; BM Satires 12354
Presented by Henry W. Martin

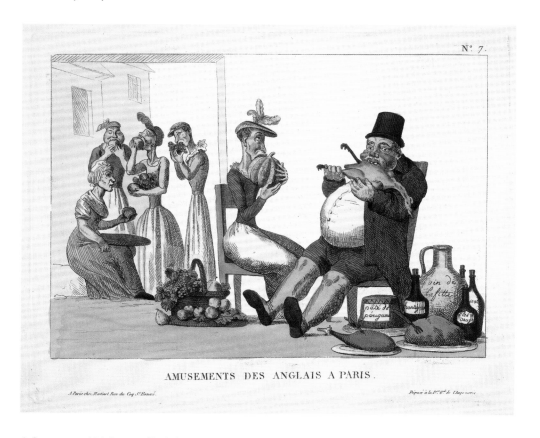

AMUSEMENTS DES ANGLAIS A PARIS.

A fat man and his bony wife sit in their outdoor clothes taking huge bites at, respectively, a whole chicken and a whole melon. They are clearly overwhelmed by the delights of food that is not to be tasted at home. On the ground beside the woman's chair is an overflowing fruit basket, and beside the man are plates with joints of meat, a huge *pâté de périgueux*, a flagon of '*vin de Lafitte*' and four other bottles. Three other grotesque Englishwomen can be seen through an open doorway gorging on fruit, having purchased all the stock of a modest street-seller who offers them her last peach. The women wear small caps with large feathers, and the man the 'flower-pot' hat seen in cats 128–129.

The print is number 7 in a series of which earlier plates carry the title *English Scenes drawn in London by a French prisoner of war*. The scenes of London life show men indulging in excessive drinking, attending boxing matches, reading sentimental poetry and committing suicide; women are plain, bored and neglected, and a husband holds out smelling salts to his horse while his wife who has been thrown lies fainting, attended by her groom.

This plate was listed in the *Bibliographie de la France* for 12 November 1814 as published by Jean Roehn, 12 rue de Seine.

131

Anonymous

La famille Anglaise au Museum à Paris

Published by Geneviève Chéreau, 17 September 1814

Hand-coloured etching; 219 x 384 mm

1989,1104.13; BM Satires 12354

Presented by Henry W. Martin

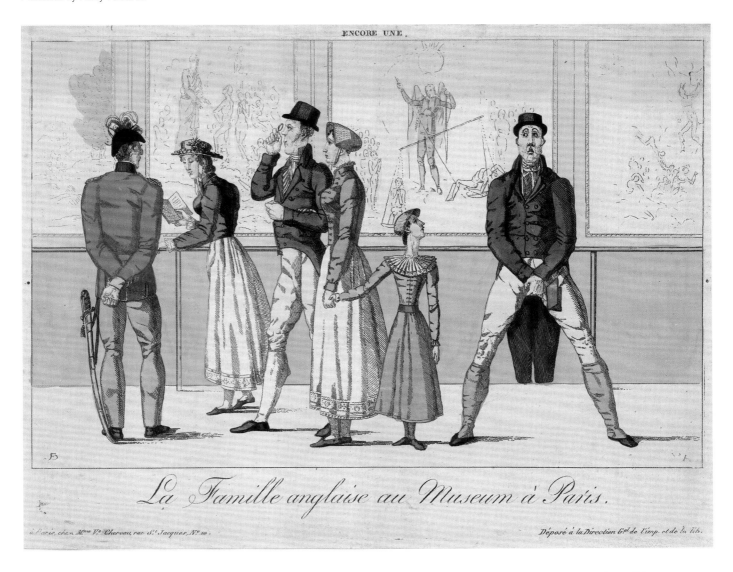

ENCORE UNE.

La Famille anglaise au Museum à Paris.

One of the great sights of Paris in 1814 was the Louvre where Napoleon had assembled most of the paintings and other treasures acquired through treaties signed after his conquests (see cat. 9). Louis XVIII had retained Napoleon's 'plunder' and the paintings, statues and other treasures that France had garnered were not returned to their original owners until after the Battle of Waterloo. The satirist here shows the English visitors as standing bored and confused in front of the paintings in the Louvre, and many ordinary visitors no doubt did so, but British artists and connoisseurs were thrilled to see paintings that they knew only from prints. Benjamin Robert Haydon describes how he 'flew up three steps at a time, springing with fury at each remembrance of a fine picture'.[1]

This bringing together of great objects from different contexts was an inspiration for the nineteenth-century concept of the universal museum. Earlier museums had been based on the personal collections of monarchs and aristocrats, scholars and aesthetes. Napoleon introduced the notion of a collection of treasures as a public asset that conferred prestige on the nation. The desire to emulate Napoleon's Louvre was at least part of the motive for parliament's support of the development of the British Museum and the commissioning of the building designed by Robert Smirke in the 1820s.

1 Haydon 1926, I. p. 178.

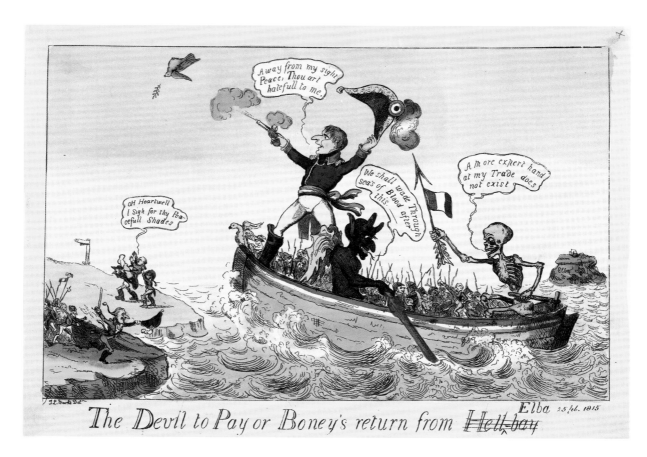

The Devil to Pay or Boney's return from ~~Hell-bay~~ Elba 25 feb. 1815

132

John Lewis Marks (c. 1796–1855)
The Devil to Pay or Boney's Return from [Hell-bay] Elba
March 1815(?)
Hand-coloured etching; 243 x 348 mm
1868,0808.8184; BM Satires 12516
From the collection of Edward Hawkins

Napoleon left Elba on 26 February 1815 on his brig *Inconstant*, accompanied by seven smaller boats and a force of around 1,000 men. Lewis Marks shows him standing in the bows of a dinghy shooting down the dove of peace. The Devil rows the boat, anticipating with delight: 'We shall wade through seas of Blood after this'. Death, holding the rudder, agrees: 'A more expert hand at my Trade does not exist'. The boat is crammed with his tiny army. On shore, a troop of delighted soldiers rushes to greet Napoleon, while in the distance two Frenchmen carry off the fat gouty King Louis who sighs, recalling the peace of his exile at Hartwell, Buckinghamshire. The print was probably published after news had reached England of the king's nocturnal flight from Paris on 20 March, just hours before Napoleon's arrival there. This far from flattering depiction of the king shows that a caricaturist who depicted Napoleon as a bloodthirsty villain was not necessarily a supporter of a Bourbon restoration.

Marks was aged only nineteen in 1815, and like many others he was inspired by the market for prints of Napoleon. The British Museum collection includes a dozen caricatures dealing with the events of the final year of the war that he made for publishers such as Thomas Tegg and Samuel Knight; he went on to publish many political satires in his own right.

133

Thomas Rowlandson (1757–1827)
Hell Hounds Rallying Round the Idol of France
Published by Rudolph Ackermann, 8 April 1815
Hand-coloured etching; 260 x 361 mm
1868,0808.8207; BM Satires 12527
From the collection of Edward Hawkins

On 8 April 1815 when this print appeared, there were mixed feelings in France over Napoleon's return, but with few exceptions the military was on his side. Mobilization was ordered against the massive allied armies preparing to invade France. Rowlandson portrays Napoleon's generals and ministers as half-human 'hell hounds' dancing around a colossal bust of the emperor that emerges from a mound of decollated human heads. Two demons fly towards him holding a burning wreath with the inscription: 'He deserves a Crown of Pitch'. Another demon gallops through the air on a goat, blowing a horn. In the foreground lie dead and dying soldiers, one is decapitated, another is naked and holds out his severed arm towards Napoleon. In the background soldiers are feeding a bonfire with 'English Goods' (an aspect of Napoleon's Continental blockade from which the publisher Rudolph Ackermann may well have suffered).

The German version of this design (right, below) has been thought to be a copy of the Rowlandson.[1] We believe it more likely that the inspiration was the other way round and that the subject of the German print is the end of the armistice between Napoleon and the allies on 15 August 1813, celebrated by the dancing French 'hell hounds' who cheer at the coincidence that war begins again on Napoleon's birthday. Napoleon had, in fact, decreed that his birthday should be celebrated by his troops a week early because he expected hostilities to recommence on 15 August. Ackermann had already employed Rowlandson to copy several German prints and he would have noticed the suitability of this design for adaption to present circumstances. This would explain the unusually dark tone of the Rowlandson.

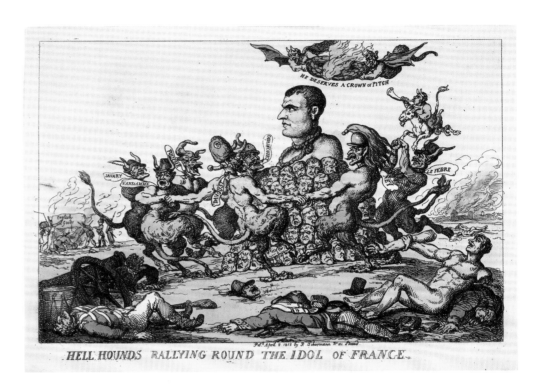

HELL HOUNDS RALLYING ROUND THE IDOL OF FRANCE.

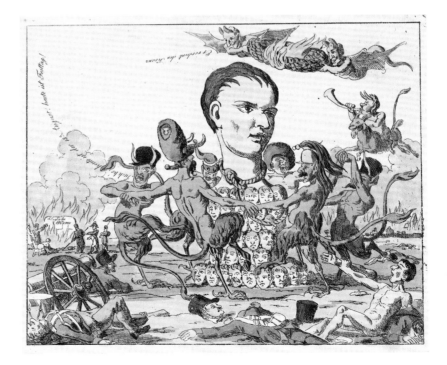

Devils dancing around Napoleon
German, 1813
Hand-coloured etching:
166 x 201 mm
British Museum,
1989,1104.124

1 Scheffler 1995, cat 7.4.

134

Thomas Rowlandson (1757–1827)
The Corsican and his Blood Hounds at the Window of the Tuilleries
Published by Rudolph Ackermann,
16 April 1815
Hand-coloured etching; 240 x 344 mm
1868,0808.8210; BM Satires 12529
From the collection of Edward Hawkins

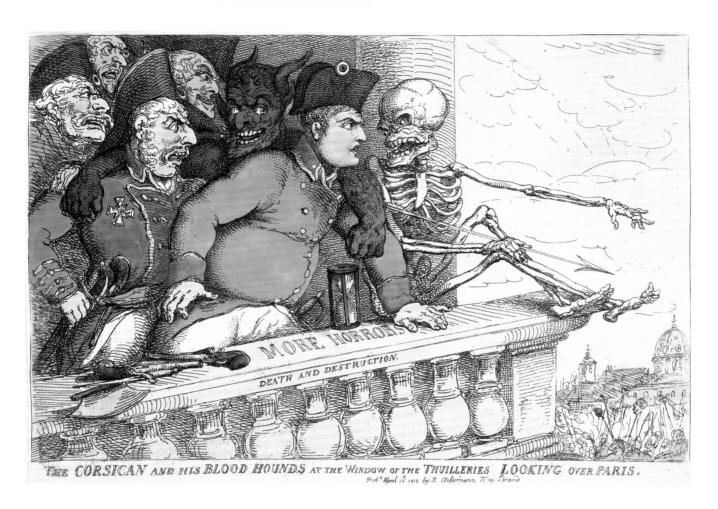

THE CORSICAN AND HIS BLOOD HOUNDS AT THE WINDOW OF THE THUILLERIES LOOKING OVER PARIS.

A week after the emblematic *Hell Hounds Rallying Round the Idol of France*, Ackermann published this print by Rowlandson in a quite different mode. The treatment is the more typically British one of heightened reality. Napoleon stands on a balcony, looking across Paris. He is portrayed naturalistically, although accompanied by the Devil and Death and by four generals whose features are caricatured. The street is filled with a mob carrying severed heads on pikes, an image – to the British audience – reminiscent of the worst days of the Revolution. Napoleon appears anxious, but the Devil is thrilled, and the atmosphere is ominous.

135

William Dickinson (1746–1823) after
François Gérard (1770–1837)
Napoleon Bonaparte
Published by William Dickinson 6 April 1815
Mezzotint; 405 x 298 mm
1902,1011.659
Bequeathed by William Meriton Eaton,
Baron Cheylesmore

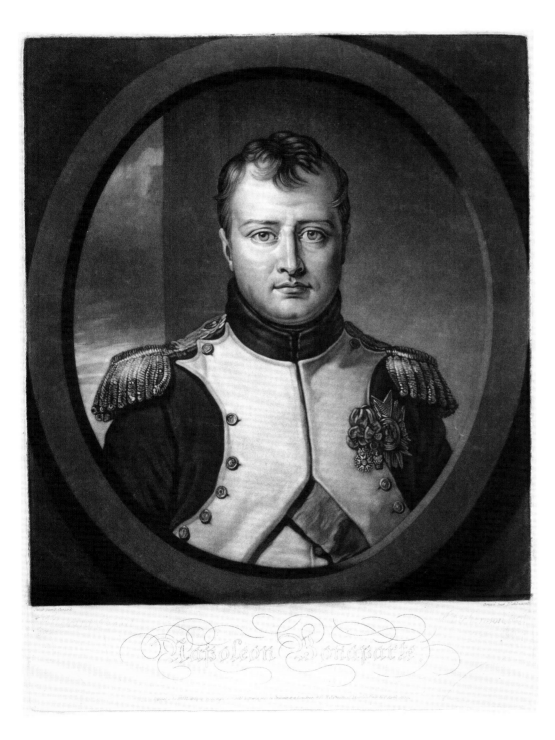

The publication line beneath this portrait states
that it was published jointly by William Dickinson
in Paris, and by F.J. Smith in London, just two-
and-a-half weeks after Napoleon returned to his
capital. Mezzotints can be produced quickly, and
nineteen new portraits of Napoleon were listed in
the issues of the *Bibliographie de la France* for March
and April 1815, together with views of his landing
and his entry into the capital. It is also possible
that Dickinson reissued an earlier print to meet
a new demand, but against that theory it could
be argued that this fine proof looks too clean
and fresh to be a reprint. F.J. Smith has not been
identified as a London publisher, and his name
may be fictitious: traces of an earlier address can
be seen below the present lettering of that name,
though the remainder of the publication line has
not been altered.

Dickinson made a number of mezzotints
after François Gérard, one of Napoleon's
favourite painters. The painting on which this
print was based is now in the Napoleon Museum
at the Arenenberg Castle, Salenstein.

136

Jean Baptiste Joseph Duchesne
de Gisors (1770–1856) after
Robert Lefèvre (1755–1830)
Snuff box inset with miniature of
Napoleon bordered with diamonds in
silver settings
Enamelled gold, the portrait painted
on ivory; 83 × 58 × 20 mm
1828,1111.1
Bequeathed by the Hon Mrs Anne
Seymour Damer

Diplomatic gifts were as important for Napoleon as any other ruler and during his first year as Consul he directed that 'the customary present from the French government to foreign ministers will be a gold box … decorated with diamonds.' Prices for different levels of recipients were originally capped at sums between 5,000 and 15,000 francs (about £200 and £600 respectively), but during the Empire more than 30,000 francs were spent on the most important gifts.[1] The diamonds were a potentially valuable cash gift, as it was assumed that they would often be replaced with paste. The fact that the diamonds on this box were not replaced is significant.

An engraved gold oval plaque inside this box records how it came to be given to the English sculptor, Mrs Damer:

This box was given by the Emperor Napoleon of France to the Honorable Anne Seymour Damer as a 'souvenir' (the word he used) in consequence of her having presented him with a bust of Mr. [Charles James] Fox executed in Marble by herself. The bust had been promised at the Peace of Amiens, was finished 1812 and sent to France where it remained but was not presented till May 1st 1815 when by command of His Imperial Majesty Anne Seymour Damer had an audience for that purpose at the Palais Elysée where the Emperor then resided.

This was not Mrs Damer's first meeting with Napoleon. She had met the then Consul and Josephine when she had gone to Paris in 1802 with the chief intention of presenting the Consul with a terracotta bust of Charles James Fox. Joseph Farington recorded in his diary on 11 September of that year that he had seen that bust of Napoleon's famous British supporter, together with one of Nelson, one of his greatest adversaries, when he had visited the private apartments at the Tuileries.

John Cam Hobhouse described Mrs Damer's second meeting with Napoleon and the presentation of the marble bust of Fox (now at the Château of Malmaison) in his diary on Tuesday 2 May 1815:

[I] called on Mrs Damer, who gave an account of an interview she had yesterday with Napoleon. Three years ago she sent a bust of Mr Fox by herself to Paris for the Emperor. The man who brought it got into disgrace – the bust was not delivered. She comes to Paris just as Napoleon comes, and contrives to find her bust, which is unaltered except that the inscription, Napoleon Empereur et Roi, is scratched out. She contrives to get it presented through Denon – she is at first mistaken for an artist who wants to sell it – the appointment was for the Elysée Napoleon at ten – she goes there, and waits till twelve, when she is shown through a dark passage into a room in which she finds Napoleon standing at a table, on which stood the bust. The Queen of Holland [Hortense de Beauharnais, Napoleon's stepdaughter] was standing at a little distance. Napoleon received her very graciously; he said the bust not only showed the face of Mr Fox, but the mind: 'It was the man'. He praised the original, said had he lived much blood would have been saved. He talked of his own pictures – Mrs Damer told him she had seen none like him. He asked if she had seen Canova's naked statue – she said yes, but did not think it resembling, nor good – 'You are right,' he said. He asked her opinion of David – they talked ten minutes – he asked her to what family she belonged – she said the chief of her father and mother's were the Dukes of Argyle and Somerset. This, she said, he contrived to ask to do away the mistake respecting her trade in marble. He asked about the story of the Duke of Bedford – knew his name was Russell. The Queen Hortense spoke not at all. She (Mrs Damer) curtsied backwards out of the room. Napoleon asked her when she came to Paris. She answered, 'About the same time as your Majesty'. He smiled, and added, 'N'avez-vous pas peur de moi?' [Are you not afraid of me?] to which she answered, 'Non, Sire – les grands hommes n'effrayent pas' [No, Sire, great men are not frightening], an answer with which he was satisfied….[2]

1 K. Huguenaud, 'The Emperor's presentation boxes', in T. Gott et al., *Napoleon: Revolution to Empire*, Melbourne 2012, p. 202.
2 petercochran.files.wordpress.com.

137

Pierre-Philippe Thomire (1751–1843)
after Antoine Denis Chaudet
(1763–1810)
Two eagles of National Guard
regiments with their flags
Eagles; gilt bronze; Height:
approximately 210 mm
Flags, silk embroidered with silver
thread; approximately 1000 x 1000 mm
On loan from Apsley House, The
Wellington Collection, English Heritage

The eagle, symbol of Jupiter and standard of the Imperial Roman legions, was adopted by Napoleon when he became Emperor. The eagle was sacrosanct, a rallying point for troops, to be defended and preserved at all costs. Examples appear in many of the prints shown in this exhibition. As with everything connected with the promotion of his public image and that of his regime, eagles and their flags were produced to the highest quality.

There were three main distributions of eagles, all based on designs by Antoine Denis Chaudet and cast by Pierre-Philippe Thomire. On 5 December 1804, shortly after his coronation, Napoleon presented more than 1,100 eagles in a spectacular ceremony at the *Champs de Mars*. In 1810–11 slightly lighter versions were designed. The majority of these were destroyed by Louis XVIII when he came to power in 1814, although some Bonapartist colonels succeeded in hiding their eagles. On his return the following year, Napoleon ordered a third version to be cast. More than 200 were presented to army regiments on 1 June at the *Champs de Mars*, and 87 to the National Guard of each *départment* on 4 June at the Tuileries. After Waterloo, Louis XVIII presented 67 of the eagles of the National Guard and their flags to the Duke of Wellington.

CONFLICTING BRITISH VIEWS

The international powers meeting in Vienna at the time of Napoleon's return to France immediately prepared for war and Wellington soon left Austria to join his army in the Netherlands. But feelings were not so certain at home. Whereas in 1803 the government had succeeded, more or less, in uniting the country against Bonaparte and in favour of war, in 1815 voices were no longer undivided. Before the unexpected successes of 1813 there had been a gradual hardening of feeling against the apparently endless and unsuccessful war. In 1811 the principled and popular George III had become physically and mentally incapable of ruling and the unprincipled and unpopular Prince Regent took over. Critics saw government placemen filling the Commons to secure majorities; the Opposition press became stronger and more outspoken against corruption.

William Cobbett (1763–1835) was the son of a farmer and publican. He served in the army for eight years and produced his first publication as a result: a pamphlet entitled *The Soldier's Friend* (1792) complaining about the harsh treatment and low pay of the lower ranks. Believing that he might be arrested, he fled to France and then to the United States where, as 'Peter Porcupine', he threw himself into journalism of an anti-Jacobin stance, writing violently against Thomas Paine. After losing a libel case against a physician he fled back to Britain where, in 1801, he founded the long-running *Political Register*, a journal partly funded by William Windham whose warlike anti-Jacobin views Cobbett shared. Despite his opposition to the peace terms, the violence of the government-inspired attacks on the apparently moderate and meritocratic First Consul seems to have been one of many factors that turned Cobbett against the establishment by 1804.[1] He was increasingly alarmed by Pitt's financial measures, use of placemen and promotion of financiers in order to sustain an endless and unsuccessful war. In 1810 he was found guilty of treasonous libel after objecting in the *Political Register* to the flogging at Ely of local militiamen by Hanoverians and was imprisoned for two years in Newgate, becoming in the process the hero of the Radicals.

Gillray's eight-plate *Life of Cobbett*, published while Cobbett was awaiting trial for sedition, was about as accurate as his life of Bonaparte (cat. 37). In plate 7, Cobbett is seen with other radicals drinking 'Damnation to the House of Brunswick' beneath a portrait of Napoleon and busts of Robespierre and Edward Despard who had been executed in 1803 for planning a coup d'état; Despard was involved with Irish revolutionary groups and French agents but the evidence of the conspiracy is still uncertain.[2] Cobbett noted on 19 November that 'ministers and their partizans have been employed for more than six months publishing libels of me' and 'that there were caricatures prepared under the eye of Canning &c.'[3] Since Gillray signed the plates '*invenit et fecit*' the involvement of Canning's cronies may have been slight.

1 Cobbett 1802–36, IV, pp. 706–13.
2 M. Elliott, 'The "Despard Conspiracy" Reconsidered', *Past and Present*, LXXV, May 1977, pp. 46–61.
3 Letter to John Wright (British Library Add MS 22,907 f.215) in Hill 1965, p. 117.

138

James Gillray (1756–1815)
The Life of William Cobbett. No 7
Published by Hannah Humphrey, 29
September 1809
Hand-coloured etching; 420 x 226 mm
1851,0901.1281; BM Satires 11378
Presented by William Smith

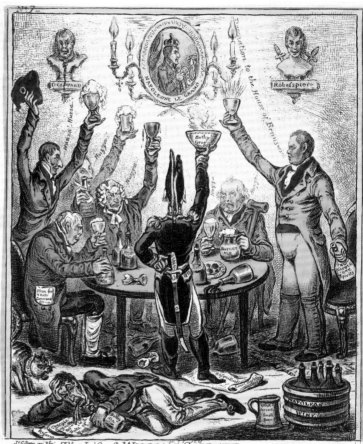

139

Charles Williams (active 1797–1830)
Modern Idolatry – or – Editors and Idols
Published by William Naunton Jones, 1 April 1814
Hand-coloured etching; 216 x 525 mm
1868,0808.12769; BM Satires 12207
From the collection of Edward Hawkins

The Scourge, or Monthly Expositor of Imposture and Folly was published monthly from 1811 to 1815 by William Naunton Jones of Newgate Street, London, working with a printer known only as M. Jones in nearby Green Arbour Court. Each issue had a fold-out frontispiece dealing with current political events, but the articles in the journal were a mixture of news and entertainment as well as political comment. According to an editorial of 29 November 1811, *The Scourge* aimed to take a middle way, 'equally detesting the subservience of the Ministerial Journals, and despising the fury of the Burdettite scribblers'.

This caricature was the frontispiece to the April 1814 issue, appearing at the point of Napoleon's defeat. It is explained in a mock letter in the journal purporting to be from a man who is visiting London from the country and finds conflicting reports in the newspapers he picks up in a coffee house:

> I was much surprized, however, upon looking into the Chronicle, to find that Bonaparte, whom I hate as I do the devil, was conquering on all sides, and raising Armies by the mere influence of the love which the people bore him. I could not help growling out an imprecation upon Frenchmen for the baseness, and wishing them nothing but wooden shoes and frog broth for the next century. Luckily, however, my chagrin was a little dissipated by taking up the Courier, who pronounced the downfall of Napoleon, and the restoration of the Bourbons, as an event certain to take place…. I happened to look into the Morning Post, which was lying before me, and there, to my great astonishment, I found that Lord Liverpool was for making peace with Bonaparte. This threw me into a fresh fit of despondency, from which I was relieved by the Times, who, in good old English, railed at the Corsican, and called him ruffian, murderer, tyrant, upstart, despot, &c…. (see cat. 140)

The writer falls asleep and sees in his dream journalists with their idols, as illustrated in Charles Williams's print. The ministerial press is on the left: *The Times* at the feet of Bellona and Marquis Wellesley who wears Indian dress (Wellington's elder brother, the former Governor-General of Bengal had vastly expanded British power on the sub-continent), the *Morning Post* addressing Lord Liverpool, then Prime Minister, the *Morning Herald* adoring the prince regent, the *Courier* in front of Mammon, the chief of all the idols ('Glorious News, the allies at Paris, Bonaparte killed! … I shall sell eleven thousand to day!'). The remaining journals were anti-war, anti-Bourbon and to some extent pro-Napoleon: the *Monthly Magazine* and the *Statesman* at the feet of the 'Imperial Fugitive', William Cobbett's *Political Register* below the figure of Francis Burdett, the *Morning Chronicle* lamenting the downfall of the Whigs. On the far right John Bull stands beside the figure of Peace raging, 'I'm bamboozled … the highest bidder has you all!!!'

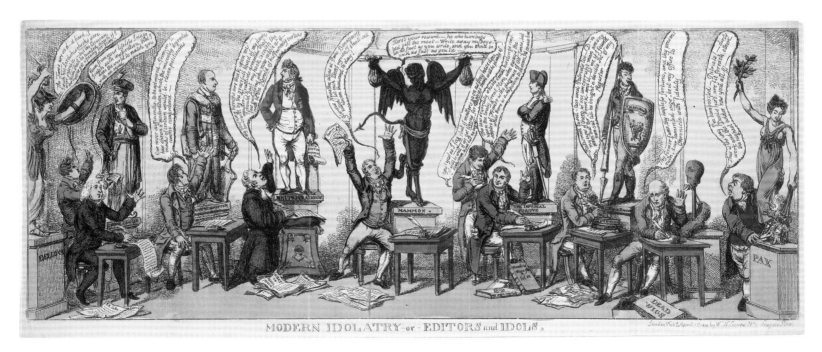

MODERN IDOLATRY-or-EDITORS and IDOLS.

Buonaparte-phobia, or Cursing Made
Easy to the Meanest Capacity
Published by William Hone, May 1815
Letterpress with etched and stipple
illustration; 547 x 285 mm
1866,0407.987; BM Satires 12545

A year after *The Scourge*'s attack on *The Times* and
other newspapers, the radical publisher William
Hone again takes issue with the bellicose attitude
of *The Times* editor John Stoddart. There was
much disquiet in political and literary circles
at Stoddart's extravagant attacks on Napoleon.
The broadside takes the form of a tirade by Dr
Slop, the incompetent High-Tory man-midwife
of Laurence Sterne's *Tristram Shandy*. Slop's
speech incorporates 'easy epithets and choice
curses against Buonaparte' all of which had been
published by Stoddart in *The Times* in the two
months since Napoleon's departure from Elba.
In the 1820s Hone returned to Stoddart (then
running his own *New Times*) in a mock newspaper
and series of pamphlets entitled *A Slap at Slop*.

The illustration on this sheet is taken from
the portrait by Jacques-Louis David of Napoleon
in his study at the Tuileries (now in the National
Gallery of Art, Washington), which was painted
for Alexander Douglas, future Duke of Hamilton,
in 1812 for a fee of 1,000 guineas.[1] Douglas was a
great art collector and an admirer of Napoleon:
the sale of his collection in 1882 included a
bust by Bertel Thorvaldsen, given to him by
Pauline Bonaparte, Sèvres vases with portraits of
Napoleon's sisters and a ring with the emperor's
initial. At least one print was made after David's
painting before it left Paris[2] and a number of
others appeared in London in 1815.[3] Hone
advertises larger engraved versions at 1s. 6d.

1 A. Schnapper and A. Sérullaz, *Jacques-Louis David 1748–1825*,
 Paris 1989, pp. 474–7.
2 British Museum PD 1917,1208.3784.
3 See, for instance, British Museum PD 1850,0211.106.

Second Edition, Corrected----Price One Shilling.

With the *PORTRAIT OF NAPOLEON AS HE NOW IS*; from the fine original Picture painted by the celebrated DAVID.

BUONAPARTE-PHOBIA, or
Cursing made Easy

TO THE MEANEST CAPACITY:---*A DIALOGUE*
Between the EDITOR of " The Times,"---DOCTOR SLOP, MY UNCLE TOBY, & MY FATHER;
EMBRACING,

The Times

VOCABULARY of Easy EPITHETS, and choice CURSES, against BUONAPARTE--from his leaving
Elba; shewing HOW TO NICKNAME AND CURSE NAPOLEON, to the best advantage, upon
all occasions; being the approved terms regularly served up for some time past, in many respectable Families, with
the Breakfast apparatus: (Designed FOR THE USE OF MEN, WOMEN, & CHILDREN, of "all Ranks
& Conditions," throughout his Majesty's Dominions of England & Wales, & the Town of Berwick upon Tweed.)

By the Editor of " The Times:"

EXHIBITING THE ELEGANT PHRASEOLOGY OF THAT EMINENT LEADER OF PUBLIC OPINION.

SCENE, a Room at DOCTOR SLOP'S in Doctors' Commons.—Present, DOCTOR SLOP, MY FATHER, and MY UNCLE TOBY.

DAVID'S PORTRAIT OF **Napoleon**, AS HE NOW APPEARS.

Printed for W. HONE, 55, FLEET STREET, and sold by E. WILSON, 88, CORNHILL, and by all Booksellers, Printsellers, Stationers, and Newsmen,
throughout the United Kingdom.—FINE PROOFS OF THE PORTRAIT, Price 1s. 6d. worked separate, in Royal Quarto, before the Plate was reduced.

[TO BE CONTINUED OCCASIONALLY—SHOULD THE EDITOR OF THE TIMES RETAIN HIS FERTILITY.]

141

George Cruikshank (1792–1878) after
George Humphrey (1773–1831)
A New Way to Enforce an Argument!!!!!
Published by Hannah Humphrey, 3 May 1815
Hand-coloured etching; 370 x 280 mm
1859,0316.98; BM Satires 12538

Parliament was divided on the question of war, although members in favour vastly outnumbered those against. One who never faltered in his opposition was Samuel Whitbread, an important ally of Charles James Fox against return to war in 1803, who continued to make demands for peace negotiations over the next decade. Whitbread was the son of the famous brewer and was not allowed to forget the family business: Cruikshank has dressed him as a drayman with an apron carrying a large mug of beer. The scene is a debate on 20 April 1815 on the subject of Napoleon's return to France when the Opposition was infuriated by Castlereagh's refusal to give an account of current negotiations in Vienna. Whitbread's powerful, but sometimes barely controlled, oratory is caricatured as a physical attack and his furious speech is quoted verbatim: 'I do insist that those who justified their own misdeeds by their success would also allow the misdeeds of others to be justified by their success, and they who could swallow Copenhagen down, might well swallow the recapture of Paris and the Imperial Throne' (a reference to the British bombardment and burning of Copenhagen in September 1807 – a pre-emptive strike designed to prevent the possibility of Danish naval support for Napoleon). On 28 April, Whitbread's motion against a war to destroy Napoleon was rejected by 273 votes to 72 and the following months saw him in a state of increasing agitation as financial problems piled on his political dilemma. On 6 July he killed himself.

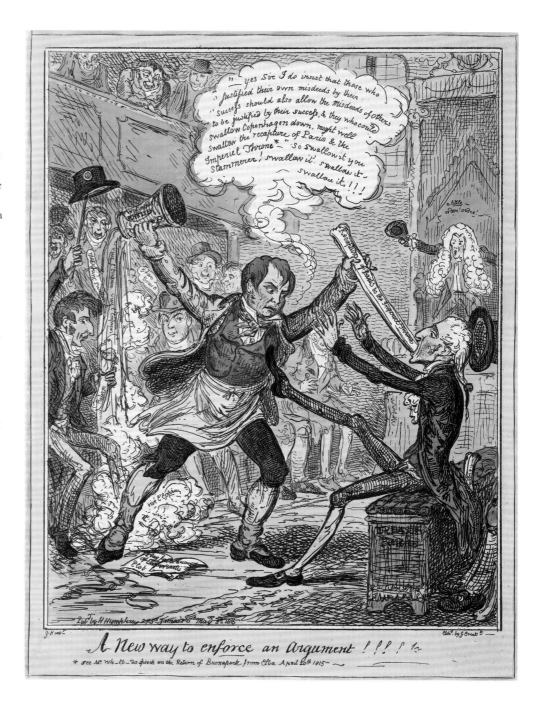

142

George Cruikshank (1792–1878)
Preparing for War
Published by M. Jones, 1 June 1815
Hand-coloured etching
1868,0808.12813; BM Satires 12550
From the collection of Edward Hawkins

This is the frontispiece to the June 1815 issue of *The Scourge* (see cat. 139). John Bull, the British taxpayer, is a bull prepared for sacrifice on an altar 'Sacred to the Bourbon Cause and dedicated to the Downfall of illegitimate Tyranny'. On the cloth across his back is a list of the taxes already introduced to pay for the war. Nicholas Vansittart, Chancellor of the Exchequer, who has a crown in place of a head, wields a poleaxe lettered 'New War Taxes'; he stands balanced on the tub that will collect John Bull's blood. Lord Castlereagh, Foreign Secretary, presides over the sacrifice – he was offering cash subsidies to keep the allied powers in the field against Napoleon (see cat. 150). Lord Liverpool, prime minister, stands to the left of the altar, dressed as a butcher sharpening a large knife. A barefoot urchin, face concealed, is seated on the ground beside Vansittart's tub turning its tap so that coins pour out into a large bag on his lap labelled 'Secret Service'. Beside him twelve other beggar boys line up to receive their shares of the bull's sacrifice: their bodies are open-mouthed money bags lettered 'Civil List', 'Contractors', 'Army', 'Navy' and, on three bags, 'Subsidys'. On the left the Prince Regent sprawls on his throne while a stay-maker measures him for a corset, a barber trims his whiskers, and Sir John McMahon, Keeper of the Privy Purse, combs his hair. The prince exclaims to McMahon: 'Why this looks like War! order me a brilliant Fete, send me a Myriad of Cooks & Scullions, say to me no more of Civil lists and deserted wives but of lascivious Mistresses & Bachanalian Orgies....'

Behind the altar is a narrow strip of water representing the English Channel beyond which are shown two alternatives for France. On the right, Napoleon is mounted on a snorting charger and the 'Dogs of War!' are let loose; on the left, lines of soldiers prepare for war while Louis XVIII, wearing full armour and attended by aged soldiers carrying medicine-bottles, rides a mule with the head of Talleyrand. The king worries about a supply of 'fleecy hosiery' and decides, 'I had better fight my battles over a cool bottle with my friend George.'

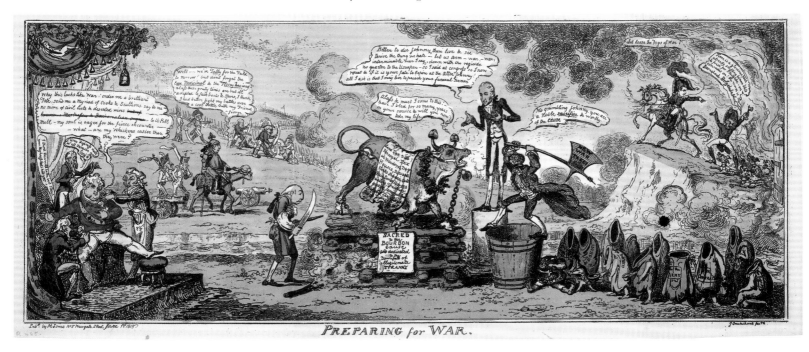

PREPARING for WAR.

143

George Cruikshank (1792–1878) after
George Humphrey (*c.* 1773–*c.* 1831)
The Pedigree of Corporal Violet
Published by Hannah Humphrey, 9 June 1815
Hand-coloured etching; 415 x 245 mm
1868,0808.8219; BM Satires 12551
From the collection of Edward Hawkins

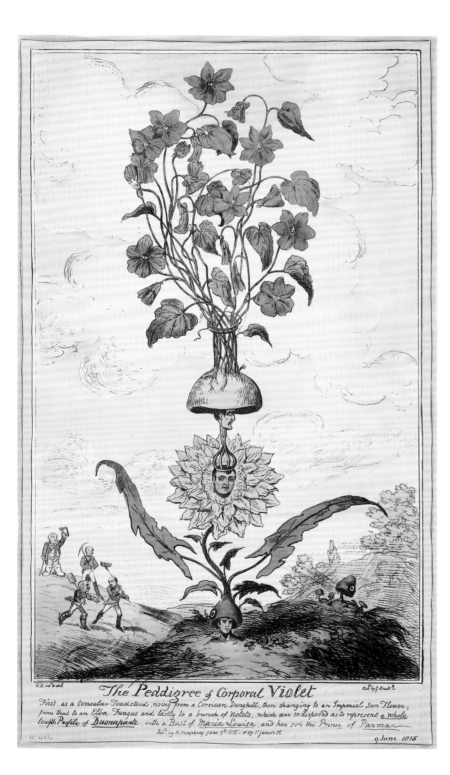

The Peddigree of Corporal Violet

First as a Consular Toadstool, rising from a Corsican Dunghill, then changing to an Imperial Sun Flower, from that to an Elba Fungus and lastly to a bunch of Violets, which are so disposed as to represent a Whole length Profile of Buonaparte, with a Bust of Maria Louisa, and her son the Prince of Parma.

Pubd. by H. Humphrey June 9th 1815. Nº 27 St James's St

9 June 1815

In this print published by Hannah Humphrey, Cruikshank is unequivocally anti-Napoleon. The emperor is said to have told his followers before leaving France in 1814 that he would return when the violets bloomed. In the following months his partisans wore a violet on their breasts and drank the health of 'Corporal Violet' and in late March and April 1815 at least eight prints turning on this motif were published in Paris. Two, and maybe more, were puzzle pictures in which the profiles of Napoleon, Marie-Louise and their son were hidden among the flowers. This print is one of several published in London that incorporated that design.

At the base is a dunghill from which rises the head of Napoleon as a young Republican officer. The text below explains the elements: 'First as a Consular Toadstool, rising from a Corsican Dunghill, then changing to an Imperial Sun Flower, from that to an Elba Fungus and lastly to a bunch of Violets….' A contemporary broadside[1] also includes a toadstool or mushroom as an emblem of Napoleon and explains that it 'denotes the obscurity of his lineage, and his vast rapidity to power.' British satire against Napoleon made much of his obscure background and this mock family tree indicating that he came from nothing – or worse – emphasizes that his claim to rule France had no legitimacy in a system that was founded on hereditary power.

In the background three figures approach with tools to remove the dunghill: Blücher, Wellington, and Tsar Alexander. Louis XVIII stands behind them with gouty legs supported on a crutch.

1 BM Satires 12205.

144

Matthew Dubourg (active 1805–1838) after
John Heaviside Clark (1771–1863)
The Field of Waterloo
Published by Edward Orme, 1817
Colour aquatint; 531 x 811 mm
1872,0608.198

The final battle took place on 18 June 1815 in the
countryside near Brussels. After a day of British
retreat and French pursuit in torrential rain,
the troops spent the night of 17–18 June soaked,
shivering in biting wind and unfed, up to their
ankles in mud in fields two or three miles south
of the village of Waterloo. Then they fought one
of the most determined and closely contested
battles of the Napoleonic wars. Wellington was
expecting Prussian help but, because mud and
floods delayed their march, the Prussians only
just arrived in time. Napoleon very nearly broke
through the British line before they intervened
but, having gambled all on that last chance of
success, his defeat was catastrophic.

The harrowing scenes depicted here show
the battlefield on the morning of 19 June as
imagined by John Heaviside Clark, a Scottish
painter and draughtsman who worked in London
from 1802–32. No British soldier or civilian had
seen anything like it. The battlefield was very
small and in places such as the farm called
La Haye Sainte, corpses intermingled with
wounded men lay in piles. The density of killing
was significantly greater than in First World War
battles such as the Somme (1 July–13 November
1916).

This print was advertised in December 1816
in *Ackermann's Repository*:[1]

> To be Published in the course of the Year,
> an Engraving of the Field of Waterloo, As
> it appeared the Morning after the Battle of
> the 18th June, 1815, from a Picture by John
> Heaviside Clarke – Size of the Print, 30 by
> 18 inches, to be engraved by M. Dubourg.
> Price in Colours £3. 3s. To be published
> by Edward Orme, Bond-street, corner of
> Brook-street, where a Book is open to receive
> Subscribers names.

Smaller aquatints of the battle, produced in
series with this print, were designed to be bound
with Walter Scott's poem, *The Field of Waterloo*,
the proceeds of which were destined for widows
and orphans of the fallen.

1 Second series II, no.12, Dec 1816, unpaginated.

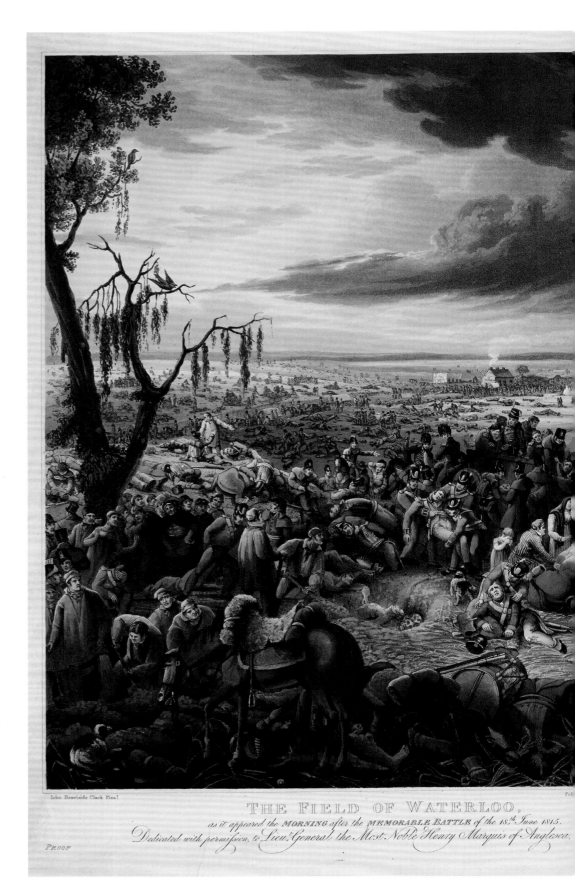

John Heaviside Clark Pinx.t Pub.

THE FIELD OF WATERLOO,
as it appeared the MORNING *after the* MEMORABLE BATTLE *of the 18th June 1815.*
Dedicated with permission, to Lieut. General the Most Noble Henry Marquis of Anglesea.

PROOF

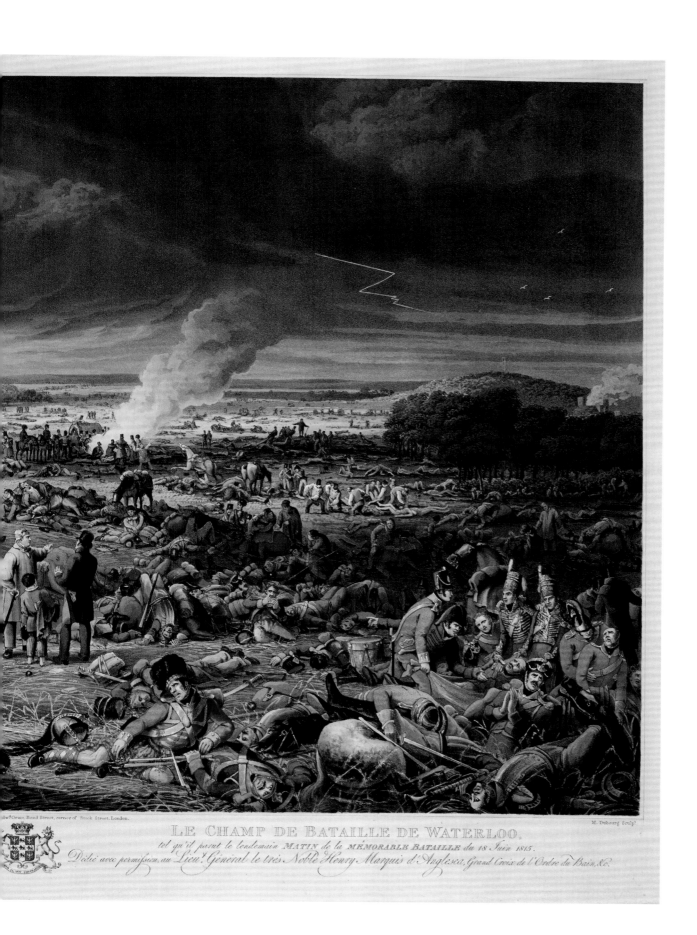

LE CHAMP DE BATAILLE DE WATERLOO.

tel qu'il parut le lendemain MATIN de la MÉMORABLE BATAILLE du 18 Juin 1815.

Dédié avec permission, au Lieut. Général le très Noble Henry Marquis d'Anglesea, Grand Croix de l'Ordre du Bain, &c.

Edwd. Orme, Bond Street, corner of Brook Street, London.

M. Dubourg Sculpt.

145
Thomas (?) Stoney
Views of the Battlefield of Waterloo
Watercolour over graphite, 20–21 June 1815
Private collection

These watercolours appear to be the earliest studies of the battlefield of Waterloo made just two and three days after the fighting. They were found mounted in an album of views of Ireland and northern Europe with the name 'T. Stoney' lettered on the spine. The artist was probably a member of the prominent Irish family of that name, possibly Thomas Johnston Stoney (1780–1869) or perhaps his father Thomas Stoney (1748–1826). He was not a soldier, for there are no Stoneys in the army lists for 1815, but there were many British civilians in Belgium in 1815. He had evidently been taught to draw and handle watercolour, not an unusual part of a gentleman's education. The drawings show not only the most famous sites of the battle on 18 June – Hougoumont and La Haye Sainte – but also rare views of the buildings at Quatre Bras, and a shocking panorama of that battlefield, still littered with naked corpses unburied five days after the bitter fighting that took place there two days before the climactic battle fought ten miles further north near Waterloo.

The inn at Waterloo was Wellington's headquarters and he passed the nights before and after the battle there. At the time that Stoney made his drawings every cottage in the village was full of badly wounded officers, their names chalked on the doors; wounded soldiers covered the ground outside.

The observation derrick is variously described as a hunting tower or as the structure built for surveyors of the area. Immediately after the battle people believed that it had been Napoleon's post during the fighting; this was not true but it is reasonable to assume that it had been used by French observers, as it was about a mile south of the French front line.

The Château du Goumont (now known as Hougoumont owing to a mistake on the map used by the armies) was owned by an aging aristocrat and had been let to a farmer; until 18 June 1815 it boasted the remains of beautiful formal gardens. Wellington placed great importance on the site and it saw some of the fiercest fighting, the sixteenth-century buildings being burned out and destroyed. It was occupied by German riflemen and light infantry and later, more famously, by British Guards. The loopholes in the garden wall survive as evidence of their determined defence.

The farm of La Haye Sainte was, if anything, even more fiercely contested. Lying in the centre of the battlefield, its capture was crucial for the French and it was stubbornly defended by Hanoverians and British officers of the King's German Legion.

On 16 June there was fierce fighting near the crossroads of Quatre Bras and the Gordon Highlanders had their backs to the farm, which was also used as a makeshift hospital during the battle. The Duke of Brunswick was killed close to the alehouse diagonally across the road. Fighting took place in baking heat that was followed next afternoon by torrential rain. Wellington's army retreated hurriedly towards Waterloo, taking time only to bury the bodies of officers. Other corpses, stripped naked by scavengers, were washed by the rain into the ditches, or else they remained on the surface of muddy clay into which the rich crops had been trampled.

View from the Window of the Inn at Waterloo
20 June 1815
134 x 105 mm

The Village of Waterloo
20 June 1815
100 x 370 mm

The Farmyard of Goumont, annotated
'burned on the 18 June'
verso: *Garden wall at Goumont pierced
with loopholes*
100 x 373 mm

The Back of Goumont
20 June 1815
103 x 189 mm

La Haye Sainte
21 June 1815
102 x 194 mm

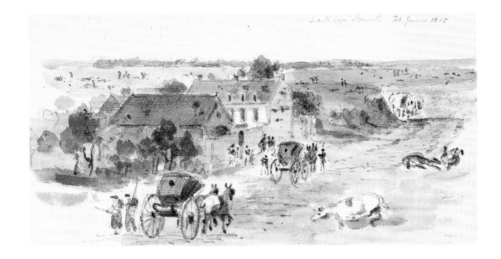

The Farmhouse of Quatre Bras
20 June 1815
102 x 188 mm

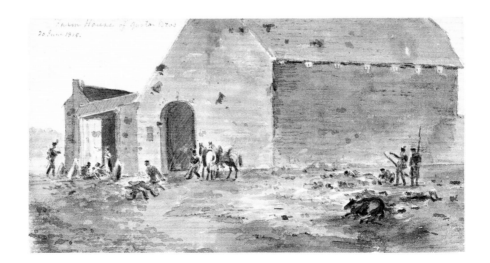

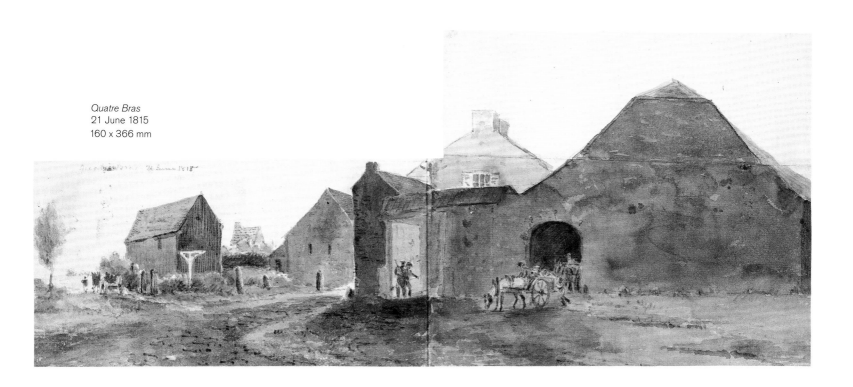

Quatre Bras
21 June 1815
160 x 366 mm

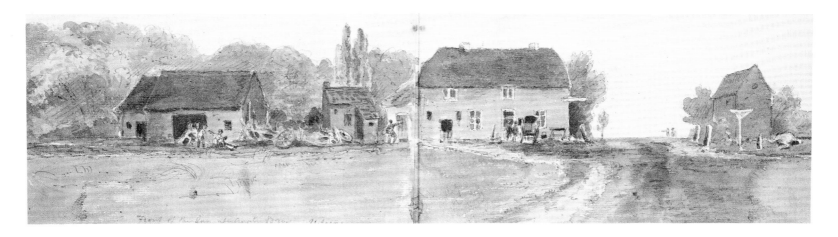

Front of the Inn at Quatre Bras
21 June 1815
100 x 380 mm

Panorama of the Battlefield of Quatre Bras
100 x 863 mm

Panorama of the Battlefield of Waterloo
100 x 1368 mm

Panorama of the Battlefield of Waterloo from near Rossomme, annotated 'Observatory/ Hollow Road/ Braine La Leude/ Hougoumont/Mt St Jean'
100 x 1640 mm

*Observation derrick with soldiers and a
horseman around its base*
100 x 100 mm

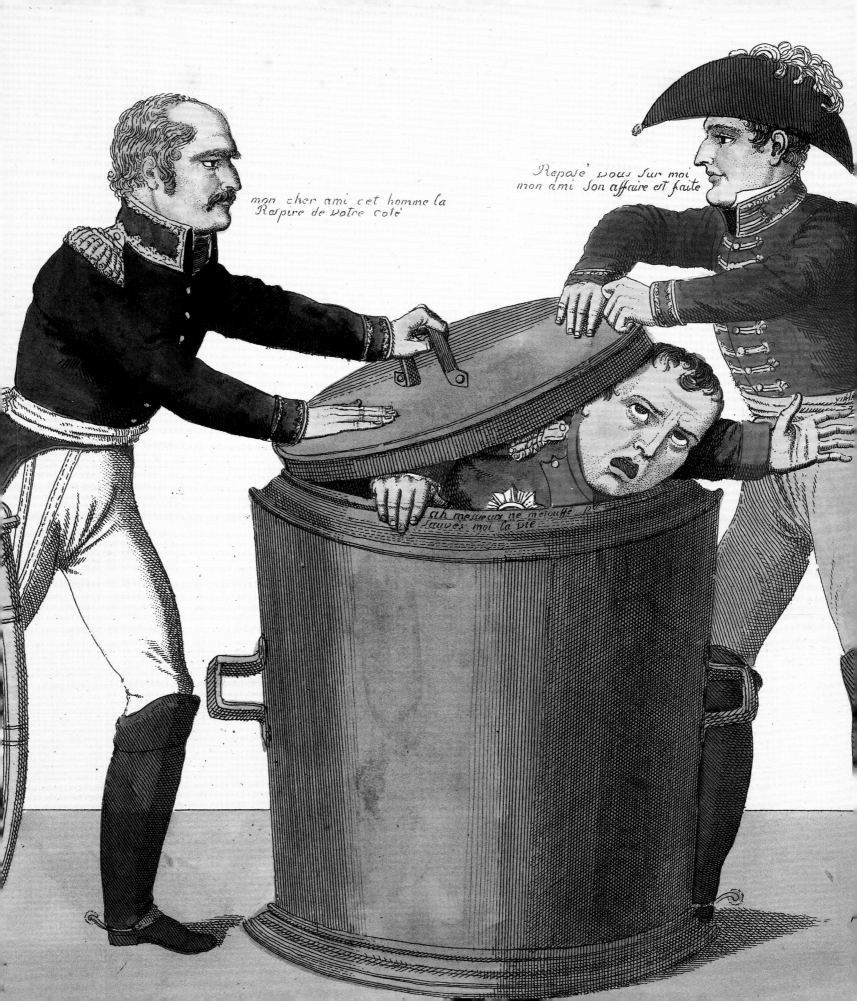

10
After Waterloo

When the first Treaty of Paris was signed in 1814, there had been extravagant celebrations throughout Britain. The events of the following year deflated spirits: the return of the Bourbon regime was not a war aim for most Britons, but Napoleon's return made people uneasy. They dreaded the renewal of a war that had been fought for over twenty years. Napoleon's defeat at Waterloo was greeted almost universally with relief, but jubilation was muted; from September to December the *Examiner* published a series of articles entitled 'The Gloomy State of Things in France' reporting the proceedings of the Congress of Vienna at which representatives of the European powers were striving to establish a post-war settlement.

Napoleon escaped after the battle; he abdicated a second time and made his way to Rochefort hoping to sail for the United States. When that proved impossible, he appealed to the Prince Regent for asylum and retirement in Britain, and gave himself up to Captain Maitland of the *Bellerophon* on 15 July. Napoleon's only glimpse of Britain was to be from the deck of the ship; on 8 August he was transferred to the *Northumberland* and set sail for exile on St Helena.

146

Thomas Rowlandson (1757–1827)
Transparency Exhibited at Ackermann's Shop on 27 November 1815
Published by Rudolph Ackermann,
27 November 1815
Hand-coloured etching; 281 x 370 mm
1868,0808.8288; BM Satires 12621
From the collection of Edward Hawkins

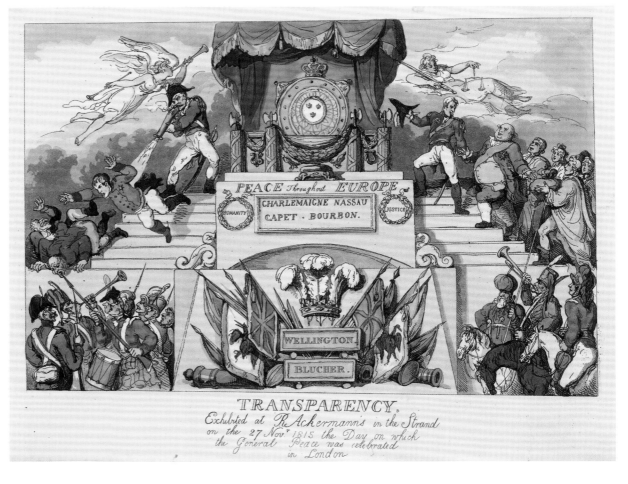

The Second Peace of Paris was signed on 20 November 1815 and news was published in London three days later. An official 'illumination' (see cat. 118) was announced for the night of 27 November. Rudolph Ackermann exhibited this triumphalist transparency at his shop in the Strand: Blücher drives Napoleon down a flight of steps while Wellington leads Louis up to the throne. Though naturalized British in 1809, Ackermann took great pride in Germany's part in Napoleon's defeat and organized funds for the relief of the people of his native Saxony which had been devastated by war. He raised over £200,000 for the German relief fund (to which even the notoriously parsimonious Queen Charlotte gave £200) and was rewarded by the King of Saxony with the Order of Civil Merit. In 1815 he collected and distributed further large sums to assist wounded Prussian soldiers and their relatives.

While Ackermann and others rejoiced, two radical writers drew comparisons with the extravagant celebrations of the Peace of 1814.[1] Leigh Hunt (who had recently spent two years in prison for describing the Prince Regent as 'a violator of his word, a libertine over head and ears in debt and disgrace, a despiser of domestic ties, the companion of gamblers and demireps, a man who had just closed half a century without one single claim on the gratitude of his country, or the respect of posterity') announced in the *Examiner* on 3 December: 'The Illuminations were not general…. Private houses were as gloomy as if their inhabitants had no share in those blessings which were so splendidly commemorated by the offices of the Public Ministers.' William Cobbett's *Political Register* had reported the day before: 'How "dull", how "mournful" the scene…. No illuminations except "Ex-Officio" in London. It is peace in such dismal circumstances as to shut up the hearts of the people against any feeling of joy.'

1 See J.J. Kierkuć-Bieliński and A. Rich, *Peace Breaks Out! London and Paris in the Summer of 1814*, London 2014, *passim*.

147
Charles Turner (1774–1857) after
Carl Daniel Friedrich Bach (1756–1829)
His Highness Prince Blücher of Wahlstadt
Published by Rudolph Ackermann,
1 August 1815
Mezzotint; 635 x 535 mm
1891,0414.201

Rudolph Ackermann quickly celebrated the Prussian part in the victory of Waterloo by publishing a print of the seventy-two-year-old Prussian commander, Gebhard Leberecht von Blücher after a painting by Carl Bach, director of the art school at Breslau and a member of the Berlin Academy. When Blücher visited London after the first Peace of Paris in 1814, Ackermann escorted him as guest of honour at a charity concert in aid of those in Germany who were suffering as a result of the wars. He presented the prince with a copy of Gilbert Stuart's portrait of George Washington and it is highly likely that Blücher gave Ackermann a copy of his own portrait in return.

The print was widely advertised. This example is from the *Ipswich Journal* of 1 July 1815:

> Proposals for publishing by Subscription a large Print of Field-Marshal Prince Blucher of Wahlstadt, from a Painting by Professor C. Bach, of Breslaw. The Portrait from which this Print is engraved was painted for Princess Blucher. This correct Portrait represents the Veteran Hero on Horseback, full of martial fire. In the back ground is seen the bustle of the Battle of the Katzbach. This most interesting subject is now engraving, in mezzotint, by Charles Turner, and will be ready by the middle of this month, July. The size of the Print will be 23 inches by 19 inches, and the Price to Subscribers £1 11s. 6d.; proofs £3 3s. The print to be delivered in the order of Subscription, and paid for on delivery. Subscriptions are received by R. Ackermann, 101, Strand, and by all the print and booksellers in the United Kingdom.

The battle of Katzbach was Blücher's first great victory over the French in August 1813.

148

William Bromley (1769–1842) after
Thomas Lawrence (1769–1830)
The Duke of Wellington
Proof: etching and engraving on
chine collé; 710 x 477 mm
1842,0806.351

This engraving of the Duke of Wellington reproduces a painting by Thomas Lawrence, the most fashionable painter of the day. Joseph Farington's diary entry for 20 July 1817 records that he dined with Lawrence that day and saw the unfinished picture:

> The figure of the Duke was painted … but the horse was not drawn in. Sir Thomas told us that the horse was to be brought to him tomorrow. It is the horse which he rode at the Battle of Waterloo and before, and on which he sat sixteen hours on the day of the battle. He calls the horse Copenhagen.

On 13 April 1818, Lawrence told Farington that Lord Bathurst, Secretary of State for War and the colonies and a close ally of Wellington's, had paid 800 guineas for the picture; it was to be shown in the centre of one of the walls in the Royal Academy exhibition that summer. Not only was Wellington riding the horse he was riding at the battle, he was also dressed as he was at Waterloo, wearing a great Spanish cape against the rain. Copenhagen was a former racehorse and a grandson of the unparalleled Eclipse; when he eventually died in 1836 he was buried with military honours at the Duke's country estate, Stratfield Saye.

As was often the way with line engravings, William Bromley took many years to complete the plate. The print was eventually completed in 1830. It was reviewed in the *Spectator* for 16 October of that year:

> Mr. Bromley has just finished a beautiful line engraving from the equestrian portrait of the Duke of Wellington painted by Sir Thomas Lawrence immediately after the battle of Waterloo. The Duke is represented in his undress uniform as a Field-Marshal, and mounted on his favourite charger Copenhagen. He is in the act of waving his hat, and carries a reconnoitering-glass in his bridle-hand. He also wears the short military cloak and Hessian boots, instead of those of the fashion which he immortalizes. The air and attitude of the Hero of Waterloo are graceful and showy; his face and features are skilfully flattered in the resemblance, and wear a look of freshness and gaiety, very different from the stony imperturbability of his Grace's granite visage. The fore part of the horse is well drawn, the neck arched, and the head full of fire; but the foreshortening of the hind-quarters we think is incorrect. As a whole, the print is imposing in its effect, the simplicity of character and costume being contrasted by the splendid quality of the art. The engraving is elaborate, and very finely executed, in a style of excellence worthy of Mr. Bromley's high reputation: we hear that it has been several years in hand.

State of POLITICKS at the close of the year 1815.—

149

George Cruikshank (1792–1878)
State of Politicks at the Close of the Year 1815
Published by M. Jones, 1 December 1815
Hand-coloured etching with aquatint; 225 x 485 mm
1868,0808.12819; BM Satires 12622
From the collection of Edward Hawkins

Even *The Scourge*, which identified itself as middle-of-the-road (see cats 139 and 142), was disillusioned by the end of 1815. This is the illustration to the December issue where the first article summed up the post-war situation:

> Never perhaps did the pen of History register a year, more pregnant with great and unforeseen events than that which now approximates so nearly to its close. An abdicated Emperor suddenly returns to the country he so lately governed … Europe again flies to arms … Louis re-ascends his tottering throne … the principle of hereditary right … is re-established … Priests and the devil rule in Spain … Four great powers, England, Russia, Austria, and Prussia, have … been busily employed in carving out Europe….

George Cruikshank portrays the situation emblematically using groups of figures arranged in a landscape. In the centre, the obese Louis XVIII is raised on a platform balanced on a flimsy prop lettered 'Bourbon party' but actually supported by the rulers of Britain, Russia, Austria and Prussia. The last three pocket papers documenting their gains up to date as a result of Napoleon's defeat: Poland for Russia, Italian states for Austria and Swedish Pomerania for Prussia – they all expect further profit to come. The Prince Regent only cares about his own position: 'Hereditary right for ever D[am]n all upstarts'. The Pope – always a target for anti-Catholic Britain – stands beside Louis hooking him by the nose, and monks, priests and nuns crowd around the throne. A winged serpent with the head of Talleyrand whispers in the king's ear.

On the left, Wellington leads a group of soldiers (the army of occupation) dressed as night-watchmen. Behind them is a pile of packing cases presumably containing works of art (see cats 9 and 131), labelled 'Stolen goods to be restored to the right owners'. Blücher, wearing an academic cap and gown addresses Wellington, 'I think we've doctored [i.e., castrated] them at last.' The phrase and his dress allude to one of the many lavish ceremonies of the 1814 peace celebrations when honorary degrees of the University of Oxford were conferred on Blücher, the Tsar and the King of Prussia during the state visit to Britain prior to the Congress of Vienna. In front of Blücher and Wellington is a warning of French duplicity as two-faced Frenchmen emerge on the scene crying out '*Vive le Roi*' and from the other mouth: '*Vive l'Empereur*'.

On the right is another jibe at Catholic political power, now again a force in Spain. Three figures advance along a winding path that leads eventually to the flaming mouth of hell: a grinning friar who, echoing the Pope beside Louis's throne, has attached a hook to the nose of King Ferdinand VII; the king holds 'Hymns to accompany the Dying Groans of the Spanish Patriots' (the Spanish guerrillas who fought Napoleon's army in Spain had been much admired in Britain); he is blindfold and steered forward by the director of the restored Holy Inquisition in the form of a devil wearing the square cap associated with the Jesuits.

In the background on the left, Vesuvius erupts, releasing a cascade of tiny soldiers and a large rat (Murat), which is fired at by Ferdinand IV, newly restored King of Naples. Murat had been created King of Naples by Napoleon in 1808 and remained in power after 1814. During the Hundred Days he realized his position was at risk and declared war on Austria, only to be defeated at Tolentino on 2 May. After Waterloo he attempted to regain his kingdom by landing with a small army in Calabria; he was captured by Ferdinand's troops, court-martialled and executed by firing-squad on 13 October.

On the right, in the distance, Napoleon stands on the rocky island of St Helena, far out at sea. Dark clouds are gathered above him and a trumpet emerges from them, pointing towards King Louis with the words: 'O! ye Kings of the Earth! take warning and let the fate of your outcast brother be of benefit to mankind.'

150

George Cruikshank (1792–1878)
The Present State of France Exemplified
Published by Thomas Wooler, December 1815 (?)
Hand-coloured etching and letterpress; 440 x 310 mm
1862,1217.550; BM Satires 12623

George Cruikshank again shows Louis XVIII enthroned on a platform, but the tone is harsher than in the previous print. The platform is now supported on the points of giant bayonets and the bodies of dead allied soldiers lie below. Talleyrand and Fouché stand beside the throne (made up of weapons of war) and a friar sits at Louis's feet. On the left, Prussian hussars throw coppers at a crowd of French men and women; the soldiers are seated on sacks of money labelled 'Contributions for the Allies' (presumably the reparations paid by the French). On the right a firing squad takes aim at Marshal Ney, executed in Paris on 7 December; he refused the blindfold and insisted on giving the soldiers the order to fire. Beyond him is a row of gibbets, and a line of chained men leave a prison heading for an executioner's block (a reference to the 'White Terror', the eradication of Bonapartists deemed to be traitors to France). Soldiers are massed on a hillside beneath a flag inscribed, 'It is not the wish of the Allies to interfere with the internal government of France'; in May, Castlereagh had signed a declaration stating that the treaty of 25 March was 'not to be understood as binding his Britannic Majesty to prosecute the War with a view of imposing upon France any particular Government'.[1]

The printed text is a mock Old Testament passage from 'the First Chapter of the Second Book of The Restoration of Kings'. It gives an ironic account of the refusal of 'the rulers of the earth' to accept Napoleon because 'he hath not within him the blood of our forefathers; and he hath violated his word before heaven, and hath shed innocent blood; which things were an abomination to kings in the ages aforetime....'

This is an early publication by Thomas Wooler who was to become famous as the publisher of the radical journal, *The Black Dwarf*, from 1817–24. The broadside was priced at 6*d*. plain, 1*s*. coloured, and on larger paper with finer colouring at 1*s*. 6*d*.

1 Foreign Office, *British and Foreign State Papers, 1814–1815*, London 1839, p. 450.

The present State of France exemplified,
IN THE
FIRST CHAPTER OF THE SECOND BOOK
OF
The Restoration of Kings.

1. AND it came to pass, in the eleventh month of the first year of the reign of Louis, called the DESIRED, that the Man of Elba returned from his retirement, and invaded the kingdom of France.

2. And the heart of Louis the Desired failed him, for the Man of Elba had invaded him with a numberless army of six hundred fighting men ; and Louis called the Desired fled in haste from the capital city of his dominions, even unto Ghent.

3. And the sovereigns of the earth took pity upon the aged King, and solemnly swore they would restore unto him the throne of his fathers.

4. In the mean while, Napoleon, the Man of Elba, entered into the capital, called Paris, and seated himself on the throne of Louis the Desired ; and when he had clothed himself with fine purple, and received also from the people a diadem of gold, he called himself Emperor, and sought friendship with the rulers of the earth ; but they would not.

5. For, said the rulers of the earth, he hath not within him the blood of our forefathers ; and he hath violated his word before heaven, and hath shed innocent blood ; which things were an abomination to kings in the ages aforetime.

6. And moreover he had liberated the negro, whom the Lord hath ordained to draw water, and to hew wood, and set the tongue of the slanderer free, which he called giving liberty unto the press : which thing was heretofore unknown throughout all the Kingdoms of the earth.

7. And the princes and rulers assembled themselves together, and collected their fighting men, and went forth against him.

8. And they discomfited the armies of the Man of Elba, and made a mighty slaughter of his fighting men : and they pursued him very far :

9. Even unto the capital called Paris, from whence he fled, even unto the shores of the sea, where he surrendered himself unto them.

10. Now the princes and rulers had made war only upon the Man of Elba ; but nevertheless they deemed it prudent to destroy his friends.

11. And it came to pass, that when they would have placed Louis now become the INEVITABLE upon the throne of his forefather, behold it was become slippery with blood, and full of prickly thorns.

12. And they took counsel together, and determined to build him a new one, and they sought for m n cunning in such matters.

13. And amongst the cunning men behold there was one Blucher,

who said, Let us build it of bayonets, and lay for it a foundation of the bodies that have fallen beneath them. And upon them let us lay a platform, and place thereon a chair, with a cushion for the King, who is become old and gouty.

14. And the workmanship of this chair shall be as follows , the back thereof shall be composed of muskets, and pistols and daggers ; and the arms of brazen cannon, as the best supporters of the King.

15. And the counsel applauded the design, and, lo! the throne was erected, and all the people were amazed thereat.

16. And some among them cried out aloud for the throne of the Man of Elba ; but the cunning man called Blucher had carried away all the precious gems thereof, as hire for the workmanship of the newer throne.

17. Whereat the people murmured extremely, and the King heard it, and was wroth.

18. Then came two men from amongst the crowd, and they placed themselves on the right of the King, and on the left, and said unto him, O King ! Live for ever ! Listen unto us, and we will teach thee how to govern this people.

19. And he that stood at the left hand of the King, whose name was Fouche, spoke in this manner ; O King, eat, drink, and be merry, for I will take care of thy treasury and the wants of thy people ; for, verily, I am thy friend, and the friend of all that are mighty.

20. And, he on the right, named Talleyrand, said, I also am the friend of the powerful, and am well skilled in the art of ruling.

21. But it came to pass, that the princes and rulers deemed themselves wiser than these men, and they would rule the kingdom.

22. And that the people might cry out for Louis, they distributed to them much money ; so that the portion of each man was in the money of those days, one sous ; that is to say, three farthings. And they were warned against intemperance and extravagance in their rejoicing.

23. And all those that would not cry out for the King, they put to death : and they took to themselves the care of the possessions of those that did ; And the King was much beloved by all the people.

24. And it came to pass, as the king was going unto the temple, a prophet of the Lord, called a monk, exclaimed, Son of St. Louis, ascend to heaven ! And all the people shouted, AMEN. SO BE IT.

Printed by T. J. Wooler, 50, Houndsditch.—Price 6d. plain,—Coloured, 1s.,—Impressions on large paper, finely coloured, 1s. 6d.

151

Lacroix (active 1809–37)
Origine de l'étouffoir impérial
Published by Lacroix, August 1815
Hand-coloured etching; 235 x 308 mm
1868,0808.8256; BM Satires 12582;
de Vinck 9596
From the collection of Edward Hawkins

152

Frédéric Dubois (1760–after 1815)
*Enfin Bonaparte met à l'éxécution son
project de Descente en Angleterre*,
September 1815
Hand-coloured etching; 310 x 197 mm
1866,0407.932; BM Satires 12595;
de Vinck 9751

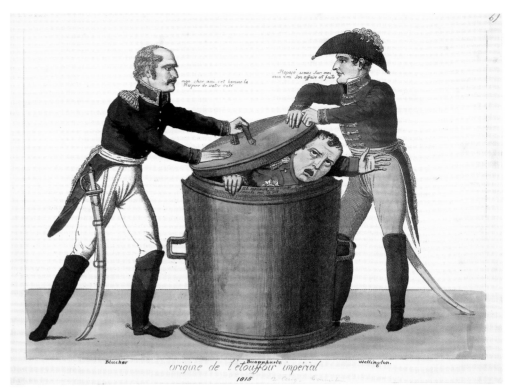

Many Frenchmen were pleased to see the back of
Bonaparte, who represented eternal war for them
just as much as he did for the British. In these two
French prints, Wellington and Blücher dispose
of the former emperor. In the first, Napoleon
begs for his life, fearing suffocation in a dustbin;
Blücher complains that he is being allowed to
breathe (the Prussians wished to execute him)
but Wellington presses down the lid assuring his
ally that the former emperor's time is over. The
print was listed in the *Bibliographie de la France* for
26 August 1815 as sold by Lacroix, a printmaker
and printseller with a shop on the rue Sainte-
Croix that specialized in caricature.

The second print was listed in the
Bibliographie de la France for 16 September 1815
as sold by Dubois. Wellington drives Napoleon
before him along a seashore. The title mocks
Napoleon whose eventual '*Descente en Angleterre*'
is very different from the invasion that he had
planned in 1803 in fact, the authorities were
extremely careful that Napoleon never set foot
on British soil (cat. 153). Dubois repeats the
caricatured depiction of Napoleon as a tiny man
dwarfed by Wellington, but in reality the English
general at five feet nine inches was not much
taller.

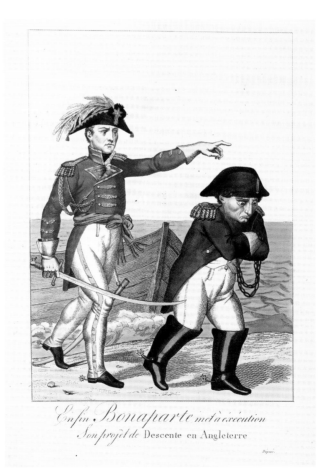

153

Charles Turner (1773–1857) after Charles Eastlake
(1793–1865)
Napoleon Bonaparte
Published by Charles Eastlake, 26 June 1816
Mezzotint; 720 x 467 mm
1871,0513.20

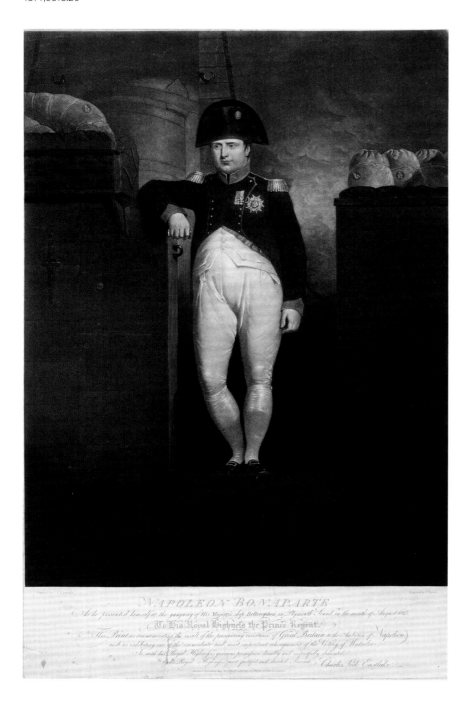

Napoleon surrendered to Captain Maitland of the *Bellerophon* at Rochefort on 15 July. They reached Torbay on 24 July, before sailing on to Plymouth Sound, arriving on 27 July. Not surprisingly, the British public was eager to catch a glimpse of the man who had directed the course of European history for more than a decade – whether he was thought of as a hero or a villain, the chance to see him was not to be missed. Robert Trewman's *Exeter Flying Post* reported on 3 August that 'there were on Plymouth Sound from 500 to 1,000 boats of all descriptions, filled with spectators'. Several people were killed in the crush. Napoleon appeared on deck and was described as 'very well made, rather inclined to be lusty, his belly rather protuberant, but appearing by no means large or heavy; his leg and thigh muscular and remarkably handsome….' On 8 August the *Morning Post* noted with regret that 'a large proportion of the spectators not only took off their hats, but cheered him, with respect and consideration; him whose whole life has been a series of exultations in the calamities of others'. On 4 August the *Bellerophon* returned to Torbay and on 7 August Napoleon was transferred to the *Northumberland* for his long voyage to St Helena.

The print reproduces Charles Eastlake's painting of Napoleon on the *Bellerophon* at Plymouth. Eastlake had been in Paris studying the works of art in the Louvre when Napoleon left Elba and he was one of many visitors who quickly returned home. It so happened that his home was Plymouth and he had the unexpected opportunity to encounter the former emperor there. Benjamin Robert Haydon heard his story:

> Eastlake, being at Plymouth, went out in a boat and made a small whole length. Napoleon seeing him, evidently (as Eastlake thought) stayed longer at the gangway. The French officers gave him this certificate: 'I have seen Mr Eastlake's portrait of the Emperor Napoleon and I find that the resemblance is accurate, and that furthermore it has the merit of giving a precise idea of His Majesty's habitual stance'.[1]

Eastlake's career was set on its successful course by this portrait. A large version, now in the Royal Museums Greenwich, was purchased by five Plymouth gentlemen for 1,000 guineas, allowing the artist to spend several years studying and cultivating influential patrons in Rome. Further financial reward and wider publicity would have come from publishing this large and impressive mezzotint. Eastlake commissioned the print from the well-known printmaker Charles Turner; the dedication to the Prince Regent in the lower margin describes the print 'as commemorating the result of the persevering resistance of Great Britain to the Ambition of Napoleon, and as exhibiting one of the immediate and most important consequences of the Victory of Waterloo'.

1 Haydon 1926, II, p. 220

RELICS OF WATERLOO AND OF NAPOLEON

Museums have exploited Napoleon's fame from 1815 to the present, and relics have never ceased to be collected by admirers. Within months of Waterloo, panoramas had been painted (Barker's in Leicester Square, March 1816), re-enactments were staged at Astley's Amphitheatre and Vauxhall Gardens, and in Pall Mall Napoleon's horse Marengo was displayed (his skeleton is now part of the collection of the National Army Museum). When he was sent as ambassador to London in 1822, Chateaubriand, 'found that great town revelling in Bonaparte. People had passed from denigrating *Nic* to wild enthusiasm. Souvenirs of Bonaparte were everywhere; his bust adorned every mantelpiece; his portraits were conspicuous in every printseller's window; his colossal statue adorned the staircase of the Duke of Wellington.'[1]

1 F. de Chateaubriand, *Mémoires d'outre-tombe*, 1849–50, XXVII.3.

154

George Cruikshank (1792–1878)
A Scene at the London Museum Piccadilly
Published by Hannah Humphrey, January 1816
Hand-coloured etching; 280 x 360 mm
1859,0316.111; BM Satires 12703

George Cruikshank and Hannah Humphrey take a sardonic view of the vulgar hordes who 'peep at the spoils of ambition' taken at the battle of Waterloo. The wild crowd seems to have forgotten the horror of the battlefield just six months earlier, and only a Frenchman in the background feels any sadness, weeping unrestrainedly as he looks at a bust of Napoleon: 'Ah! Mon dear Empereur dis is de Shocking sights.'

Blücher had sent Napoleon's carriage – abandonned at Genappe, eight miles south of Waterloo – as a gift to the Prince Regent who promptly sold it for £2,500 to the showman William Bullock. The carriage and its contents became the prime attraction at Bullock's London Museum at the Egyptian Hall in Piccadilly; the flamboyant façade of the Hall was built in a style that was fashionable, thanks to Napoleon's

Egyptian campaign and the archaeological treasures brought back by the British army. Napoleon's coachman Jean Hornn, seriously wounded during the pursuit after Waterloo, was also in attendance.

The carriage was on show in London from January to August 1816 before touring the country. Bullock wrote to Thomas Bewick in Newcastle on 7 October 1817:

> For the last eighteen months my attention has been a great deal taken from my natural history by a far more profitable concern. Chance threw into my possession a considerable quantity of the public and private property of the late ruler of France. I believe I have more of his goods and chattels than any person living and hope in a few months to visit you in the very carriage he went to Russia in and which was taken at Waterloo, drawn by the same horses driven and attended by the same servants who still wear their old master's liveries. I have also his gold plate, diamonds, wardrobe, magnificent fire-arms, marble and bronze busts, historic pictures of his battles, family portraits, furniture of his palace, etc., etc. They will be shortly on their way to Edinburgh and will stop at Newcastle. It is probable I may be with them.[1]

It was said that 800,000 people visited Bullock's Napoleon show and that he made a profit of £35,000. He eventually sold the carriage to a coachmaker; it was purchased in 1843 by Marie Tussaud and was displayed in her waxwork museum until it was lost in a fire in 1925.[2]

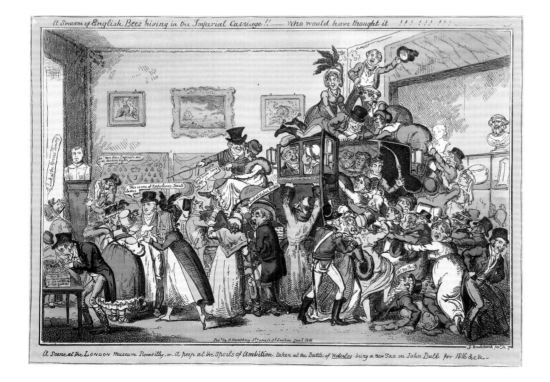

A Scene at the London museum Piccadilly, or a peep at the Spoils of Ambition, taken at the Battle of Waterloo being a new Tax on John Bull for 1816 &c&c

1 Tyne and Wear Archives, 4388 DT.BEW.
2 R.D. Altick, *The Shows of London*, Cambridge, Mass. and London 1978, pp. 239–43.

155
Byron's spoils
Private collection and National Library
of Scotland NLS Ms.43545

These 'spoils' – a shot, a group of badges, buttons, leather *tricoleur* cockades and a French soldier's pay-book – were collected by Lord Byron from the field of Waterloo on 4 May 1816. The larger badge is a shako plate from a *voltigeur* of the 55th *régiment de ligne*, the smaller badge with a horse and the motto '*Nunquam Retrorsum*' came from the shako of a soldier of the 1st Brunswick line battalion; one of the buttons is lettered with the name of the elite military academy founded by Napoleon at St Cyr, the Ecole Spéciale Impériale Militaire. The pay-book or *livret*, however, came from a humbler member of the French army: Louis Marie Joseph Monsigny was one of thirteen children of a farmer living in the tiny village of Doudeauville in the Pas de Calais, just 150 miles from Waterloo.[1] Monsigny was twenty-three years old when he joined what was then the 43rd *régiment de ligne* on 13 September 1814. He was 1.65 metres tall with chestnut hair and eyebrows, grey eyes, a long nose, round chin and oval face. On 11 March, with Napoleon en route to Paris, he was issued with a pair of shoes, a pair of trousers, a leather bag and a copper cartridge pouch.

By 18 June the regiment had been reorganized as the 46th *régiment de ligne* in the brigade led by General Antoine Noguès. Monsigny might have been among those who fell victim to the British heavy cavalry at Waterloo. His brigade took part in the first assault by the corps of General d'Erlon. Noguès described the experience in grim detail.[2] They marched through a hail of bullets and cannon shot and had almost reached the English line when the cavalry – possibly the Scots Greys – fell on them, taking them by surprise in the smoke, breaking into their ranks and cutting them down.

George Gordon Byron, 6th Baron Byron, the aristocratic poet, would never have encountered the French farmer's son Louis Monsigny in life, but he was clearly pleased to acquire his pay-book with its connection to Napoleon, his great romantic hero. Byron had been shocked by the emperor's abdication in 1814. His *Ode to Napoleon*, published anonymously on 16 April expresses his feeling that it would have been better to die than accept defeat and ignominious exile:

> Tis done – but yesterday a King!
> And armed with Kings to strive –
> And now thou art a nameless thing:
> So abject – yet alive!
> Is this the man of thousand thrones,
> Who strewed our earth with hostile bones,
> And can he thus survive?

In the jubilant mood of 1814, John Murray paid 1,000 guineas for the copyright and the poem ran to ten editions in one year.

When Napoleon returned from Elba the following year, Byron took back his words, writing to Thomas Moore on 27 March: 'I can forgive the rogue for utterly falsifying every line of mine Ode.... Nothing ever so disappointed me as his abdication, and nothing could have reconciled me to him but some such revival as his recent exploit; though no one could anticipate such a complete and brilliant renovation.'[3]

On 24 April 1816, Byron left Britain, travelling in a large coach based on the one that Bullock showed at the Egyptian Hall (cat.154), and for which he had not paid the coachmaker. He reached Waterloo on 4 May and his experience of the battlefield inspired the third canto of *Childe Harold* that he began to write as he travelled on to Geneva:

...How that red rain hath made the harvest grow!
And is this all the world has gained by thee,
Thou first and last of fields! king-making victory?

But whatever Byron thought of Napoleon, he certainly had no time for Wellington. Canto IX of *Don Juan*, was published in 1823 by John Hunt, elder brother of Leigh Hunt (cat. 146),

after it had been declined by the Tory John Murray for obvious reasons:

...You are 'the best of cut-throats' – do not start;
The phrase is Shakespeare's, and not misapplied: –
War's a brain-spattering, windpipe-slitting art,
Unless her cause by right be sanctified.
If you have acted – once – a generous part,
The World, not the World's masters, will decide,
And I shall be delighted to learn who,
Save you and yours, have gained by Waterloo?

1 See www.geneanet.org
2 A. Noguès, *Mémoires du général Noguès 1777–1853 sur les guerres de l'empire*, Paris 1922, pp. 274–5.
3 T. Moore, *Letters and Journals of Lord Byron with notices of his Life*, Frankfurt 1830, p. 261.

156

Samuel De Wilde (1751–1832)
Sketch for a Prime Minister or How to Purchase a Peace
Published by George Manners, 1 February 1811
Etching and aquatint; 235 x 194 mm
1868,0822.7176; BM Satires 11710
Bequeathed by Felix Slade

The most prominent and arguably the most consistent of
Napoleon's British admirers were Lord and Lady Holland. Henry
Fox Vassall, 3rd Baron Holland was the nephew of Charles James
Fox and, like him an ardent Whig; the Hollands were in Paris
with Fox during the Peace of Amiens (cat. 50). Elizabeth, Lady
Holland was politically influential but never fully accepted at the
highest levels of society (she was not received at court) because
she had lived with Holland before obtaining a divorce from her
first husband.

This print is an illustration to the *Satirist*, published in February
1811 at the time of the passing of the Regency Act that transferred
royal authority from the ailing George III to the Prince of Wales.
The prince was expected to reward his old Whig friends with
government office and there was a suggestion that Holland might
be prime minister. The print implies that if Holland were to take
over, the forceful Lady Holland would be in charge – she wears her
husband's breeches and he is wearing her petticoat. She holds out a
paper inscribed 'Lord Wellingtons Recall' (there was talk at the time
of making peace in Spain) and, what is more, she shelters Napoleon
beneath her cloak. The emperor holds up an olive-branch and a
money-bag inscribed 'Peace Offering', but in his right hand is a
dagger. Spencer Perceval, the Tory prime minister, appears at a
window above the door of the Treasury holding a blunderbuss and
crying out, 'Away Rogues you can't come in here'. By an ironic
coincidence, a *Satirist* journalist William Jerdan was standing beside
Perceval in the House of Commons at the moment when the prime
minister was shot dead at 5 o'clock on 11 May 1812.

The *Satirist, or Monthly Meteor* had been launched in 1807 and
was run until 1812 by George Manners, who described it as 'devoted
to the purposes of exposing and castigating every species of literary
and moral turpitude'.[1] Manners's politics were Tory, and in 1811 he
was imprisoned for three months for a libel in the *Satirist* against the
radical William Hallett. In July 1812 he sold the journal to William
Jerdan who toned down the satire with the result that sales fell and
the journal closed two years later. Like *The Scourge* (cats 139 and
142), each issue contained a fold-out caricature; in Manners's time
these were usually aquatints by Samuel De Wilde, who is better
remembered for his theatrical subjects.

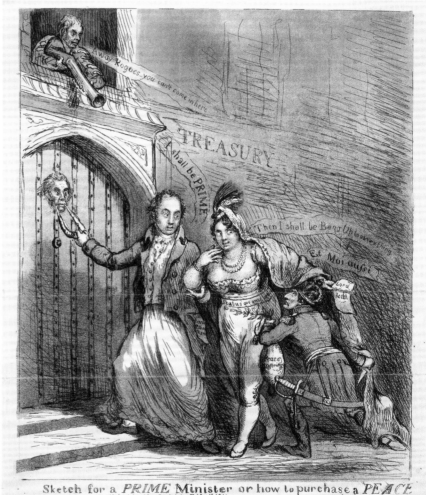

Sketch for a PRIME Minister or how to purchase a PEACE
Published the Satirist. Feb.y 1st 1811.

1 G. Manners, *Vindiciae Satiricae or, Vindication of the principles of the Satirist,
 and the Conduct of its proprietors*, London 1809, p. 5.

157
Antonio Canova (1757–1822)
Bust of Napoleon
Bronze; Height: approximately 900 mm
Private collection

The most striking visual sign of the Hollands' position was this large bronze head of Napoleon by Antonio Canova, which was put up in the garden of Holland House in Kensington in 1818.

Canova had produced several sculptures of Napoleon, his family and allies; after Waterloo, he was made responsible for the repatriation of works of art from the Louvre to Italy. Before returning home he and his brother spent a month in London, from November to December 1815, and met influential collectors and politicians on both sides of the divide. In 1817, gifts of four marble 'ideal heads' arrived for Wellington, Castlereagh, William R. Hamilton and Charles Long as thanks for their contribution to the return of works of art; Long was probably included in his capacity as arbiter of taste for the Prince Regent rather than as paymaster-general of the forces.[1] Canova's gigantic statue of Napoleon as *Mars the Peacemaker* had been bought by the Regent as a gift for Wellington and was installed at Apsley House in 1817.

Wellington's motive for displaying so prominently such a striking reminder of his enemy has puzzled many commentators,[2] but for the Hollands, placing a large sculpture of Napoleon in a conspicuous position was a clear political statement in support of the former emperor whose exile they vehemently opposed. Like the Apsley House statue, the bronze bust was based on studies made in 1802, and the 'Napoleonists' who saw it must have enjoyed the riposte to Wellington. The casting was probably the work of the sculptor and bronze founder, Francesco Righetti (1749–1819) who had worked with Canova in 1809 on a full-length bronze figure of Napoleon for Eugene de Beauharnais (now at the Brera, Milan), based on the Apsley House statue.

A curved bronze plaque at the base of the Holland House head is lettered with a quotation from the *Odyssey* (Book 1, 196–9) that was translated by Lord Holland as:

> He is not dead, he breathes the air
> In lands beyond the deep!
> Some distant sea-girt island, where
> Harsh men the hero keep

In the following verses Athena prophesies that Odysseus will find a way to return home.

1 K. Eustace, *Canova: ideal heads*, Oxford 1997.
2 J. Bryant, 'How Canova and Wellington honoured Napoleon', *Apollo*, 1 October 2005, pp. 38–43.

158

Adrien Jean Maximilien Vachette (1753–1839)
Snuffbox inset with antique classical cameo
Enamelled gold; 72 x 52 x 20 mm
1846,0124.1
Bequeathed by Elizabeth Vassall Fox, Lady Holland

This exquisite box bears the mark of the celebrated goldsmith
Vachette and the name of Etienne Nitot and Son, court jewellers
to Napoleon. The classical agate cameo portrays a young Bacchus
seated on a goat nibbling a vine branch. The lid is formed of two
parts which open on separate hinges to reveal a second transparent
oval agate below the cameo allowing the gold base to shine through
so that the cameo can be read more easily. Gold-chased Bacchic
emblems surround the cameo and the sides and base are enamelled
and decorated with engine-turned geometric ornament.

 In 1864, Lady Holland's son, General Charles R. Fox wrote
a note that explains its context: 'This Snuff box was left by the
first Emperor Napoleon to my Mother Lady Holland in 1821 in
grateful remembrance of her sending him many comforts to
St Helena.'[1] Lady Holland sent regular packages to Napoleon
during his exile on St Helena, including more than 1,000 books and
pamphlets as well as seeds for his garden, prune jam from the trees
of Holland House and sweetmeats. In spite of her best efforts, she
had failed to win concessions from the notoriously authoritarian
Hudson Lowe before he left London in January 1816 to become
governor of St Helena and 'Napoleon's gaoler', but she kept up
an ostensibly friendly correspondence with him, sending news of
political affairs in Europe that she clearly hoped might somehow
reach Napoleon:

Holland House
Saturday July 29, 1820

Dear Sir Hudson,

I have this day closed my accustomed packages for your Island, and by Lord Bathurst's permission have sent them to his office; there are two cases only chiefly of books, one contains a glass locket in which there is a portrait of the late Empress Josephine. It came from the Duchess of St. Leu. The list of books I enclose, some are the suite of sets I sent upon former occasions. The whole was packed in my own room, and I can vouch on my honor that there is nothing contraband. The box of sweetmeats are as usual the Neapolitan Mostaccioli, which are much relished by your illustrious captive. The newspapers will apprize you of the strange revolution which has taken place at Naples. Some say it is an Austrian plot to get possession of that Kingdom again, others that it has been effected solely by the clubs of the carbonieri and that it will extend to the north of Italy and end in the expulsion of the Austrians from thence….[2]

She goes on to describe at length 'this sad business' of Queen Caroline (George IV having just succeeded to the throne was trying to divorce his wife on grounds of adultery) 'that has inflamed the public mind to a most extraordinary degree of heat…. The danger is that mischievous and artful persons will take advantage of this feeling, and under the name of the Queen's cause effect an overthrow of the present Institutions for their own objects.' Even more obviously intended for Napoleon is a report that the French wished for his son to be restored to the throne. She hoped to send a few weeks later a copy of Thomas Lawrence's sketch of the child made the previous year for the then Prince Regent (in the event the prince rejected the drawing; its present whereabouts are unknown).[3] She also intended to send a copy of Giovanni Battista Belzoni's recently published *Discoveries in Egypt and Nubia*, which would have shown Napoleon how Egyptian excavation was continuing since his time there.

As a sign of his gratitude for her support, Napoleon left this elegant snuffbox to Lady Holland; she was the first person named in his will after members of his family. The box contains a note in his hand reading: '*Lempereur Napoleon a Lady Holland temoignage de satisfaction et destime*' (above). He had been given the antique cameo by Pope Pius VI at the time of the Treaty of Tolentino in February 1797 and subsequently had it set into the lid of the gold box.

On hearing of the bequest, the elderly Earl of Carlisle, who had supported the wars with the French from the Revolution onwards, published a protest in the *Gentleman's Magazine*, November 1821:

> Lady, reject the gift, 'tis tinged with gore!
> Those crimson spots a dreadful tale relate.
> It has been grasped by an infernal power,
> And by that hand – which seal'd young Enghien's fate.
>
> Lady – reject the gift, beneath its lid
> Discord, and slaughter, and relentless war,
> With every plague to wretched man, lie hid –
> Let not these loose, to range the world afar….

Byron's response was:

> Lady, accept the box a hero wore,
> In spite of all this elegiac stuff:
> Let not seven stanzas written by a bore,
> Prevent your Ladyship from taking snuff![4]

Lady Holland, of course, accepted the box and at her death in 1845 she bequeathed it to the British Museum.

1 Object file, Department of Britain, Europe and Prehistory, British Museum.
2 British Library Add. MS. 15,729, ff. 55, 56. Letters to Sir Hudson Lowe.
3 K. Garlick, 'A catalogue of the paintings, drawings and pastels of Sir Thomas Lawrence', *Walpole Society*, XXXIX, 1964, pp. 238–9.
4 T. Medwin, *Journal of the Conversations of Lord Byron … at Pisa*, London 1824.

159
Finger ring
Gold with an emerald and twenty-
six diamonds in silver settings;
length of setting 25 mm
Private collection

160
Miniature enamelled badge of the
Légion d'honneur
Gold, enamelled; length 25 mm
Private collection

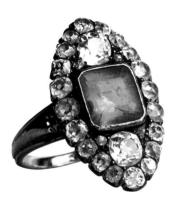

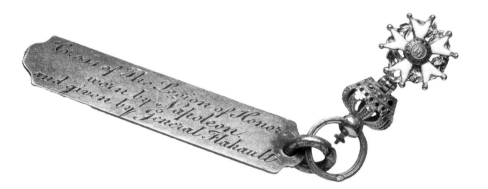

The emerald in a gold rubbed-over setting is from the narrow gold ring with two diamonds sent by Napoleon to Lady Holland. It now appears in a later marquise (or pointed oval) setting with twenty-six diamonds, the hoop with raised openwork frame below allowing light to shine through the stones. The original ring was brought to Lady Holland from St Helena by Marshal Henri Bertrand, Napoleon's loyal aide who had accompanied him into exile and remained on St Helena with his young family until 1821. In 1840 Bertrand travelled back to the island to bring Napoleon's remains for burial in Paris.

In 1802, Napoleon inaugurated the *Légion d'honneur* to take the place of royal honours. He wore this miniature cross himself. In the centre on one side is a tiny head of Napoleon surrounded by the letters: 'NAP. EMP. DES FRANC.', and on the other an eagle surrounded by 'HONNEUR ET PATRIA'.

The cross was given to Lady Holland by Auguste Charles Joseph, Count de Flahaut. The count was the illegitimate son of Talleyrand. He had been taken to England as a child by his mother who fled France in 1792, but returned in 1799 and joined the *Grande Armée*. By 1811 he was the lover of Napoleon's stepdaughter, Hortense de Beauharnais, who bore his child; in 1813 he was promoted to general and served as Napoleon's senior aide-de-camp at Waterloo; after the abdication he supported the succession of Napoleon's young son as Napoleon II. The protection of Talleyrand allowed Flahaut to cross the Channel and on 15 December 1815 he dined at Holland House. Eighteen months later he married – to the horror of her father – the Hon Margaret Mercer Elphinstone, free-spirited daughter of Admiral Lord Keith, commander of the fleet at Egypt at the time of the capitulation of the French army in 1801 and of the fleet in the English Channel in 1815; it was Keith who informed Napoleon that he was to be exiled to St Helena. The collection of Napoleonica accumulated by Flahaut passed to his daughter, who married the Marquess of Lansdowne, and remains at Bowood, Wiltshire.[1]

1 Lean 1970, pp. 176–7.

161
Benjamin Robert Haydon (1786–1846)
Napoleon Musing at St Helena, 1843–4
Oil on panel; 153 x 117 mm
Private collection

Benjamin Robert Haydon was an ambitious painter frustrated by what he described as 'the agony of ungratified ambition'.[1] He believed fervently in the importance of art and campaigned for its encouragement in Britain, but could not support his family as a history painter and had to resort to what he saw as the less worthy genre of portraiture – even then finding himself in debtors' prison on several occasions. His unfinished autobiography and diaries were published after his death, and he is best remembered for providing an intimate account of the British art world of the early nineteenth century.

Haydon's first painting of Napoleon was made for his lawyer Thomas Kearsey in 1829; the following year, Robert Peel commissioned the version now in the National Portrait Gallery. On 12 April 1831 Haydon recorded in his diary: 'Wordsworth called after an absence of several years: I was glad to see him. He spoke of my Napoleon in high poetry of language, with his usual straightforward intensity of diction. We shook hands heartily. He spoke of Napoleon so highly [Haydon means his painting of Napoleon, Wordsworth certainly did not think highly of Napoleon the man in 1831] that I wrote and told him to give me a sonnet. If he would or could, he'd make the fortune of the Picture.'[2] Two months later, he received Wordsworth's sonnet *To B.R. Haydon, on seeing his Picture of Napoleon Buonaparte on the Island of St Helena*. Six lines praising the artist's composition are followed by the poet's condemnation of the former emperor:

> And the one Man that laboured to enslave
> The World, sole-standing high on the bare hill–
> Back turned, arms folded, the unapparent face
> Tinged, we may fancy, in this dreary place,
> With light reflected from the invisible sun
> Set, like his fortunes; but not set for aye
> Like them….

Haydon returned to the subject in November 1843 and this tiny painting must be one of those he painted in four hours and sold for 5 guineas. By then he was in severe financial straits and 'resolved to paint cheap and small, rather than borrow; so far it succeeds, and I hope God will bless it, and that I may get out of debt.'[3] By 7 March 1844, he had painted 'nineteen Napoleons. Thirteen musings at St Helena, and six other musings'.[4]

On 22 June 1846, Haydon, desperately in debt, killed himself. One of his suicide notes read: 'Wellington never used evil if the good was not certain. Napoleon had no such scruples, and I fear the glitter of his genius rather dazzled me.'[5]

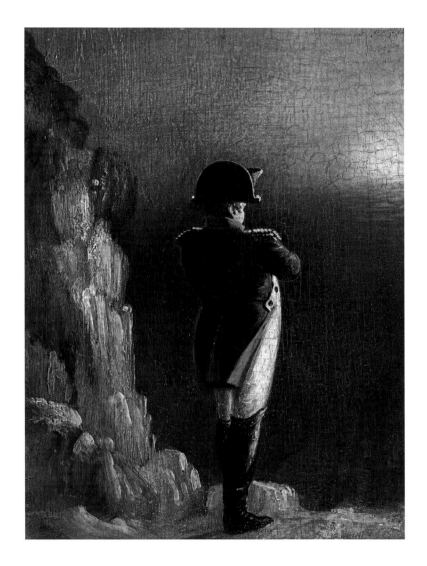

1 Haydon 1926, II, p. 717.
2 Ibid., p. 507.
3 Ibid., p. 760.
4 Ibid., p. 765.
5 Ibid., p. 819.

162

Octagonal locket with a lock of Napoleon's hair
tied with a *tricoleur* string
Rock crystal, engraved with the word
'Napoleone', with gold eagle and enamel
suspension wreath; 70 x 40 mm
Private collection

163

Mourning ring with a lock of
Napoleon's hair
1822
Gold; Height: 20 mm
Sir John Soane's Museum

The locket, and the ring and brooch shown as the next two exhibits, all contain locks of Napoleon's hair. Each has a provenance that not only gives it authenticity, but also illuminates an aspect of the former emperor's fascination for contemporary Britons: Lady Holland, the Whig activist; Elizabeth Balcombe, a young girl who met him in exile; John Soane whose interest could be described as an antiquarian concern to preserve the memory of a great man; Walter Henry, the military surgeon who attended his autopsy.

The locket was a gift to Lady Holland from Countess Bertrand, wife of the Marshal, and was taken to London by Major Thomas Poppleton, orderly officer at Longwood from December 1815 to July 1817. Poppleton had fought in Egypt and in the Peninsular Wars but was nevertheless won over by close contact with Napoleon. He long treasured another lock of hair and snuffbox that the former emperor gave him.

The ring bears a London hallmark of 1822 and inside is engraved with the words (in French), 'This lock of hair of Napoleon Bonaparte was given to John Soane Esquire by Miss Elizabeth Balcombe/Pray for me'. Elizabeth Balcombe was twelve years old when Napoleon arrived on St Helena. She was the daughter of an official of the East India Company at whose house, The Briars, the former Emperor stayed while Longwood was being prepared for him; the Company remained the colonial authority, although heavily reinforced by British military. Elizabeth records that her earliest idea of Napoleon was 'that of a huge ogre or giant, with one large flaming red eye in the middle of his forehead, and long teeth protruding from his mouth, with which he tore to pieces and devoured naughty little girls, especially those who did not know their lessons'; by the age of twelve, she had grown out of that fear, although she was still afraid: 'I had heard the most atrocious crimes imputed to him; and if I had learned to consider him as a human being, I yet still believed him to be the worst that had ever existed.'[1] However, she soon succumbed to Napoleon's charisma and was convinced that he in turn enjoyed her company. When the time came for the Balcombe family to leave the island in March 1818, he gave each member a lock of his hair.

A note in the Sir John Soane's Museum archive reads: 'Knowing how much Mr Soane esteems the reliques of great men Miss E. Balcombe presents him with a lock of Bonaparte's hair received by her from the hands of that great Personage.' The ring did not pass into public ownership like most of Soane's estate but, presumably because it meant so much to him, Soane left the ring to his grandson, John. It was purchased by Sir John Soane's Museum in 2009 with the help of the Art Fund and several private donors.

Soane would have been eager to acquire this lock of hair, not merely because it belonged to a great man: he would have wanted it specifically as a relic of Napoleon. As well as the early portrait by Francesco Cossia (cat. 2) and a miniature by Jean Baptiste Isabey, he owned three busts of Napoleon, a pistol said to have belonged to him, a sword that he is said to have presented to one of his officers, a set of the *Histoire Metallique* (see cats 64–67) said to have belonged to Josephine and more than fifty books on Napoleonic subjects.[2]

1 A. Sutton (ed.), L.E. Abell, *Napoleon and Betsy: Recollections of Napoleon on St Helena*, Stroud 2012, p. 46.
2 O. Carter-Wakefield, *Napoleonica in Sir John Soane's Museum*, Sir John Soane's Museum: unpublished catalogue 2014.

164
Brooch with a lock of Napoleon's hair
Three-colour gold; 22 x 28 mm
1978,1002.1204
Presented by Professor and Mrs John Hull Grundy

The brooch is inset with a glass-covered compartment containing knotted hair; an inscription on the reverse reads, 'Hair of Napoleon Buonaparte given to Mr Henry by Genl. Count Montholon 1 July 1821'.

Walter Henry was an army surgeon in the 66th Foot who had served in the Peninsular War and later in India before his battalion was sent to St Helena in 1817. Charles Montholon had been with Napoleon when he surrendered at Rochefort and, with his family, accompanied the former Emperor to St Helena to take charge of the household at Longwood. Montholon and Henry were both present at Napoleon's autopsy.

165
Death mask of Napoleon
Plaster of Paris cast; 270 x 150 mm
OA.4277

Napoleon died on St Helena on 7 May 1821 after several weeks of painful decline. The cause of his death is still disputed.

It was normal practice for a death mask to be made as the final portrayal of a prominent figure. As with so much of Napoleon's story, there are many conflicting accounts of the making of his death mask and its subsequent history. It would have been appropriate for Francesco Antommarchi, Napoleon's physician and fellow Corsican, to undertake the procedure, but no plaster of Paris was immediately available. In the event, the death mask was taken by Francis Burton, one of seven British surgeons present on St Helena. This produced a negative mould in several pieces. Unfortunately, when Burton attempted to take a positive cast from the mould the facial part was damaged. The damaged mould was taken by Antommarchi who set about reconstituting the missing parts with the help of a drawing of Napoleon on his death bed made by the artist Joseph Rubidge (1802–27). It seems that a small number of casts from the mould were made on St Helena, including the death masks now at Malmaison and the Musée de l'Armée in Paris, two in Ajaccio and another at the Maison Française in Oxford; the present mask is a second, or perhaps third, generation cast taken from one of these originals. Its acquisition by the British Museum is not recorded, and it may have come from one of the early editions of the mask made in 1833 or 1839.

Biographical notes

Biographies are based on the *Oxford Dictionary of National Biography*, where possible, and for British members of parliament on www.historyofparliamentonline.org. Foreign names have been anglicized.

Henry Addington (1757–1844)
On Pitt's resignation, took over as prime minister and Chancellor of the Exchequer, 14 March 1801–10 May 1804. Under his administration the Peace of Amiens was signed in March 1802 and war was again declared in May 1803.

Alexander I, Emperor of Russia (1777–1825)
Succeeded as Tsar after the murder of his father Paul I in 1801.
Sided with Britain and Austria in 1805, but after defeat at Friedland he formed an alliance with Napoleon at Tilsit in 1807. After Napoleon's disastrous Russian campaign of 1812, Alexander remained a leader of the winning coalition.

Paul Barras (1755–1829)
As a member of the Convention appointed Napoleon to suppress the Royalist rising in Paris on 13 *Vendémiaire* Year IV (5 October 1795). He was a member of the French Directory, 1795–9. A former lover of Josephine, he was said to have encouraged both her marriage to Napoleon and the young general's appointment as commander of the army of Italy in 1796.

Jean Baptiste-Jules Bernadotte (1763–1844)
Served as a general in Napoleon's army of Italy in 1797 and in 1798 married Désirée Clary who had previously been engaged to Napoleon. He was appointed Marshal of France under the Empire. In 1810 he was elected as Crown Prince by the Swedish government and acted as regent until the death of Charles XIII in 1818 when he succeeded to the throne as Charles XIV John. In 1813 joined the sixth coalition against Napoleon.

Louis Alexandre Berthier (1753–1815)
Served as chief of staff to Napoleon in Italy from 1796 and remained in that role until 1814. He was appointed Marshal of France under the Empire. He did not rejoin Napoleon during the Hundred Days and died on 1 June 1815 following a fall from an upstairs window.

Gebhard Leberecht von Blücher, Prince of Wahlstatt (1742–1819)
Commander of the successful Prussian army at Leipzig and Waterloo.

Joseph Bonaparte (1768–1844)
Elder brother of Napoleon. King of Naples and Sicily (1806–8), and of Spain (1808–13). Settled in the United States after the fall of Napoleon.

Louis Bonaparte (1778–1846)
Younger brother of Napoleon. King of Holland (1806–10). Married to Josephine's daughter, Hortense de Beauharnais; their son became Emperor Napoleon III.

Georges Cadoudal (1771–1804)
Royalist leader initially taking part in counter-revolutionary uprisings in the Morbihan and the Vendée, but later involved in conspiracies supported by the British secret service to assassinate Napoleon: the '*machine infernale*' of 1800 (cats 41–42) and the 1803 conspiracy. He was guillotined on 25 June 1804.

George Canning (1770–1827)
Held various offices of state from January 1796 to March 1801 when he resigned with Pitt. Treasurer of the navy, May 1804–January 1806; Foreign Secretary, March 1807–October 1809; ambassador extraordinary to Portugal, October 1814–June 1815; president of the Board of Control, March 1816–December 1820; Foreign Secretary, September 1822–7; prime minister and Chancellor of the Exchequer for four months in 1827. Orchestrated much of the government propaganda campaign against Napoleon.

Robert Stewart, Viscount Castlereagh (1769–1822); 1821, succeeded as Marquess of Londonderry
Chief Secretary to the Lord Lieutenant of Ireland, 1798–1801; Secretary for War and Colonies, July 1805–February 1806 and March 1807–November 1809; Foreign Secretary, February 1812–1821. Born into a prominent Ulster Presbyterian family, his severe reaction to the rebellion of the United Irishmen in 1798 was never forgotten. A long-running rivalry with Canning led to a duel on Putney Heath in September 1809. Led diplomatic negotiations towards the end of the war and at the Congress of Vienna. Suffered a mental breakdown in 1822 and killed himself by cutting his throat.

Charles (Carlos) IV, King of Spain (1748–1819)
Ruled Spain from 1788–1808. Initially maintained a neutral stance to the French Revolution, but fought against France after the execution of Louis XVI. Allied with France from 1795–1805, and again from 1807; abdicated in favour of his son Ferdinand in 1808 (see below).

Archduke Charles of Austria (1771–1847)
Brother of Emperor Francis of Austria; successful commander of the Austrian army on the Rhine in 1796, but defeated by Napoleon in Italy in 1797. Instituted important reforms to the Austrian army. Defeated at Wagram in July 1809.

Louis Antoine de Bourbon, Duke of Enghien (1772–1804)
A member of the French royal family. Fought in the Counter-Revolutionary army set up by his grand-father, Louis Joseph, Prince of Condé, that joined forces with Austria, Russia and Britain between 1791 and 1801. In 1804, he was suspected by Napoleon of involvement in the assassination plot organized by Georges Cadoudal (see above), and was abducted from his house in Baden, hastily tried and executed (see cat. 80). There was no evidence against the duke and the abduction across a national border shocked Napoleon's admirers as well as his enemies.

Ferdinand VII, King of Spain (1784–1833)
Succeeded to the throne on the abdication of his father, Charles IV, in March 1808, but was forced to abdicate by Napoleon a month later and replaced by Joseph Bonaparte. He returned as king in 1814.

Joseph Fouché (1759–1820)
As a radical Jacobin member of the National Convention, he gained a reputation for the cruelty with which he crushed Counter-Revolutionary movements during the Terror of 1793–4. Minister of police during the early years of the Consulate, under the Empire from 1804–10, during the Hundred Days, and after the 1815 restoration of Louis XVIII; his network of police spies made him extremely powerful.

Charles James Fox (1749–1806)
The most colourful and brilliant of the Whig leaders; a consistent opponent of war with France; only in office briefly as Foreign Secretary, March–July 1782, April–December 1783 and, after Pitt's death, February–September 1806.

Francis II, Holy Roman Emperor (1768–1835), from 1804 Francis I, Emperor of Austria
Ruled the Holy Roman Empire until its dissolution in August 1806 after the battle of Austerlitz; in 1804 he had founded the Empire of Austria. Earlier military campaigns had been largely unsuccessful and he had allowed Napoleon to marry his daughter Marie-Louise in 1810, but in 1813 he led Austria in the Sixth Coalition culminating in the capture of Paris in 1814.

Frederick William III, King of Prussia (1770–1840)
Remained neutral until 1806 when he was influenced by his queen, Louise of Mecklenburg-Strelitz, to join the Fourth Coalition. After defeat at Jena-Auerstädt Prussia lost territory by the treaty of Tilsit. He joined the Sixth Coalition in 1813 and was present in the field at the battle of Leipzig.

George III, King of the United Kingdom of Great Britain and Ireland (1738–1820)
By the time Napoleon came to notice in Britain, ill health had forced the king to play a less active political role than in former years, although he still exercised the right to appoint and dismiss ministers. From 1801 onwards episodes of delirium increased and on 7 February 1811 the Regency Act was passed.

George, Prince of Wales (1762–1830); from 1811–1820, Prince Regent and thereafter George IV, King of the United Kingdom of Great Britain and Ireland and King of Hanover
Notoriously extravagant and dissolute; as Regent, and later as king, he left most of the governing of the country and the conduct of the war to his ministers.

William Wyndham Grenville, Baron Grenville (1759–1834)
Held various offices from the early 1780s. Leader of the House of Lords from 1790. Home Secretary, June 1789–June 1791; Foreign Secretary, April 1791–February 1801 (resigned with Pitt); prime minister, February 1806–March 1807. Cousin and close collaborator with Pitt until 1804 when his goal of a national government led to an accommodation with Fox. He became leader of the Whig party in 1807 although still not in agreement with the Foxite Whigs who advocated parliamentary reform, Catholic emancipation and peace rather than war.

Gustav IV Adolf, King of Sweden (1778–1837)
Remained neutral until 1805 when he led Sweden into the Third Coalition; in 1806 joined the Fourth Coalition. After the Treaty of Tilsit in July 1807 Sweden and Portugal were Britain's only allies against Napoleon. Gustav was deposed in a military coup in March 1809 and lived thereafter in exile in Germany.

Sir William Hamilton (1731–1803)
From 1764 to 1800, British envoy-extraordinary, later minister plenipotentiary, to Naples where he built up a remarkable collection of antiquities, especially Greek vases, and devoted much scholarly effort to the study of vulcanology. His official duties included reporting on Jacobin activities in Naples and Rome and on the consequences of Napoleon's successes in Italy (see cat. 9). From 1799 lived, notoriously, in a *ménage à trois* with his second wife Emma and her lover Horatio Nelson.

William Richard Hamilton (1777–1859)
Diplomat and Foreign Office official from 1799–1822. While attached to Lord Elgin's embassy to Constantinople, he was responsible in 1801 for ensuring that Egyptian artefacts including the Rosetta Stone were sent to England (see cat. 31), and in 1802 for superintending the shipping of the Parthenon marbles from Athens to London. He was instrumental in ensuring that the second treaty of Paris in 1815 included provision for the return of works of art to Italy.

Robert Jenkinson (1770–1828); 1796–1803, known as Lord Hawkesbury; 1808, succeeded as Earl of Liverpool
Held various offices from the early 1790s; Foreign Secretary, February 1801–May 1804; Home Secretary, May 1804–January 1806, and March 1807–October 1809; Secretary for War and the Colonies, 1809–12; prime minister, May 1812, 16 June 1812–20 April 1827. Strongly opposed to all types of reform. His much mocked proposal in April 1794 of a 'march to Paris' was never forgotten, but in 1801 he was responsible as Foreign Secretary for opening the negotiations that led to the Peace of Amiens.

Louis XVIII, King of France (1755–1824)
Brother of Louis XVI (guillotined on 21 January 1793), came to the throne after Napoleon's first abdication in 1814, and was restored after Waterloo as head of a constitutional monarchy (see cats 132, 142 and 143).

Amabel, Lady Lucas (1751–1833)
Political writer and art collector. Born Lady Amabel Yorke, granddaughter of Lord Chancellor Hardwicke, she took a keen interest in events in which her male relatives played significant roles in various ministries, and published (anonymously) two substantial books on current events in France and their origins, as well as political pamphlets. Several prints from her large collection, given to the British Museum in 1917, are included in the present exhibition and her diaries are quoted frequently in this catalogue. She inherited the title Baroness Lucas in 1797, and in 1816 she was created Countess De Grey in her own right.

Joachim Murat (1767–1815); 1808–15, King of Naples
Came to Napoleon's attention by fetching cannons to defend the National Convention from counter-revolutionary attack on 13 *Vendémiaire* Year IV (5 October 1795). He became the most distinguished cavalry commander in the armies led by Napoleon in Italy, Egypt, Spain and Russia. In 1800 he married Napoleon's sister, Caroline. He was made Marshal of France in 1804, and King of Naples and Sicily in 1808. He attempted to retain the throne after Napoleon's fall but was defeated by forces of the restored Ferdinand IV of Naples and killed by firing squad (see cat. 149).

Horatio Nelson, Viscount Nelson (1758–1805)
The most popular of all British naval commanders. His first great victory against Napoleon was at the Battle of the Nile on 1 August 1798 (see cats 21–25), after which he remained in the Mediterranean to support the Kingdom of Naples against French attack; it was then that he began his famous love affair with Emma Hamilton. On 2 April 1801 he led the successful attack on Copenhagen, turning his blind eye to an instruction to withdraw. He was killed during the crucially successful battle of Trafalgar on 21 October 1805.

Louis Guillaume Otto, Comte de Mosloy (1753/54–1817)
French diplomat. Served in London as minister plenipotentiary from 1800–3 when he agreed the preliminaries of the Treaty of Amiens (signed in 1802). He was sent to Munich in 1803, and in 1810 to Vienna to negotiate Napoleon's second marriage.

Paul I, Emperor of Russia (1754–1801)
Succeeded his mother Catherine the Great as Tsar in 1796. Allied with Britain, Austria and the Ottoman Empire in the Second Coalition against France from 1798–9; his alliance with Britain ended in 1800. He was planning a joint attack with France on the British in India when he was assassinated in March 1801.

Jean Charles Pichegru (1761–1804)
Began his career as a teacher at the Military Academy at Brienne where Napoleon was among his pupils. He entered the army as an artillery officer in 1783, rose rapidly after the Revolution and led successful campaigns in the Netherlands before, from 1795 onwards, becoming involved in attempts to restore the monarchy. In 1803, he was involved in Cadoudal's conspiracy (see above) and was arrested; he was found strangled in prison.

William Pitt (1759–1806)
Chancellor of the Exchequer, 1782–3; prime minister and Chancellor of the Exchequer, 1783–March 1801, May 1804–January 1806. Pitt became prime minister at the age of 24 and remained in that office for all but a three-year interval until his death at the age of forty-six when, after Napoleon's victory at Austerlitz, it seemed that Britain was isolated in opposition to the French empire.

In his early years his main concern was to stabilise the economic position of the country after the American War of Independence. He was opposed to the French Revolution, but saw the necessity of war primarily in order to preserve British trading interests and national prosperity. Britain was at war for more than half his long premiership during which Pitt and the country were beset by fierce divisions in parliament and crises ranging from the question of Catholic emancipation to scandals in the royal family.

Roustan Raza (d. 1845)
An Armenian from Georgia who was sold as a slave in Egypt as a child. He was presented to Napoleon in Cairo in 1798 and served as his bodyguard until 1814.

Richard Brinsley Sheridan (1751–1816)
Born into a successful Irish theatrical family, his plays *The Rivals* and *The School for Scandal* ensured him lasting fame, and his part-ownership of the Theatre Royal Drury Lane was his chief source of income from 1778 until it burnt down in 1809. He was a member of parliament from 1780–1812, a close ally of Charles James Fox and the Prince of Wales and a consistent opponent of the war and of Pitt. Contemporaries found him unreliable both politically and personally, that tendency no doubt exacerbated by his heavy drinking, but no one denied what Lord Holland described as his 'exquisite wit'.

Sir Sidney Smith (1764–1840)
A daring and unconventional naval commander and intelligence agent. He was a particular target of Napoleon's anger because of two incidents: the burning of the French fleet at Toulon in 1793 when Napoleon, as a young artillery commander, forced the evacuation of British forces supporting a Royalist insurrection, and the successful defence of Acre against Napoleon's siege in 1798 (see p. 71). He was imprisoned from 1796–8 at the Temple in Paris charged with arson for burning the fleet at Toulon (see British Museum PD 1963,1214.14). In 1807 he escorted the Portuguese fleet, the royal family, their treasury and court to Brazil, escaping the French invasion by days.

Charles Maurice de Talleyrand-Périgord (1754–1838)
Foreign minister and diplomat working for all the French regimes from 1797 to 1834. An aristocrat who supported the Revolution, he was closely allied to Napoleon until 1807 when he resigned, objecting to continued war, and began to work secretly with Austria and Russia. He led the Senate after Napoleon's defeat in 1814 and supported the restoration of the Bourbon regime. He was the chief negotiator for France at the Congress of Vienna by which the country preserved its 1792 boundaries.

Arthur Wellesley (1769–1852); 1809, Viscount Wellington; February 1812, Earl of Wellington; October 1812, Marquess of Wellington; 1814, Duke of Wellington
After his first military successes in India from 1796 to 1805, he commanded the British army in the lengthy Peninsular War from 1809 (following an initial campaign in 1808) until French forces were finally driven across the Pyrenees early in 1814 (see cat. 116). He acted as minister plenipotentiary at the Congress of Vienna and from April 1815 shared responsibility for the defence of the Netherlands with Blücher, the Prussian commander. After Waterloo he became a national hero. He was charged with implementing the peace settlement and commanding the allied army occupying France. His later career was largely political and he was prime minister from 1828–30.

William Windham (1750–1810)
Secretary at War, July 1794–February 1801 (resigned with Pitt); Secretary for War and the Colonies, February 1806–March 1807. A vehement advocate of war and champion of French Royalists, by 1793 he was leading a group of Whig MPs who supported Pitt.

Prince Frederick, Duke of York and Albany (1763–1827)
Second son of George III who made him commander-in-chief of the army in 1798. His campaigns in Flanders, 1793–5, and the Batavian Republic, 1799, were unsuccessful, but he brought about reforms to the inefficient organization of the army. In 1809 it was revealed that his former mistress, Mary Anne Clarke, had been taking money from officers in exchange for promises of promotion.

Glossary of printmaking terms

With the exception of catalogue number 23, a theatrical poster printed from the inked surface of a woodblock, all the prints in this exhibition were printed from **intaglio** copper plates. Intaglio prints are made by incising images into a plate using one of a number of processes. The plate is then inked, wiped clean so that ink remains only in the incisions and printed under great pressure using a roller press. The pressure exerted by the rollers forces the dampened paper into the incisions and sucks out the ink. The pressure also creates a plate-mark outside the image.

The term '**engraving**' is often used loosely to describe all types of intaglio prints, but strictly speaking it applies only when incisions have been cut directly into the metal plate. The tool normally used for this technique is a burin. The process is highly-skilled and laborious and prints usually take months if not years to complete. A fine example in the exhibition is catalogue number 84, a portrait of Napoleon. Engraved lines are sometimes added to a copper plate in combination with another technique in order to create a particular surface effect.

Most of the prints in this exhibition were made by **etching** the image into the copper plate using acid. An impervious ground is laid on to a copper plate and the artist draws the image into the ground using a needle. When acid is applied the exposed areas are bitten away and will retain ink.

Stipple engraving was developed in England and became extremely popular from the 1770s onwards. It is actually an etching technique, but rather than drawing lines into the ground with a needle the artist uses a metal point to build up areas of dots of varying density. The softly modulated tones of stipple work well with the delicacy of neo-classical taste. The most successful stipple engraver of the period was Francesco Bartolozzi, see catalogue number 40.

The technique of **mezzotint** also avoids the use of line. A toothed 'rocker' is used to roughen the entire copper plate and areas intended to hold less ink are then scraped and burnished. The printed image appears in light tones out of a dark background and it is particularly effective at reproducing paintings with strong light–dark contrasts. Mezzotint was so much associated with British printmakers that it was known as the '*manière anglaise*'. The English mezzotinter William Dickinson settled in France and was a favourite printmaker of Napoleon, see catalogue numbers 43 and 135.

Aquatint is a type of etching where the ground is made up of minute particles of resin that are fused to the copper plate by heat. The acid bites around each particle so that when printed the effect is of a soft grain. The technique lends itself to experiment: particles of different sizes can be used to vary the grain, acid can be applied repeatedly with areas progressively protected by applying varnish, or the resin can be brushed on using alcohol which then evaporates leaving the grain on the surface. Specialist aquatinters in the late eighteenth century were able to imitate watercolours by building up even gradations of tone, as in the view of Waterloo by Matthew Dubourg (catalogue number 144). James Gillray, on the other hand, was not only a brilliant satirical draughtsman, but also a fine experimental printmaker who used aquatint along with a whole range of inventive techniques to create variety of surface tone and texture, see for instance, catalogue numbers 48 and 81.

Bibliography and abbreviations

The literature on the relationship of the British with Napoleon is vast and we have limited this bibliography to publications that have been particularly useful in studying the place of the pictorial print in that relationship. Other more specific references are given in footnotes throughout this catalogue.

ALEXANDER 1998
Alexander, David, *Richard Newton and English Caricature in the 1790s*, Manchester 1998

BAGOT 1909
Bagot, Josceline, *George Canning and his Friends*, 2 vols, London 1909

BAINBRIDGE 1995
Bainbridge, Simon, *Napoleon and English Romanticism*, Cambridge 1995

BANERJI AND DONALD 1999
Banerji, Christiane and Diana Donald, *Gillray Observed: the Earliest Account of his Caricatures in London und Paris*, Cambridge 1999

BERTAUD 2004
Bertaud, Jean-Paul, 'Le regard des Français sur les Anglais, des révolutionnaires de l'an II au "Jacobin Botté"' in Annie Jourdan, Jean-Paul Bertaud and Alan Forrest, *Napoléon, le monde et les Anglais: guerre des mots et des images*, Paris 2004

BERTAUD 2006
Bertaud, Jean-Paul, '*Quand les enfants parlaient de gloire: l'armée au cœur de la France de Napoléon*, Paris 2006

BINDMAN 1989
Bindman, David, *The Shadow of the Guillotine: Britain and the French Revolution*, London 1989

BM SATIRES
George, Mary Dorothy, *Catalogue of Political and Personal Satires preserved in the Department of Prints and Drawings in the British Museum*, VII–IX, London 1942–9

BROADLEY 1911
Broadley, Alexander Meyrick, *Napoleon in Caricature, 1795–1821*, 2 vols, London and New York 1911

BURROWS 2000
Burrows, Simon, *French Exile Journalism and European Politics, 1792–1814*, Woodbridge 2000

CILLESSEN ET AL. 2006
Cillessen, Wolfgang, Rolf Reichardt and Christian Deuling, *Napoleons Neue Kleider: Pariser und Londoner Karikaturen im klassischen Weimar*, Berlin 2006

CLAYTON 1997
Clayton, Tim, *The English Print 1688–1802*, New Haven and London 1997

CLAYTON 2010
Clayton, Tim, 'The Market for English Caricatures on the Continent' in Wolfgang Cillessen and Rolf Richardt (eds), *Revolution and Counter-Revolution in European Prints from 1789 to 1889*, Hildesheim 2010

CLAYTON 2014
Clayton, Tim, *Waterloo: Four Days that Changed Europe's Destiny*, London 2014

CLERC 1985
Clerc, Catherine, *La Caricature contre Napoléon*, Paris 1985

COBBETT 1802–35
Cobbett, William, *The Political Register*, London 1802–35

CORRESPONDENCE DE NAPOLÉON I^ER^
Correspondence de Napoléon I^er^, 31 vols, Paris 1858–70.

CRAIG 1799
Craig, William, *Anecdotes of General Bonaparte compiled from original and authentic papers*, London 1799

CROUZET 1985
Crouzet, François, *De la supériorité de l'Angleterre sur la France: l'économique et l'imaginaire, XVIIe-XXe siècles*, Paris 1985

DONALD 1996
Donald, Diana, *The Age of Caricature: Satirical Prints in the Reign of George III*, New Haven and London 1996

DUPUY 2009
Dupuy, Pascal, *Face à la Révolution et l'Empire – Caricatures anglaises (1789–1815)*, Paris 2009

FARINGTON 1978–79 AND 1998
Farington, Joseph, *The Diary of Joseph Farington*, edited by Kenneth Garlick and Angus Macintyre and index by Evelyn Newby, 16 vols, New Haven and London 1978–79 and 1998

FORD 1983
Ford, John, *Ackermann 1783–1983: the business of Art*, London 1983

FORREST 2011
Forrest, Alan, *Napoleon*, London 2011

FRANKLIN AND PHILP 2003
Franklin, Alexandra and Mark Philp, *Napoleon and the Invasion of Britain*, Oxford 2003

GATRELL 2006
Gatrell, Vic, *City of Laughter: Sex and Satire in Eighteenth-Century London*, London 2006

GODFREY 2001
Godfrey, Richard, with an essay by Mark Hallett, *James Gillray: the Art of Caricature*, London 2001

GORGONE AND TITTONI 1997
Gorgone, G. and M. E. Tittoni, *1796–1797 Da Montenotte a Campoformio: la rapida marcia di Napoleone Bonaparte*, Rome 1997

HANLEY 2008
Hanley, Wayne, *The Genesis of Napoleonic Propaganda*, New York 2008

HAYDON 1926
Haydon, Benjamin Robert, *The Autobiography and Memoirs of Benjamin Robert Haydon*, T. Taylor (ed.), 2 vols, London 1926

HEARD 2014
Heard, Kate, *The Comic Art of Thomas Rowlandson*, London 2014

HILL 1965
Hill, Draper, *Mr. Gillray: The caricaturist, a biography*, London 1965

HOLTMAN 1950
Holtman, Robert, *Napoleonic Propaganda*, Baton Rouge 1950

JOURDAN, BERTAUD AND FORREST 2004
Jourdan, Annie, Jean-Paul Bertaud and Alan Forrest, *Napoléon, le monde et les Anglais: guerre des mots et des images*, Paris 2004

JOURDAN 1998
Jourdan, Annie, *Napoléon: héros, imperator, mécène*, Paris 1998

KAENEL 1998
Kaenel, Philippe, 'The Image of Napoleon' in Hans Peter Mathis (ed.), *Napoleon I im Spiegel der Karikatur*, Zürich 1998

KNIGHT 2013
Knight, Roger, *Britain against Napoleon: the organization of victory, 1793–1815*, London 2013

LEAN 1970
Lean, E. Tangye, *The Napoleonists: A Study in Political Disaffection 1760/1960*, Oxford 1970

LECESTRE 1897
Lecestre, Léon (ed.), *Lettres inédites de Napoléon Iᵉʳ*, 2 vols, Paris, 1897

LUCAS DIARY
Diary of Amabel, Lady Lucas, later Countess de Grey, 1769–1827, West Yorkshire Record Office, Acc 2299

MEYER 2005
Meyer, Véronique, 'Heurs et malheurs d'un interprète de Gérard: le peintre et graveur Jean Godefroy', *Bulletin de l'Association de Historiens de l'Art Italien*, no.11 (Paris 2005), pp. 80–111

MUIR 1996
Muir, Rory, *Britain and the Defeat of Napoleon 1807–1815*, New Haven and London 1996

PELTZER 1985
Peltzer, Marina, 'Imagerie Populaire et Caricature: La Graphique Politique Antinapoleonienne en Russie et ses Antecedents Petroviens', *Journal of the Warburg and Courtauld Institutes*, 48 (1985), pp. 189–221

PELTZER 2008
Peltzer, Marina, 'From Propaganda to Trade: Russian and European Political Prints in Napoleonic Time' in Alberto Milano (ed.), *Commercio delle stampe e diffusione delle immagini nei secoli XVIII e XIX*, Rovereto 2008, pp. 411–34

PHILP 2006
Philp, Mark (ed.), *Resisting Napoleon: The British Response to the Threat of Invasion, 1797–1815*, Aldershot 2006

ROY 2008
Roy, Stéphane, 'The Art of Trade and the Economics of Taste: the English Print Market in Paris, 1770–1800', *Studies on Voltaire and the Eighteenth Century* (June 2008), pp. 167–92

SADION 2003
Sadion, Martine (ed.), *Napoléon, images de légende*, Epinal 2003

SCHEFFLER 1995
Scheffler, S. and E., *So zerstieben geträumte Weltreiche: Napoleon I in der deutschen Karikatur*, Hanover 1995

SEMMEL 2006
Semmel, Stuart, *Napoleon and the British*, New Haven and London 2006

SIMON
Simon, Jacob, *National Portrait Gallery research programmes* www.npg.org.uk/research.php

SLUB
Sächsische Landes und Universitätsbibliothek, Dresden

SPARROW 1999
Sparrow, Elizabeth, *Secret Service; British agents in France 1792–1815*, Woodbridge 1999

TULARD 1984
Tulard, Jean, *Napoleon: the Myth of the Saviour*, Theresa Waugh (transl.), London 1984

VETTER-LIEBENOW 2007
Vetter-Liebenow, Gisela, *Napoleon: Genie und Despot*, Hanover 2007

DE VINCK
Marcel Roux, *Bibliothèque nationale, département de estampes. Un siècle d'histoire de France par l'estampe, 1770–1871. Collection de Vinck, inventaire analytique, volume IV: Napoléon et son temps*, Paris 1929

WOLF
Wolf, Reva, *Goya and the Satirical Print in England and on the Continent, 1730–1850*, Boston 1991

Authors' acknowledgements

Our first acknowledgements must go to Hugo Chapman, Keeper of Prints and Drawings, who suggested the idea of an exhibition about Napoleon Bonaparte and the British based on the Museum's rich collections, and to his predecessor Antony Griffiths. Both have been endlessly supportive throughout the project, have read through drafts of the catalogue and made innumerable helpful comments. Our editor, Claudia Bloch, has been as encouraging and patient as any author could hope. Andrew Shoolbred has worked wonders in fitting together text and image.

Special thanks go to colleagues in France and Germany: Véronique Meyer, Martine Sadion, Wolfgang Cillessen, Rolf Reichardt, Pascal Dupuy for invaluable advice on journalism and caricature in England and France, and Philippe de Carbonnières, whose book on the Grande Armée in caricature will appear in the near future. Our thoughts on the image of Spain in British caricature were stimulated by conversations with Jesusa Vega of the Universidad Autónoma de Madrid. Kate Heard and Emma Stuart of the Royal Collection went out of their way to provide fascinating information on the Prince Regent's collecting of Napoleonic material. John Ford generously shared his continuing research on Rudolph Ackermann. We are also grateful to scholars who have spent time considering the complexities of the British relationship with Napoleon and have shared their thoughts and their enthusiasm: Christopher Woodward, Alexandra Franklin of the Bodleian Library, and Mark Philp and Kate Astbury of the University of Warwick whose virtual exhibition *Napoleon: 100 Days in 100 Objects* will coincide with ours.

Besides these key characters, we have called for help of many and varied kinds from colleagues and friends within and outside the British Museum. We particularly have to thank: David Agar, David Alexander, Christina Angelo, Philip Attwood, Caroline Barry, Giulia Bartrum, Jenny Bescoby, David Bindman, Horatio Blood, Barbara Canepa, Frances Carey, Esther Chadwick, Isabella Chapman, Charles Collinson, Barrie Cook, Guillaume Cousin, Sarah and Jean-Louis Cousin, Paul Cox, Oskar Cox-Jensen, Anthony Cross, Aileen Dawson, Agnieszka Depta, Stephen Dodd, Diana Donald, Helen Dorey, The Marquess of Douro, Harriet Drummond, William Drummond, Andrew Edmunds, Oliver Flory, Charlotte Gere, David Giles, Paul Goodhead, Jane Greenwood, Mark Hallett, Rebecca Haywood, Peter Hicks, Thomas Hockenhull, Dudley Hubbard, Jane Kennedy, David Kenyon, Ivor Kerslake, Jerzy Kierkuc-Bielinski, Edmund King, Joanna Kosek, Charlotte Lepetoukha, Kevin Lovelock, Janine Luke, Anne Lyles, David McClay, Tanya Millard, Megumi Mizumura, John and Virginia Murray, Josephine Oxley, Ian Park, Carolyn Parker-Williams, Richard Parkinson, Saul Peckham, Mary Peskett-Smith, Jean Rankine, Jude Rayner, Angela Roche, Philip Roe, Kevin Rogers, Lydia Rousseau, Michael Row, Judy Rudoe, Alice Rugheimer, Francis Russell, Axelle Russo-Heath, Ann Saunders, Diana Scarisbrick, Helen Sharp, Monica Sidhu, Kim Sloan, Christopher Stewart, Martin Stiles, Nigel Talbot, The Hon. Mrs Charlotte Townshend, Sarah Turner, Patricia Usick, An Van Camp, Susan Walby, Emma Webb, James Weddup, Lady Jane Wellesley, John Williams, Pam Woolliscroft and Alison Wright.

Illustration credits

The publishers would like to thank the copyright holders for granting permission to reproduce the images illustrated. Every attempt has been made to trace accurate ownership of copyrighted images in this book. Errors and omissions will be corrected in subsequent editions provided notification is sent to the publisher.

All photographs of British Museum objects are © The Trustees of the British Museum, courtesy of the Department of Photography and Imaging.

Page 13, fig. 1: Library of Congress

Page 31, fig. 10: © Musée Carnavalet/Roger-Viollet

Page 34, fig. 12: The Bodleian Library, University of Oxford. Curzon B.4(178)

Page 35, fig. 13: © Musée Carnavalet/Roger-Viollet

Page 43, fig. 18: Bibliothèque Nationale de France

Page 47, fig. 20: Bibliothèque Nationale de France

Page 54, cat. 2: By Courtesy of the Trustees of Sir John Soane's Museum

Page 63: Bibliothèque Nationale de France

p. 169: © Iberfoto/Superstock

p. 233, cat. 155: National Library of Scotland

p. 240, cat. 163: © Christies/Bridgeman Images

Index